IMPRISONED IN A LUMINOUS GLARE

IMPRISONED IN A
LUMINOUS GLARE

Photography and the African American Freedom Struggle

Leigh Raiford The University of North Carolina Press CHAPEL HILL

All rights reserved. Designed by Kimberly Bryant and set in Warnock Pro and Avenir types by Tseng Information Systems, Inc. Manufactured in the United States of America. The paper in this book meets the guidelines for permanence and durability of the Committee on Production Guidelines for Book Longevity of the Council on Library Resources. The University of North Carolina Press has been a member of the Green Press Initiative since 2003.

Library of Congress Cataloging-in-Publication Data
Raiford, Leigh.
Imprisoned in a luminous glare : photography and the African American freedom struggle / Leigh Renee Raiford. — 1st ed.
p. cm.
Includes bibliographical references and index.
ISBN 978-0-8078-3430-5 (cloth : alk. paper)
1. African Americans—Civil rights—History. 2. African Americans—Civil rights—History—Pictorial works. 3. African Americans—History—Pictorial works. 4. African American civil rights workers—Pictorial works. 5. Civil rights movements—United States—History. 6. Civil rights movements—United States—History—Pictorial works. 7. United States—Race relations. 8. United States—Race relations—Pictorial works. 9. Photography—United States—History—20th century. I. Title.
E185.61.R234 2011
323.1196073—dc22

1006362 70X 2010034642

Part of chapter 2 appeared in "'Come Let Us Build a New World Together': SNCC and Photography of the Civil Rights Movement," *American Quarterly* 59, no. 4 (December 2007): 1129–57. Parts of chapter 3 appeared in "Restaging Revolution: Black Power, *Vibe* Magazine, and Photographic Memory," in *The Civil Rights Movement in American Memory*, edited by Renee C. Romano and Leigh Raiford (Athens: University of Georgia Press, 2006), 220–49. Used with permission.

cloth 15 14 13 12 11 5 4 3 2 1

To

Goldie Green Robinson (1912–2010),

Andrew Mordecai Raiford (1987–2010),

and

Maya and Maceo Raiford-Cohen

CONTENTS

This project is well traveled. It has visited three continents, lived in four states, had audiences in at least six more (and the District of Columbia). It has taken form in classrooms, conference rooms, kitchens, and dining rooms; front porches, backyards, playgrounds, and hotels; offices, bars, libraries, and hallways; airplanes, automobiles, Metronorth, and long hikes. It came into materiality on no less than six separate computers and countless notebooks, legal pads, journals, and scraps of paper. As such, this project bears the imprint of its journeys and the varied communities in which it has found long- and short-term homes.

Hazel Carby, Glenda Gilmore, and Laura Wexler guided this project at its earliest stages. For over a decade they have been generous, brilliant, insightful, at turns patient and prodding, and always encouraging. They have continuously helped me see more and see better. And their models of intellectual engagement have been an inspiration. At Yale, I had the good fortune to learn from Jean-Christophe Agnew, Cathy Cohen, Michael Denning, Paul Gilroy, Jonathan Holloway, and Matt Jacobson, all of whose probing questions I am still striving to answer. Before I arrived in New Haven, I spent four years up the road in Middletown, Connecticut. At Wesleyan, Ann du Cille, Joel Pfister, and Ashraf Rushdy showed me that cultural criticism has both intellectual and political merit. Along with Krishna Winston, they set me on the road to academia.

This project has been strengthened by the knowledge and enthusiasm of many librarians. I am thankful to all of them for their patient assistance, especially Pat Willis at the Beinecke, Polly Armstrong at Stanford, Mary Yearwood at the Schomburg, Julie Herrada at the Labadie, Erika Gottfried at the Tamiment, Lisa Marine at the Wisconsin Historical Society, and Phyllis Bischof at the Bancroft. This book has been enriched immeasurably by the activists and photographers who generously granted interviews, spoke with me via telephone or email, and shared their memories. I am deeply indebted to all. Kathleen Neal Cleaver, Emory Douglas, Matt Herron, Billy X Jennings, Julius Lester, Elizabeth Martinez, and Maria Varela have been especially magnanimous. I hope at the very least to have told a story that is worthy of their experiences and their contributions to social justice. I would also like to thank all the artists who have allowed me to reproduce their

work in this book, images that I continually find powerful and thought-provoking. And thanks to the artists Deborah Grant, Leslie Hewitt, Hank Willis-Thomas, and Soul Salon 10, who agreed to be included and whose work helped crystallize my own thinking about what and how we as the "post–civil rights generation" see history.

I am grateful to the numerous institutions, foundations, and fellowships that found this work worthy of financial support: the Beinecke Rare Book and Manuscript Library and the John F. Enders Research Grant, both at Yale; the ongoing support of the Mellon Minority/Mays Undergraduate Fellowship Foundation; the Ford Foundation Predoctoral, Dissertation, and Postdoctoral Fellowships; the Woodrow Wilson Foundation Postdoctoral and Career Enhancement Fellowships; and at the University of California–Berkeley, the Townsend Center for the Humanities, the Abigail Reynolds Hogden Publication Fund, and the Hellman Family Faculty Fund.

Many people read parts of this book; many more listened to pieces in the form of conference papers, talks, and symposia; and still more endured my struggling to make intellectual sense of this project. Thanks especially to the Photographic Memory Workshop at Yale University, which has provided intellectual community and ongoing friendship since 2000; the members of the John Hope Franklin Humanities Institute Seminar on Race, Justice, and the Politics of Memory at Duke University, expertly convened by Srinivas Aravamudan and Charlie Piot; and to the participants in the Race/Gender/Visual Culture Working Group, convened by myself and Elizabeth Abel. I also must thank the organizers and participants of symposia at Brown University, Connecticut College, Cornell University, Seoul National University, Smith College, Stanford University, University of North Carolina at Chapel Hill, University of Illinois at Urbana-Champaign, University of San Francisco, University of Toronto, and Yale University for creating space and opportunity to develop ideas. Thanks especially to Courtney Baker, Robin Bernstein, Jayna Brown, W. Fitzhugh Brundage, Tina Campt, Katherine Mellen Charron, Bridget Cooks, Cheryl Finley, Jay Garcia, Jonathan Holloway, John Jackson, John Jennings, Charles McKinney, Eden Osucha, Robert Perkinson, Thy Phu, Richard Powell, Kevin Quashie, Renee Romano, Rebecca Schreiber, Naoko Shibusawa, Maurice Stevens, Ruby Tapia, John Tagg, Jennifer Tucker, Maurice Wallace, and Laura Wexler for their collegiality, hospitality, and thoughtfulness. Thank you also to Jacqueline Francis, Robin Hayes, Ayize Jama-Everett, John Jennings, David Marriott, Mireille Miller-Young, Mendi+Keith Obadike, Ngozi Onwurah, Kamau Amu Patton, Yoruba Richen, and Carla Williams, who all graciously

participated in two speaker series I organized on the subject of black visual culture; their thoughtful presentations greatly shaped my thinking about what blackness can be and can do. I would be remiss if I did not mention Shawn Michelle Smith and Renee Romano, who have been mentors, collaborators, and friends. Their scholarship has guided my own work, and their willingness to lend support to junior colleagues has been a gift and an inspiration. I have been profoundly influenced by a host of scholars whom I know primarily through their work: Stuart Hall, Kobena Mercer, Isaac Julien, Charles Payne, Jacqueline Goldsby, Jacqueline Stewart, and John Berger.

All of my colleagues at UC-Berkeley in the Department of African American Studies have been incredibly supportive, offering the wisdom of their time at Cal and the freedom to pursue my research interests. In addition to being incredible scholars, Robert Allen and especially Hardy Frye have shared their memories of and insights on political activism. Ula Taylor has provided a model of graciousness and integrity. Brandi Catanese and Darieck Scott have been cultural studies co-conspirators, and Brandi's friendship has brought levity to even the most complex of problems. Elizabeth Abel reached out early in my time here, and together we carved out a niche to think race and photography. Kathleen Moran and Richard Hutson opened their home(s), their family, and the incredible entity that is the American Studies Program to us; I only hope that we will one day have the opportunity to reciprocate. Teresa Stojkov has made the resources of the Townsend Center for the Humanities available to me. And Evelyn Nakano Glenn has made the Center for Race and Gender a comfortable interdisciplinary outpost. Waldo Martin and Saidiya Hartman have provided perspective and guidance. Abena Dove Osseo-Asare and the monthly Black Women's Faculty Luncheons have offered a forthright presence on campus. Kathleen Donegan, Scott Saul, and their families have extended the gift of their friendship.

My students at UC-Berkeley have been an impressive lot, diverse in ways I could never have imagined, and frankly heroic in the face of budget cuts and fee hikes. They never cease to surprise me with their interest, delight me with their creativity, and force me to clarify my ideas. They remind me that the questions that guide this project resonate with younger generations and are worth struggling over. I am also deeply indebted to Jasminder Kaur who, as my research assistant, provided invaluable labor in securing permissions.

UNC Press has been a nurturing publisher. Sian Hunter has been patient

and forthright. Beth Lassiter fielded every one of my neophyte questions with grace.

The manuscript has benefitted enormously from the careful reading and unwavering encouragement of two writing groups. The first met in the lounge of 493 College in New Haven and consisted of Cheryl Finley, Eric Grant, Françoise Hamlin, Lisa McGill, Qiana Robinson Whitted, and Heather Williams. The second emerged in 2008 like a gift from the Pacific Ocean and made all the difference in the final push. SURPLUS meets in and around Berkeley and Oakland and is comprised of Michael Cohen, Robin J. Hayes, Tori Langland, Susette Min, and Grace Wang. Brilliant and caring, they have seen me at my most fragile, heard me at my most incoherent, and guided me through moments of debilitating self-doubt. Writing bonds have become bonds of friendship. And I look forward to many years of exchanging work.

Two other groups have been a source of tea (or wine) and sympathy. Monthly meetings with Janet Shim, Jiwon Shin, and Irene Yen, simply called GROUP, gave space for junior faculty women to make sense of being junior faculty women. Outside of the academy, Ladies Who Lunch (LWL) gave space to working moms to make sense of being working moms. I am grateful to Yavette Holts and Andrea Woloschuk for easy laughter, yoga, Mexico, and a standing lunch date.

With each move I've made, I've managed to get further from my family of origin. I remain humbled by and grateful to my various communities who have become surrogate family; who ate and drank with me; ran up and down a soccer field with (or against) me; hiked the Fire Trail, the Nimitz, or Yosemite; indulged photos of my children, my garden, and/or every meal I've ever eaten; spent time on my front porch; marched a picket line; played hooky with me; settled into serious work with me; cared for my children or entrusted their children to me; endured my complaining and celebrated my successes; or saw fit to share their own joys and sorrows with me. I am fortunate that there are so many to name: Andrea Becksvoort, Kathleen Donegan and David Goldsmith, Françoise Hamlin, Robin J. Hayes, Rebecca Hendrickson, Brian Herrera, Christie Keith and Josué Revolorio, Rachel Knudson and Jason Wilkinson, Ayize Jama-Everett, Annie Leonard, Kari Main, Shannon and Carter Mathes, Katherine Mellen Charron, Alondra Nelson, Nima Paidipaty, Kamau Patton, David and Pennie Warren, and Miya Yoshitani and Danny Kennedy. The reemergence in my life of Alison Perry, Kyla Kupferstein Torres, and Hayley Man has been an incredible gift (three actually).

My own family of origin has remained steadfast. The Raifords, the Mordecais, the Abarcas, the Robinsons, the Cohens, and the Cooks have granted me time, money, a good laugh, and safe retreat time and again. I am especially grateful to Shirley Mordecai and Goldie Robinson, my mothers, my brothers Joshua and Andrew Raiford, and a host of cousins, including Lindsay Abarca, Anissa Ford, Marta Alaina Holliday, and Caroline Cohen Lindsley. Thank you to Joan and Steve Cohen for Michael, for unquestioning support, and for boundless love for their grandchildren. And I have not enough words for my parents, Iris Raiford, who gifted me with practicality, and Dwight Raiford, who gifted me with ambition and the ability to craft a sentence. They are a model of integrity, love, and the power of partnership. I thank them for believing in me, for letting me go and letting me come back, and for letting me stand on their strong and impressive shoulders.

Every word of this book was written as a parent, and I am endlessly grateful to my children, Maya and Maceo Raiford-Cohen. Their wit, charm, intelligence, tenacity, creativity, adventurousness, and loving impatience have made this a better book and me a better person. As their great-grandfather, Haley Mordecai, used to tell me, they've been nothing but good news.

Finally, I would be nowhere without my partner, Michael Cohen. He has been an enthusiastic and critical reader and a most trusted confidant and collaborator. He has been Samwise to my Frodo, Pheoby to my Janie, stick to my melting clock. A brilliant scholar, gifted teacher, and tireless agitator, he has unceasingly inspired me by his energy. And I am humbled by his devotion to me and our children. Thank you, Michael, most of all, for taking this journey with me.

IMPRISONED IN A LUMINOUS GLARE

For nearly two weeks in early May of 1963, national and international audiences rose each morning to images of violence, confrontation, and resistance splashed across the front pages of their major newspapers. Black-and-white photographs paraded daily through the *New York Times* and the *Washington Post* depicted white police officers in Birmingham, Alabama, wielding high-powered fire hoses and training police dogs on nonviolent black and often very young protesters (figures i.1, i.2). Organized by the Southern Christian Leadership Conference (SCLC), "Project C" (for "confrontation") brought center stage the publicly unacknowledged terror, violence, and daily inequities African Americans had long suffered at the hands of white southerners. Through forced confrontations between blacks and whites, between constitutional right and segregationist practice, between the genteel, progressive image of the New South and the dehumanizing Old South reality, the thousands of men, women, and children who participated in Project C confronted a watching world with the contradictions of contemporary southern race relations. They vividly and visually challenged an entire economic and social regime of power.

A year later, SCLC's leader, Dr. Martin Luther King Jr., recognized the importance of such vivid imagery in galvanizing support for the Civil Rights Act of 1964. King wrote of the campaign in his book *Why We Can't Wait*, "The brutality with which officials would have quelled the black individual became impotent when it could not be pursued with stealth and remain unobserved. It was caught—as a fugitive from a penitentiary is often caught—in gigantic circling spotlights. It was imprisoned in a luminous glare revealing the naked truth to the whole world."[1] For King, the visual media proved a crucial component in capturing "fugitive" brutality, holding it still for scrutiny and transmitting this "naked truth" to watching and judging audiences. King praises photography and film for their work of exposure, revealing through mechanical reproduction facts that had remained hidden and therefore difficult to prove. By the time King penned *Why We Can't Wait*, he had witnessed, deployed, and been the subject of photographs of movement events both spectacular and quotidian. He believed deeply in their power to image African Americans as U.S. citizens who, like their white counterparts, were deserving of equal treatment. Images of the broken body

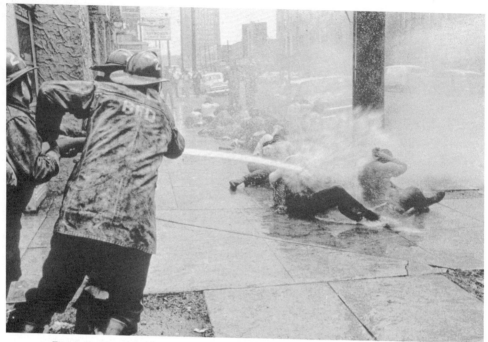

Figure i.1. Firemen blast protestors with high-pressure hoses, corner of Fifth Ave. North and 17th Street, Birmingham, Alabama, May 3, 1963. Photograph by Charles Moore. (Charles Moore/Black Star)

of Emmett Till, of whites' abuse of four African American North Carolina A&T students sitting in at a Greensboro Woolworth's lunch counter, of baseball bats and firebombs that greeted Freedom Riders in Mississippi and Alabama bus stations each reveal how vulnerable African Americans were when demonstrating for the most basic and fundamental of rights. They laid bare to nonblack audiences what African Americans of the Jim Crow era had long known, seen, and experienced. With bright enough lights and an army of cameras trained in the right direction, images were central to changing public opinion about the violent entrenchment of white supremacy in the South and that system's overdetermination of black life and possibility. The visual proved a tool as effective as bus boycotts and as righteous as nonviolence.

But white violence and black resistance are not the only captives imprisoned within the camera's luminous glare and vigilant eye. For many viewers today, almost the entirety of the civil rights movement is captured, quite literally, in the photographs of Birmingham 1963. These images have shaped and informed the ways scholars, politicians, artists, and everyday people re-

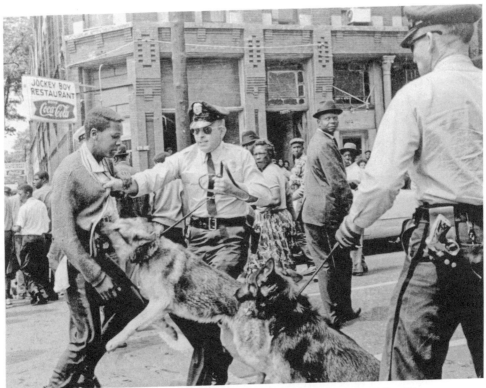

Figure i.2. William Gadsen attacked by police dogs in front of 16th Street Baptist Church, during a nonviolent protest, Birmingham, Alabama, May 3, 1963. Photograph by Bill Hudson. (AP Photos/Bill Hudson)

count, remember, and memorialize the 1960s freedom struggle specifically and movement histories generally. The use and repetition of movement photographs in contexts as varied as electoral campaigns, art exhibits, commercials, and, of course, academic histories have crystallized many of these photographs into icons, images that come to distill and symbolize a range of complex events and ideologies. These icons, in turn, become integral to processes of national, racial, and political identity formation. Even as these photographs mark movement participants' attempts to rewrite the meaning of black bodies in public space, the photographs also imprison—frame and "iconize"—images of legitimate leadership, appropriate forms of political action, and the proper place of African Americans within the national imaginary. The repeated use of many of the more recognizable photographs of African American social movements has had a "surplus symbolic value" in the work of constructing and reconstructing our collective histories.[2]

And they become guides to appropriate forms of future political action. Photographs become tools to aid memory. We are invited, expected, even demanded to recount and memorialize. To remember. But what exactly are we being asked to remember? How are we being asked to remember? And to what end?

King's apt phrase "imprisoned in a luminous glare" as metaphor for the work of the camera in African American social movements alerts us to the dialectical relationships between mass media and mass movements, photography and race, history and memory. It also suggests the tensions between captivity and fugitivity, the contradictions inherent in attempting to fix that which by its nature is mobile and mercurial. It calls attention to how mass media attempt to capture mass movements, photography tries to name and regulate "race," and history works to tame memory. The photograph in particular imposes a unitary vision and helps fix the meaning of that which it records. It provides the illusion of seeing an event in its entirety as it truly happened.

Just as Project C has become a touchstone of the civil rights movement, the photographs themselves have come to epitomize the power of photography in this moment. Even photographs as compelling as these cannot tell the whole story, cannot imprison all. One method of reading images would have us turn to the blurry figures appearing at the edges of the Project C photographs, Birmingham's other black youths (figure i.3). Not so properly attired or as well-behaved, these young, poor men and women refused to participate in the nonviolent actions that captured the world's attention. They were less interested in the desegregation of public spaces than in economic equity. In the photographs we might catch them with their arms folded, intransigent witnesses. But outside the picture's frame they threw bottles and shouted obscenities at Bull Connor's police force. Subsequently, they were disciplined by the Birmingham police, by the organizers of Project C, and by the photographic frame that excised them from the documentary evidence of those events. The now-iconic photographs from Birmingham 1963, as noted by King, imprison Jim Crow order; yet what remains elusive in this framing is the expansive expressions of black political desire, constantly changing and evolving over the course of the twentieth century.[3]

But my examination of these photographs is not about recovering lost histories, to suggest that with more cameras or more sensitive photographers, we could fully understand the movement. Rather than reading from the edges, we need to consider the photograph's very center. What work

Figure i.3. Crowd watches Birmingham protests, Birmingham, Alabama, May 3, 1963. Photograph by Charles Moore. (Charles Moore/Black Star)

does the photograph as a "disciplinary frame" perform in narrativizing the civil rights movement?[4] The photographs of Birmingham imply African American unity and imagine a saintliness of the movement and its non-violent participants, certainly a necessary vision to project at the time. They also suggest the spontaneity of actions that were instead well-planned and tested intensively in locations within Alabama and throughout the South prior to those days in May. These narratives of spontaneous uprising are facilitated by equally circumscribed beliefs in "the innocent eye" of the photographer, the observer who became witness with the release of the shutter.[5] Yet the images that appeared in national and international newspapers were made by accomplished, professional photographers. Alabama photojournalist Charles Moore carefully chose equipment that forced him to enter the fray, in turn producing photographs of great power. However, to focus on the subjects at the center of the frame is to miss the labor not only of the movement itself but of the photograph and its processes of meaning-making. Photographs of the violence of Birmingham had to be placed within a new discursive frame that understood black protesters as heroic rather than simply impervious to pain, where stoicism represented righ-

teousness rather than subhumanity. And even as civil rights activists were largely successful in shaping the national discourse, they could not always guarantee that their meaning would adhere. When *Life* printed Moore's Birmingham photographs, the magazine described the protesters as inciters of "simmering racial hatred," bringing violence upon themselves in order to manipulate the press. Photographs meant to provide irrefutable evidence of the brutality of the Jim Crow system could still be made to testify to the poverty of black moral character. It is not that photographs "lie," but we unduly invest them with the burden of an all-knowing truth.

We also need to consider what it means that a photograph is itself a mode of arrest and incarceration. Not just considering the margins and the center, a third method of reading compels us to interrogate photographic passage through time. The fecund irony of the "movement photograph"— the frozen document of a world-changing popular mobilization—reveals the complex work of photography in the long African American freedom struggle. Moore's photographs capture a specific lionized mode of black politics: of middle-class, and thus deserving, citizens making legitimate and righteous claims on the state, the spectacle of black strength and suffering facing overt and unmistakable acts of white supremacy. Surely these photographs are inspiring and moving, mobilizing audiences to join or support the second Reconstruction. But as photographs made to signify as document, illustration, and testimony, they are locked in the moment of their production, frozen in time yet moving through history. What marks the success of the photograph in the fight for the Civil Rights Act is also what initiates its limitations for future generations: How does one engage in antiracist struggle in a "color-blind" era when racism "looks" so different? We must then continually read the photograph, especially in the context of the long African American freedom struggle, as both artifact and artifice, as indexical record and utopian vision, as document and performance.

Taking King's metaphor as guide, *Imprisoned in a Luminous Glare: Photography and the African American Freedom Struggle* examines the vital yet contentious role photography has played in the mobilization, expansion, and consumption of three twentieth-century African American social movements. This book charts the changing relationship of black political activism to the photographic medium by detailing the history of photography in the service of antilynching, civil rights, and black power movements. It takes multiple collections of photographs—of lynchings and police brutality, public parades and demonstrations, family and community activities, as well as the media of their dissemination in pamphlets and newsletters, as

posters and buttons—and reinserts them into histories of the long African American freedom struggle. In doing so, we see the premium Ida B. Wells, the NAACP, the Student Nonviolent Coordinating Committee (SNCC), and the Black Panther Party (BPP) placed on photography as a democratic and versatile medium through which to engage in the fraught politics of black representation, address a range of constituencies, and give a visual shape to courageous movements for social justice. Through this history, the book demonstrates the impact the movements themselves have had on black representation and the ways these movements have been memorialized and appropriated through their imagery. Not only do I argue that photography had an impact on African American social movements, by publicizing aims, mobilizing participants, and visually narrating histories, but I further contend that African Americans' changing relationship to the photograph itself, as evidenced in the deployment of the medium in political activism, reveals that African American social movements have profoundly shaped the ways we understand the politics of photography specifically and of black visuality more broadly.

To examine the dialectics between movement and medium, between (cultural) visibility and (political) invisibility, we are required to ask how and why African American activists chose to enlist photography as part of their political strategies, across a period in which the stakes of cultural representation were often dangerously high. What secrets could this visual technology—which by the turn of the twentieth century was used to depict everything from the illustrious to the illicit, the comedic to the catastrophic—expose about African American life on the margins of the American Dream that sociological studies, journalistic accounts, and political rhetoric could not? What kinds of political and cultural possibilities did the relationship between photography and social movements both thwart and engender? In the context of the long African American freedom struggle, the decision to use or not to use photographs came with a host of questions and doubts as well as occasioned a series of creative and interventionist strategies.

I am concerned with how the attempt to represent black political interests photographically proved at once a seemingly natural and effective tactic and an aporetic strategy, rife with ambivalences. Through their use of photographs, we can see how African American activists worked to transform national consciousness through the critique of racial logic, through the assertion of themselves as viewing and acting subjects, not simply objects, and through the attempt to provide a fitting memorial for black lives

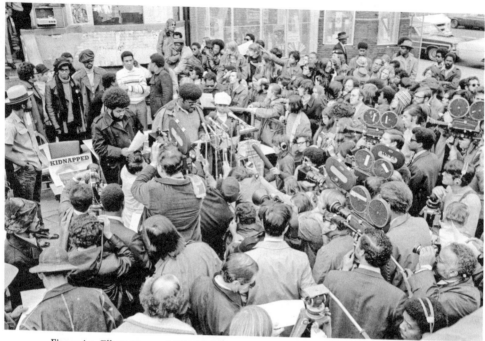

Figure i.4. Elbert Howard (Big Man) of the Black Panther Party holds press conference, Washington, D.C., 1970. Photograph by Stephen Shames. (Polaris)

so viciously cast aside. For African Americans, photography necessitated an opportunity and a challenge to reclaim, repair, remake, reimagine, and redeem.

At times quite successful, activists also ran aground on photography's shoals. Indeed, the aspects of photography that made lynching images so readily available for antilynching activism, cameras so accessible to SNCC field workers, or photographers so attracted to the Black Panthers, are the same characteristics that beleaguer photography's use (figure i.4). Despite the camera's capacity to accurately fix a sight or event before it, photographic meaning always proves far more protean. Is it possible in the changing racial landscape of twentieth-century America to reconceive long-held commonsense narratives of blackness that crystallize and adhere in the photograph?

Moreover, the intense circulation of photographs as postcards, trade cards, posters, buttons, and in newspapers suggests that the image was always in danger of reproducing the violence or spectacularizing the figures it documents without occasioning an opportunity for action, engendering both shock and silence. And in its manifestation as photograph, a medium

so closely aligned to the circulation and distribution of commodities, the reproduction of black images always has the potential to reify the black body (in pain or in triumph) as commodity. Likewise, the photograph has been central to the rapidity of the news industry, potentially rendering African American issues as shocking news items today, easily forgotten tomorrow, in spite of efforts to narrate otherwise. Taken together, we can see how photography—its antinomies of knowing and unknowing—emerged as a significant, if obstreperous, site of antiracist struggle.

This book interrogates photography in the service of African American social movements as the site of a threefold struggle through and for the black body, the black eye, and black memory. In the first site, social movement activists employed photography as a means of critiquing the racial logics and received meanings assigned to the black body. By reimaging and reframing the visual presentation of African Americans in the context of political struggle, the activists considered in this study enlisted photography to both unmake and remake black identity. That is, photography could be used to challenge dominant representations of African Americans as ignorant, poor, and unfit for citizenship and simultaneously be used to visually assert an image of worth, dignity, and self-possession. Rather than visualizing African Americans as the scourge of the nation, activists employed photography to depict state crimes against an aggrieved people. The form, frame, and location that these images took, however, reveal much about the different political platforms of each movement and what place they saw for African Americans within the United States. Antilynching activists included photographs of black corpses within pamphlets circulated among prominent white citizens, placing the burden of political action on whites even as African Americans were the most tireless antilynching campaigners. The SNCC Photo Agency produced posters made from portraits of nameless figures to assert the universality of the southern poor while reaching out to a youthful constituency. Black Panther Party members, both leadership and rank and file, photographed themselves bearing arms and in self-fashioned uniforms declaring a militant nationalism that flouted the authority of the U.S. state and formed a visual alliance with Third World liberation struggles. Photography then, offered activists a seemingly democratic and versatile medium through which they could visually reference, reframe, or reject dominant political categories. In doing so, activists from Ida B. Wells to Emory Douglas worked to recast the meaning of black identity and national belonging and illuminated the contradictions of racial ideology.

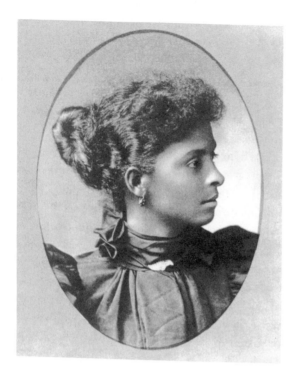

Figure i.5. African American woman, head-and-shoulders portrait, 1899 or 1900. (Library of Congress, Prints and Photographs Division, Daniel Murray Collection, LC-USZ62-124798)

The archive of social movement photography is in conflict and conversation with other photographic representations of African Americans. How are these movement photographs destined for public space and put to explicitly political purpose made to signify in relation to a spectrum of images of black bodies, from the noble to the ignoble, the chaste to the depraved, the victimized to the violent? Disjunctures in racial epistemology come into sharp relief when we consider the crucial if unacknowledged place social movement photographs have occupied in the shadow archive of black representation. Photographer and theorist Allan Sekula describes a "shadow archive" as an all-inclusive corpus of images that situates individuals according to a socially proscribed hierarchy. Sekula tells us:

> The *private* moment of sentimental individuation [embodied in portraiture] . . . is shadowed by two other more *public* looks: a look up, at one's "betters," and a look down at one's "inferiors." . . . The general, all-inclusive [shadow] archive contains subordinate, territorialized archives: archives whose semantic interdependence is normally obscured by the "coherence" and "mutual exclusivity" of the social groups registered within each. This general, shadow archive neces-

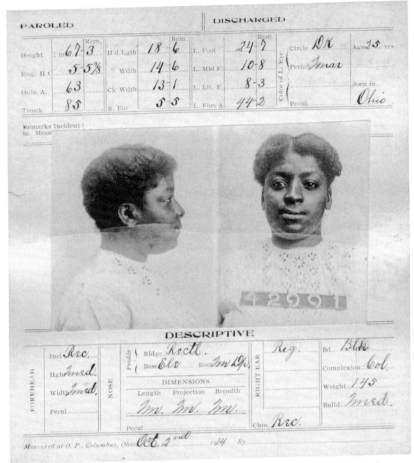

Figure i.6. Bertillion card of Pearl Enoch, Ohio, 1914. (Ohio Historical Society)

sarily contains both the traces of the visible bodies of heroes, leaders, moral exemplars, celebrities, and those of the poor, the diseased, the insane, the criminal, the nonwhite, the female, and all the other embodiments of the unworthy.[6]

According to Sekula then, photographs are not simply singular images of exemplary or common or degenerate individuals. Nor are the subordinate archives—police mug shots or bourgeois portraiture—from which these singular images emerge, wholly distinct. Rather these archives and the photographs within signify in relation to one another. They function as visual indicators of the social and moral status of their subjects (figures i.5, i.6). More than this, each form, each visual territory, works to discipline its

subjects and its viewers into discrete class groups, "provoking both ambition"—the look up—"and fear"—the look down.[7]

Sekula's assertion that the paradoxes of photographic portraiture in a capitalist society function to produce a "characteristically 'petit-bourgeois' subject" is useful here for considering how photography has simultaneously produced racial subjects and indeed "confirmed" the existence of race itself. Photography's uniqueness as a medium and its early and enduring appeal lay in its ability to *record*, not merely depict that which exists in the material world. Called a "mirror with a memory" by physician and inventor Oliver Wendell Holmes not long after its inception in this country in 1839, photography quickly surpassed painting in its imagined capacity to capture history and human experience *as it truly was*, unmediated by human hands. For now, in the words of an April 13, 1839, *New Yorker* magazine article, "All Nature Shall Paint herself!"[8] The medium's magic rests in its function to offer an index, a sign of a "truly existing thing." In the same spirit in which emergent genetic technologies are heralded for their ability to deduce our unique biological essences, so too was photography lauded as a "guaranteed witness" offering evidence of our interior selves.[9] Indeed, photography emerged (and continues to thrive) in an epoch of colonial and imperial conquest, in feverish desire to order, contain, and exploit the physical world.

And yet, as John Tagg reminds us, any such technology is a tool whose "status . . . varies in the power relations that invest it."[10] So perhaps there is no better technology than photography to document—to fix and to archive—the so-called fact of race. "Rather than *recording* the existence of race," artist, curator, and cultural critic Coco Fusco asserts, "photography *produced* race as a visualizable fact."[11] Through emphasis of physical characteristics, enframement of and by text, and formalization of pose and iconization of dress and gesture, race from the nineteenth century onward became more distinctly visible and identifiable, common sense confirmed by scientific apparatus. Visual signifiers captured by the camera served as *proof*, signs of difference, excavations of interiority, especially when juxtaposed with one another.[12] In portraits and pornography, snapshots and mug shots, we *knew* race was real because we could see it, circulate it, desire it, abhor it, by way of the photograph. In turn, the photograph itself became a way of seeing, a visual means of relaying fact and imposing order.

Many of these reasons account for why Holmes emerged as one of photography's early and most ardent enthusiasts. In an 1859 essay, "The Stereoscope and the Stereograph," Holmes celebrated a coming epoch in visual representation. He declared, "*Form is henceforth divorced from matter. In*

fact, matter as a visible object is of no great use any longer, except as the mould on which form is shaped . . . Matter in large masses must always be fixed and dear; form is cheap and transportable . . . Every conceivable object of Nature and Art will soon scale off its surface for us. Men will hunt all curious, beautiful, grand objects, as they hunt the cattle in South America, for their *skins*, and leave the carcasses as little worth."[13] For Holmes, the stereograph specifically, and photography more broadly, offered an opportunity for common people to access aspects of the world that were otherwise out of reach, a means of democratization. And yet even as the carcasses hold "little worth," what gives the form its relevance is its referent, that object of Nature or Art that exists out in the world and remains too cumbersome or too unstable to be contained either within the image or the archive. The surface, for Holmes, does not lose its meaning even when removed, transported, and displayed thousands of miles and several cultures away from its substance.

Though not speaking about race, Holmes's prediction and general enthusiastic commitment to photography offers a compelling, if paradoxical, framework for thinking about the relationship between racial ideology and visual technology. By skinning the surface and leaving the carcasses, by divorcing surface from substance, photography can and has provided an opportunity for African Americans to reinscribe the meaning of the black body, a chance to challenge and dismantle racist identities constructed for them by centuries of white domination. Throughout the social movement photographs considered in this study, we witness how African Americans have utilized the medium in a mode that at once relies upon photography as not just a depiction but as a sample of the subject's flesh and bone, while at the same time questioning the connotations of what the skin (photographic and racial) is meant to denote.

African Americans themselves sought to unmake the identity created for them in popular racist depictions (whether scientific, criminal, comedic, or pornographic) that posited the "truth" of black essence through the fact of photography. By countering with their own, carefully cultivated self-images, whether by reframing the cruelest and most sadistic of these portrayals as the shared shame of the entire nation, or by creating a spectacle of black masculine excess, social movement activists intervened in the complicity of racial ideology and visual technology. Taken together, this shadow archive depicting both the revered and the reviled, containing images of striving and of shame, of personal loss and political desire reminds us that for African Americans, multiple visual representations of themselves, as a photographic form of what W. E. B. Du Bois called "double consciousness," are

always in intense dialogue with one another. With so many depictions vying for prominence, variously summoned to "represent the race," how then do we read or know the "facts" of blackness and the realities of black life? These contrapuntal depictions opened a space for challenging the primacy of any single representation and for extending the difficult experience of black spectatorship into the sight of the nation.

The visual critique of race by African American social movement activists compels us to consider the fundamental question of black spectatorship, which I identify as the second site of struggle. What does it mean for black people to look at representations of themselves, whether in the cultural landscape of the turn of the twentieth century in which black bodies were a visual blight or in the late 1960s when black bodies incited open fascination as well as fear? How have African Americans refused or invited such looking? And how are African Americans constituted as subjects, not merely objects, through spectatorship?

Since its inception in the United States in 1839, photography has been both a cultural site of subjugation and a technology of liberation. Throughout the nineteenth century, African Americans understood the capacity of the medium to publicly convey notions of black criminality and inferiority as well as to project images of dignity and gentility. Scientists used photographs as visible evidence to support theories of anthropomorphic difference and racial hierarchy. Abolitionists circulated photographs of "whip-scarred" slaves to solicit sympathy, anti-Confederate sentiment, and contributions. Likewise, Frederick Douglass and Sojourner Truth sat for portraits from which carefully cultivated images of integrity and respectability emerged. These images featured their subjects in trim clothing, with proper posture, within genteel interior settings. They circulated in public arenas in pamphlets, as cartes de visite, and as frontispieces in books. With their trappings of middle-class domesticity, these photographs served as public interventions on racial dialogues by indicating the respectable private lives of African Americans.[14]

Douglass and Truth were public figures who possessed the means, both financially and socially, to have such portraits made. Early photography, especially the genre of portraiture, professed to offer confirmation of status, to excavate the interiority of the individual subject. By the end of the nineteenth century, studio portraits became affordable to nearly all classes of African Americans, and enough black photographers located themselves in major towns and cities throughout the country to meet the demand. The proliferation of photographs made of African Americans in the years

following Reconstruction testifies to the extraordinary desire for such images.[15]

The significance of photography as a liberatory tool of black self-representation cannot be overstated. For example, portrait sitters more often than not collaborated with photographers, choosing backdrop or setting, pose, and dress, to achieve just the right "mirror" of themselves. Both cultural critic bell hooks and artist Clarissa Sligh have suggested that the arrangement of photographs in albums and in homes has constituted a means of reconstructing black identity and self-image. Hooks further states that photographs made by, for, and of African Americans can defy "those ways of looking . . . overseen by a white colonizing eye, white supremacist gaze." She avers that "these images created ruptures in our experiences of the visual . . . Many of these images demanded that we look at ourselves with new eyes, that we create oppositional standards of evaluation."[16] In this sense then, black photographic portraiture functioned not simply as a private sentimental memento but within the shadow archive of black representation, the process of black visual self-representation also produced public documents of African American citizenship and middle-class belonging. In the century after Emancipation these images of uplift functioned as constructions of identity. They were at once performances of idealized identity and documents of dignified lifestyles. They were projections of an aspiring bourgeoisie and reflections of a thriving middle class. Black photographic self-representation must be understood then as a constant dialectic between private and public, personal and political, fiction and biography.

Photography has been used to express a freedom to define and represent oneself as one chooses and a freedom from the ideological and material consequences of dehumanizing depictions. These portraits of uplift, self-possession, often of middle-class patriarchal respectability, are inextricable from the shadow archive of black representation. More than merely "the reconstruction of the image of the black" or a "decolonizing of the eye," photography has also enabled a confrontation with, a staging of, alternative futures.[17] Such a confrontation with the self as other has, of course, profound implications for the question of black spectatorship. For marginalized groups especially, bearing on their shoulders the burden of representation, photography can simultaneously establish intimacy with its subject and articulate distance. As self-crafted, though always negotiated and forming a dialectic with dominant cultural depictions, these images are neither the thingly Other nor the thing itself, but reside in the interstices. Photography mapped onto but not ontologically of the black body enables

a space of transfiguration in the disaggregation of blackness, as "an abject and degraded condition," from the humanity of actual black people.[18]

The photography of African American social movements functions as a third site of struggle, here over the multitude of questions that emerge over memory. The circulation of social movement photography in later periods informs the ways scholars and critics, politicians and curators, artists and activists choose to remember and recount movement histories. Certainly, the placement of civil rights and black power images in advertising campaigns and fashion spreads at the turn of the twenty-first century suggests the transformation of history into nostalgia through the cooptation, depoliticization, and commodification of the movements themselves.[19] The recent proliferation of art books and exhibitions of African American social movement photography also compels us to consider how context— place and time—informs interpretation: What are the political and historiographical stakes when Charles Moore's Birmingham photographs hang on the walls of Atlanta's High Museum or antilynching posters are included as plates in high-quality art press books?[20]

Looking further back through the archive of social movement photography reveals how activists have consistently drawn on a set of shared icons, incorporating photographs from the past to draw connections with their present moment. These activists have utilized photography to interpret and critique a dominant history that more often than not has excised, abjected, and silenced them. In doing so, they have engaged in a practice of what I am calling *critical black memory*, a mode of historical interpretation and political critique that has functioned as an important resource for framing African American social movements and political identities. Activists and artists have returned again and again to the specific archive of lynching photography. Both SNCC and the BPP incorporated lynching photographs into their posters at a time in which formal lynching—that is, lynching as a persistent feature of black life in the South—had ended, and in particularly bleak moments in the history of each organization. To borrow from Walter Benjamin, these organizations "seize[d] hold of a memory as it flashe[d] up in a moment of danger," recognizing these images of the past as a present concern that gave clear expression to their own "moment of danger."[21] The invocation of lynching photography then "teaches us that the 'state of emergency' . . . is not the exception but the rule" and presents a challenge to dominant history.[22]

The uses to which photographs are put suggest the ways that photography functions as what French historian Pierre Nora calls a *lieu de me-*

moire, a site in which the past becomes tangible and "memory crystallizes and secretes itself."[23] We need to consider memory as a mode of criticism "that makes visible what has been obscured, what has been excluded and what has been forgotten."[24] This practice of critical black memory is one of many tools New World blacks and African Americans in particular have employed as a response to the dislocation, subjection, and dehumanization that has marked their experience of modernity. African American political uses of photography as a site of memory suggest a mode of historical interpretation in which African Americans mobilize the medium's documentary capacity, its function as historical evidence, in order to critique the "truth-claims" of history that have worked to classify, subjugate, and marginalize black life.

Imprisoned in a Luminous Glare interrogates these struggles for the black body, the black eye, and black memory through the use of photography in three well-known African American social movements. Chapter 1, "No Relation to the Facts about Lynching," examines the production and dissemination of photography in the context of the antilynching campaigns of Ida B. Wells and the NAACP. Through an examination of these harrowing images from 1893, the year in which Ida B. Wells first included a lynching photograph in an antilynching tract, through 1923, the culmination of the Dyer Anti-Lynching Bill, the first major legislation of its kind, I chart the emergence of lynching photography as a tool of racial oppression to its employment as a weapon in the fight against mob violence. The deployment of similar, and at times the same, photographs for such radically different purposes in the same historical moment reveals a crisis of representation—here, the instability of the photograph as evidence of anything *but* African American inferiority, or in James Weldon Johnson's query, what relation do facts indeed have to ending racial terror? Activists' employment of these images also signals a recognition of the opportunity for publicity and political intervention that the photograph as a modern technology occasioned. These initial if uneven visions reveal a struggle with the possibilities and limitations of such an employment of photography.

I begin this study here, with this archive, to highlight as well the seemingly ineluctable juncture of photography and lynching. Photography and lynching are at the very heart of U.S. modernity, the former as one of modernity's triumphs, the latter as its shame; one as a key sign and symbol of "progress," and the other as a sign of its atavism. Both have irrevocably mapped modernity, defining the reaches and boundaries of progress, of technological and industrial achievement, of social order, of racial and gen-

der hierarchy. The tempestuous marriage of photography and lynching constitute a "spectacular secret," one in which lynching's violence "could command the public's attention and yet will the nation to a collective silence."[25] This secret, this "enigma," forces us, in Jacqueline Goldsby's estimation, to rethink the tenets of modernity. To do this, we must unearth what lynching and photography reveal about the other.

To consider lynching through the cultural logic of photography compels us to recognize such violence as wholly part of modernity, as not simply endemic to the southern United States but able to travel, like the expanding modes of transportation, to spread as far and wide as the photograph (or the stereograph or the film or the audio recording) might take it. The constant mediated repetition of "the black body in pain for public consumption" suggests that the negation/annihilation of black people in act and image is constitutive of American identity, "is central to our processes of building a nation."[26] Why do we tell ourselves these particular stories about race, gender, and national belonging in these particular ways? To consider photography through lynching, we must consider how the camera and its offspring disciplined individuals to see "the fact of blackness" collectively, as well as to visualize its negative, whiteness.

Imprisoned in a Luminous Glare begins here as well because lynching and its photographic reproduction have been a central concern, a spectral presence, and an acute reality in black social movements since the NAACP's first attempt at passage of an antilynching law. Whether it is the present absence of the lynched in Marcus Garvey's Universal Negro Improvement Association seeking sanctuary in an Africa free of racial subjugation; the various modes of framing the nearly twenty-year fight against the "legal" lynching of the Scottsboro Nine; Mamie Till Mobley's marshalling of the force and fury of her son Emmett Till's murder as a catalyst for the modern civil rights movement, and the framing of vulnerable, often beaten protesters at the center of that movement's visual strategy; or the cries for land, bread, housing, and the freeing of all political prisoners exclaimed by virile and sometimes armed black men, the concern for and image of the brutalized and abject black body, of a human being reduced to "bare life" lies uncomfortably and unburied at the center of the twentieth-century black freedom struggle.[27] As history and memory, as metaphor and metonym, as trauma and trace, as event and image, lynching, like slavery, has not *not* been contended with by African American activists and artists.[28]

Whether to repair, to redress, to mourn, or to call to action, activists and cultural producers have returned repeatedly to "the sight of a black [per-

son] hanging from a tree," making of it an icon.²⁹ Such visual revisitations and iconographic reinscriptions suggest that this powerful and troubling archive is a constitutive element of black visuality—"how we are able, allowed, or made to see" blackness "and how we see this seeing or the unseen therein"—since these images began their intense circulation in the years following the end of Reconstruction.³⁰ Indeed lynching itself as a "regime of racial terror" has played a formative role in "configuring modern black political cultures."³¹ The mechanical reproduction of lynching by way of the photograph has been central to the recounting and reconstitution of black political cultures throughout the Jim Crow and post–civil rights era. From the usage of lynching photography in pamphlets by early twentieth-century antilynching activists, to posters created by midcentury civil rights organizations, to their deployment in contemporary art and popular culture, we can see how this archive has been a constitutive element of black visuality more broadly.

Chapters 2 and 3 turn attention to the modern African American freedom struggle, to consider how two signal organizations engaged the question of representing the black body in a period in which lynching and its photographic representation had declined. SNCC and the BPP deployed photography in ways that earlier antilynching activists could neither have imagined nor achieved due to their own limited access to cameras, darkroom equipment, and the dominant media outlets, as well as the limits of the technology itself. These later movements also emerged in a vastly different and more diffuse media climate, one in which African Americans were increasingly visible (and audible) in film, in magazines, and even in the exploding medium of television. From black criminality to black celebrity, from Hazel Scott to *Amos 'n' Andy*, from Jackie Robinson to Muhammad Ali, African American audiences in the postwar era had more opportunities to both see and critique black representation than their predecessors.

In SNCC and the BPP, not only do we observe the use of photography by youthful activists who had come to maturity in the "age of television," and for whom still cameras, processing equipment, reproductive capacity, and technical knowledge were readily accessible. But we also witness the development of activists who possessed an expansive media consciousness and knew how to capture national attention quickly. By examining the place of photography in two of the most well-known organizations of the 1960s movements, we can chart black political activists' changing relationship to mass media, to African American cultural representation, and to photography itself. Over the course of the decade from 1962 when SNCC recruited

Danny Lyon as its first photographer, through 1972 when the Panthers' call for a conference to rewrite the U.S. Constitution produced a photo-collage poster as variegated as the movement itself, the uses of photography demonstrate a shift in race and the politics of photography: from faith in the photograph as righteous witness to open skepticism and irreverence; from the photograph enlisted as documentary evidence to the photograph cast as part of a performative ensemble; and from a belief in the unifying power of a single photograph to represent and build a movement to an embrace of photography as "heteroscopic," in which differences cannot and should not be contained. Put another way, SNCC's and the BPP's uses of photography in the evolving media landscape of the 1960s reveal a shift from a black visual modernity to a black visual postmodernity.

Chapter 2, "Come Let Us Build a New World Together," uncovers the history of the SNCC Photo Agency, a unit under the wing of the Communications Department created to serve all of the organization's visual needs, including publicity, fund-raising, documentation, and journalism. Building on sociologist Todd Gitlin's notion of the unfixed yet situated relationship between mass movements and mass media, I trace the constantly evolving relationship between SNCC and the medium of photography—from a documentary tool, to a compass for self-expression, to a weapon of black power.[32] From the organization's founding in 1961 through the watershed successes (and horrors) of Freedom Summer in 1964, SNCC deployed photography to give a face to their organization and intervene in dominant media frames of the movement, frames that were themselves in formation as the civil rights movement became the feature story in domestic news. In this period, the organization established the SNCC Photo Agency and recruited a number of young, politically committed photographers to document the organization's activities, from the banal to the extraordinary. But from the end of 1964 through SNCC's uneasy embrace of black power in 1966, as the organization grew in size and in recognition, photography served less to document the movement and provide a unified public image. Rather, many within the organization used the camera as a tool to express a personal vision, a compass to individual, as opposed to collective, freedom. The various images produced in this period, as well as the conflicts that emerged within and around the SNCC Photo Agency, illuminate growing fissures around gender, class, race, and the very concept of freedom itself. These photographs and the contexts in which they appear also begin to raise questions about the place of photography in the movement: photography to achieve what kind of work, aimed at which audiences? Though he

attempted to restate the SNCC Photo mission during his tenure as head of the unit, artist and activist Julius Lester would embrace photography for exactly these ambiguities. In 1966–67, photography allowed him to speak to multiple audiences and to explore the various avenues of the emergent black power movement, visually challenging his own fiery writing on the meanings of black power.

If Ida B. Wells and the NAACP came to the photograph as a mode of illustration, and SNCC embraced photography for its multiple and simultaneous capacities to document, to fund-raise, and to explore ideas about self and community, then we might consider the photograph the point of departure for the Black Panther Party. Chapter 3, "Attacked First by Sight," examines the constant struggle and negotiation between the Panthers and their observers, both supporters and detractors alike, over the meaning, direction, and legacy of the BPP that took place first and foremost in the visual (and visible) field. Staging early encounters with the state and producing a recognizably militant antiauthoritarian image, the Panthers were in many ways emblematic of the "Society of the Spectacle," French philosopher Guy Debord's name for the postwar epoch in which capitalism commodified human relationships largely through the mobilization of visual technologies, reality becomes representation and representation reality. However, the Panthers' performative and visual practices, especially their harnessing of photography, illustrate the subaltern's challenge to the alienation and political impotence wrought by the Society of the Spectacle. The BPP produced an emergent visuality, in which they "attacked first by sight," in the words of ally Jean Genet, and set in motion new ways of seeing the black body while forcing an explicitly confrontational interaction with dominant media in particular. This emergent visuality led to the BPP's iconization, which, I argue, took two forms. One form manifested as incorporation, a means by which dominant media and the state colluded to belittle the Panthers through a focus on image, while aggrandizing their threat. The spectacle of the Panthers served as a cover story to destroy the organization through a government-sponsored program of surveillance, incarceration, infiltration, and murder, as well as media assassination. The second form of iconization was enacted by the Panthers themselves and appeared as institutionalization. Here, the BPP worked to establish a uniform vision through the steady publication of the *Black Panther* newspaper, in which photography played a key role, and through the artwork of Minister of Culture Emory Douglas. Photography enabled different chapters to connect to the vision of the organization through the use of Panther "stock images"—

Huey Newton in the wicker chair, Newton and Bobby Seale armed in front of the Oakland office—while still expressing their local specificities. The photograph presented itself as a nearly ready-made medium to convey complex ideas about race, gender, and revolution and to contain the multiple contradictions animated by the party. Yet the BPP's use of photography and Douglas's collages in particular reveal the work necessary to build a movement, a labor of assemblage that contests the isolation of spectacle.

I have chosen these well-known movements not only because they represent eras of heightened African American political agitation and cultural self-production but precisely because the photographs that emerged from antilynching, civil rights, and black power movements are themselves so eidetic they offer an opportunity to bring new insight to familiar photographs. And because these images are seared as they are in national and racial imaginaries, revisited and repeatedly invoked well beyond their moments of origin, the photographs compel an examination of ongoing processes of iconization, to ask how history crystallizes and meaning accumulates. The conclusion, then, turns specifically to the question of memory. The almost surprising cathexis that quickened around the Allen-Littlefield collection of lynching images and their circulation through the *Without Sanctuary* book, traveling exhibit, and Web site in the first decade of the twenty-first century, pried open a space in which to consider lynching's visual longevity, and compelled attention to the deep embeddedness of these images in our present "scopic regimes" and ways of seeing.[33] Likewise, a recent spate of exhibits of civil rights and black power photography has introduced new audiences to these movements and raised new ethical and historiographic questions about the contemporary circulation of these images. Why have social movement activists and visual artists returned to these images over and over? How have they been referenced and quoted? What does such an engagement reveal about the contours of African American movements for social justice? *Imprisoned in a Luminous Glare* concludes with a consideration of four museum shows, *Without Sanctuary* (2000–2002), *Road to Freedom* and its companion show *After 1968: Contemporary Artists and the Civil Rights Legacy* (2008), and *Black Panther Rank and File* (2006), as a space to reflect upon the legacies and implications that social movement photography has for racial subjectivities, for national identities, for visual representation, and for black memory. What acts of state terror and what notions of blackness are imprisoned in these photographs? And what remains fugitive?

To begin to chart the constellation of this project's concerns, let me draw

attention to two posters from the 1960s that return to the lynching archive. Around 1965, SNCC reproduced a lynching photograph by Mississippian O. N. Pruitt as a poster (figure i.7). The members of SNCC Photo Agency and SNCC Communications left the original image intact: the bodies of African Americans Bert Moore and Dooley Morton lynched in July 1935 fill the frame vertically, a white man dressed crisply in white kneels before Moore and Morton grasping the men's tattered, bullet hole ridden pants legs to hold their hanging bodies steady for Pruitt's camera. In large capital letters beneath Moore's and Morton's bare feet and next to Pruitt's assistant, SNCC has added the single word, "MISSISSIPPI." This word functions at once as an anchor situating the state, both geographic and mental, in which this act took place; as a report, like others the organization had put out on Mississippi and Danville, Virginia; and as affidavit, sworn testimony of the violence that was a key feature of African American life in Jim Crow Mississippi, from the end of the first Reconstruction to the beginning of the second, offering evidence of the terror that SNCC workers faced on a daily basis but were not always able to document visually. And the word is also a sardonic call to those in the know, to those who had experienced the costly success of the previous year's Mississippi Summer Project, the effort to register black Mississippians to vote. There were few photographs that documented the murder of four summer volunteers by Klansmen, the more than eighty people beaten by police as well as white citizens, the hundreds arrested, and the scores of homes, businesses, and churches bombed; yet, in the words of singer Nina Simone, "everybody knows about Mississippi Goddam."[34]

In each of these functions, however, the text remains reliant on the photograph to convey shock and to indicate the crisis. SNCC has left the original photograph as unmediated as possible. The tag of authorship, "Pruitt Photo" etched on the photograph, remains in the poster while there is no evidence of SNCC authorship, the organization identification and address that appeared on all SNCC materials; this was no doubt due to the incendiary nature of the image itself. The only thing that outwardly identifies the poster as a SNCC product is the white lettering, a similar layout to the half-dozen posters the organization had previously created. The design of this poster suggests not only faith in, but the primacy of, the photograph to convey unambiguous meaning. The photograph should and will speak for itself.

Four years later, Emory Douglas created a cover for *The Black Panther* that demanded that the U.S. military "Free the GI's," the sixth of the BPP Ten

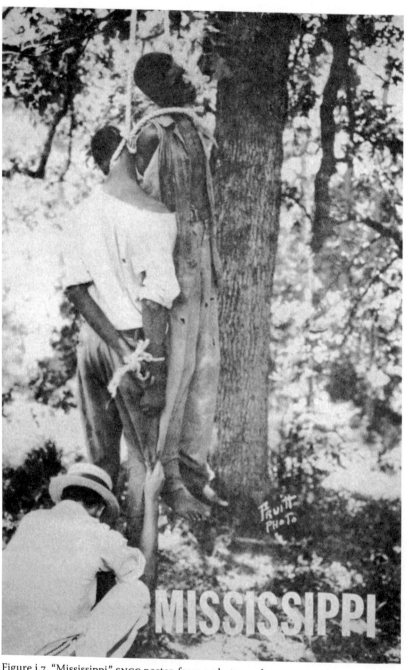

Figure i.7. "Mississippi," SNCC poster, from a photograph
by O. N. Pruitt, c. 1965. (Pixel Press)

How photos used to
be used for — Lead & used
turned on its political achier
for power.
still current today)
Obama campaign

Point Platform (figure i.8). By September 20, 1969, when the issue appeared, black men were dying in Vietnam in unprecedented numbers, and they were dying in the streets of Oakland. The Panthers had already buried their first and youngest recruit, Bobby Hutton, and were fighting to keep leaders Huey P. Newton and Eldridge Cleaver out of the gas chamber. "Our fight," a cartoon placard on the cover reads, "is not in Vietnam." In his signature hand-drawn style of thick, black lines, Douglas renders an African American soldier in profile, two heavy tears falling from his eye as he marches off to war. His helmet fills the center of the cover, and within its outline, Douglas has created a montage of photographs: scenes of police in riot helmets wielding billy clubs to brutalize black men until they are bloody and prostrate are juxtaposed with a fragment of the now-iconic photograph of the lynching of Thomas Shipp and Abram Smith in Marion, Indiana, in 1930. At the center is the burning body of William Brown, lynched in Omaha, Nebraska, in 1919. The past and present run into each other while a barefoot black child sees sights no child should have to endure. Both the GI and the viewer are impressed with the weight of history and ongoing conditions of violence, images sutured together almost cinematically that occupy every inch of the soldier's mind. The collage reveals not just the affective work of photographs in building a movement, but how photography works on and through individuals. The photograph here is deployed not as document but as an accumulation of crises, burdens that African Americans bear but should no longer have to. At every turn, the maker's hand is evident and visible, destabilizing the cohesiveness of any single photograph and challenging photography's collusion with state power.

When juxtaposed, these two images highlight key concerns of this book. For SNCC and BPP activists, lynching provided a referent for the continued terror experienced by African Americans whether in rural enclaves or urban ghettos. The return to these older images reveals a concern with representing the past and a means to engage history through a critical practice of memory. But its appearance in moments of extreme despair highlights the unifying work of the camera and an ongoing compulsion to visualize black (male) victimization as legitimating claims on the state. Violence imprisoned but then constantly repeated.

The posters demonstrate as well the use of photography as a means to speak politically while intervening in discourses of racial representation. And they mark a transition, even in the short expanse of four years, from investing photographs with the burden of communicative work, to under-

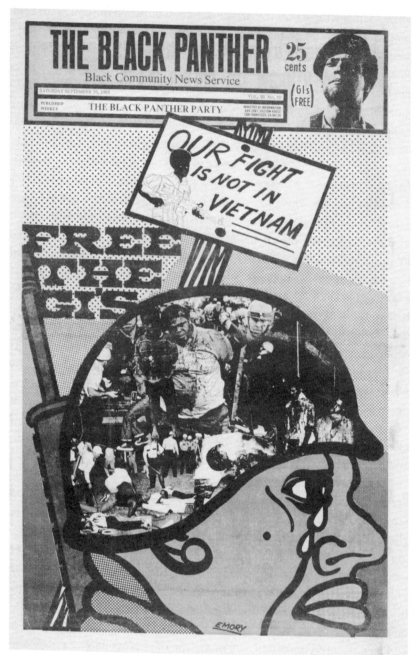

Figure i.8. Cover of the *Black Panther*, September 20, 1969, by Emory Douglas.
(© 2010 Emory Douglas/Artists Rights Society [ARS], New York)

mining photography's power, from photographs' power to contain to wielding representational power to contain photography.

Not only can we begin to understand photography as a social practice within these movements—the what, why, when, where, and how social movements used photographs—but we are also compelled to consider how photography, entrenched in a discourse of "evidence" and "truth," disciplines viewers to see race. When social movement photography is examined from the vantage point of its African American practitioners and audiences, of three recognizable movements of the African American freedom struggle, continuities of strategic goals and shared concern emerge. Discontinuities also come into focus: varying access to technology, the evolution of photographic forms, and changing beliefs in the photograph shape the ways in which photography is deployed by the organizations under consideration. Simultaneously, transformations of formal political ideology and platform impact activists' modes of presenting the black body—as outside or within the nation. Further, we can appreciate the myriad ways photography changed the African American freedom struggle, and how that struggle has shaped the ways we see blackness as a cultural and political entity.

The struggle with and through social movement photography indicates that we need to reconsider the role of vision and visuality in black social movements. A concern with black visuality, not simply the visual, was almost always at play throughout the course of the African American freedom struggle. It is my contention that black visuality is inextricable from African American movements' efforts to change the conditions of black people's lives.[35] Not least of that to be transformed is the individual and collective sense of one's own power, efficacy, and being in the world; how we see blackness, the meanings we attach to black people, and the value we attach to black life because of this "sight." Likewise, we cannot comprehend the African American freedom struggle in the twentieth century without making sense of its photographic representations. Equally important, we must wrestle with what these social movements' visual reproductions reveal about the mechanisms and social practices of photography. Photography then is neither "good" nor "bad" for African American social movements. Rather, from the twentieth century onward, photography as a political tool and movement strategy is unavoidable. These images remind us that for African Americans, the political stakes of cultural representation and the cultural terrain of political representation are (in the tradition of cultural studies) never very far apart.

No Relation to the Facts about Lynching

On Thursday, November 30, 1922, James Weldon Johnson, executive secretary of the National Association for the Advancement of Colored People (NAACP), sat in his by-then familiar place in the gallery of the United States Senate. Johnson watched wearily as the fruit of the labor of thousands of women and men worldwide slowly rotted below him. After more than two years of tireless lobbying, editorializing, propagandizing, fund-raising, and protesting, the fight for the Dyer Anti-Lynching Bill was coming to an end. The Dyer bill, the first legislation of its kind sponsored by the NAACP, sought "to assure persons within the jurisdiction of every state the equal protection of the laws, and to punish the crime of lynching." It proposed to do so by holding state government officials culpable for failing to curtail lynchings or to bring lynchers to justice, threatening fines or imprisonment for such failure, and securing monetary restitution for the families of lynching victims. In conjunction with the NAACP, Representative Leonidas Dyer (R-Missouri) first devised the bill in late 1919 as a response to the racial massacres earlier that year. Dubbed "Red Summer" by W. E. B. Du Bois, from July well into October scores of African Americans, including many World War I veterans, were lynched, burned, and driven from their homes by irate white mobs in cities throughout the United States. Dyer introduced the bill into Congress in April 1921 and, finally after a very bitter struggle—delays bringing the bill to the floor, fierce opposition from southern Democrats, and extensive organizing on the part of the NAACP—the House passed the bill on January 25, 1922, by a vote of 230 to 119. From there the bill headed to the Senate, where the Democrats, led by a strong cadre of southern senators, mobilized opposition against federal intervention into southern affairs, specifically the handling of local "Negro problems." The Democrats threatened a filibuster, going so far as to lay down the ultimatum that they "would not allow any government business whatsoever to be transacted until the Anti-Lynching Bill was withdrawn . . . for the entire remaining term of the 67th Congress." Though the bill could be reintroduced into the next congressional term, beginning March 4, 1923,

THE SHAME OF AMERICA

Do you know that the United States is
the Only Land on Earth where human
beings are BURNED AT THE STAKE?

In Four Years, 1918-1921, Twenty-Eight People Were Publicly
BURNED BY AMERICAN MOBS

3436 People Lynched 1889 to 1922

For What Crimes Have Mobs Nullified Government and Inflicted the Death Penalty?

The Alleged Crimes	The Victims	Why Some Mob Victims Died:
Murder	1359	
Rape	571	Not turning out of road for white boy in auto
Crimes against the Person	615	Being a relative of a person who was lynched
Crimes against Property	320	Jumping a labor contract
Miscellaneous Crimes	402	Being a member of the Non-Partisan League
Absence of Crime	175	"Talking back" to a white man
	3436	"Insulting" white man

Is Rape the "Cause" of Lynching?

Of 3,436 people murdered by mobs in our country, only 571, or less than 17 per cent., were even accused of the crime of rape.

83 WOMEN HAVE BEEN LYNCHED IN THE UNITED STATES

Do lynchers maintain that they were lynched for "the usual crime"?

AND THE LYNCHERS GO UNPUNISHED

THE REMEDY

The Dyer Anti-Lynching Bill Is Now Before the United States Senate

THE DYER ANTI-LYNCHING BILL IS NOW BEFORE THE SENATE
TELEGRAPH YOUR SENATORS TODAY YOU WANT IT ENACTED

NATIONAL ASSOCIATION FOR THE ADVANCEMENT OF COLORED PEOPLE
70 FIFTH AVENUE, NEW YORK CITY

THIS ADVERTISEMENT IS PAID FOR IN PART BY THE ANTI-LYNCHING CRUSADERS.

Figure 1.1. NAACP ad, "The Shame of America," *New York Times*, November 22, 1922.

it would be dead if the Republican senators did not counter the filibuster. "The outlook is rather dark," Johnson telegrammed his assistant Walter White that day. "But the fight is by no means yet lost. If we can only prevent the Republicans abandoning the bill on the terms laid down by the Rebels, we still have a chance."[1]

Just eight days earlier, the NAACP struck their boldest public move in the Dyer effort. On November 22, 1922, "The Shame of America" advertisement appeared in ten major white-owned newspapers throughout the United States, including the *New York Times*, the *Atlanta Constitution*, the *Chicago Daily News*, and the *Nation* magazine (figure 1.1). Full-page advance copies were sent to each member of the Senate on November 20. The ad posed the question to a national, largely white, mass readership, "Do you know that the *United States* is the *Only Land on Earth* where human beings are BURNED AT THE STAKE?" Assistant secretary Walter White and publicity director Herbert Seligmann designed the advertisement, which was

paid for by the Anti-Lynching Crusaders, a short-lived umbrella organization of black women's groups nationwide dedicated to raising money and awareness for the NAACP's antilynching campaign. Following the strategy pioneered by activist Ida B. Wells, the ad combined lynching statistics, a refutation of rape as the cause of lynching, and an outline of the Dyer Anti-Lynching Bill itself, ultimately affirming the constitutionality of the bill, one of the alleged reasons for its being contested. The ad appeared in half-, full-, and two-page spreads. It was large and loud, meant to draw attention to and heap ignominy upon the country whose laws could not, and would not, protect twelve million of its citizens. It announced itself in a forum, the white print media, whose pages were filled primarily with reports of black crime, almost entirely ignoring black victimization and often black achievement.

James Weldon Johnson felt that the text of "The Shame of America" was deeply powerful yet firmly situated within democratic discourse. In large print that drew reader's eyes to *"Rape,"* "BURNED," "UNPUNISHED," and "3436 People Lynched," the ad proved striking enough to catch one's attention. But it was not so shocking that its message could be dismissed. It listed U.S. governmental apparatuses and individuals who had either affirmed the constitutionality of the bill (the judiciary committees of both the House and Senate, the U.S. attorney general) or lent their support to it ("19 State Supreme Court Justices, 24 State Governors, 39 Mayors of large cities, north and south"). With this notable register, the NAACP affirmed that the goal of the bill was to ensure equal access to due process, *not* to excuse crime, to guarantee order rather than promote lawlessness.

The "Shame of America" garnered an immediate and compelling response. The following day, November 23, 1922, White telegrammed Johnson that "The *Times* 'ad' is certainly kicking up the biggest sensation in New York in many a day. . . . Every newspaper in New York City has had one or more representatives here [at the office] pleading to be allowed to repeat the advertisement in their papers."[2] In a 1924 pamphlet entitled "Lynching: America's National Disgrace," Johnson expressed his own pleasure with the efficacy of the ad, stating that "it constituted the greatest single stroke of publicity propaganda ever made in behalf of justice of the American Negro." And in his 1933 autobiography, *Along This Way*, Johnson asserted that this publicity "probably caused more intelligent people to think seriously on the shame of America than any other single effort ever made." Like a camera's flash illuminating a scene too dark for the naked eye, the NAACP described itself as "the organization which has brought to light the facts about lynching."[3]

So compelling was this ad that White and Seligmann drafted a second version that would incorporate photographs of lynchings. This version was to appear in the December 14, 1922, issue of the *New York Times Mid-Week Pictorial*. Begun in 1914 as a forum for the deluge of war photographs pouring in from Europe, by 1922 the Wednesday and Saturday "pictorial editions" were precursors to photo magazines to come, such as *Life* and *Look*. The newspaper featured photographs and photographic advertisements primarily in this twice-weekly format, which, according to White, had "a circulation of 62,500. . . . Eleven per cent of that circulation is local, 89% nation-wide." The *Times* offered the NAACP a "good" price for the placement of the new version, $250, and White urged Johnson to approve the copy and give the go-ahead. "Yes, it is another page in The Times which will include photographs of lynchings and will answer the arguments that the Southerners are attempting to advance," White telegrammed Johnson on November 29. White seemed to think this new ad was the most effective one the NAACP had produced to date. This new version would serve up a potent marriage of legal fact and visual document, a union that the assistant secretary believed could not be ignored. White closed his letter to Johnson with the rhetorical question: "Don't you think it is time for us to take off the bridle and use the sledge hammer? Personally, I do."[4]

But as Johnson sat in the gallery the next day and watched the Democrats hijack the Senate floor and the Republicans sit by idly, he wondered if the sledge hammer, the photograph as blunt instrument, this late in the fight would prove the right weapon for the job. Johnson wired White on the morning of November 30 at his home and wired him again that afternoon at the Fifth Avenue offices of the NAACP, both times with the same message regarding the photographic version of "The Shame of America": "I [will] wait for the copy of the ad, but I [doubt] that the proposed ad would have any effect on the present situation here. You see the crisis on the bill has no relation to the facts about lynching! Indeed, the facts about lynching have up to this time played an almost negligible part in the whole Senate fight." The facts, Johnson seemed to think, no matter how volatile or visceral their presentation, fell short in the quest to gain black subjectivity within the law. A photograph could not prove the bill's constitutionality. A photograph could not change the centuries-long tradition of white violence in the South. Or could it?[5]

Johnson's reticence was certainly born of the "politricking" he witnessed during the course of the Dyer fight, the active marginalization of black citizenry, and the aggressive disregard for their concerns and complaints ac-

complished through the formal mechanisms of government. That Johnson expresses this dilemma over and about the form and force of "publicity propaganda" urges us to consider the possibilities and limitations engendered by the use of photography in the antilynching struggle. Since its inception in 1909, the NAACP regularly reproduced photographs of lynchings in their many antilynching pamphlets (about three per year between 1909 and 1922), in issues of *Crisis*, the organization's news organ edited by W. E. B. Du Bois, and even as printed postcards. Following the lead of journalist and activist Ida B. Wells, who first included lynching images in her 1893 essay "Lynch Law" and again in her 1895 investigative pamphlet *A Red Record*, the NAACP similarly chose to arm itself with photographs as weapons in its arsenal of evidence. Photographs, celebrated for their veridical capacity, as documents of "a truly existing thing," could stand side by side with other forms of "proof"—statistics, dominant press accounts, investigative reports—utilized by these antilynching activists to offer testimony to lynching's antidemocratic barbarism. Wells and the NAACP augmented their literature primarily with professionally made photographs of lynchings. Widely circulated and relatively easy to obtain, these images were readily available for public consumption.

"Readily available," however, does not mean easily digested, transparently comprehended, or resolutely acted upon. For White, photographic images stood as the most decisive fact among facts. His enthusiasm for the second layout of the "Shame of America" reveals a faith in the truth-telling and democracy-building work of photographs, that the good, white citizens comprising the *Times* readership need only *see* the horrible reality of lynching to be moved to end it. But in Johnson's grim diagnosis, facts could be, and often were, easily ignored or simply fit into a patently antiblack framework. The facts of lynching—evidence of the true violence that coerced compliance and defined the terrain of black life—meant little without a new lens through which to view and interpret them. Social change, we might infer from Johnson's frustration, cannot take root without the radical renovation of racial consciousness.

White's certainty and Johnson's lack of confidence in the power of photography to accurately and movingly represent the absurd brutality of lynching reveal inherent ambivalences about the employment of the photograph as part of social movement strategy. Their exchange speaks to a keen awareness on the part of these deeply committed and highly accomplished activists of photography's revelatory potential, and also to the nagging apprehension that the photograph may occlude more about black existence

in the United States than it exposes. It testifies to black engagement with the discourses and techniques of American modernity (mechanical reproduction of the photographic image being a signal technological achievement), while also belying a fundamental critique of modernity and its cultural logics. It wrestles with the question of whether the photograph could successfully shoulder the evidentiary, sentimental, and political burdens placed upon it, or if it would flounder and collapse under the weight of these multiple demands. White and Johnson's telegrammed conversation illuminates the collision and collusion of political representation and cultural representation in the context of the long African American freedom struggle that lay at the heart of this study; photography as apposite to political struggle and yet also as aporia.

This chapter interrogates the battle waged by antilynching activists to reframe lynching discourse with and through photography, and the implications of such reframing for black viewers. First, through an examination of lynching and antilynching photography in the late nineteenth and early twentieth centuries, I reveal these images to be a site of struggle over the possession of the black body between white and black Americans in this period, about the ability to make and unmake racial identity. In the hands of whites, photographs of lynchings, circulated as postcards in the late nineteenth and early twentieth centuries, served to extend and redefine the boundaries of white community beyond the localities in which lynchings occurred to a larger "imagined community." In the hands of blacks during the same time period, these photographs were recast as a call to arms against a seemingly never-ending tide of violent coercion and transformed into tools for the making of a new African American national identity. Similar, if not the same, images of tortured black bodies were used to articulate—to join up and express—specifically racialized identities in the Progressive Era, a period marked by the expansion of corporate capitalism, the rise of the middle classes, and the birth of consumer culture. It is necessary to ask: what is the process by which activists transformed lynching photographs, advertisements for and consolidators of white supremacy, into "antilynching photographs," testaments to black endangerment? How exactly were photographs that celebrated the triumph of "civilization" made to herald civilization's demise?

By uncovering and pulling apart the threads of white supremacy and black resistance invested in these photographs, we can also begin to understand how lynching photography unmakes racial identity. Indeed, the very

need to use photographs in campaigns for racial domination or racial justice points to cracks and fissures in these identities. Exposed are the social, sexual, political, and class anxieties that the framing of these images attempt to deny. In their various contexts and incarnations, we can discern how lynching photographs create and coerce, magnify and diminish, the appearance of unified racial identities. In the creative hands of antilynching activists especially, these photographs were employed to critique the racial logic from which they initially emerged. In doing so, Wells and the NAACP, the foci of this chapter, worked to recast the meaning of black identity and national belonging and illuminated the contradictions and ambivalences of racial ideology.

Antilynching activists' employment of photography made available and discernible other ways of interpreting blackness in which the black body is read "against the grain," in which alternative meanings of blackness are asserted. This effort to reinscribe the connotation of the lynched black body and its photographic representation is one born out of the "problems of identification" for black spectators.[6] Indeed, if lynching photographs were meant for white consumption, to reaffirm the authority and certainty of whiteness through an identification with powerful and empowered whites who enframe the black body, what then did black looking affirm? What concept of the black self could emerge from an identification with the corpse in the picture? Can one refuse such identification, or is "the identification . . . irresistible"?[7] Black identity of course is itself neither unified nor without its anxieties. The various contexts among African American audiences in which lynching photography, meant to do antilynching work, appeared, reveal a more variegated black spectatorship, highlight more clefts of class, gender, and geographic location than the image's singular focus on the hopeless figure at its center might initially suggest.

Johnson's lament, that the life-or-death fight for equal protection under the law has "no relation to the facts about lynching," signals an antinomy embedded in the lynching archive, an antinomy produced through its repeated invocations and juxtapositions. Can photography serve to construct new racial epistemologies or does it always edify dominant paradigms? That is, can the black body (photographed) as abject and discredited sign be made to signify differently? Such conflicts alert us to the constraints faced by these early twentieth-century activists in deploying visual representation as a strategy for liberation, constrictions that later African American social movement activists would encounter, struggle with, and resist.

The history of lynching in the United States is a long and brutal one. At its apex, between 1882 and 1930, this strain of American violence claimed over three thousand lives, approximately 88 percent of whom were African American.[8] White-on-black lynching, which saw its peak in 1892, can best be understood as the cruel physical manifestation of white patriarchal anxiety over a perceived loss of power in the years following Emancipation; as a communal and ritual act in response to the threat of social, political, economic, and sexual displacement by African Americans, particularly African American men; and as a performance of white racial identity that placed black bodies center stage as it attempted to exorcise those bodies and their perceived threat to the future of white civilization from white communities. The reality and threat of lynching—lynching as both concrete act and shared narrative—worked to hold African Americans in their (subordinate) place and to help imagine and construct a unified white identity.

Lynching also needs to be considered a leisure activity deeply embedded in the rise of consumer culture in the South in the late nineteenth and early twentieth centuries. As historian Grace Hale has argued, lynchings helped ease white anxiety about a new culture of consumption that exposed holes in the blanket segregation of the New South. This new mass society signaled a "raceless" consumer culture, one in which any person, of any race, gender, or class, could purchase goods in any number of mixed public spaces. Not only did lynchings "reverse the decommodification of black bodies begun with emancipation," writes Hale, but they enforced a segregated consumer society, a commodity culture in which only whites could experience or consume the "amusement" of lynching, and only blacks could be lynched and consumed, often literally by fire.[9]

Lynching reduced African Americans, cloaked in newly granted post-Emancipation citizenship, back to black bodies, vessels suitable for physical and ideological labor. Walter Johnson has described how white traders and buyers in antebellum slave markets disaggregated black bodies according to size, color, hands, teeth, and so on, and reassembled the parts to indicate "likely slaves," bodies fit for labor and amenable to subordination. Johnson writes, "The rituals of the slave pens taught the inexperienced how to read black bodies for their suitability for slavery, how to imagine blackness into meaning, how to see solutions to their own problems in the bodies of the slaves they saw in the market. Gazing, touching, stripping and analyzing out loud, the buyers read slaves' bodies as if they were coded versions of

their own imagined needs . . . the ritual practice of the slave pens animated the physical coordinates of black bodies with the purposes of slavery."[10] With the end of slavery, the "text" of black bodies became obscured and was no longer so easily read. These bodies now held different truths, their "interior" character proved no longer as visible or as self-evident. Though still black, freed persons could "pass," cloaked in newly granted citizenship. Moreover, if black bodies were read in the antebellum period for their suitability for slavery, if the logic of the market found its ultimate home on the farm or plantation, what then was the purpose of reading black bodies post-Reconstruction? Where did white desire and repulsion, fantasy and anxiety, migrate if not onto the black-body-as-slave? Lynching remanded African Americans back to slaves. Lynching functioned as both an end and a means of "reading meaning into blackness" in a postslavery society, a way of containing the black body's ability to pass as citizen by re-reifying, and often disembodying, it as commodity.

This is seen most clearly in the postlynching scramble for fetishistic mementos of the event, such as scraps of victims' clothing, charred bits of bone, locks of hair. These gruesome trophies, these relics, were sources of pride for those who had participated in the murder, or for those who were able to get to the corpse before it was finally buried. A framed photograph of the 1930 lynching of Thomas Shipp and Abram Smith contains a tuft of hair attached to the matte board. Next to the remnant of thick black hair is penciled the inscription, "Bo pointn to his niga."[11] Such souvenirs could also provide a source of income for those who got to the body first. In her report to the NAACP about the 1915 lynching of young Jesse Washington in Waco, Texas, white investigator Elizabeth Freeman writes: "Some little boys pulled out the teeth and sold them to some men for five dollars apiece. The chain was sold for twenty-five cents a link."[12] The collection of relics as religious fetishes is a practice that dates back to ancient and medieval times, when the devoted would gather, trade, and keep close the remnants of saints' lives or their bodies. Indeed, in a complex manner lynching incorporated elements of ancient traditions and antebellum nostalgia.

Yet lynching is also a "peculiarly modern phenomenon."[13] As the New South grew and industrialized rapidly, lynching made use of some of the most modern technologies available: the telephone and telegraph to announce and advertise the event; print media to carry the message; and cars and trains to carry participants to the designated location. The specificity of lynching's modernity lies in the prevalence and pervasiveness of photographers, both amateur and professional. Indeed, photography emerged as

integral to the lynching spectacle. For those not close enough to the scene or for those not lucky enough to obtain clothing or body parts for souvenirs, photographs proved the next best things. As postcards, trading cards, and stereographs, lynching images held a strong, popular, commercial appeal. For professional photographers, lynching spawned a cottage industry in which picture makers conspired with mob members and even local officials for the best vantage point, constructed portable darkrooms for quick turnaround, and peddled their product "through newspapers, in drugstores, on the street—even . . . door to door."[14] If lynching was a return to the slave block, a reinscribing of the black body as commodity, then lynching photographs functioned as the bill of sale and receipt of ownership. If lynching helped construct a unified white identity among those whites present and in the surrounding areas, then photographs of lynchings helped extend that community far beyond the town, the county, the state, the South, to include whites nationwide and even internationally. Now all whites, rich or poor, male or female, northern or southern, could imagine themselves to be master. Such was the case not only of the images made professionally and sold commercially, but also of those amateur photographs taken by everyday folk with cameras readily available through a burgeoning photographic industry.

Historian W. Fitzhugh Brundage has argued persuasively that scholars of lynching must pay close attention to the range of types of mob violence. In his study of lynching in Georgia and Virginia in the years 1880 to 1930, Brundage notes that lynchings were committed by one of four different types of mobs: small mobs, either private or terrorist, consisting of fifty participants or less; posses, serving a "quasi-legal function" and made up of a few to hundreds of participants; and mass mobs in which there were fifty to hundreds or thousands of participants and witnesses. The significance of Brundage's distinctions lies in the extent to which white communities were unified or divided by each type of lynching. For example, terrorist mobs often sought to expel vulnerable and presumably tractable black labor in order to curb the rise of a planter elite at the expense of white laborers. Private mobs, composed of family and friends of the alleged crime victim, sometimes meted out punishment for offenses many other whites did not deem worthy of a lynching, as in the case of an African American man who was lynched by a private mob for testifying against two white men in court. Such acts animated and exacerbated divisiveness among whites.

Yet while small mobs and posses sometimes operated in a manner at odds with the beliefs of the rest of their communities, Brundage points

out, mass mob lynchings, especially prevalent from 1890 until well into the twentieth century, "gave vent to the most fulsome and virulent expressions of the racist pathology at the heart of southern mob violence."[15] These lynchings, more so than the other types Brundage outlines, were rituals that lent themselves to performance and dramaturgy, ceremony and symbolism. As such, these lynchings were most about visibility, about spectacularizing white supremacy and the cohering of white subjectivity through and against "the spectacle of the dead black other."[16]

Lynching spectacles placed their black victims at the center for all to see, and in doing so drew clearly defined ideological and spatial lines around the communities for whom its warnings were intended. As whites were meant to identify with the power of the photograph's white participants, so too were blacks meant to identify with the abject figure at the image's core, the nucleus of this racial/ontological cell. As Michel Foucault wrote in his 1977 history of the prison, *Discipline and Punish*,

> torture forms part of a ritual. It is an element in the liturgy of punishment and meets two demands. It must mark the victim: it is intended, either by the scar it leaves on the body, or by the spectacle that accompanies it, to brand the victim with infamy. . . . And from the point of view of the law that imposes it, public torture and execution must be spectacular, it must be seen by all almost as its triumph. The very excess of violence is one of the elements of its glory: the fact that the guilty man should moan and cry out under the blows is not a shameful side-effect, it is the very ceremonial of justice being expressed in all its force. Hence no doubt those tortures that take place even after the death: corpses burnt, ashes thrown to the winds, bodies dragged on hurdles and exhibited at the roadside. Justice pursues the body beyond all possible pain.[17]

Though Foucault writes here of state-sanctioned public execution in eighteenth- and early nineteenth-century Europe and the United States, his argument is salient to the discussion of community-performed (though also state-sanctioned) public execution one hundred years later. Through a macabre exhibition of torture, lynching simultaneously retraced the always already inscribed mark of infamy, the victim's blackness, while celebrating the triumph of mob law. On the surface, lynching is about race and race alone. But lying just beneath, lynching is about the intersection of racial identity with gender ideology, class background, and associations. Through a pageant of excessive violence and torture situated in, on, and about the

black body, lynching masks these anxieties. Even while antilynching and antiracism work built cross-racial and cross-class coalitions and filiations, though tenuous, the spectacle of lynching reminded everyone who looked that in the end, one was either black or white, either wrong or right. It returned everyone to his or her corporeal essence, to the "truth" that is skin deep.

Whether a lynching occurred at the hands of three people or three thousand, cameras recorded all types of lynchings. For example, a circa 1900 photograph shows a posse of approximately fifteen white men carefully posing with their bullet-riddled victim strewn over a horse. And a small group of lynchers took photographs of the charred remains of John Wise in a 1902 coastal Georgia lynching. Cameras then did not record mass spectacle lynchings only. Visual documents exist of *all* types of lynchings, indicating *all* lynchings as spectacular events worthy of capturing on film, signaling that lynching and its terrors were eminently reproducible.[18] In doing so, lynching photography worked to "fix" racial identities "like a dye."[19]

"Compelled to look lynching in the face": Antilynching Photography

Antilynching activists, black or white, would not always be frightened into submission by either the threat of lynching or the recounting of the tale as framed by lynchers, their proponents, or their apologists. Antilynching activists chose to tell the story in a different manner, indeed to invert and subvert the common tale of black bestiality resulting in swift white justice that culminated in, and forever echoed through, the frozen black and white still photograph. Photographs of lynchings appeared in antilynching propaganda and pamphlets, as well as in reports of mob violence in the black press. In such contexts, these images reconceived the received narrative of black savagery as one of black vulnerability; white victimization was recast as white terrorization. Though actors and the fundamental story of crimes remained the same, in this new forum photography changed the roles and the ultimate moral.

This transformation from lynching photography to "antilynching photography" was realized by reframing the lynching photograph, enabling African Americans to "return the gaze" of the "dominant other." Maurice Wallace alerts us to the power and persistence of "frames" in the construction of black masculinity specifically and in the hermeneutics of blackness more broadly: "An interpretive imposition on black men's being in public space, the frame(-up) restricts, if not altogether dooms, a black man's

potential for transcending the chasmed otherness of race by establishing boundaries (screens, image repertoires, stereotypes), mental parerga, that thwart sameness . . . [and] delimits representational range of the 'photographed' black male by keeping him in his place."[20] "Enframement" then is a means of imprisoning black men in the gaze of the dominant other, contained by the fears and fantasies of black men found therein, most especially in the lynching photograph. To produce antilynching photographs, activists first dismantled piece by piece the racist beliefs about African Americans perpetuated in the dominant press especially. These components—beliefs in the innate criminality, essential barbarity, wanton lasciviousness, and meretricious aspirations of African Americans—were reassembled to reveal the fractures and flaws in the edifice of white supremacy; white criminality, barbarism, lasciviousness, and meretriciousness become visible. Such a dismantling and reframing played and preyed upon a faith in "evidence," calling into question the truthfulness of the dominant press. Antilynching activists further reframed lynching images by placing them within alternative and sympathetic outlets such as pamphlets and the black press. This was the strategy pioneered to great effect by Ida B. Wells.

Most eyes never beheld a lynching directly. For those who viewed lynching, especially mass spectacles that involved torture or burning, as apocryphal, photographs quite simply offered proof. Encouraged in part by a southern rhetoric that claimed special and exclusive knowledge about how best to deal with "the Negro problem," northern and international white audiences preferred to turn a blind eye toward lynching spectacles. When activists did speak out against lynching, they were often dismissed as exaggerating the truth or fabricating it entirely. Antilynching activists made use of lynching photographs as a form of evidence. In order to mount a plausible and effective case against the crime of lynching, antilynching crusaders believed they would have to show the body, almost literally. In her autobiography, Ida B. Wells recalls that Reverend C. F. Aked of Liverpool refused to invite the journalist to address his congregation on her first speaking tour of Great Britain because he did not "believe what I said is true." It was not until Reverend Aked visited America and read detailed accounts of lynchings in white newspapers that he believed in Wells's veracity and invited her to speak to his congregation when she returned to England in 1894.[21]

Like the reports published in the "reputable" white press, photographs gave legitimacy to the words of African American antilynching activists, since even drawings of lynchings were suspect. Wells relied on audiences'

confidence in the power of photography to faithfully apprehend and dispatch the "truths" of the material world. When Sir Edward Russell, an editor and journalist himself, saw a lithograph made from a lynching photograph reproduced in the British journal *Anti-Caste*, he denounced the image in an editorial "as an illustration drawn from the imagination." Informed that the image was taken from an actual photograph, Russell became wholly sympathetic with the antilynching cause, lending his name and support to Wells's efforts in England.[22]

From such incidents as these, which occurred during Wells's two successful speaking trips to Great Britain, in 1893 and 1894, she came to understand the power of photographs, along with other documents produced by whites, to corroborate her accounts of lynching and to open an avenue for further discussion. As an outspoken black woman denouncing the American South, and sometimes even calling to task well-respected American reformers who happened to be lynching apologists, she used photographs as passports that provided her entry into progressive circles and the dominant public sphere. While some of the white press in the United States attempted to besmirch Wells's character, as the *Memphis Commercial Appeal* had sought to do beginning with *Southern Horrors*, her first antilynching polemic in 1892, Wells armed herself with facts—written, quantitative, as well as visual—gleaned mostly from the dominant press. As she herself declared, "All the vile epithets in the vocabulary nor reckless statements [could] not change the lynching record" that the press had so copiously reported in their own pages.[23]

Expertly, Wells wielded these textual weapons as part of a well-crafted public speaking persona that both played upon and drew attention away from her black female body. Indeed, in Britain as well as throughout the United States, Wells's own "body became an exhibit for her arguments about the South." Wells, like other black women activists of the period, had to navigate the minefield of public discourse surrounding black women, a discourse that, as Sandra Gunning points out, could not "conceive of her either as a woman writing in protest or as a woman in need of respect and protection," but only as silent victim or as grating perpetrator.[24] Under the carefully chosen pen name "Exiled," Wells authored dispatches from her tours. The coupling of the androgynous moniker with charged words centered on the violent intermixture of race, sex, and place attempted, as historian Patricia Schechter tells us, to "resist the negative or even *non*subjectivity assigned to black women in American culture . . . [to] abandon the

dominant culture's racist demand for bodily fixity . . . and challenge others to join her." Photographs helped further dislodge these "coordinates," to widen the space between the incontrovertible nature of Wells's facts and argument on the one hand, and the dubious "nature" of the body that presented them on the other. Photographs achieved this in part by luring attention away from Wells's "nonsubjectivity" as a black woman, assumed to be wanton and lascivious, a cheap imitation of white "true womanhood," and refocusing her audience's gaze on the atrocious reality of racial violence as evidenced in the brutalized black male body.[25] Simultaneously, Wells asserted herself as "unwilling spokes*woman*"; drawn ineluctably to the antilynching cause, she forged a space for herself and her voice in public discourse.

Upon her return to the United States after her first speaking tour, in June 1893, Wells hastened to produce, publish, and distribute "a credible little book" protesting the exclusion of African Americans from, and the debased representation of black people in, that year's World's Columbian Exposition taking place in Chicago.[26] Already an accomplished journalist and just beginning her lifelong antilynching work, Wells authored three of the six essays in *The Reason Why the Colored American Is Not in the World's Columbian Exposition*. The short piece entitled "Lynch Law" would serve as the foundation for her 1895 pamphlet, *A Red Record: Tabulated Statistics and Alleged Causes of Lynchings in the United States, 1892–1893–1894*. Both "Lynch Law" and *A Red Record* drew on a variety of sources to buttress Wells's analysis of the proliferation and severity of lynching throughout the southern United States. Like *Southern Horrors* and "Lynch Law," *A Red Record* was supported by accounts of lynchings in the white press, editorials, and Wells's own investigations. Notably, Wells reproduced two images, the first a drawing made from a photograph and the second a photographic postcard of the lynching of Ray Porter in Clanton, Alabama, in 1891 (figure 1.2). These are the first examples of the deployment of antilynching photography in the political fight against mob violence.

Each of these resources—visual, statistical, journalistic—helped substantiate Wells's accusations and turn prolynching rhetoric on itself. As Wells declared, "Out of their own mouths shall the murderers be condemned."[27] Here, in the vein of a rising social science discourse, Wells employed photographs as indisputable visual documents to draw attention to the victimization of not only black people in the South but all victims of lynching, regardless of race, to denounce the claims of impotence on the part of local

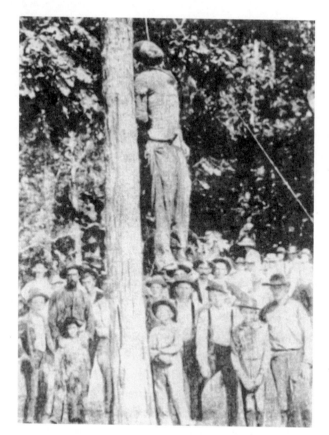

Figure 1.2.
Postcard of the
lynching of Ray
Porter, Clanton,
Alabama, 1891.
Photograph by
W. R. Martin,
reproduced in
Ida B. Wells,
A Red Record
(1895).

government officials, and to categorically challenge each one of lynching's underlying assumptions. She achieved this by distinctly, yet differently, linking the images to her own analysis.

The compositions of the two images Wells reproduced in *A Red Record* are similar: a black male hangs lifeless from a wooden post while a crowd of white onlookers—men, women, and children—poses behind the victim. The photograph is positioned in the pamphlet at the end of a discussion regarding the innocence of many lynching victims, including several whose guilt is questioned by their murderers even as they are hoisted up a tree or a match is thrown at their feet. Here, image and text are juxtaposed in order to reinforce one other. As Roland Barthes suggests, "the text constitutes a parasitic message designed to connote the image, to 'quicken' it."[28] Wells's juxtaposition extends the work of "naturalizing the cultural" reversal of the lynching narrative that the essays within *A Red Record* begin. By locating this corpse within a context of doubt and uncertainty, Wells effec-

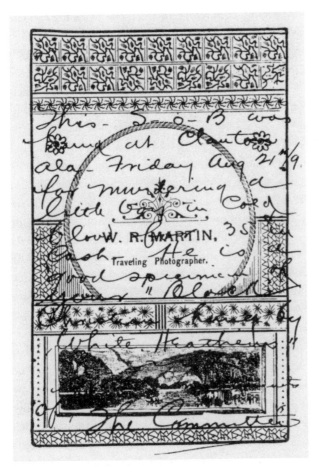

Figure 1.3. Obverse of the lynching photographic postcard, bearing a handwritten note and the printed inscription, "W. R. Martin, Traveling Photographer."

tively makes the reality and sureness of this man's death, "proven" by the irrefutable nature of the photograph, cause to question. If this person was innocent, why then is he dead before my eyes? Here, image and text are juxtaposed in order to create a disjuncture in our visual epistemology.

This disruption is underscored by a handwritten threat sent to Judge Albion W. Tourgee, a northern white writer and advocate for black civil and political rights, on the back of the image: "This S-O-B was hung in Clanton, Ala., Friday August 21, 1891, for murdering a little [white] boy in cold-blood for 35-cents cash. He is a good specimen of your 'Black Christians hung by White Heathens'" (figure 1.3). Is Ray Porter a murderous "S-O-B" or a victim punished "without any proof to his guilt"? Wells casts her own interpretation into the fray. Because the photograph's evidentiary weight is assumed and understood, Wells's reframing intervenes in the received and

accepted narrative of lynching, competing for the meaning of the act, the meaning of the black body.[29]

Through reframing the photograph, Wells presented a competing way of "seeing" lynching, working to reverse the gaze that coheres whiteness and fixes blackness. Indeed, antilynching photography returns the black gaze disallowed by lynching photography and the lynching spectacle itself. Southerner Winfield H. Collins, one of the first historians of slavery, advocated lynching as a necessary evil to prevent African Americans returning the gaze of justice, questioning her blindness and evenhandedness.[30] Public institutions, especially the legal system, and public spaces, especially the lynching site, were thought to be the domain of white men only.[31] With the black victim center stage, sometimes on special podiums built especially for the execution, "justice" as the privilege of white men alone could turn its deadly gaze upon any body of its choosing and execute that "justice" to the extent it saw fit. "Justice," however, could not be questioned or looked back upon. "Barbarous criminals," wrote Collins in his 1918 pamphlet *The Truth about Lynching and the Negro in the South,* "require barbarous laws." In his opinion, African Americans had no right to a trial by a jury of their peers. Lynching preserved the dignity of white women who had already been disgraced and defiled by rape at the hands of black beasts, but who would be spared the humiliation of having to relive the brutal crime against them by simply avoiding that phase of the legal process altogether. Collins further asserts that African Americans are incapable of participating in a jury trial. "Moreover, instead of a Negro's being overawed by the solemn deliberations of a court, rather as he is the center of interest, he all but enjoys it. For once in his life he finds himself in a position of prominence. It would be contrary to Negro nature if he were not somehow elated at being the object of so much attention." The irony of course is that as the object of white violence in spectacle lynchings, "the Negro" is *made* "the center of interest."[32]

Collins fears black subjectivity within the legal system and its implications of miscegenation. He describes how in two cases of legal execution, black men when given the chance to speak their last words "took advantage" of their public platform. In the first instance, which Collins cites from the *Richmond Enquirer,* May 4, 1775, Joe Clark confessed to and described his crime of murder before three thousand people, mostly black, who were present for the execution. "'He advised all present to live an upright life . . . Clark's last request was that the black cap be kept off, so that all might see how easily he could meet death.'" Rather than meeting death blindly, Joe Clark wanted to see his demise coming. Further, he wanted to *be seen* see-

ing death, seen facing his own mortality. Collins thinks Clark's final wish is shameless and brazen, and indeed it is. Clark had a keen awareness of his body in public space. His use of this final public forum offers an alternative concept of the function of justice, as an opportunity for reciprocity and mutual recognition rather than as an arena that renders the perpetrators of justice invisible and their victims glaring and mute in its wake.[33]

Collins takes his second case from the *Baltimore Sun*, August 27–28, 1915, nearly a century and a half later, but a similar account to the first. The accused black man advised the crowd of onlookers to take heed from his example and avoid his fate by joining the church. Collins thought this religiosity fabricated. He quotes the article as reporting that the unnamed African American man met his doom with "indifference": "'Passing undismayed through the throng which had gathered along the way from the prison to the gallows, *his gaze* passed fearlessly around surveying the people.'" Collins emphasizes the words "his gaze," suggesting that as a black criminal sentenced to death, this man had no right, nor should he be allowed, to look upon or survey the people who gathered to watch him die. Nor should there exist a space within the legal system for African Americans to speak in their own defense or to those who might be in danger of meeting a similar fate. Collins fears this *gaze* because it is simultaneously a demand for recognition from what should be a passive participant and a disruption of the accepted roles, defined by race, of the players in this juridical drama. To borrow from Frantz Fanon's rethinking of Hegel's master-slave relationship figured in *Black Skin, White Masks*, here we are confronted with a moment in which the victim, "the object" and "mirror" for a society's practice of justice, looks back at his executioners, "the subject," and reflects back a "flawed" image. The subject suddenly stands "naked in the sight of the object." By returning the gaze of his executioners and those gathered to watch him die, the accused begins to challenge, disrupt, and even dismantle the "corporeal . . . and historico-racial schema" of himself constructed by "the white man, who had woven [him] out of a thousand details, anecdotes, stories." The accused intervenes in his racial making and begins to undo the racial making of his executioners.[34]

Compounding the condemned's gaze is the fearlessness with which this look considers and inspects the crowd. According to Collins, only white justice, extolled for its blindness, should be allowed to gaze, survey, consider, condemn. Justice, according to Collins, is meant to strike fear in the heart, mind, and eyes of the accused. But because the legal system could not assure that African Americans would not return the gaze of their accusers, or

take advantage of their central position and speak, lynching emerged as the preferred, if not only, alternative. The lynching spectacle was rigidly controlled, narrated if you will, where there would be no surprises and no fear of recrimination. Moreover, lynchers derived power from the fear instilled in their victim. Collins here expresses a need for blacks to be seen, to be enframed, in a way that does not disrupt the script. He wants the law to tightly orchestrate the fine line between black visibility and black invisibility, when they can be seen and when they cannot or should not. But what erupts is a concern around black hypervisibility, excess from the margins. In Collins's myopic account, the only thing on display should be the true workings of justice where the legal system failed.[35]

But in the spectacle of lynching, what was actually on display? Black bestiality was put on display for all to see, or imagine they did. It was the alleged crime, especially rape, which caused such outrage and such titillation. While the crime usually had few, if any, witnesses, it surfaced as self-evident in the blackness of the "criminal." Lynching suggested visibility as a form of justice: If the accused had not committed the crime, then why was he or she being punished for all to see? Lynching "illuminated" the unseen crimes of black individuals and communities throughout the South: sabotage, subversion, and miscegenation. It made the shadowy and uncertain face of white supremacy visible. And the recounting of the lynching functioned as a form of surveillance or policing of those who might consider transgressing social, economic, or political boundaries.

For all that was brought to light, there was much that lynching obscured and occluded: whites' criminality, both as perpetrators of lynchings and as persons responsible for crimes for which African Americans were blamed; historic and systematic white male sexual assault of black women; anxiety about white female sexuality; and the breakdown of the justice system. Antilynching activists sought to bring all of this into view, to make a spectacle of white supremacy. They employed photographs to help accelerate and focus this message.

The Eye/I: Black Spectatorship and Struggles in the Shadow Archive

Lynching photographs raise confounding questions regarding the complexity of black spectatorship, bringing into sharp relief the knotty and often unruly relationship African Americans have to the processes and practices of looking at themselves. At first glance, this relationship may appear an open and shut case of black identification with and resistance to

the lynching spectacle—they see, they identify with the black victim, they reject the white supremacist messages imparted—a linear relationship in which black viewers are constituted as a single, monolithic, "ideal" black subject through the act of looking at these violent images. Rather, as a host of scholars have demonstrated, particularly in the context of film, black spectatorship is never merely complicit or resistant, neither wholly absorptive nor completely oppositional. Instead, black spectatorship is "fluid," "negotiated," "heterogeneous," and "polyphonic."[36] What emerges from this literature, what we are reminded of, quite simply, is that the act of viewing elicits an array of responses from diverse individuals, in varying contexts, who differently interpret and incorporate visual messages into their lives.

Though lynching photographs may hail black audiences as a singular "other," black spectators are not so easily interpellated. Jacqueline Stewart's concept of "reconstructive spectatorship" proves particularly useful in that it builds upon notions of spectatorial fluidity by placing an emphasis on "the collective, contextual, and physical dimensions of black spectatorship."[37] Stewart argues that closer attention must be paid to the public and group aspects of early twentieth-century black spectatorship; to the conditions and locations in which viewing took place (whether in spatially segregated or racially mixed circumstances); to the expectations black viewers placed on each other as "representative of the race" (or not); and to the aggressive tension between the circulation of black images and the evaluation of actual black people as embodied subjects of "blackness."

In placing concerns of context, community, and embodiment alongside questions of identification and resistance, "we can account for the range of ways in which Black viewers attempted to reconstitute and assert themselves in relation to the cinema's racist and textual operations."[38] Though Stewart formulates "reconstructive spectatorship" in the specific context of early film, it is largely applicable to photography and black spectatorship generally. Indeed, the word "reconstructive" focuses attention on the kinds of political, social, and psychological work to which images are put by black audiences. Whether to restructure a discourse from which African Americans have been silenced in spite (or because) of their visibility, to reorganize and reassert a black viewing public that has been marginalized, or to recreate a self fragmented by confrontations with racist, dehumanizing depictions, black spectatorship requires labor in the effort to produce or disavow an ideal subject. Black spectatorship then can be understood as the modes and paths by which black viewers navigate a hostile representational terrain structured in dominance, a "war of position" fought over many fronts with

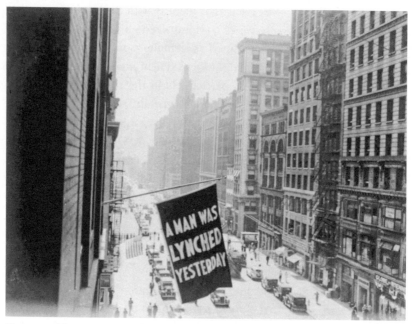

Figure 1.4. Flag, announcing lynching, flown from the window of
the NAACP headquarters on 69 Fifth Avenue, New York City, 1936.
(Library of Congress, Prints and Photographs Division, Visual
Materials from the NAACP Records, LC-USZ62-110591)

multiple strategies, as opposed to a "war of maneuver" marked by a single
confrontation and decisive battle.[39] Through the framework of reconstruc-
tive spectatorship, we become alert to the multiple axes that pressure and
fissure black spectatorship—most notably, geography, gender, and class in
the context of early twentieth-century lynching photography—and the per-
sonal and political work to which black viewers put images.

During the 1930s, the NAACP unfurled a flag outside the windows of their
New York City headquarters high above Fifth Avenue each time the office
received news of a lynching (figure 1.4). The bold capital letters in white
against the mournful black background spelled out "A MAN WAS LYNCHED
YESTERDAY," alerting passersby to the violence that plagued (black) com-
munities in other parts of the country. Photographs of the flag would ap-
pear in the organization's magazine, *Crisis*. Though the image of an actual
corpse is absent, we can include this photograph as part of the lynching ar-
chive as a reference to and representation of lynching violence. Like other
lynching photographs, this image (and the practice it documents) also at-
tempted to interpellate an audience of concerned citizens into an imag-

ined community. But with its densely packed, multistory buildings, clusters of pedestrians, and bustling car-lined avenue reaching back toward a seemingly infinite perspective point, the photograph indicates its distance from the small towns or rural back areas where its brutal referent took place. Sixty-nine Fifth Avenue was far from the peanut farms between Greenwood and Marianna, Florida, where Claude Neal was lynched, or the bridges over the Canadian River in Okemah, Oklahoma, from which Laura Nelson and her son, L. W., were hanged, or even lively Commercial Avenue in Cairo, Illinois, where an enormous crowd strung Will James from the newly electrically lit "Hustler's Arch."[40] Indeed the very need to announce that a lynching had occurred indicates how geographically and psychically distant many New Yorkers, white and black, were from lynching itself. "A Man Was Lynched Yesterday" was the New York version of the lynching spectacle, flagpole as tree limb, banner as body, an understated urban expression of that remoteness.

Not just evidence of the geographic distance from sites of lynching, the banner also attempts to coalesce diverse black constituencies into a unified viewing and acting community. Migrations from the southern black belts and Caribbean islands produced a complex diaspora within a single urban center, emergent black communities further troubling the notion of a unitary black identity. Though they arrived with similar sets of concerns, engendered by experiences structured in relations of dominance, the specificities of these concerns varied. These black populations diverged on the best means to address the various manifestations of the economic, social, political, and cultural oppressions they faced.[41] Void of people and place, and with no mention of race, the text of the banner stands in for all. The white lettering on the black background provides a visual meditation on the racial dynamics of lynching. The use of text as a surrogate for a corpse suggests an attempt to bridge the distance of life journeys and produce a uniform context below 69 Fifth Avenue. As James Weldon Johnson intoned as early as 1916, "Let us remember that we hold the only political protection for our brethren in the South. Let us not forget that their fate is in our hands."[42] The form and context of "A Man Was Lynched Yesterday" signals the fragmentation of black peoples through its attempt to constitute a unified and resistant black spectatorship.

Place and distance each determine one's proximity to the terror of lynching and to the experience of viewing its representation. Gender clearly does as well. By referencing the lynching of men only, the NAACP banner stands in textually for the absent black male corpse; it functions as a surrogate.

Joseph Roach has described the process of "surrogation" as one in which "survivors attempt to fit satisfactory alternates . . . into the cavities created by loss through death or other forms of departure." He continues, "the fit cannot be exact. The intended substitute either cannot fulfill expectations, creating a deficit, or actually exceeds them, creating a surplus."[43] The NAACP's banner announced the lynching of men, purposefully deracializing and degendering the victim to impress upon all viewers the murder of an "everyman." With the nameless, placeless "man" offered here as universal subject, the banner generates a "surplus" spectatorship in which all audiences can identify with the lost, can mourn, and can act. Yet in this attempt to "fit a satisfactory alternate" for lynching, the banner also creates a "deficit" that leaves little or no place for black women as victims of lynching.

Indeed, while the lynching spectacle worked to reinscribe hard and fast racial lines and was itself an expression of them, the gendered dimensions of looking at lynching images, and of black spectatorship, erupt at nearly every turn. In practice, lynching emerged as a violent (one-sided) conversation between white men and black men for political, economic, and sexual power mapped onto the bodies of white women. In photographs, this is often evidenced in the triangulated presence of the black male victim, white male mob members, and white female mob members.[44] Black women were confined to the periphery of this narrative, and unless they themselves were the victim of a lynching, absent from the picture's frame.[45] Rendered both discursively and visually invisible, black women could be subsumed under the category of the "black beast," generally the epithet raised against the brutal black rapist, but one that interpolates all black sexuality as dangerous. As Hortense Spillers has so powerfully argued, slavery succeeded in the ungendering of black people into an undifferentiated yet highly sexualized "flesh" as "primary narrative"; so too does the lynching narrative place black men and women into an indiscriminate bestial body.[46] The text of the "Shame of America" advertisement recognizes this conflation when it informs readers that "83 WOMEN HAVE BEEN LYNCHED IN THE UNITED STATES. Do lynchers maintain that they have been lynched for 'the usual crime'?"

Yet, the citing of this particular statistic is not foremost a recognition of mob violence against black women but a tool to refute rape as lynching's primary cause, a challenge to the defamation of black masculinity. "The white fetishization of the black male body as the object of a white mob's fury" implanted and reinscribed through lynching narratives and images, then becomes the focus of antilynching activists and beyond.[47] As stereo-

type and as symbol, the image of "the lynched black man" has emerged and evolved as visual shorthand, as a powerful icon paradigmatic of the suffering of all African Americans and understood only through the abject black male body. Most notoriously, during the Senate confirmation hearings for Clarence Thomas's appointment to the Supreme Court, his cry of "high-tech lynching" rendered Anita Hill and her accusations of sexual assault unintelligible. The interpellation of black women into the lynching narrative, in which "all black victims [are reduced] to this one obliterating stereotype," effectively erases the specificity of black women's experiences from the lynching record. If black men are enframed—fixed and entrapped—within the lynching photograph, then black women are utterly expunged.

When antilynching activists locate black women in the lynching narrative, they generally appear as either victims who lost their lives for protecting black men and children or mourners grieving the loss of black men and children. Tied to the familial and the domestic, such inclusion reflects the discursive spaces available to "respectable" middle-class women in public space during the Progressive Era, a "politics of respectability" that beleaguered black women especially, well into the twentieth century (and beyond).[48] For example, Laura Nelson, lynched in Okemah, Oklahoma, and Mary Turner, burned alive in Valdosta, Georgia, in 1918, are both described first as mothers: Nelson was lynched for protecting her son, L. W., accused of theft; Turner is described as a pregnant woman who protested her husband's lynching only days before she was lynched and her unborn child cut from her swollen belly and stomped to death.[49] Likewise, photographs of the mothers of the "Scottsboro Boys," nine young men who barely escaped a mob lynching in 1931 only to face a legal lynching and life sentences for a crime they did not commit, and 1955 photographs of Emmett Till's grieving mother, Mamie Till, were all part of more broadly conceived antilynching campaigns in the wake of the Dyer bill. These visual strategies were not based on shock value of a brutalized corpse alone but on the creation of sympathy and pity for a grieving mother and of anger for the outrageous violation of sacrosanct motherhood. The use of images of the mothers aim to embody the loss of the male victims, best understood as a mother's loss of her male child.[50] Such a tactic suggests mourning as a political act. As Deborah McDowell has argued about contemporary postmortem photographs of black male homicide victims, "survivors reject the role of passive mourners scripted by the media . . . they represent families that choose to exhibit the body not as still life, but as living still in memory."[51] Yet because these mothers are not the victims themselves, their images create a surro-

gation deficit and cannot replace the absence of the image of the black male victim.

Such strategies, while making visible the crimes committed against black men, obscure the extent of violence practiced against black women and children, almost never documented by a camera. Ida B. Wells reinserted black women into the lynching narrative first by explaining that "the women of the race have not escaped the fury of the mob," being lynched not for sexual offense, but for other alleged assaults against whites, everything from murder to "being drunk and saucy to white folks."[52] Wells went further by highlighting the sexual dimensions of lynching. Among other aspects of the sexual knot of racial violence, Wells noted that many relationships between white women and black men were consensual rather than forced and pointed to lynching's work as cover story for white men's sexual abuse of black women. With sex functioning as fear and motivation, lynching projected white men to positions of supremacy, demonized black men, restricted white women to the domestic sphere and rendered them dependent upon their men. Lynching and its narratives completely silenced and erased black women, leaving them vulnerable to violence outside of the public eye. In turn, black women's antilynching work in particular, as Hazel Carby and others have powerfully argued, had at its unspoken center the restoration of black womanhood. Such work asserts that racial uplift and racial justice are impossible without addressing women's concerns, for women's issues are inextricable from the crises facing the race as a whole.

Black women's antilynching work also recognizes the inextricability of visible violence from violence that is unseen. Black women engaged in forms of reconstructive spectatorship that enabled them to traverse a visual discourse in which they themselves were implicated but from which they were censored (and censured) at every turn. Through the lens of reconstructive spectatorship, we can see how black viewers took up Progressive Era black feminist concerns and expressed explicitly gendered expectations of one another. The October 30, 1915, issue of the prominent black newspaper, the *Chicago Defender*, features a front page article about the lynching of an unidentified black farmer and his sons (figure 1.5). The headline in all capitals reads: "FATHER AND THREE SONS ASSASSINATED FOR RAISING THE FIRST COTTON, NEWS NEVER REACHED WORLD FROM TEXAS."[53] The angry article frames a large photograph of the lynching of the four men, still in their work overalls. The subheading commands, "Women! You Go Out and Protect Your Sons and Husbands." The caption addresses women directly, still as wives and mothers of black male victims. But in its intona-

FATHER AND THREE SONS ASSASSINATED FOR RAISING THE FIRST COTTON, NEWS NEVER REACHED WORLD FROM TEXAS

Figure 1.5. Article in *Chicago Defender*, October 30, 1915, on the lynching of four black men in Texas.

Women! You Go Out and Protect Your Sons and Husbands

The gruesome assassination of four race men! Look at it; see these men hanging from a limb of a tree simply because they have been able to raise better cotton than their white neighbors. Then look at the other race farmers who were made to come and look at them. Women, get your guns ready; the men lack the backbone. Sharpen anything that will leave its mark and prepare. Prepare to strike the blow. Not satisfied with the horrible crime they had pictures taken on postal cards and sold. The U. S. government refuses to act; we must start the initial blow. Strike. Men have failed; it is up to the women to protect their homes, as the son and father and brother refuse to do it. We learn that some of the men who help do the crimes are well known and that they have lived openly with race women. Don't it make your blood boil? Look! Look! These women are the ones that we speak of as wenches. They sell their soul for gold. They stay with this sort of a barbarian and give birth to their children to see them hanged from a limb simply because a white man knows that there are no laws in the South to stop it and that this government sits like a wooden Indian and does nothing. Look again at the picture and see how the poor farmers are made to look at them. It is dreadful. We print from the postal card to show you that these things are facts that you can't deny. This crime must be stopped and it will only be done so when the race will strike and blood will be sacrificed. This lynching was never recorded, although done three weeks ago; no press, no pulpit, white or black, to speak a word. This is the lesson that is being taught by the "Birth of a Nation." This is the thing the daily papers of America is upholding. Remember that any paper that carries the ad of that photo play you should not buy. Any moving picture house that uses any of Griffith's plays should be boycotted, and any woman of the race who living now at the South like they had to do in slavery time should be run out of your neighborhood; or do as the race men have done in Savannah, Ga., call the white fiends to the door and shoot them down.

tion to both "go out" from their homes and "protect" the men in their lives, the juxtaposition of words and image is a call to action. The text below follows this same pattern between announcement and directive. It moves between demanding readers to look at the photograph: "Look at it; see these men hanging from the limb of a tree . . . Look again at the picture"; directing readers' attention to what they need to see: "Look at the other race farmers who were made to come and look at them . . . see how the poor farmers

are made to look at them"; and prescribing a forceful response: "Women, get your guns ready . . . Prepare to strike the blow." In so doing, the author presents a guide to "reading" the photograph, one directed to and for black women specifically, and by extension, shamed or "feminized" black men.

"Men have failed," the author tells us. "It is up to the women to protect their homes, as the son and father and brother refuse to do it." The text presents the photograph as a critique of the failure of black men to either protect themselves from the wrath of white communities or defend the women and children who rely upon them from abuse. As Ula Taylor writes, "progressive African American women . . . challenged black men to step up their activism or be prepared to be put down and led by those who were better equipped."[54] Black men are now in need of black women to defend the black community and more specifically the black home from personal loss: economic, sexual, personal.

But not just any black women. The article admonishes "race women" whom some of the white men who committed lynchings "have lived openly with." Though not in the picture's frame, readers must "Look! Look!" and see these "wenches" as well for their silent and invisible complicity in white supremacy: "They stay with this sort of a barbarian and give birth to their children to see them hanged from a limb simply because a white man knows that there are no laws in the South to stop it and that this government sits like a wooden Indian and does nothing."[55] Indeed, the directive presents a tacit sanction of "best" black women's public work in this period, particularly as ambassadors of the race to the white community in a fraught context in which black men advocating on their own behalf was deemed politically and sexually threatening and black women's sexuality was deemed illicit. Middle-class black women's public leadership comes to the fore on behalf of their men, of their domestic spaces, and of their own respectability. An explicitly gendered call to action, the *Chicago Defender*'s framing of the lynching photograph argues for a particular way of seeing and interpreting lynching and its representation that presses both black men and black women into expected roles.

Finally, through the lens of reconstructive spectatorship, we can better understand how black viewers situate themselves amid and against a complex range of black visual representations, of which lynching photographs are only one genre. How have African Americans employed lynching photography to offer revised readings of black subjectivity, potentially transcending, or reinscribing, as in the *Defender* example, the frames to which black people have been confined, to move beyond racial fixity?[56] By juxta-

posing the multiple visual representations of African Americans—as scientific object of study, as refined elite, as slave caricature, as criminal type, and as quieted savage—we can see clearly the interdependence of the various subordinate archives of the larger shadow archive articulating hierarchies on the social terrain of this period.

African Americans used photography to reconstruct their image, in part, against the humiliation of minstrel icons and against the vulnerability of lynched black bodies. Blacks chose to represent themselves not only as cultured and refined, but also as thriving and self-possessed, as the embodiment of bourgeois ideals. Utilizing the affirming and often liberating genre of portraiture, in particular, signified a conscious and public choice meant to counter the repressive functions of lynching images. The use of lynching images was likewise a performance, an attempt to affect public opinion and envision freedom through the specific dramaturgy, or staging, of black death at the hands of white Americans.[57]

From the time Dyer devised the antilynching bill in late 1919, the *Crisis* published numerous accounts of lynchings, antilynching "Opinions" and photographs of lynchings. The NAACP secured the services of the Southern Press Clipping Bureau to provide them with ample material. But once the House passed the bill in January 1922, the news organ toned down its use of photographs. Indeed, the absence of antilynching photographs throughout 1922 until the bill went to the Senate speaks volumes. Throughout the debate, there was no shortage of passionate, yet reasoned, words against mob violence in *Crisis*. The Dyer bill was often the first item of each issue, and central throughout, garnering space in Du Bois's "Opinion," White and Johnson's "NAACP" section, and the cleverly named "The Looking Glass," which monitored the stance taken by the mainstream national and international press on issues deemed significant to African Americans. The *Crisis* urged African Americans who could vote to no longer align themselves with the party of Lincoln. They were impelled instead to cast their ballots for the politicians who cast their ballots in favor of the Dyer bill. "If the Senate does not pass the Dyer Anti-Lynching Bill," wrote Du Bois in his April 1922 "Opinion" column, "any Negro who votes for the Republican party at the next election writes himself down as a gullible fool."[58]

Photographs of antilynching protests, parades, and the National Association of Colored Women delegation to President Harding were included in the June, August, and October issues, respectively. But only two photographs of a lynching appeared that year, side by side in the November 1922 issue, just as the Senate fight heated up. The photographs depict the July 14

lynching of Joe Winters in Conroe, Texas. The first photograph bears the caption, "The Burning Body." In the foreground, a dense black cloud of smoke rises, and surrounding at a distance is a dense white crowd. Just below is an accompanying photograph of white people stretching throughout Conroe's downtown streets. Under a headline that reads "A Larger Crowd than . . . the Circus," the photograph reveals thousands of people lining the streets, standing on rooftops, even balancing on the awnings of local businesses, hoping to get a look at the black mass burning in the public square. These images come as part of a lengthy response to a letter from a well-meaning white woman from Baltimore who asks of the NAACP antilynching campaigners, "Why so hard? Why so intolerant?"[59]

Throughout 1922, the *Crisis* chose to reproduce images of well-dressed, serious African Americans exercising their constitutional rights of free speech and assembly, gaining an audience with the president to voice their grievances in the fight against lynching. In short, these photographs portrayed African Americans as citizens worthy of all the privileges and protections extended to that category, all the more deserving because they also looked the part: rational, dignified, systematic. The proper course for Dyer bill advocates, the *Crisis* seemed to answer, was calm and thoughtful action, inspired by and modeled after the carefully organized demonstrations of silent protesters and antilynching lobbyists.

Indeed we should consider the use of lynching images a difficult choice rather than a natural one. James Weldon Johnson described the painfulness of publicizing lynching, such as that of Henry Lowery in Nodena, Arkansas, January 27, 1921, in *Along This Way*:

> The national office of the Association had dealt with a number of cases equally atrocious and had tried through publicity and protest to make them means of arousing the conscience of the nation against the Shame of America, the shame of being the only civilized country in the world, the only spot anywhere in the world where such things could be. These happenings caused in me reactions that ran the gamut from towering but impotent rage to utter dejection, and always set me wondering at the thoughtlessness of people who take it as a matter of course that American Negroes should love their country.[60]

But it was just this love of country through which the NAACP structured its antilynching campaign. The fight for the Dyer bill, the "Shame of America" advertisement asserted and assured readers, was a fight for "100 per cent

Americanism," a struggle for and about national belonging. A vestige of World War I preparedness campaigns, "100 per cent Americans" had been Teddy Roosevelt's nativist cry against "hyphenated Americans," the waves of immigrants from Eastern and Southern Europe who were changing the face of America's urban centers. As historian John Higham writes, the 100 percent Americanism movement sought "no hostility to the existing social order, but rather a zeal to maintain it; no desire to build an omnipotent state, but rather an appeal to state power only as a court of last resort when public opinion seemed incapable of enforcing conformity."[61] Navigating the minefield of the existing social order to change it from within, the ad addressed its audience as fellow American citizens in the midst of debates over immigration quotas that occupied the front pages of the newspapers in which the "Shame of America" ad ran.[62] The appeal to 100 percent Americanism sought acceptance and inclusion of African Americans as U.S. citizens, not as outside agitators. It signified an antiradical sensibility and an appeal to conformity. For the purposes of passing legislation, the ad's architects cast their lot with and as Americans, born and bred, simultaneously foreclosing transnational connections like those cultivated (quite differently) by W. E. B. Du Bois and Marcus Garvey. Though African Americans had been slaves, in the words of Oscar Micheaux's New Negro character, Dr. Vivian, in the 1920 film *Within Our Gates*, "We were never immigrants." The advertisement presented the Dyer bill as the most patriotic answer, indeed "the remedy," to this shameful, undemocratic, and, above all, un-American disgrace.

In this period, blackness is the identity that is both disavowed (the denial of the contributions of African Americans' labor since the country's origins and more recently their patriotism and military commitment in World War I) and disallowed (through disenfranchisement and Jim Crow segregation) in the construction of the nation. To make visible the abject black body could potentially trouble the careful "American" frame through which the NAACP organized its antilynching campaign. To present *this* black body—brutalized, weakened, undignified, ragged, often only partially clothed, poor or impoverished-looking, dead—to a broad audience (especially the sixty-two thousand readers of the *New York Times Mid-Week Pictorial*) would have sullied and disrupted the careful portrait of black character and respectability—clean, strong, dignified, well-dressed, self-sufficient, nonsexual, alive, and thriving—cultivated by elite African Americans in this period. This latter black body was the visage of an American citizen, not the

former. For the NAACP and many African Americans conforming to a politics of respectability, the sight of the lynched black body was truly shameful, capable of arousing feelings of "towering but impotent rage" and "utter dejection."[63] Dishonorable for African Americans, reprehensible for white Americans, it was a sight so shameful it could not be presented.

But Du Bois recognized early in his career that "one could not be a calm, cool, and detached scientist while Negroes were lynched, murdered and starved."[64] For those who did not understand what was at stake in the fight for the Dyer bill—the lives of African Americans and of democracy itself—the NAACP believed lynching photographs, recontextualized as antilynching photographs, could transmit the urgency of the crisis in a way that editorials and statistics could not. Antilynching photographs captured, or at least imagined, that final moment before death in which the accused addresses his or her executioners. Whether the look back was challenging, uncertain, or pleading, antilynching activists attempted to reconstruct the black gaze back at injustice that lynching apologist Winfield Collins so feared and abhorred.

Through their use of these images juxtaposed with the images of the organized protesters, the NAACP recognized that the black body as citizen could easily become the black body as lynching victim. In this way, antilynching activists both refused and accepted the black corpse and its photographic representation, identifying with its vulnerability while disavowing its defeat. Through this strategy, antilynching activists attempted to reconstruct themselves as subjects within representation, as well as assert themselves as architects of a new visual hermeneutic.

By employing antilynching photographs in the quest for African Americans' civil rights, activists attempted to redefine a national community and identity, at the center of which hung the tortured black male body. These images made visible James Weldon Johnson's often-repeated cry that the fight against lynching "involved the saving of black America's body and white America's soul." Located in pamphlets and newspapers, lynching photographs placed the fractured and broken national body in the hands of elites and laypeople alike. Antilynching activists remade the degraded, racialized body as American citizen. The innovation of such a campaign lay in its centering of the black male body as the body of the entire nation. When attempting "to balance the sufferings of the miserable victim against the moral degradation of the mob . . . the truth flashed over" Johnson that redemption for both white and black Americans could only occur when lynching ended.[65]

The NAACP hoped that on December 14, 1922, the thousands of readers of the *New York Times Mid-Week Pictorial* would seek such redemption; they would recognize the injustice reflected back at them in the image of the lifeless black body that they held in their hands and feel compelled to act, to pressure their senators to vote in favor of the Dyer bill. But two weeks before the graphic version of "The Shame of America" was to appear, Johnson sensed the defeat of the bill by a Democratic filibuster and requested his assistant, Walter White, to pull the advertisement. "I [doubt] that the proposed ad would have any effect on the present situation here," he wrote. "Indeed, the facts about lynching have up to this time played an almost negligible part in the whole Senate fight."[66] Since the Dyer bill's introduction to the House on April 11, 1921, the bill had been dogged on the one side by emotional rhetoric from southern Democrats claiming lynching was necessary to protect white womanhood and on the other side by an overly rigorous interrogation into its incursion on states' rights by northern Republicans. Silenced by a nearly weeklong filibuster by southern Democrats, Republicans conceded, and the Dyer bill died on December 2, 1922.[67]

Johnson, Du Bois, and the whole of the NAACP were incensed by what Du Bois referred to as the Democratic Party's "lynch[ing] of the anti-lynching bill."[68] However, Du Bois and Johnson saved their greatest disdain for the Republican Party, especially supposed allies like powerful Senator Henry Cabot Lodge of Massachusetts, who had expressed public if tepid support for the bill and the NAACP but showed no fight when the Democrats began to filibuster. "The Southern Democrats roared like a lion," bristled Johnson, "and the Republicans lay down like a scared 'possum."[69] According to Johnson and Du Bois, the Republicans had "abandoned" the bill, indeed "never intended to pass it," and "lied [to] and deceived" the NAACP and, by extension, all African Americans.[70] Senator William Edgar Borah of Idaho, an NAACP sympathizer, would later admit as much to Du Bois: "It is one of the finest illustrations of how we played politics with the negro that I know of."[71]

Out of this loss and betrayal, Du Bois and Johnson used the opportunity to reevaluate and reorganize. Making good on his earlier counsel that "any Negro who votes for the Republican party at the next election writes himself down as a gullible fool," Du Bois urged *Crisis* readers that the time had come to vote third party, either Socialist or Farmer-Labor.[72] Both Du Bois and Johnson rallied African Americans to prepare themselves for a

long fight against lynching. And both praised the publicity work done on behalf of the Dyer bill and antilynching more broadly. In choosing to spend over five thousand dollars on "The Shame of America," Du Bois wrote, "We therefore picked our advertising media with just one aim in mind: how many people can we reach not familiar with the facts about lynching? We reached at least five million readers in a day—the greatest single stroke of propaganda ever struck in behalf of justice for the Negro. The bill was not passed but the effect of this advertisement is beyond estimate. It was copied all over the US and in Europe, Asia and Africa."[73]

Others agreed with the attention paid to publicity. In the wake of the Dyer bill, the *Crisis* held a symposium in its pages, entitled "Our Future Political Action." Fifty African American leaders were asked to comment on "the next political step you think the Negroes should take." John Hope, president of Morehouse College, expressed the desire that future political struggle would continue to incorporate striking visual images and make use of propaganda. "The Dyer bill failed," he wrote, "but America has been compelled to look lynching in the face."[74]

Finally the NAACP encouraged a continued spirit of dignity and struggle, to not forget either black progress or white betrayal. "We are not the ones who need sympathy," wrote Du Bois. "They murder our bodies. We keep our souls."[75] A press release summarizing the NAACP's year-end report for 1922 concluded with the following: "Beyond these concrete achievements the National Association for the Advancement of Colored People has continued to carry out one of its most vital purposes, that of keeping intensely alive the sense of racial vigilance and the conviction that the future depends upon a realization by the race of what it is justly entitled to and a determination to secure it. So long as that spirit is kept alive there can be no ultimate defeat."[76] The defeat of the NAACP's first and, up to that moment, most significant battle against lynching forced the organization to regroup, to intone a warning to its constituents to not forget the betrayal by their political leaders and, by extension, the failures of democracy, and to remain ever-vigilant. In short, to fold the experience of the Dyer fight into a critical black memory.

By "memory," I refer to the processes by which people recall, lay claim to, and understand the past. Memory is an active and integral element in the composition of social and political communities. For social movements especially, memory is never an end in itself but rather a tool to make sense of history, declare lineages, clarify allegiances, and mobilize constituents. I employ the term "critical black memory" to invoke both Walter Benjamin,

for whom memory served as an important political resource, and Houston Baker, who emphasizes the critical capacity of a memory attuned to "ethical evaluations of the past" with an eye toward revolution and distinct from "the distraught sentimentality" of nostalgia.[77] Critical black memory implies the negotiation, the *use* of history for the present. For both Benjamin and Baker, memory is an essential site of political and social struggle.

With this term, I also want to suggest that critical black memory emerges out of and is motivated by both survival ("We keep our souls"; "the conviction that the future depends upon a realization by the race of what it is justly entitled to and a determination to secure it"); and failure ("They [continue to] murder our bodies"). On the one hand, memory offers a space to organize for the future while making critical assessment of the past and present. For African Americans in particular, traditionally denied access to formal historical institutions, memory has been more than mere repository of experience. Rather, black memory has challenged official stories and given voice to historical silences. It has attempted to suture continuity in the face of rupture and fragmentation. It has proffered futurity woven out of "the ineffable terror" of the past.[78] As living entity, memory has proven critical to identity formation and self-creation. In W. Fitzhugh Brundage's keen words, "the rituals of black memory represent a form of cultural resistance."[79] And even more, black memory "implies a certain act of redemption."[80]

Black memory also describes and carries within it the failures of the past: the failure to produce the desired political transformations, the failure to create or sustain a culture of mourning or to successfully work through that mourning. Black memory has also been a burden, turning experiences into icons, forcing racial and gender conformity and eliciting prescribed responses to racial events.

In the immediate wake of the Dyer bill, and in the wake of lynchings throughout the twentieth century, activists have had to ask what narratives do we then produce to put the individual and collective self, fragmented by trauma, back together?[81] Photographs of lynching embody the will to survive and the anguish of failure entrenched in critical black memory. This is a theme I will take up in more detail in the final chapter. But for now we must consider how the beginning volley of the antilynching struggle set the terms for Mamie Till-Mobley and later activists. Photography has been central to the narration of lynching across the twentieth century, and lynching photography is nearly omnipresent in the narration of black life in this long century as well. The lynching archive functions as a site of struggle over how

to memorialize the dead, how to organize for the future, that also reveals the vagaries of an ossified memory.

Survival comes in the retelling. Indeed, to be able to tell the tale means one has lived. Likewise, to look at a photograph of the dead means that the viewer is living and breathing and looking. For James Cameron, a black man who survived a lynching that took the lives of his friends Thomas Shipp and Abram Smith, survival was most clearly articulated in the ability to recount the tale in both written memoir and through engagement with the now well-known photograph of Shipp and Smith hanging lifeless in front of the white Marion, Indiana, crowd. "To survive . . . is to immerse oneself in photographic representation," writes David Marriott, to distinguish between the (black) hands that hold the photograph and the (black) body that hangs dead within the photograph's frame. "Re-presentation is what brings the spectacle of injury and death to an end."[82] And in Trudier Harris's estimation, keeping these images "alive" and in circulation demonstrates a retelling of history, "an awareness that has survival at its basis."[83]

The need to mourn, to fight, to offer proof, to exorcise, to understand why one quivers with shame and anger in one's own skin have each motivated black artists, writers, and activists, including those who did not directly experience a lynching, to revisit lynching as a primal narrative of Jim Crow. For this group, lynching photographs "provide an occasion for self-reflection as well as for an exploration of terror, desire, fear, loathing and longing."[84] It is a way of wresting possession of the past, reclaiming the black body in pain.[85]

Failure comes in the retelling. The NAACP certainly worked to keep racial vigilance "intensely alive," persisting in its antilynching struggle. In the decade following the Dyer bill, the NAACP would help introduce two more antilynching bills, the Wagner-Costigan bill in 1934 and the Gavagan-Wagner-Van Nuys bill in 1937; like the Dyer bill, both were defeated. Significantly, publicity, especially photographs, continued to play an important role in the NAACP's battle against lynching. Pamphlets and press releases increasingly made use of lynching photographs. But by 1934, the organization, now under the direction of Walter White, no longer used photographs for strictly documentary purposes. White seems to have embraced Johnson's lament that the fight against lynching had nothing to do with facts at all. As evidenced in the sensational "Report on the Lynching of Claude Neal," the NAACP used the photograph not to convey "facts" but instead to harness the moral power of the antilynching narrative, to engage in an emotional and rhetorical battle. "An Art Commentary on Lynching," a 1935

exhibit sponsored by the NAACP in New York City, brought together sculptures, drawings, and paintings by a host of vanguard modernist artists to raise funds for and awareness about the antilynching cause. Through the show, the NAACP expressed its desire to work affectively, to reach audiences through emotion before information.[86] Such attention to publicity had been crucial to changing the discourse around lynching, since the NAACP "wanted to save not facts but lives."[87]

Over the course of its crusade, the NAACP effected a moral and ethical shift in American tolerance for mob murder and, as I suggested at the beginning of this chapter, created a new lens through which to view and interpret the data of lynching and the "facts of blackness." However, the constant repetition of these images wedded to a particular narrative helped spectacularize the spectacle of lynching, "helped maintain the power of the practice as a cultural form and aided in the cultural work these narratives performed."[88] Such repetition has both compounded the violence of lynching and has served to anesthetize audiences to black pain and suffering. Audiences, "distracted and dispersed" rather than focused and readied for political action, in turn expressed increasing desire for more and more graphic accounts.[89] The public's seeming insatiability for tales of racial violence and transgression has kept the tale of the black male rapist/criminal, at the heart of the lynching narrative, alive and well and circulating in our cultural and political imaginary.

LYNCHING PHOTOGRAPHY HAS BEEN a fundamental means of seeing blackness and a crucial archive in the formation of black visuality and American identity. African American political and cultural engagement with these difficult, horrible, and unforgiving images reveals an ongoing challenge to dominant racial regimes, the persistent reconstruction of African Americans as viewing subjects in contexts in which black looking is both unwanted and dangerous, and a sustained commitment to critical (and not so critical) memory practices. But lynching photography also represents a crisis of representation, an archive whose cultural and political life continues to be an antinomy, at once wholly true and, by its very nature, without resolve. Why do we keep returning to these photographs? Why do we keep telling ourselves this story with these images?

To offer a conclusion, I return to the space where lynching and photography make their pact and also the space in which they expose one another. The *Chicago Defender* writer quoted earlier found him or herself at this crossroads: "We print from the postal card to show you that these things

are facts that you can't deny . . . This lynching was never recorded, although done three weeks ago: no press, no pulpit, white or black, to speak a word."[90] The photograph reveals the silent indifference of both God and human to the wanton killing of black people. And because we are forced to look both *at* the photograph and *within* it, as both document and social practice, at its margin and its center, we are confronted with photography's own silent indifference.

The photograph, in the perpetual motion of its stillness, replays the moment of terror over and over. As Roland Barthes notes, "the corpse is alive [in the photograph] as *corpse*: it is the living image of a dead thing." In this sense, these corpses can never be buried within our political imagination. They can never be at peace. And because the photograph only comes alive when looked at, we remain in the eternal present and eternal presence of black death. We grieve, we mourn, but the photograph does not allow for closure. We remain in perpetual melancholy. In his pained and scathing response to *Without Sanctuary*, Hilton Als likens the lynched men and women in the pages of the collection to the "bones of the black ancestors" carried in the ark in the story "The Ark of Bones" by African American author Henry Dumas. "The ark that carries them is 'consecrated' ground, but it is divine ground that cannot settle since its home is a stream."[91] The photograph is the ark, the hallowed but set apart vessel for the dead. The photograph is the wound that will not heal. We have no place else for the bones.

Come Let Us Build a New World Tog

In July 1962, nineteen-year-old Danny Lyon, a white man from Forest Hills, Queens, New York, hitchhiked from Chicago 390 miles south to Cairo, Illinois. Lyon had just completed his junior year at the University of Chicago where he was studying photography and history. Inspired by the nineteenth-century "historian with a camera" Matthew Brady, renowned for visually chronicling the Civil War, Lyon set out to photograph another civil war and sought to document the activities of the radical youth organization, the Student Nonviolent Coordinating Committee, better known as SNCC ("snick"). Only two years old, SNCC had already gained a reputation among other civil rights organizations and with the Kennedy administration as unorthodox and uncompromising, a cadre of mostly black, mostly southern, students willing to challenge white southern repression in its most entrenched forms and its most dangerous locations.[1] Arriving in Cairo under cover of night, Lyon was greeted by SNCC field secretaries Carver "Chico" Neblett, a sharecropper's son and Southern Illinois College student from Tennessee, and Selyn McCollum, a northern white female Freedom Rider. Neblett and McCollum found Lyon housing, and the next day, July 14, 1962, escorted him to a small church. After listening to a number of stirring speeches, Lyon followed SNCC Field Secretary John Lewis, local high school student leader Charles Koen, and the small gathering of mostly children, as they marched out into the street and down to the segregated "public" pool.

Lyon possessed the only camera to document the small yet effective demonstration, one of nearly a hundred to take place that summer and fall in Cairo; one of thousands during the course of the movement to take place outside the glare of the national news media. Lyon photographed the group of demonstrators standing in line, some with towels tucked under their arms, some with their arms folded or with their hands on their hips in bold exasperation. He captured the anxious white men hiding, contained, corralled behind a large sign propped up on a desk spelling out their resistance: "Private Pool. Members Only." And he recorded as the protesters knelt down in prayer in front of the pool building. It was this last photo-

graph that one year later SNCC would reframe and reproduce as a poster with the caption: "Come Let Us Build a New World Together."[2] Ten thousand copies were printed and sold "for a dollar each, mostly in the North." The posters sold out.[3]

The genesis, transformation, and composition of this photograph begin to suggest the way SNCC viewed itself, its role in the southern civil rights movement, and the place of photography to support and advance both. SNCC was extremely conscious of the importance of documenting its activities, particularly protests that went largely unwitnessed by those outside of the communities in which they took place. The photograph chosen by Lyon, Director of Communications Julian Bond, his assistant Mary King, and Mark Suckle, who ran the photo offset presses, was not an image of police brutality or violent confrontation, the type of drama highlighted by the mainstream media and, for the most part, the sort of frame that has been passed on to subsequent generations.[4] Rather, they thoughtfully selected an image that highlighted the goals and beliefs, actions and interactions SNCC itself deemed important: higher morality, as evidenced by the posture of prayer; the central role of youth as architects of an integrated future, evidenced by the lanky brown girl who occupies the middle of the frame.

This photograph literally envisions an alternative concept of leadership. Here, there is not one identifiable charismatic personality at the forefront leading the masses, a hallmark of more established, traditional civil rights organizations like the NAACP and the Southern Christian Leadership Conference (SCLC) with Dr. King at the helm. Rather, a group-centered leadership is privileged in which all stand, pray, and work side-by-side. Longtime activist, adult educator, and SNCC "midwife" Ella Baker inculcated in the young organization the belief that leadership of all types can be found in the smallest and most unlikely of sources.[5] As the lone female head of the male-dominated SCLC headquarters before becoming SNCC's founder and primary adviser at its inaugural conference in April 1960, Baker experienced firsthand the limitations imposed on both an organization and its members when "the prophetic leader turns out to have heavy feet of clay."[6] In 1961, when asked by a meeting of "interested Atlanta citizens" how SNCC raised money, Executive Secretary James Forman "replied that . . . we wanted to [raise money] on the basis of our program rather than any single image of a leader's personality. Too often have we seen masses of people out in the streets, aroused and willing to stay there in the face of brutality, only to have some big leaders off in a cosy [sic] negotiating room making decisions

which do not represent the wishes of the people."[7] According to Forman, then, it was the masses of determined local people putting their bodies on the line in order to change the conditions of their lives who were at the center of SNCC's program. Therefore, it was their image that would be the public face of the organization and at the center of its fund-raising efforts.

Of course, there were many public faces, and not all of them easily recognized or even visible. The framing of the Cairo image emphasizes the possibility of realizing a utopian vision through the collective effort of thousands working not for fame and recognition but for freedom. Again, Baker infused SNCC with the idea that all who were willing to work were welcome and needed in the struggle to attain racial justice; as Baker said, "either take part or step aside." In the poster, only John Lewis, on the left, is a recognizable figure. In 1963, the year when the poster was made, Lewis was catapulted to the national civil rights stage when he replaced Charles McDew as SNCC chair and represented the organization on the podium at the August march on Washington.

Yet it is the gangly brown girl at the center of the frame, bowed so deep in prayer and contemplation that only the top of her head is visible, who captures the viewer's attention. The fact that she is flanked by the two older, similarly dressed men on either side, who almost appear as pillars, might initially indicate that the picture was selected to emphasize female vulnerability and the need for older male protection. But if we look closely, we see a young girl in possession of her own body. The fingers on her right hand brace her small frame on the concrete and her index finger serves as a compass. This seems to be a familiar position for her, yet she is alert and at the ready, like runner Wilma Rudolph, 1960 three-time Olympic gold medalist, at the starting line anticipating the sound of the gun.[8] She has entered this position of spiritual defiance willingly. She is faceless, suggesting that leadership and movement will come from a host of people whose names and faces we will not know, whose image is in some ways unnecessary. Yet her body is on the line for change. As longtime activist and white SNCC member Casey Hayden informs us,

> Nonviolence took one out of the role of victim and put her in total command of her life. By acting in this clear, pure way, in which the act itself was of equal value to its outcome, and by risking all for it, we were broken open, released from old and lesser definitions of ourselves in terms of race, sex, class, into the larger self of the Beloved Community. This was freedom as an inside job, not as external to my-

self, but as created, on the spot and in the moment, by our actions. This was ideology turned inside out.[9]

Consciously, willingly, and equally with her male counterparts, the young girl has entered the beloved community, a circle of redeeming kinship in and through which each individual aimed for their greatest personal and collective potential.[10] Doing so forces each member of this trinity to recognize themselves and each other as free from fear, internal doubt, and external degradation. Indeed, after this photo was taken, this young girl was the only protester to remain in the street while a white man in a blue pickup truck threatened to mow down the demonstrators. "We all scattered," recalls Danny Lyon, "except this girl, who wouldn't move."[11] She defiantly "stood her ground" until the truck knocked her to the pavement. She was taken to the hospital, treated for injuries, and released later that evening.[12]

The text accompanying the image provides an open invitation and an opportunity, a call to action. Here, the juxtaposition of words and image function as a catalyst to transform audiences into active participants, or at the very least distant and/or financial supporters. The poster could be found in Friends of SNCC offices—organs for publicity and fund-raising outside of the South—progressive college campus organizations, and church basements as far away as San Francisco.[13] That SNCC chose this photographic poster as representative and appealing suggests that this was the image of themselves that they most wanted to promote. That the poster sold out suggests that, at least in 1963, this was the image of SNCC that audiences found most compelling.

Lyon's Cairo photographs proved to SNCC the power of documentation. Based on the compelling images he made of SNCC activities in Cairo, Illinois, and Albany, Georgia, that summer and fall, Danny Lyon was hired by SNCC executive secretary James Forman as SNCC's first staff photographer in 1962. Until then, SNCC used photographs made by Forman, longtime white activist Bob Zellner, and whoever else was fortunate enough to avoid getting their camera confiscated during an action arrest. The organization also borrowed images made by sympathetic photojournalists, including George Ballis, for use in their newspaper, *The Student Voice* (*TSV*). But as the organization grew, so too did the need for effective communications and a public image. Forman worked as a publicist for the Congress of Racial Equality (CORE) in Chicago before joining SNCC in 1961. Immediately he recognized the organization's "critical weakness was in the area of communications." In addition, they "faced two major public relations problems.

The first was simply to establish in the minds of the public that we existed, who we were and what we were about. The second was . . . to remove from the minds of those few people who knew we existed the idea that SNCC was an arm of SCLC."[14] And even as SNCC became better known, organizers still felt "we must try to project SNCC's image or else we'll be continually over-ridden."[15]

SNCC leadership tightly orchestrated its visual images. For two years, under Forman's direction, Lyon traveled from location to location. The organization's elder statesman told Lyon where to go and sometimes even instructed him what to photograph. Lyon's images appeared in the SNCC newspaper TSV, in *Life* magazine, and even on the front page of the second section of the Soviet Union newspaper *Pravda*. They were reproduced and sold as posters and album covers, distributed in recruitment brochures and propaganda pamphlets. They were the primary visual component of *The Movement: Documentary of a Struggle for Equality*, a 1964 collaboration between SNCC and African American playwright Lorraine Hansberry, orchestrated by the head of SNCC's New York office and editor at Simon and Schuster, Elizabeth (Sutherland) Martinez. As Julian Bond, SNCC's first communications secretary and editor of TSV, would later recount, Lyon's pictures "showed what we did and how we did it and who we were and who we worked with and where the work was done. And they showed who wanted the worked stopped, how angry they could become, and what damage they could do . . . [Lyon's pictures] helped to make the movement move."[16]

By the time Danny Lyon left SNCC in 1964 following Freedom Summer, he was one of a staff of twelve photographers and at the center of a larger constellation of "field workers with cameras," black, white, Asian, Latina, male, female.[17] African Americans Joffre Clark, Doris Derby, Fred deVan, Bob Fletcher, Doug Harris, Rufus Hinton, Julius Lester, Francis Mitchell, and Clifford Vaughs, as well as Latina Mary Varela, Japanese-Canadian Tamio "Tom" Wakayama, Norris McNamara, and Dee Gorton, a white man from Mississippi, all joined SNCC between 1963 and 1965. Some arrived with technical expertise and equipment of their own, while others, like Harris and Fletcher, took part in a weekend-long tutorial by prominent photographer Richard Avedon in New York City. Others received training from Matt Herron, an independent photojournalist and former student of fine art photographer Minor White.[18] Many learned from Lyon before he left the organization. Some received cameras through donations from photographers sympathetic to the movement, and many would have their

cameras, damaged in the course of field work and the chaos of demon-strations, repaired by Marty Forscher at no charge.[19] Almost all served in the field on voter registration, literacy training, or direct action programs, visually documenting the people they worked with and the events, demon-strations, and projects they helped organize. The photographers developed their film in SNCC darkrooms in Atlanta, Selma and Tougaloo, funded by donations from actor and activist Harry Belafonte, photographer Aaron Sis-kind, among many others.[20] And their final products were printed on the photo-offset press in the "constantly expanding printshop" in the Atlanta headquarters and distributed by the SNCC Photo Agency, established offi-cially in 1964.[21]

SNCC, perhaps more than any other civil rights group of the time, under-stood the importance of photographs not only as documents of efforts of thousands to raze the world of southern oppression; but also as visual bricks in the raising of a new, integrated, free world. SNCC recognized that it was not enough to simply intervene in dominant media frames and overcome the national press blackout, or in Forman's parlance "whiteout," of move-ment activities. As Lyon reflected in recent interviews, "political action has to be coupled with control of the media. I think that you have to have an active media." And "SNCC was its own media."[22] Under the general and expansive title "Communications," SNCC developed a formidable media structure of its own through which the organization published its own newspaper and promotional materials; printed its own posters and press re-leases; and conducted research and incident investigations. In 1964–65, this structure would expand to produce political primers and teaching tools, and beginning in 1965, art exhibits, calendars, postcards, and more photo-essay books in the vein of *The Movement*.

Integral to each of these endeavors, photography constituted one cog of the vast cultural work through which SNCC framed and popularized the movement. SNCC activists collaborated with San Francisco director Harvey Richards to produce the movement films *We'll Never Turn Back* (1963) and *A Dream Deferred* (1964). Field worker Bernice Johnson Reagon was one of the founders of the Freedom Singers and would later establish the a cap-pella ensemble Sweet Honey in the Rock, musical groups that wrote, per-formed, and recorded freedom songs, the music of the movement.[23] And three black volunteers, Doris Derby, John O'Neal, and Gil Moses, created the Free Southern Theater "for those who have no theater," which employed stage performance as a means of political education and consciousness-raising.[24] Photographs along with these various other cultural forms mo-

bilized constituents, expanded the reach of the organization, and created communities of financial, intellectual, and political support throughout the country and the world.[25] SNCC went further than any other civil rights organization of the time in creating its own extensive media structure. Photographs in particular helped to reframe the extant dominant media narratives and emerged as stories that SNCC told of the new world it was in the process of building. The blueprint and vision of what this new world would look like would change, adapt, and evolve over time.

SNCC photographs reveal its continually transforming and always transformative vision of the world it inhabited and strove for. In his study of another radical youth organization of the 1960s, Students for a Democratic Society, sociologist Todd Gitlin argued that, "As movement and media discovered and acted on each other, they worked out the terms with which they would recognize and work on the other, they developed a grammar of interaction." This relationship proved to be unfixed and constantly changing, while also "*situated*, sewn into an historical context."[26] The trajectory of this unfixed yet situated relationship between SNCC and the dominant media reveals how the civil rights vanguard utilized photography. Gitlin's framework provides only one means of tracing this vision: it is necessary to understand also the relationship between movement and *medium*, in order to more fully contemplate SNCC's relationship with the mass media, with itself, with its constituents, and with its history. The camera first offered SNCC a way to intervene in dominant media frames, a tool to document its activities with its own consistency of message. This developed into a means of presenting itself and its vision to the world. The camera would then provide a technology for self and communal expression, a way of presenting and representing rural black southerners to themselves. As SNCC grew more sophisticated and expansive in its ideology and programming, so too did its use of photography. SNCC's photographs and the uses to which they were put proffer a lens into SNCC's image and reflection of the movement and a mirror in which we can make out the way SNCC wanted to see itself.

In order to fully explicate SNCC's engagement with photography, I begin the remainder of this chapter with an examination of the shifting grounds of the dominant media landscape in the early 1960s. The eruption of the modern civil rights movement became the stage upon and through which print and television journalism developed new modes of reporting while confronting the parameters and limitations of long-held attitudes about African Americans. In trying to report and indeed translate the southern black movement for largely nonblack and nonsouthern readers and viewers,

the dominant media outlets confronted their own ignorance of black life and struggle. The movement itself proved photogenic, however, and though the stories and images were uneven, the draw to the southern "race beat" was ineluctable. While the dominant media began to establish its "grammar of interaction," its movement vocabulary, SNCC recognized a need to document that which the press did not cover and to amend much of what the press did cover.

Once the organization entered the media landscape, SNCC's photographic evolution may be seen in three historical frames. These moments mark a transforming though persistent concern with a revaluation of the black body and the relationship of such a reinterpretation to black spectatorship. From 1961 through 1964, SNCC Communications' first endeavors were largely corrective and documentary. While SNCC often made use of mainstream news stories—using the NBC documentary *Sit-In* for training and recruiting purposes, or reproducing articles about the organization as publicity brochures, for example—SNCC Communications began to seek out opportunities for alternative reporting and self-representation. This impetus led to the hiring of Danny Lyon who, as SNCC's primary photographer from 1962 to 1964, visually chronicled the escalating struggle for black enfranchisement and integration throughout the South. For nearly two years, Lyon's camera acted as a prism through which SNCC refracted the light and energy of the southern movement throughout the country and abroad.

SNCC found itself on extremely "floodlit social terrain" from the summer of 1964, when it guided the massive voter registration and education effort in Mississippi known as Freedom Summer, through the end of 1965, during which the organization reluctantly participated in the Selma to Montgomery March.[27] This period of intense media attention and internal strife and dissention is the next moment the chapter chronicles. The officially established and newly expanded SNCC Photo Agency discovered creative ways to aid the organization's search for a clear identity and direction under the media's bright lights and vigilant cameras. In this period, SNCC's own cameras began to turn inward and became more reflective. They became compasses for exploring as well as challenging ideas, aesthetics, personal and political relationships, and individual and collective freedom.

Finally, between 1966 and 1967, as SNCC began to embrace black nationalist ideologies and subsequently experienced a media backlash, the camera became a weapon of black power. Photographs, previously destined for the pages of white newspapers and magazines, were aimed at the African

American press and Third World markets specifically. And with even more frequency, images made by what was then an almost entirely black male photography staff, were intended for the walls of southern black homes, helping to articulate a burgeoning black aesthetic and elaborating competing visions of black power while the organization as a whole struggled to articulate its own.

Dominant Media Frames of the Early Civil Rights Movement

When Danny Lyon first photographed the Cairo confrontations, the dominant media frames of the civil rights movement could be found right of center, in a constantly shifting landscape that ranged from virulently white supremacist and segregationist to adamantly indifferent to the movement's seriousness.[28] Turbulent events in the South beginning with violent recriminations of desegregation efforts at the University of Alabama (1956), Little Rock's Central High School (1957), and Ole Miss (1962) had initiated significant reorientation in dominant news reportage toward fuller coverage of "the race beat." However, the terms and patterns of such coverage were still mired in long-established modes and attitudes, from segregationist bias to an inability to converse effectively and respectfully with African Americans. In the South, civil rights organizations could expect the white press to be typically hostile to the movement, speaking the minds of the white constituencies they served. Newspapers like the *Montgomery Advertiser* and the *New Orleans Times-Picayune* labeled activists "outside agitators," "trouble makers," and "communists." Even the presumably "liberal" *Atlanta Constitution* dispensed what in the cold war era were tantamount to epithets implicitly, and sometimes explicitly, implying that southern blacks were not smart enough, organized enough, or disgusted enough to sit-in, kneel-in, or engage in other forms of protest against the dehumanizing conditions of segregation. But for a few, notable exceptions, especially the reportage of Claude Sitton of the *New York Times*, attention to the ground activism of African Americans was generally absent. Also missing was an understanding of the development of the movement, where it came from, and where it might be headed next. Indeed, those papers whose editors did not fully embrace segregation, like James Kilpatrick of the *Richmond News-Ledger*, who crafted much of the "interposition" framework that claimed states' rights in defiance of federal mandate, took a stance of "inconceivability." They believed—hoped—that by downplaying or ignoring the movement it just might go away. More moderate southern voices like Hodding Carter Jr.

of the Greenville, Mississippi, *Delta Democrat-Times* found themselves isolated in their recognition that change was inevitable.

SNCC early took on the task of admonishing newspaper editors for blatant distortions of the movement's goals. "How tragic," began an August 11, 1960, SNCC letter to the editors of the *Atlanta Journal*, "you should attempt to put the American Negro, or any other 'inflamed civil righter' on the defensive in your editorial on Senate maneuverings."[29] SNCC staff congratulated others, like the nascent *Atlanta Inquirer*, for rare, more balanced, or even affirmative views of the movement, and thanked groups and individuals for their own outraged letters to the editors.[30] These sorts of letters decreased as SNCC's own media structure expanded and strengthened.

Though press attitudes toward the civil rights movement were changing due in large part to the violence that reporters and photojournalists of all political stripes found themselves subjected to, northern and national press outlets, though somewhat more sympathetic to the movement, conveyed a message similar to that of their local southern counterparts. Paul Good, a reporter covering the South for ABC television in 1963–64, observed that "white America and ABC producers were anxious to believe in" the image of patience, accommodation, and expertise on the "nigra problem" that Atlanta, Georgia, Saint Augustine, Florida, and other major southern cities projected to the world. Good noted that, by 1963, he had "received the impression that they [editors and producers] were weary of civil rights stories, they were in basic sympathy with the image Atlanta presented, and they did not want or need any analyses of current white-black attitudes or projections of how these attitudes could affect the course of the civil rights story in the days ahead."[31] The style of reporting practiced by the television news bureaus reflected this attitude. For example, Good interviewed local white officials primarily for news stories. If an African American or movement perspective was desired, Good and others sought out already established spokespersons cum leaders. Conversations with local African Americans, when Good and his crew had time to gather them, often ended up on the cutting room floor. By focusing on white participants and identifying and zeroing in on black leaders, ABC and others neglected the participation and work of countless people who gave their physical, spiritual, and intellectual energies to the movement.

Moreover, the dominant media chronicled only the most "newsworthy" events: sit-ins, marches, the Freedom Rides, and the acts of violence that these protests engendered. Good writes: "We operated with a policy of crisis reporting, moving on a story as it boiled up, quickly dropping it the moment

its supposed public interest had died, and racing off to a newer crisis." This "hit and run" type of reporting manifested above all in stories involving violence. Knowing that his reports had a better chance of airing if they contained footage of physical confrontations, Good sometimes found himself "unhealthily elated" by aggression between protesters and mobs or between protesters and cops. Competition among news outlets further fed the desire for such stories and turned news producers into "slaves to wire service concepts of what was news instead of developing independent ideas on what was newsworthy." But even when Good attempted to present a broader picture of the events, to provide a context for the violence, he found his efforts curtailed: "If I got film or tape of gas grenades exploding or police shooting during riots, congratulatory cables usually followed. But if I attempted to explain quietly why the grenades had gone off, or where they might go off the next time because of what reasons, the cables would read: 'Let's hold the analysis for the time being.' . . . If there were violence, fine. That concept we all can understand and get interested in."[32] By serving up such dramatic moments, the press created the image that the black protest movement of the early 1960s, whose foundations lay in years of backroom organizing and clandestine consciousness-raising, were so many nonviolent Molotov cocktails exploding haphazardly and unpredictably across the South.[33] As former "race beat" reporters and authors Gene Roberts and Hank Klibanoff note, "The newspapers missed the evolution of the movement."[34]

The very nature of news work and the structures of the media industry generated such flashes, breeding pithy and incomplete pictures of civil rights activity. National news reporters were dispatched from location to location to produce reports of major "events" as they happened, or shortly thereafter. Good opened ABC's first news bureau in the South in Atlanta in the fall of 1963 and began to develop relationships with civil rights organizations based in "The City Too Busy to Hate." However, Atlanta served only as his base as he traveled across the South reporting various incidents. But unless they were working in a town large enough to have the capacity to transmit the reel over special phone lines (not available in every location), television crews had to complete their newsgathering while leaving enough time to pack up equipment, get to a local affiliate, develop and edit the film, splice it together with sound, write a script, and feed the day's report to New York City by 5:30 PM Eastern Standard Time, 4:30 PM in the Central Zone states of Alabama and Mississippi, in time for the six o'clock evening news. John Chancellor of NBC faced similar problems when reporting from Little Rock in 1957: he was forced to charter a plane to Oklahoma

City to edit his film.[35] "So many things could and did go wrong in this process," Paul Good recalled anxiously years later. "All this was for a piece of film that might run one minute if virtually nothing else were happening on the globe that day."[36]

Nationally distributed newspapers and magazine weeklies faced their own set of challenges. These news organizations found themselves relying on local newspapers to supply information. Yet local press proved unreliable when it came to accurately reporting civil rights incidents, whether as a function of being ill-equipped, disinterested, or simply hostile to the story. Sometimes local press could not be counted on to report newsworthy events at all, as was the case when the two Jackson, Mississippi, daily papers failed to carry news of James Meredith's attempt to integrate Ole Miss and the ensuing battle on that campus. Yet the incident drew hundreds of national and international reporters to cover the violent conflict between national guardsmen and local segregationist protesters.

With movement activity occurring throughout the South simultaneously, it was simply too expensive to the networks, even the larger, better-funded news bureaus of NBC and CBS, to have crews, generally consisting of reporters, producers, cameramen, sound technicians, and their myriad pieces of equipment settle in any place any longer than the duration of "the story." Similarly, print and photojournalists "would tend to get a call from *Life* [for example] saying, 'We want you in Birmingham, or Atlanta, or Jackson.' And they would say, 'Okay, I'm on the next plane' . . . They were more working at the direction of the magazine."[37] Rarely did reporters remain in one area and situation long enough to provide more detailed accounts of the "why" and "who" that accompanied the "what," "where," and "when." Claude Sitton of the *New York Times* was an exception, a dedicated reporter whose "continuing day in, day out presence on the movement's front line gave the *Times* an advantage that newspapers responding to only the big stories could not match."[38] Moreover, as television crews and newspaper reporters saw themselves as comrades as well as competitors of other television crews and newspaper reporters, white Mississippian and SNCC photographer-activist Dee Gorton observed, they "often paid more attention to each other than to the subjects they were covering. That was only natural, since they traveled and worked together. However, it often cut them off from intimate contact: those serendipitous moments at dinner or lunch or along the road."[39]

While the dominant media created the impression of an erratic, even volatile movement, what erupted in a more disconnected fashion were

the flashes of so many photojournalists' cameras, dispatched to capture civil rights confrontations. Unlike television, photojournalists portrayed the South exploding in the form of public and collective challenges to a southern racial hierarchy. Movement and segregationist leaders alike began studying the press for cues on what kinds of stories garnered attention, and of concern to segregationists, which ones did not. As Roberts and Klibanoff write, "One thing was unambiguous: the greater the violence, the bigger the news, especially if it could be photographed or filmed."[40] SNCC and other civil rights organizations staged demonstrations specifically to expose violence and inequity. Such performances appeared as *tableau vivant* of an entire economic and social regime of power.

Such dramatic performances proved camera-ready. The images that emerged from these demonstrations embody what Walter Benjamin has described as "dialectics at a standstill." With regard to photography, he writes: "It isn't that the past casts its light on what is present or that what is present casts its light on what is past; rather, an image is that in which the Then and the Now come together, in a flash of lightning, into a constellation. In other words: an image is dialectics at a standstill."[41] These photographs at once offered a watching world a microcosm of the whole of race, class, and gender ideologies and practices, past and present; and a glimpse of that which could not be understood as finished or complete, a glance at a process and a promise of an alternative future. Further, "then and now" are more than past and present in that, juxtaposed as they are to one another, they render the past and present legible and recognizable only when the process of history is arrested in the photographic text, only as image.[42] Demonstrations and their photographic documentation are images of historical process first condensed, then frozen.

Photographs made by Charles Moore, chief photographer for the *Montgomery Advertiser* in the early 1960s and photographer with Howard Chapnick's Black Star photo agency, best exemplify Benjamin's proposition. Some of the best-known images from the period, Moore's photographs depict people in action, marching, protesting, engaging in charged, nonviolent confrontations. Moore's photographs document some of the most dramatic moments of "Project C"—"C" for confrontation—SCLC's bold and involved plan that simultaneously challenged the political, economic, and social powers and power structure in Birmingham over the course of five weeks. Preceded by nearly a month of nightly mass meetings, Project C began officially on April 3, 1963, with small sit-ins and the release of the Birmingham Manifesto, all of which was largely ignored, dismissed, or disparaged by the

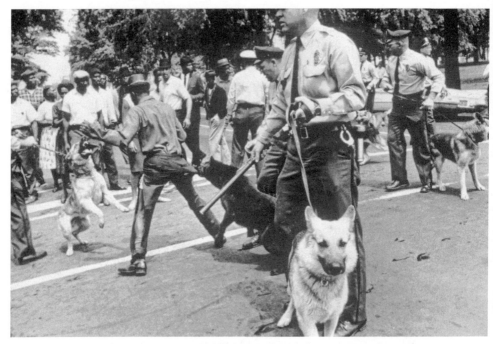

Figure 2.1. Demonstrator attacked by Birmingham police K-9 unit, Birmingham, Alabama, May 3, 1963. Photograph by Charles Moore. (Charles Moore/Black Star)

press. It escalated into full-fledged demonstrations and marches provoking the violent rage of deposed Commissioner of Public Safety Eugene "Bull" Connor, who refused to step down, and the police and fire squadrons still under his control. Following a "jail—no bail" strategy, Project C, with Connor's livid cooperation, filled the jails with thousands of men, women, and children—959 children were arrested on May 2 alone. Finally, when "the City of Birmingham . . . reached an accord with its conscience," more than 150 local, national, and international reporters gathered at a news conference on May 10 to hear SCLC leader Reverend Fred Shuttlesworth detail the end of the conflict.[43] The settlement, negotiated between SCLC and the white business leaders of the city, brought an end to Project C and aimed to end desegregation and discriminatory hiring practices.

Though Project C lasted for sixty-three days with multiple phases, history largely remembers it through its images, both still and moving, as well as through Martin Luther King's potent "Letter from a Birmingham Jail." An extended, multifront battle became condensed into a series of snapshot confrontations: the attacks on young protesters by Bull Connor's force wielding high-powered fire hoses and trained police dogs. Indeed, the world

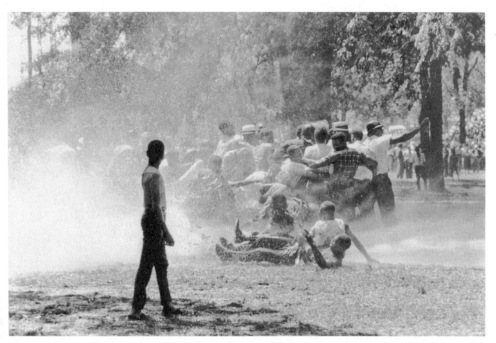

Figure 2.2. Demonstrators blasted with fire hoses, Kelly Ingram Park, Birmingham, Alabama, May 3, 1963. Photograph by Charles Moore. (Charles Moore/Black Star)

of 1963 came to know Birmingham, and by extension "understand" the South, especially through the images of Moore and others, including Bob Adelman and Flip Schulke, gripping and powerful photographs that appeared in the *New York Times* and the *Washington Post* for nearly two weeks (figures 2.1–2.2).[44] These images display a palpable sense of movement, in all its meanings. One can feel the spray of the water as it ricochets forcefully off of clustered black bodies. One can hear the police dogs barking as they attack protesters and then the sound of nails on pavement and sudden panting as the dogs are yanked back by their chains.

Moore's animated photographs transmit to viewers the intensity of this moment and by extension the stakes being fought for in the Project C face-offs. Moore's photographs were so compelling that they were often picked up by the Associated Press and *Life* magazine. His images of Birmingham became the centerpiece of *Life*'s coverage of the mass demonstration and reinvigorated public outrage. Shooting with short-range, wide-angle lenses, Moore got in close to the action and fit more of it into his frame, "close enough that he wound up in the frames that other photographers were taking from farther away." Likewise some of his images re-

Figure 2.3. Theater marquee adds irony to the defiant expression on the face of African American woman arrested during demonstration, Birmingham, Alabama, May 1963. Photograph by Bruce Davidson. (Bruce Davidson/Magnum)

veal "several other photojournalists standing on the curb behind the action, some of them clearly missing the moment."[45] The images demonstrate the power of photographs for intimacy and closeness, evidenced in the photographer's own methods and choice of equipment. They also suggest that to best understand the movement and its high stakes, one had to get close and personal, to rub up against its raw and irritating edges. Moore's photographs marked a turning point in the movement.

The images by Moore and others also denote a departure in their ability to reflect more than self-containment and stoicism on the part of their black subjects. Not only can one sense the solidarity amid the chaos as black protesters hold onto one another, bracing together against the fire hoses. But tangible and unmistakable anger and defiance imprints itself throughout these photographs as well, announced, in an image made by Bruce Davidson, by the movie marquee behind a steadfast young black woman being led away by two white policemen: "Suspense! Excitement! Susan Hayward in 'Back Street' and 'Damn the Defiant'" (figure 2.3). Protesters hold onto each other for protection and hold each other back from retaliating. Jubi-

Figure 2.4. Crowd taunts police officers, Birmingham, Alabama, May 1963. Photograph by Charles Moore. (Charles Moore/Black Star)

lantly, they point and laugh, chant at, and taunt an officer who sits impotently with a billy club (figure 2.4). A black woman soaked from the hoses, her stockings displaced by the force, leans angrily toward a white policeman (figure 2.5). Black protesters are not simply letting themselves be brutalized. Moore's photographs depict black victimization *and* black resistance, white supremacy *and* white incapacity. They make the dialectics of black-white social relations discernible and lucid.

That many of the confrontations at the center of these frames highlight black female protesters and white male police officers offers a challenge to one of the most historically ignored political, social, and sexual relationships. These photographs make visible long and deeply hidden transcripts between black women and white men, in which black female vulnerability to white male sexual advances bespeaks a fraught and frightening historical intimacy. In this trio of photographs, the female subjects are exposed to white male police force. In one, a woman's arms are forcibly spread apart and twisted at an awkward angle. In another, the black woman who taunts most joyously is also seemingly the most exposed: her white dress at the

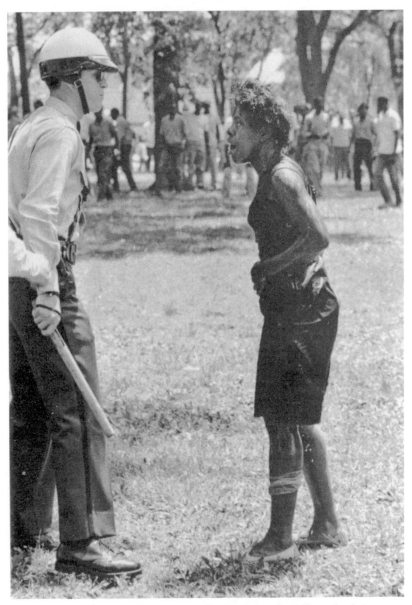

Figure 2.5. Black female demonstrator confronts white police officer after being attacked with high-pressure fire hose, Kelly Ingram Park, Birmingham, Alabama, May 3, 1963. Photograph by Charles Moore. (Charles Moore/Black Star)

corner of the frame and her wide-open mouth draw our attention. The cop's billy club, which has the effect of a barrier holding back the remaining protesters, points ominously toward the woman, drawing a direct line from his hand and genitalia to hers. White male sexual dominance of black women was historically exerted to humiliate and disempower African Americans as a group. Likewise, in the third image, of a woman whose clothes are drenched and disheveled from the force of the hoses and whose stockings are dislocated, the policeman clenches his billy club tight in his fist as he faces this woman in a condition of state-induced undress. The photographs reveal the entanglement of political and sexual power. Yet in each, the women's confrontation is electric. Their gazes are direct and trained, a clear demand for recognition. Davidson's camera finds wry humor in making the confrontation legible in Hollywood terms: *Back Street* is a melodrama of an independent, sexually outcast woman (indeed, what we might consider the condition of black womanhood), and *Damn the Defiant* dramatizes a battle of wills that results in mutiny aboard an eighteenth-century British ship. The hidden transcript here erupts cinematically in public space.[46]

The images also reveal the prominence of women on the frontlines of the civil rights movement, a presence that an emphasis on leadership or recourse to contemporary press articles or the first waves of movement history alone elide. Such an intervention reaffirms civil rights as not a conversation between black and white men alone. For example, these images counter another well-known Moore photograph of the movement: "Abernathy and King Walk toward Their Arrest in Birmingham, on Good Friday, April 12, 1963" (figure 2.6). In this image, King and Ralph Abernathy, followed by well-dressed white and black men, walk assuredly by a group of African American men who kneel, literally, before King and his assistant as they pass. Here the strength and success of the movement rest on the work of one or two divinely selected black men, who, like Christ on his Good Friday walk to the Crucifixion, carry the faith and burdens of "men." Rather, by examining the centrality of black women in these images of protest, we see the breadth and depth of movement participation. We witness the significant role black women played in the movement not just behind the scenes as organizers or "bridge leaders," but in the foreground as well, as leaders of street actions. Here, African American women are at the forefront, extending and expanding the boundaries of proper decorum, of female action.[47]

Not everyone was willing to see the disruption of traditional racial and gender roles represented in Moore's photographs. The "then and now," the

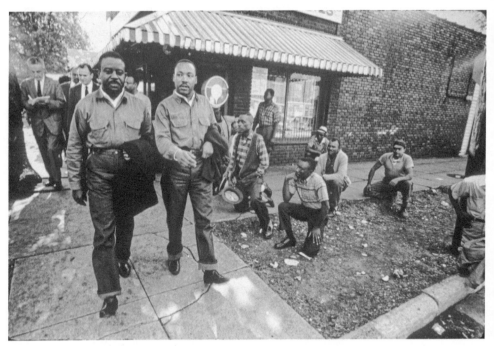

Figure 2.6. Ralph Abernathy and Martin Luther King Jr. walk
toward their arrest in Birmingham, Good Friday, April 12, 1963.
Photograph by Charles Moore. (Charles Moore/Black Star)

constellation of history and possibility charted by Moore's images, proved
to be too much for some of his audience. Many of Moore's photographs
served as the centerpiece of "They Fight a Fire That Won't Go Out," the
lead article in *Life* magazine, May 17, 1963. Only cursorily supportive of civil
rights, the essay doubts the veracity of "nonviolent" protesters, blaming the
violence on movement leaders who foment "simmering racial hatred." Even
as Moore's photographs garnered sympathy for the civil rights movement
among the American public, those same photographs were being used to
tell an opposing or less sympathetic story.[48]

While such images were in danger of freezing an ongoing and dynamic
struggle and depicting its participants solely as victims in need of outside,
elite assistance, they also had the power to galvanize viewers. Images of Bir-
mingham appeared on the front pages of the *New York Times* and the *Wash-
ington Post* for almost two weeks, generating sympathy, donations, and even
outrage from homemakers and senators alike.[49] And the images impacted
potential movement participants. Stokely Carmichael, who would become
SNCC's chair in 1966, explained to photographer Gordon Parks how images

of protesters led Carmichael to his first SNCC meeting: "When I first heard about the Negroes sitting in at lunch counters down south, I thought they were just a bunch of publicity hounds. But one night, when I saw those young kids on TV, getting back up on the lunch counter stools after being knocked off them, sugar in their eyes, ketchup in their hair—well something happened to me. Suddenly I was burning."[50] SNCC visionary Bob Moses recalled years later, "When the sit-ins broke out what just grabbed me [were] the pictures of the southern students. And what I became aware of when looking at them was that they looked how I felt. And I really responded immediately to that."[51] For Moses, a young math teacher from New York City who had grown up in Harlem projects, these images simultaneously reflected his interior life, his anger, his frustration, and his hope and projected these emotions to a wider audience. Like Carmichael, the visual documentation showed Moses the way to the South, to SNCC, and to a life in the movement.

Black photographer and head of SNCC's photography department, Julius Lester, claimed these earlier images as integral to the organization's work and the foundational expansion of the movement. "Since the beginnings of SNCC, we had photographers on staff," Lester wrote with some exaggeration in the January 1967 edition of "SNCC Photo News," the first and only issue of a newsletter intended for staff and contributors. "Their primary job in the early days was to photograph demonstrations and sell the photographs to news media. Not a few of SNCC's early supporters came from people who saw these photographs."[52]

These images, depicting African Americans actively engaged in changing the conditions of their lives, provide a crucial counterpoint to earlier galvanizing images of the civil rights movement. In 1955, in the wake of the landmark school desegregation decision, *Brown v. Board of Education*, fourteen-year-old Emmett Till of Chicago was lynched in Money, Mississippi, for allegedly whistling at Carolyn Bryant, a white woman, on August 24. The alleged victim's husband, Roy Bryant, and brother-in-law, J. W. Milam, abducted Till from his relatives' home not long after midnight on August 25 and hustled him off to a nearby plantation in Sunflower County. Bryant and Milam beat young Till and shot him in the head before fastening him to a one-hundred-pound cotton gin and dumping his body in the Tallahatchie River. Despite the anchor, the boy's body was discovered three days later. Rather than capitulating to authorities, Till's mother, Mamie Bradley invited the world to see what the southern racial and sexual caste system had done to her son. During a four-day open-casket memorial service, ten

thousand people peered into Emmett Till's decomposing and untouched face. Over two thousand people participated in the funeral service, engaging in a new ritual of witnessing and testifying. Bradley permitted the black press to cover both events, and photographs of her son's lifeless, disfigured body appeared in the popular African American picture magazine *Jet* and the African American newspapers the *Chicago Defender, Crisis, New York Amsterdam News* and the *Pittsburgh Courier*. In the tradition of earlier anti-lynching activists, Mamie Bradley reconfigured her personal grief as public crisis, utilizing the visual and visible specter of her son's battered remains as the catalyst.[53] Yet unlike an earlier corpus of lynching images, the photographs of Till were greeted by a culture not only willing but desiring to look. They emerged in a new visual climate in which photo magazines had disciplined audiences to look at and understand images as not only illustrative and demonstrative but as the embodiment of truth.[54]

For a young generation of African Americans growing up in a moment in which lynching as a specific form of political and social coercion was on a steady decline—no lynchings were recorded for 1953—Till's murder renewed lynching as a powerful symbol of black vulnerability in the struggle for social justice. Anne Moody, Charlayne Hunter-Gault, Muhammad Ali, and Shelby Steele, as well as SNCC activists Julian Bond, Joyce Ladner, and Cleveland Sellers, have each related how the lynching of Emmett Till helped shape their racial and political consciousness.[55] Both men and women identified with the vulnerability of Till's brutalized black teenage male body, locating in the images of his nearly unidentifiable corpse their own susceptible and youthful blackness. Steele, a well-known black conservative who identifies the Till story as sitting "atop the pinnacle of racial victimization," argues that constant telling and retelling, viewing and reviewing, wrongly encouraged his generation of African Americans to embrace "the immutability of our victimization."[56] Yet rather than being fixed by the image of degraded blackness, many would be mobilized by the photographs instead. Confronted with their own powerlessness, the remainder of the narrativists memorized the contours of Till's ravaged young face, memorialized his tale within their own experiences, and became activists, choosing instead to alter and transform the meaning of black bodies in the United States.

The Till photographs not only whetted the public's appetite for images of violence perpetrated on the black body, but as powerful political emblems, they indicated the potential of photojournalism, the marriage of photography and the media of its dissemination, to promote social awareness and solidarity. Photography does not do the work of community-building and

consciousness-raising alone. Rather, depending on text and context, it can encourage these processes. The technology can, for better or for worse, offer a sort of visual shorthand, "*arousing* people to take action, *inspiring* them in their isolation." Like television, photography "did not organize [people] but it energized them."[57] Historians (myopically) cite 1954 and *Brown v. Board of Education* as the genesis of the 1960s freedom struggle. Rather than a beginning, it is better understood as a resurgence of political possibility. In the same vein, the 1955 circulation of the Till postmortem photographs offered a refocusing of the liberatory and galvanizing potential of visual technology for black political communities. SNCC recognized and uniquely deployed this potential.

SNCC *Intervenes*

SNCC's original purpose as a committee was to encourage and coordinate student activism throughout the South. As such, methods of communicating events and ideas were indispensable to the goals the organization set out to achieve. Chief among these methods was *TSV*, the first issue of which appeared June 1960, almost immediately following the founding conference in April. One of the resolutions adopted from that first meeting was that *TSV* serve as the official publication of SNCC and be funded accordingly. Little more than a mimeographed, four-page newsletter, the premiere issue featured a large, if amateurish photograph of students attending the inaugural assembly. As SNCC worked to establish a clear program and organizational identity, *TSV* functioned as the group's primary information clearinghouse and political sounding board. Usually, at least one photograph, typically blurry, uncredited, and too dark, appeared in the paper, until April 1962 when, at Jane Stembridge's urging, the Atlanta office invested in an off-set press of its own. Stembridge, a white Virginia native, administered the office beginning in April 1960 and, in turn, edited the first issue of *TSV* in June of that year. In early August, she presented a convincing argument to the committee that as the representative publication of SNCC, *TSV* should be of higher quality. Moreover, as the paper's circulation increased, from six hundred copies of the first edition to a projected two thousand, a better duplication system was needed, especially for the volume of images they wanted to include (there were no photographs in the remaining issues of 1960). "On the basis of the fact that cost of mimeographing increases with the increase in circulation . . . On the basis of the fact that the newsletter would have a much better appearance if printed . . . I recommend that

we have 'The Student Voice' printed rather than mimeographed."[58] SNCC workers quickly realized that photographs could be put to wider use than just one's personal scrapbook.

An organization made of members whose average age was twenty-one, SNCC workers had come of age in the midst of the emergence and expansion of new visual technologies and media. SNCC members grew up flipping through the large-format glossy pages of *Life* and *Look*. They pinned pictures of Dorothy Dandridge and Harry Belafonte to their walls, cut out from the pages of *Ebony* and *Jet*.[59] Televisions and personal cameras were more pervasive and affordable than just a few years earlier. In 1950 only 7 percent of American homes possessed a television; by 1954, 58 percent of homes owned a set.[60] For this generation, visual images of all sorts informed their view of the world, showed them what they should look like, how they should act, and what items, material or political, they were missing. Visual images informed their sense of self. They were inextricably woven into their own cultural fabric. It would follow, then, that in trying to change the world they encountered around them, the young members of SNCC should want to amend the visual messages already received and would know that visual images capture the attention.

Photography offered SNCC a means of mobilizing prospective participants and supporters by projecting a self-crafted image, not one constructed for them by the mass media, though in dialogue and negotiation with dominant depictions. As interventions in dominant media frames of the civil rights movement, its players, and its motivations, photography was critical to a grassroots organization like SNCC in a corporate-controlled television network environment. Indeed, photography is essential to understanding the civil rights movement more generally and its participants on the ground. Significantly, television familiarized national audiences with the institutionalized violence of Birmingham and Selma, with the leadership of Martin Luther King Jr. and Fred Shuttlesworth. Yet even though the evening news brought unprecedented reels of civil unrest and movement into people's homes, the circulation of these images was limited to network television. Filmed by network camera operators, framed by network-approved scripted commentary, and viewable only as often as network executives deemed necessary, the production and dissemination of these powerful moving images remained corporate controlled.

For students scattered across the South, photography proved a more accessible, contemplative, and democratic medium than television. Photography, especially as utilized by SNCC, introduced audiences to Albany,

Georgia, and Danville, Virginia, to the leadership of Gloria Richardson and Aaron Henry, more obscure but no less significant people and places. Moreover, television oriented itself toward adult viewers, interviewing adults for nightly news programs. Photography offered a means for young activists to represent themselves to other youth. As Danny Lyon would later recount, images of the movement came and went: "The movement would appear and then it would vanish; there were Freedom Rides and there it was and then it was just gone, it didn't exist. The turning point was the photograph."[61] For a grassroots organization like SNCC, photography proved especially important as a means to position the group within the growing civil rights terrain of the early 1960s and to enlarge its ranks, to remain visible and in control of its public image within a rapidly expanding televisual climate. This climate, as Sasha Torres points out, presented a largely sympathetic view of the southern movement before 1964, aimed primarily at an ideal northern spectator, and motivated largely by a desire to produce a national consensus, thus establishing network authority and opening up southern markets to more advertisers.[62]

Cheaper and more readily available, still cameras enabled activists themselves to frame the movement as they shaped and experienced it; photographic images circulated as posters, brochures, and the like granted audiences an opportunity for more sustained consideration of what was often fleeting on the television. Created by everyday producers and distributed in mobile forms meant to be looked at, studied, and reflected upon by broader and mostly marginalized audiences—those consumers given hardly a second thought by network television—photography constituted a democratic practice that strove for the fullest representation possible.[63] Photography offered, truly, "a view from the trenches."[64]

Photographs were put to use in a variety of different contexts within the organization. Accompanying SNCC press releases, photographs were sent to major news media sources. They were employed as visual evidence of police brutality and the vulnerability of blacks as they organized and acted for equality throughout the South. Nearly two months before the world watched Birmingham police sic German shepherds on black protesters, James Forman managed to take photographs of police dogs in Greenwood, Mississippi, before his subsequent arrest. Field Secretary Charles McLaurin struggled briefly with a police officer for the confiscated camera before getting away. Forman would later write: "Knowing that those photographs—later to be seen around the world—would get into the right hands was one of the biggest helps to my morale in jail."[65]

If photographs could function as weapons in the fight for public opinion, they could also act as shields offering protection against excessive violence and mistreatment. Photographs helped provide a certain amount of safety for imprisoned activists, hidden away and sometimes forgotten about in southern jails. In another incident, Forman managed to carry "a camera and five roles [sic] of film with him" into the jail at Fort Payne, Alabama, using it to make pictures of himself and his fellow inmates.[66] In August 1963, Lyon traveled to Leesburg, Georgia, to photograph the many teenage girls detained after protesting in nearby Americus in July and August. While SNCC workers "kept 'Pop,' the guard, busy by talking to him," Lyon, "crawled around the back and shot through the bars in the rear."[67] Lyon's images taken "through the broken glass of barred windows" depict cramped, inhumane conditions: no beds or blankets, clogged shower drains, and a single, overflowing toilet.[68] Many of the girls spent as much as a month in the Leesburg stockade and, according to Lyon, "had been forgotten by the world, including SNCC's Atlanta office, which had its hands full."[69] Within a week, Lyon processed the pictures and SNCC sent them to a United States congressman, who in turn entered them into the *Congressional Record*, ultimately aiding the release of all the girls.

In addition to intervening in dominant institutions, photographs were central components of SNCC's own propaganda machine. This apparatus not only produced *TSV* but also created propaganda pamphlets like the one about the protest activities and severe police repression that rocked Danville, Virginia, in the summer of 1963. The pamphlet incorporated Lyon's photographs and text by Field Secretary Dottie Miller (later Zellner), a white activist. As part of such propaganda, photographs were utilized to enlist viewers, North and South, within and outside of the movement, as witnesses impelled to act. Forman recognized as early as 1958 that "people are motivated to action for many reasons—and one of them is that they get angry when they see their people suffering at the hands of their oppressors. . . . If the struggles, the beatings, the jailings, would rile up our people to action then they would be worth it. Therefore, it was always important to make sure that the act, the nonviolent protest, got the widest publicity and had the broadest public appeal."[70] It was important then not only that the images of suffering circulate, but that they be framed in such a way as to compel people to action. Photographs, along with films and film strips also made by SNCC, became tools to teach nonviolent resistance, literacy, and economic development. Photographs became central in recruitment and fund-raising brochures, especially for the Mississippi Summer Project,

produced by Dottie Zellner, Julian Bond, and Lyon. In the form of album covers, in books, and posters, photographs helped raise funds directly.

Vision on the Walls

Posters provide an especially significant window into SNCC's early uses of photography. "Come Let Us Build a New World Together" was one of at least six 14- × 22-inch posters, five made from Lyon's photographs, produced and distributed throughout the United States between 1963 and 1965. SNCC sold these posters on speaking engagements and through TSV for one dollar each, or four dollars for a set of five. Not only did they raise funds, but like the freedom song recorded albums *We Shall Overcome* and *Freedom in the Air*, they also raised awareness, hope, and solidarity. SNCC posters appealed to its youthful contingent for whom posters were becoming a way of showing affinity for icons and ideals. Displaying them in one's office indicated the type of work being done there, which organizations that office affiliated with, and what ideas were in circulation.

As archivist Carol A. Wells has noted, posters have long played a significant part in movements for peace and social justice, from antislavery broadsides to the extensive circulation of propaganda posters by the Popular Front of the 1930s and 1940s. However, due to the repressive practices of the McCarthy era, political posters "were one of the many casualties of the 1950s."[71] In the early 1960s, SNCC helped to rejuvenate the production and popularity of political posters, which by the latter half of the decade would be ubiquitous throughout progressive circles in the United States and internationally.[72] Posters not only projected specific images and ideals of the organization, but also literally sold those images and ideals to an audience of young people hungry to consume them. Indeed, posters constituted a new youth medium, one through which young people could express their likes, their desires, and their affiliations. By hanging a poster on the wall of a room, on a desk, or in a window, young people could lay claim to a space of their own. While photographs made by SNCC artist-activists could be found on album covers and recruitment brochures, these pictures were in the service of the enclosed music in the former case and linked to longer text and a larger narrative in the latter. Likewise, photographs that appeared in TSV functioned as illustrations or photojournalism within the context of SNCC's own media outlet. While SNCC created its own media structure to combat and intervene in dominant media frames, posters in a sense were the ultimate use of photography and a key form of intervention.

SNCC posters featured a single, blown-up photograph accompanied by pithy text. This layout wedded the documentary impulse for social change handed down from the photographers of the Farm Securities Administration (FSA) of Depression-era America with the emerging sensibilities of fashion design and graphic design of the 1950s to produce politically charged and visually hip invitations to social action. In this way, we might consider these posters the most vernacular manifestation of John Berger's "alternative practice of photography," one that simultaneously plays upon and subverts photography's twin capacities to critique and to commodify, to memorialize and to spectacularize, to challenge the world it represents and to seduce viewers into it.[73]

Posters then constitute a representational strategy through which the organization could articulate its distinctly radical—and radically distinct—position on and in the civil rights movement, often through the presentation of alternative views of movement events. Posters also emerged as sites of internal debate about democracy and representation within the movement. "Is He Protecting You?" was produced from a photograph taken amid the riots and unrest on "the University of Mississippi campus when James Meredith attempted to register as the first black student."[74] A helmeted, white, male Mississippi Highway patrolman, a stern expression on his face, is crisply defined in the foreground. Behind him are the grainy figures of other white men and, in the distance, a white woman. The trooper stands between the viewer and the milling white figures. The text "Is He Protecting You?" places the viewer in the vulnerable body of Meredith, forced to rely on law enforcement to safeguard him from agitated mobs gathered to prevent his entrance. Positioned at the trooper's eye level, the text also raises the question of whether this patrolman acts as the viewer's defense against racial violence or as the first line of terror. It draws attention to the tight boundaries of the "you," those who fall within the protected circle of citizenship and those who do not and for whose access the movement struggled. Are you in his custodial sights or in his crosshairs, safeguarded or surveilled? For African Americans and movement organizers who found themselves traveling on lonely Mississippi highways in the dark of night, the flashing lights of a State Patrol car were no source of comfort. Police and state troopers had long been "official" perpetrators of violence against African Americans in the South, carrying out a brutal and lengthy legacy of maintaining peace through state-sanctioned coercion.

State patrolmen answered to state governors, responding to the political whims of the executive office, whether to safeguard efforts at integration

and registration or to fiercely defend the segregationist order. Conceivably, ideally, they could be made to protect rather than punish. Mississippi governor Ross Barnett, a grandstander and political opportunist, claimed little control over the mobs he repeatedly incited into violent frenzy. During the course of the confrontations between a thousands-strong mob and the federal forces, including a federalized Mississippi National Guard, the State Patrol proved dangerously unreliable. On the night of September 30, 1962, these clashes claimed the lives of two people, including an international reporter, and left over sixty U.S. marshals injured. Highway patrolmen vacillated between joining the mob and aiding its victims. As a group of rioters attacked a Dallas cameraman, patrolmen were observed watching idly as "a Mississippi police officer, in uniform, lent a shoulder to the effort" of overturning the cameraman's car while he and his wife occupied it and then escorted the couple to safety, "without his camera or film."[75]

The incident at Ole Miss marked a key moment in the history of federal intervention on the part of the Kennedy administration, which, represented by John Doar of the Justice Department, had repeatedly informed SNCC, and the Freedom Riders before them, that federal authorities could not intervene in local situations until an incident occurred. Despite frequent and urgent requests for federal assistance and protection, including the initiation of "a federal suit against both Attorney General Robert F. Kennedy, and J. Edgar Hoover, Director of the Federal Bureau of Investigation, to compel them to perform their duties on our behalf," federal agents merely observed and reported violence against the movement.[76] Highway patrolmen, caught between the dictates of their local white communities, the commands of a distant authority, as well as a sworn oath to protect public safety, not to mention their personal beliefs, did nothing. Rather they stood by as irate white mobs physically attacked African American demonstrators, as well as those wielding cameras. The patrolman in the photograph stands with his arms folded, inactive, menacing and obdurate in his fixity. This poster reflects explicitly SNCC's mistrust of police officials in Mississippi particularly and throughout the South generally. It also signals implicitly the organization's increasing lack of faith in the Justice Department to use its power, specifically its police power, on behalf of African American protesters. A cropped and tightly focused version of this image came to represent "Mississippi" as the cover of a 1964 pamphlet on SNCC activities in the state.

In the fall of 1963, Lyon made another photograph of Mississippi police, this time taken from the second floor of SNCC's Council of Federated Orga-

nizations (COFO) office in Clarksdale in the northwest corner of the state.[77] Here six white policemen "pose" under a tree as "ministers from the National Council of Churches march to the local church."[78] In the center, a young tattooed officer, cigar dangling from his mouth, grabs his crotch as he looks directly into the camera. His sunglasses are tucked neatly in the breast pocket nearest his badge, and his handcuffs dangle from his belt loop. Behind him, another officer presents his middle finger and folded arm in another gesture of profanity. The answer to the question, Is he protecting you? is a vicious and resounding "no" as these officers of the law clearly flaunt their power and flout the viewer. They are unashamed. There is no ambiguity here. For SNCC photographer Tamio Wakayama, this is the image that best represents the reign of terror perpetuated and exacerbated by Mississippi law enforcement, the photograph that most accurately portrays the obstacles SNCC workers faced. "To me, that was it. That says it all."[79] Though there was discussion, such an image, despite the clarity of its visual impact, would never become a poster or even be reprinted in TSV.[80]

"Now," made from an image taken during the 1963 March on Washington, similarly offers a unique view of an extensively covered and visually iconic event.[81] The poster depicts a black male protester who seems to hold the word "Now" tentatively in his right thumb and forefinger, raised high above him against a cloudless sky. To his right, another black man claps his hands, and surrounding them are more hands reaching toward the "Now" in the sky, ready to grab it, should it fly away; ready to support it, should it fall. This poster resonates with the immediacy of their demands for freedom and reverberates with the exuberance of being in church. Freedom is not to be found in a heavenly hereafter but grasped at this instant. The poster, the union of image and text, practically shivers in its impermanence. But it ripples with possibility. It is filled with what Walter Benjamin has called *Jetztzeit*, or "now-time," the production and performance of what is to come. As Jean-Luc Nancy describes,

> "Now-time" does not mean the present, nor does it represent the present. "Now-time" presents the present, or makes it *emerge*. . . . The present of "now-time," which is the present of an event, is never present. But "now" (and not "the now," not a substantive, but "now' as a performed word, as the utterance which can be ours) presents this lack of presence. A time full of "now-time" is a time full of openness and heterogeneity. "Now" says "our time"; and "our time" says: "We, filling the space of time with existence."[82]

This poster, like so many SNCC posters, aligns multiple temporalities. Nine years after the *Brown v. Board of Education* Supreme Court decision ordering the desegregation of public schools, "Now" speaks of and to the youth gathered in the capital, frustrated and impatient with the glacial pace of "all deliberate speed." "Now," as utterance, as declaration, as performative, pronounces "this lack of presence," the undelivered promise of integration and equality. As such, the poster's power lies not in a faithful, identifiable documentation of the March; it "does not represent the present," as we have come to understand it, as integrated multitudes and charismatic leaders. Rather, it captures the "fierce urgency" of its moment. The poster calls attention to the "unfreedoms" that envelop the very moment of the photograph, a moment surrounded by a past and future of oppression and resistance. Yet at just this moment, the moment of the photograph, this man and those around him are free. They make freedom "emerge." This is an image filled with now-time, with the we. The act of this poster is an effort to rip open history.

At times, some of the tensions in SNCC's conception of its work, itself, and its constituents revealed themselves, played out on the visual field. In another poster, the dirty and impoverished face of a young, blonde-haired white child fills the frame.[83] The large text reads "For Food . . . For Freedom," indicating that the bread-and-butter issues that lie at the heart of SNCC's voter registration projects extend beyond the black community into white rural areas. It suggests that white children, like black children, suffer from economic injustice and that the social division of impoverished people along racial lines continues to oppress both African Americans and their white counterparts. Following James Baldwin's commentary on the damaged white psyche in *The Fire Next Time*, the poster offers that the repair of America's "race problem" is not solely the province of African Americans, if it is theirs at all.[84] Instead, white Americans must refocus their attention to encompass their own complicity in and confinement by this vicious and complex conundrum.

The "For Food . . . For Freedom" poster also suggests SNCC's increased awareness of the value accorded white bodies over black bodies in the estimation of America's liberals, a cognizance that prompted the recruitment of more than eight hundred predominantly white, predominantly northern college students for the massive voter registration efforts of Freedom Summer. James Forman and Bob Moses rightly anticipated the media attention and general sympathy that would come to bear as young white men and women experienced, if only for a few months of 1964, the same vulnerability

that beleaguered African Americans in the face of white supremacist violence. The poster speaks to the precarious situation of whites dehumanized by the matrices of race and poverty. But what Forman and Moses did not anticipate was the number of white volunteers who chose to remain with SNCC once the fall arrived—the number of staff leapt from 76 to 161 following the official end of Freedom Summer.[85]

The poster begins to confront the conflict and concern around the place of white organizers within SNCC, an anxiety and tension that came to a head in the final expulsion of SNCC's remaining white organizers at the 1966 conference on the estate of Peg Leg Bates in upstate New York. In its early years, up until Freedom Summer 1964, SNCC prided itself on its practice of an equitable model of interracial cooperation and collectivity, one in which black organizers held almost all positions of traditional prominence and field workers of all races worked in tandem with local African Americans to address the problems of their communities. Yet at various times black members complained that white SNCC members should redirect their energy toward their "own" communities. Only white people, some staff felt, could effectively mount and organize an antiracist agenda in white communities.[86] Who but whites could safely organize the dirty child's parents? And indeed some white staffers, such as Bob and Dottie Zellner, did attempt these sorts of conversations with southern whites, including a go at organizing white youth in Biloxi, Mississippi, during Freedom Summer.[87] Greeted with disinterest and hostility, the Zellners and others soon quit their efforts. Yet faced with hostility from black staffers emboldened by a rising black power sentiment, the Zellners and others painfully left the organization they helped build and turned their attention elsewhere, particularly to the growing movement against the war in Vietnam. The choice of the image of a vulnerable white child in need of protection, the only poster to feature a white person sympathetically, suggests the beginning of such efforts to address and mobilize white Americans. Simultaneously, "For Food . . . For Freedom" scratches the seeds of anxiety germinating around the shape and very face of SNCC itself.

Another poster occasioned open debate over this particular concern with democracy and representation within the organization. "One Man One Vote" was SNCC's slogan for the voter registration drives in Mississippi that lay at the center of the organization's work starting in 1962.[88] Borrowed from African anticolonial struggles, the phrase could be found on SNCC letterhead, bumper stickers, buttons, and posters. The most widely distributed of these posters coupled the motto with a photograph of an

elderly African American man seated in front of a simple, rundown house. He wears overalls and work boots, and the brim of his large straw hat renders his eyes invisible. His elbows rest on his knees and his weathered hands are folded, fingers intertwined, as he sits. Leaning forward on the edge of his seat, his open mouth suggests he is speaking. His engaged position and open mouth represent a person active in the world around him. He is quite simply one man, of many black men around the world, deserving of one meaningful vote. This man symbolized for people both within and outside of SNCC the black laborers, everyday folk, "local people" capable of taking control of their lives as responsible citizens, the ultimate expression of this being exercising the right to vote. In a position paper at the 1964 SNCC conference and retreat in Waveland, Mississippi, field worker Frank Smith utilized the image of "the Negro farmer sitting on a stool" as a way of questioning SNCC's commitment to democratic practices not only with respect to the people it organized but also its own field organizers, who could not vote on policy. "Does 'One Man—One Vote' include the sharecropper who has never been to school or are we really teasing when we say that? Do we really believe what the white man tells us, that the Negro is really too stupid to vote? You know that there are some Negroes in SNCC who believe that."[89]

SNCC, buttressed by this poster, placed the hardworking black laborer at the center of its voter registration campaign. As Smith imagines this man, "He more than likely lives in an old, worn-out house with a washpot in the back yard and an out-door toilet. He has never been to school. He probably does not know a verb from anything else and only goes to town a few times a year. He has always lived and worked on this white man's farm. . . . I happen to believe that every man, farmer, lawyer, illiterate, PhD has a right to speak and be heard."[90] Yet, in the poster, rather than engaging this man directly, face to face, one gets the feeling of not only looking down on him but of descending on him. Unlike the text of the poster "Now," which appears as if in a delicate dance with the photograph's subject, here the word "One" seems imposed upon this man. Awkwardly placed in the layout, the text obscures part of his hat and weighs on his head. What is especially disconcerting about this photograph is the angle of the camera: slightly above the man and almost tilting forward.

The photograph in this last poster specifically focuses on the individual not as a leader but as a universal figure in the vein of FSA documentary work of the 1930s. Photographer and art critic Allan Sekula writes, "The celebration of abstract humanity becomes, in any given political situation, the celebration of the dignity of the passive victim. This is the final outcome of the

appropriation of the photographic image for liberal political ends; the oppressed are granted a bogus subjecthood when such status can be secured only from within, on their own terms."[91] SNCC's use of these images as a means to encourage a subjecthood from within troubles SNCC practice in the field, as field workers, like Frank Smith, begin to reread such practices through the lens of photography. Simultaneously, the somewhat patronizing and demeaning angle of this photograph in particular vexes the facile employment of photography as a method of embodying SNCC ideology. Photographic representation here becomes both a way of giving voice and form to organizational anxieties and a source of anxiety in itself.

These anxieties over and about photography were only an extension of the conflicts that arrived with Lyon. Even after working with SNCC for a few months, some organizers were unclear about his role or usefulness; and on one occasion Lyon's position was the topic of an impromptu bathroom conference in which Forman convinced field secretary Marion Barry of Lyon's utility.[92] Despite Forman's defense and Lyon's boundless respect for Forman, tension pervaded the relationship between the young photographer and the executive secretary, as the photographer constantly found himself struggling to express his vision of the movement and not necessarily Forman's.[93] The relationship between photographer and subjects also proved to be fraught as well. As a young white man, Lyon would, on occasion, play the role of segregationist sympathizer to glean information about countermovement activities and police uses of photographs, as he did in one conversation held with Alabama Highway Patrolmen in the town of Gadsen in June 1963: "[One officer] said a Birmingham news man was sending them shots [of protesters]. Maybe I could send shots of Danville [Virginia] leaders to check against those in Gadsen?"[94] Lyon also recalls that Forman directed him to gain access to local newspaper offices for supplementary photographs of police violence, a task that no black staffer, even with proper press credentials, could safely undertake.

Though Lyon's race and gender enabled him to photograph white protesters and white police with some security, neither his physical presence nor his camera worked as a foolproof shield at all times. As national sympathy for the movement grew due in large part to the work of the press, segregationist mobs grew to fear the exposure that the camera as key witness surely brought. Lyon, Charles Moore, Paul Good, and CBS cameraman Wendell Hoffman all recalled moments in which they specifically became targets because of their cameras, especially at night when flashes and lights exposed the operators in the act of exposure. Hoffman recounts Selma, Ala-

bama, sheriff Jim Clark sending a group of "squirrel shooters" away from harassing voter registrants to bully Hoffman and his crew, "attempting to hit me in the testicles with their sticks."[95] As Moore imagined, to segregationists, "I was worse than 'a nigger,' I was a white nigger . . . And worse than that I was a white *Life* magazine nigger."[96]

Lyon drew not just the ire of segregationists but occasionally the fury of his black subjects as well. A photograph taken on September 18, 1963, during the funeral of Addie Mae Collins, Denise McNair, and Cynthia Wesley, who along with Carol Robertson were murdered by a bomb blast at the Sixteenth Street Baptist Church in Birmingham, forcefully depicts such a tension between white photographer and black subject.[97] Lyon photographed the joint service of the three young girls as well as capturing the hundreds of black mourners who lined the streets of Birmingham along the procession route. One mourner, a black woman, confronts Lyon in the act of documenting this scene. Her brow is furrowed, her shirttail is untucked, her chest puffs out ever so slightly, just enough to reveal the sweat pooling under her arm. Most of the other mourners in the frame do not engage Lyon or his camera. With their hands folded, arms crossed, some holding tissues, they wait with infuriated and anguished faces. But it is the woman in the foreground who, by September 1963 would have been accustomed to, though perhaps not comfortable with, the presence of white men with cameras in her city, vehemently returns Lyon's gaze. Her angry and intent face questions the white male photographer's presence, his right to document a community tragedy that his camera could not or would not prevent. Another black woman in the far left of the frame, with folded arms and tilted head, also meets Lyon's eye and echoes the first woman's gaze. Though Lyon has contended that he was always made to feel welcome in southern black communities, this photograph suggests that his camera may not have experienced the same hospitality.[98]

The woman's bold look back at Lyon and his camera seems to offer both an invitation to look more carefully at what appears before the camera as well as a challenge to the photographer to examine his own presence and uses of the image. Her look forces us to engage two questions: the first asks, what is the work of the photographer, where do his loyalties lie? In the height of media attention to the movement, Lyon's role as movement photographer, as one who makes images "in the service of a social cause," may have become increasingly indistinguishable from the social documentarian, who though committed must also retain distance, and the photojournalist concerned primarily with reportage.[99] Between the potentially divided

loyalties and the strained vision, there was little space left for the photographer as artist, as aesthete, as creator and executor of a personal vision. Indeed, Danny Lyon would leave the South and SNCC not long after he made this picture to pursue a career as a photographer of the "social landscape" in the vein of Robert Frank, desiring more creative freedom under less terrifying conditions.

The woman's look poses, as well, an ethical question to photographer, to viewer, and to SNCC: what is the work of the photograph in the aftermath of violence and in the interstices of confrontation? SNCC had employed photography "for publicity and historical record" and in doing so, had achieved enormous publicity, helped sway public opinion in favor of civil rights, and provided a record of the history it helped shape.[100] Yet the camera could neither prevent the violence it recorded nor could it provide solace in the aftermath of tragedy. In the next phase of the civil rights movement, what would be the place of photography?

All Eyes on SNCC

These questions, suggested by the Birmingham funeral image, would come to the fore in the wake of Freedom Summer. SNCC's growth due to its success in Mississippi especially, its bold though compromised challenge to the southern Democrats at the 1964 Democratic National Convention, and its tour of newly decolonized African nations, placed the organization on extremely "floodlit social terrain."[101] Watched intently by the mainstream press, SNCC's growth was also accompanied by a scattered focus and weakened internal structure.

At SNCC's Waveland, Mississippi, retreat in November 1964, the first large-scale meeting since the end of the Summer Project, participants engaged a number of questions and concerns, attempting to evaluate the organization's success and to plot a future course. Prompted by the nearly forty position papers included in each attendee's packet, participants strove for consensus on issues from the ideological to the financial to the infrastructural. A number of the papers addressed SNCC Communications, or like, Frank Smith's contribution, raised concerns related to SNCC media. In one of her position papers, Communications Secretary Mary King wrote poignantly, "It is no accident that SNCC workers have learned that if our story is to be told, we will have to write it and photograph it and disseminate it ourselves."[102]

Yet, while the lesson that SNCC workers learned may have been clear by

November 1964, who owned the rights to the story were becoming increasingly unclear. The attention to and changes wrought in the organization by the previous summer led the "we" and "our" of Mary King's declaration to become a growing point of contention. Following the summer, a number of volunteers chose to continue the work they had begun in Mississippi and asked to be placed on staff. Despite the logistical difficulties this presented with regard to salaries and training, the surprised members of the Executive Committee, who had expected most volunteers to return home at the end of the summer, consented. A close-knit band of 76 staffers, many of whom who had worked in SNCC for a year or more, became a community of 161 relative strangers.[103] And even though SNCC still remained predominantly black and southern in members and constituency, the influx swelled the numbers of white and black northern, better educated, middle-class staff. Rifts were opened as the organization struggled for consensus, as they always had, on programs, structure, and direction. For over a year, SNCC searched for common ground as its programs lapsed and members drifted from project to project and even out of the organization altogether.

But now, SNCC's conflicts and confusion were under the watchful eye of the national media for whom civil rights and the movement were the top news story. And SNCC found itself perhaps the best-known civil rights organization in the United States and possibly the world.[104] The mainstream press had served as a tool and interlocutor for the organization, but now these media had enough reporters in place to tell their own version of the freedom struggle. Papers large and small no longer relied on SNCC press releases or photographs to supplement their own accounts. With the nearly thousand volunteers of Freedom Summer came television, newspaper, wire service, and magazine reporters; freelance writers and photographers; Hollywood producers and independent filmmakers, foreign and domestic, all working to tell their version of the revolution in progress. Stories of the civil rights movement multiplied as abundantly as the verdant kudzu vine that wound through the Delta, and at times were as overgrown and far-flung. But these stories were not always SNCC's stories.

Once sympathetic to the goals of the movement, many reporters in the national media believed those goals to have been fulfilled with the Civil Rights Act of 1964 and the Voting Rights Act of 1965. The mass media grew impatient with SNCC, which was seen to be increasingly petulant. But the leadership of SNCC knew that legislation that ruled de facto segregation and disenfranchisement illegal and maintained citizens' entitlement to exercise these rights, yet did not authorize any federal action to enforce them,

was ultimately a sorry compromise. Even more pressing was the unrelenting poverty faced by the majority of black southerners. The power to vote was only the tip of the iceberg and meant little without truly representative candidates, adequate education, or basic economic security. SNCC became aware that its work was not close to being finished, and so its programs and locations expanded to include political empowerment, literacy, and economic training programs in Atlanta, Alabama, and Arkansas, as well as various though short-lived efforts to organize in white communities.[105]

SNCC's loss of direction manifested not just organizationally but also emerged as a crisis of representation that had profound effects on and in the SNCC Photo Agency. This crisis took two forms. First, it surfaced as a series of conflicts within SNCC over image and equipment ownership, "professional" versus "amateur" photographers, and the uses of photography. Second, the loss of Lyon's singular focus understandably engendered a proliferation of new visions and forms; fragmentation also gave way to polyphony. While the new and officially established SNCC Photo Agency, with its own influx of staff, continued to make images for publicity and historical record—photographs for Mississippi Freedom Democratic Party candidate posters, or images to be included in TSV—the period from late 1964 through 1965 witnessed a transformation of the kinds of images being made, the uses to which they were put, and the number and diversity of SNCC workers making them. Photo-text collaborations such as *The Movement*, literacy tools, and traveling exhibits joined the range of outlets for movement photographs.[106] In a larger operation with greater responsibilities and more photographers, at stake in this period of internal fragmentation was who would visually represent SNCC, how, and to whom?

The photography department was one of those programs that saw its numbers swell, its locations expand from a converted broom closet darkroom in Atlanta to facilities in Mississippi and Alabama, and its structure (seemingly) formalized and officially named SNCC Photo. By the beginning of Freedom Summer, SNCC had already recognized its increased photographic needs. With Danny Lyon beginning to drift from the organization, SNCC established a relationship with freelance photojournalist Matt Herron. Herron helped build and expand the Atlanta darkroom in late spring 1964, during which time he and Forman worked out a loose agreement between SNCC and Herron's Southern Documentary Project (SDP). SDP had access to SNCC resources (cars, the Atlanta darkroom, and importantly, SNCC's name), and SNCC had access to all images made during the summer by Herron, Norris McNamara, George Ballis, Dave Prince, and

Lyon, who was convinced to return South under the auspices of the SDP. In other words, SNCC partially outsourced its photographic work to SDP during the summer of 1964. According to Tom Wakayama, a photographer who took over the photo operation in fall 1964, without a clear structure or agreement between SNCC and SDP, "SNCC's photographic needs were unfulfilled" during this time. In a report to the Executive Committee, Wakayama identified the greatest problem "in the disparity of objectives between SNCC and SDP. The latter which is a documentary project is by its nature an attempt to objectively record the South and this is a long term proposition; the former, by its political nature, uses its photos for propaganda purposes and these needs are immediate." Confronting the range of photographic work, not unlike Herron's own effort to distinguish his roles as photographer, Wakayama made a series of suggestions regarding the aims and establishment of "SNCC Photo." Most notably, he sought more personnel to fulfill SNCC's "communication and propaganda needs."[107]

A year later, Wakayama's suggestions seem to have been incorporated. In late 1965, a brochure introduced SNCC Photo, "as the only agency in the South with a documentation of the Movement." With "five photographers—four in the field and one in the Atlanta office who serves as a darkroom technician and as a secretary," SNCC Photo was portrayed as a streamlined unit with clear-cut programs for the present and future.[108] Utilizing photographs by Tamio Wakayama, Bob Fletcher, and Fred deVan (Lyon's images are noticeably absent), the brochure states that "SNCC Photo relays information about the movement to communities in the South, where the press of a 'closed society' usually ignores or omits such information, Supplies photographs to Northern news agencies, campus publications and magazines, And provides a tool for publicity and fundraising by SNCC's Northern supporters." But it also saw itself engaged in a host of new endeavors, including the mounting of exhibits, the production of filmstrips for teaching literacy and organizing, and the training of local people in camera work "to develop an indigenous core of skilled photographers."[109] The brochure, though, belies the conflicts and confusion that accompanied the unit's expansion and redefinition.

Though the brochure notes five photographers, a host of people worked in and around SNCC Photo during this period. Additionally, a series of administrators cycled through SNCC Photo, including Erin Simms, Ethel Breaker, Cynthia Washington, and Marilyn Lowen.

Just as the doubling of the staff as a whole exacerbated old tensions and created new ones, so too did the photography operation experience its own

set of problems. While Lyon's departure opened up space for new visions and creative approaches, it also marked the end of the cohesive vision of a single auteur, one whose distinctive style provided a semblance of uniformity to the public image of the organization. From his arrival in 1962 until his ultimate exit in 1964, Lyon, in a sense, *was* SNCC Photo. And once he left the organization, SNCC found it needed to give formal structure and official name to the various tasks that Lyon had performed.

Lyon had often chafed under Forman's heavy hand; the executive secretary not only directed him where to go, but what to photograph, like Lyon's famous shot of Jim Crow water fountains made early in his tenure with SNCC. As he traveled back roads, made friends, and indeed came of age in the movement, Lyon increasingly wanted to photograph his own experiences of the South, whether these images proved useful to SNCC or not. He often found himself drawn away from the movement's charged frontlines and toward the quirky banalities of southern life, carnivals for example, which communicated little about SNCC's work but images a southern "social landscape." Even the Birmingham funeral image, when placed in the longer trajectory of Lyon's work, offers an early example of his ongoing and often uneasy photographic confrontation with marginalized subjects—prisoners, prostitutes, the impoverished—whose personal agonies are at once "none of our business," yet something in which we are nonetheless implicated.[110] When he left SNCC and the South in the spring of 1964, Lyon articulated his desire for artistic freedom in a letter to Forman: "I do not know what I will do now that I am on my own, but my hope is that being free, free in the not particularly high artistic sense of being able to discover something or someone and follow them wherever they may lead me with my work, without any organizational sense of guilt as to its inappropriateness, but simply with the belief that what I see is relevant now and in the future."[111]

LYON'S LONGING TO BE "FREE" names an emergent mood in SNCC following Freedom Summer: an effort to broaden or redefine "freedom" as not the liberation of the collective, the beloved community, but rather to foreground individual autonomy and free will. Such a search for personal freedom reflected a kind of existentialist crisis, one that was in part a result of the intensities of Freedom Summer, of living and working long hours under difficult and dangerous conditions for uncertain and often frustrated rewards. But these personal quests for a vague and unrequited freedom caused disciplinary and infrastructural problems as staffers, mostly north-

erners, floated in, around, and eventually out of the organization with little or no accountability. SNCC's "hardline" staff, those concerned with institutionalizing the organization, including Cleveland Sellers and Ruby Doris Smith Robinson, derisively dismissed these "floaters" as being "high on freedom."[112] As one executive committee member intoned in an effort to gain support for SNCC activities in Los Angeles, "Most of the people don't realize how crucial the situation is in L.A. They [staff] seem to be 'Freedom High' and I don't feel we can operate in that way."[113]

Lyon's resignation letter reflected the challenges faced by the organization as a whole in determining whether SNCC would continue to be nonhierarchical (and somewhat anarchic) or become more institutional, disciplined, and bureaucratic in structure. One the one hand, Lyon's work and his departure indicated a need for more people trained to photograph SNCC and its expanding programs. But his departure also indicated the confounding questions posed by the place of photographers "embedded" in the movement. Lyon's time in SNCC may have offered a model for some of movement participation that could be distinct but not wholly separate from field organizing and office administration, a means of individual expression within the collective project. As Lyon would reflect many years later, "I'm not a joiner. I absolutely hate groups. I had a lot of trouble being in SNCC because it was a group. . . . SNCC was an amazing group. Maybe that's the only group I ever could have been a part of."[114] For Lyon and perhaps other photographers as well, the camera gave license to serve as an observer and chronicler of a deeply immersive experience. By fall 1964, SNCC Photo encapsulated the conflicts of the organization as a whole in needing to impose discipline on an open structure whose draw was in part its fluidity.

With Lyon gone for good, Forman preoccupied with more pressing matters than photographers' contact sheets, and the constantly growing photography department no longer a mere wing of SNCC Communications, SNCC Photo found itself pulled in multiple directions, and its leadership changed hands many times during this period. Directors needed to oversee and manage the three distinct but integrally related aspects of SNCC Photo: administration, darkroom technician, and photography. But the jobs of these positions were unclear. Moreover, the attraction to SNCC Photo for many was the mobility the camera afforded, not the bureaucratic or propaganda demands of the organization or the crucial but less prestigious work in the darkroom. As Bob Fletcher wrote to Clifford Vaughs, "it's a shame that you, Tom, Joffre and myself should have to get so hung up about whose turn it is in the darkroom. Actually, none of us are temperamentally suited

for long periods of that kind of work, and all of us should instead be spending as much time in the field as possible . . . We definitely need a full-time darkroom person to free us to do our work."[115] Photographers pursuing a personal vision, artists who might be "freedom high," were not interested in the quotidian drudgery of movement work, whether filing reports or processing film. Such lack of clarity about divisions of labor produced disputes among SNCC Photo staffers and between SNCC Photo and SNCC at large.

Breakdown of communication, failure to follow through on assignments and commitments, and lack of clarity about individual responsibilities were chief among the criticisms SNCC Photo received and the grievances filed by the leaders themselves. In his December 1964 "Field Report" as director of SNCC Photo, Clifford Vaughs hinted that "some changes in personnel . . . may be necessary due to the irresponsibility demonstrated by certain individuals in my department."[116] SNCC's Executive Committee expressed its own consternation with the photography unit. SNCC leadership had trouble keeping track of who was actually part of SNCC Photo, where they were, and the location of cameras, prints, and negatives, even as the demands for photography increased. In the period between February and April 1965, the list of photographers and secretaries working in the photography department was constantly changing.[117] Bond admits that no one kept records about the Atlanta darkroom, and he was now "at a loss to determine what belongs to whom."[118] Bond sought clarification about the SNCC/SDP relationship in particular from Herron who offered Bond general professional advice. Here, Herron's practical knowledge of the distinctions between the three photographer "hats"—movement photographer, social documentarian, and photojournalist—became quite useful. In a reply letter, he reminds Bond, "it is customary, if a photographer is a *member* of an organization, receiving a salary and not a free lancer, that the organization owns and retains full rights to the negatives."[119] It is not clear what explicit agreement(s) SNCC had with its photographers. But the amount of correspondence about locating equipment, images, and personnel suggests that the parameters were open to interpretation.

Significantly, these competing ideas about the role of photographers in the movement also took the form of battles over ownership of equipment. The Executive Committee believed equipment and the photographs they produced belonged to the organization. Donations from Marty Forscher, Howard Chapnick of Black Star, New York photographer and filmmaker Harvey Zucker, Jay Maisel, and others were in kind gifts to SNCC, not to the

individual photographers. Likewise the photographs had been produced in the service of the movement and were housed in SNCC files. For Bond, Forman, and Smith Robinson, there was little question about to whom the cameras belonged. Just like the cars, the radios, and the mimeograph machines, the cameras and their offspring were SNCC property. Just because their operators and authors left the movement did not mean the cameras or the images were no longer necessary to or property of the struggle.

While SNCC saw the photographers as field workers whose equipment and work ultimately belonged to the organization, Mitchell, McNamara, Wakayama, and others saw themselves as artists and professionals. They had seen the movement through the eye of a camera, and in turn, the camera had become an extension of their eye. The cameras had become *their* cameras, photographers attuned to the individual quirks of this particular Nikon F or that specific Pentax. Wakayama and others learned the movement and themselves through photography, a technology that afforded them individuality, as expressed through a personal vision through collective struggle. Solidarity forged and mediated, in part, through photography. For Wakayama, photography was the most rewarding and the best thing he had left from the intense experience of the South, from "the grubby life and the fear and violence of Mississippi cops and the internal hassles which [were] just beginning to happen in Snick."[120] Moreover, in order to fulfill the multiple financial commitments—school loans, car troubles, as well as his debt to SNCC—Wakayama required the equipment in order to work. And without access to his negatives, the property of SNCC, "I can't put together a proper portfolio."[121] Wakayama describes himself and a situation that many may have experienced. In transitioning out of the South, out of the movement, and into a career as a professional photographer, he found that photography was key to making sense of his changing world (figure 2.7). "The only real thing I can or care to do it [sic] to photograph and I desperately need the equipment to do it," Wakayama ended his letter. "I still want to do this [return South] and continue my shooting, which I personally feel is valuable and good."[122] Indeed, Vaughs and Wakayama considered themselves "professionals," possessing technical skills, equipment, and artistic vision that others, those Wakayama referred to as "field workers with cameras," lacked.[123] To Wakayama, SNCC Photo initiated him into not just the brotherhood of the movement, but the brotherhood of photographers. This fraternalism was signaled by the matching equipment pouches he, Clark, and Vaughs possessed, by the shared experiences of terror as camera-eye

Figure 2.7. SNCC Mississippi Project Director Robert Moses, stands in
remains of vandalized church, Longdale, Mississippi, August 16, 1964.
Photograph by Tamio Wakayama. (Take Stock Photos)

witnesses of the movement, and by a developing perception of themselves
as artists.

Photography in the service of the movement, then, was emerging as a
slippery character in this moment, in contrast to its decidedly more fixed
originary and earlier function. For SNCC's Executive Committee, the cam-
era remained a technology of documentation and a tool of survival (both
physical and fiscal). Photographers were operators and witnesses. But for

many of the members of SNCC Photo, the camera became an instrument of personal vision, a means to artistic freedom, and a marker of professional distinction.

This tension around the roles of photographers and photography in the movement took on specific gender dimensions as well. Gender-based conflicts and inequities played themselves out in SNCC Photo just as they did in other SNCC programs. Women staffers found themselves excluded from the formal SNCC Photo structure as photographers, though women almost exclusively carried out the detailed administrative work. From 1964 until June 1965, Erin Simms handled all correspondence and photo assignments, including contacting and directing photographers according to SNCC's needs, kept track of equipment and was responsible for its upkeep, and managed supplies and finances for the Photography Department.[124] Ethel Jean (or Jeanne) Breaker, Cynthia Washington, and Marilyn Lowen succeeded Simms up until February 1966.[125] There is ample evidence, however, that women expressed interest in doing more than secretarial work and were indeed making and utilizing photographs for more than private enjoyment. A list of "Film Job Numbers and Disposition" of film shot between March 24, 1964, and around April 20, 1965, reveals that Mary King, Emmie Shrader (or Schrader), Joyce Barrett, and Dorothy Teal each procured rolls of film and had them developed in the SNCC darkroom.[126]

When women sought formal inclusion in SNCC Photo as practitioners, they were often met with indifference. When Tina Lawrence and Doug Harris wanted to join the photo staff in late 1964, only Harris received training in New York City from Richard Avedon.[127] It is not clear why Harris was sent north and subsequently joined the photo staff, while Lawrence was offered Erin Simms's administrative position; nor does the correspondence reveal why Lawrence did not take this job. It is apparent, however, that some women recognized they were being actively excluded, confined to "women's work," which did not include photography.

At the beginning of November 1964, Mary King and Casey Hayden anonymously submitted a position paper on "Women in the Movement" for discussion at the Waveland retreat. Often cited as an early emergence of second wave feminism from openings created by the civil rights movement, King and Hayden argued that gender paternalism, particularly in the form of sexist divisions of labor, was just as harmful to the movement as racism. "Consider why it is in SNCC," they wrote, "that women who are competent, qualified, and experienced, are automatically assigned to the 'female' kinds of jobs such as typing, desk work, telephone work, filing, library work,

cooking, and the assistant kind of administrative work but rarely the 'executive' kind."[128] The paper caused a stir, eliciting the often-cited statement from Stokely Carmichael that the position of women in SNCC was "prone." Though King and Hayden would years later aver that they took Carmichael's statement in a spirit of jest and camaraderie, and that it was SNCC's openness that enabled such a discussion to occur at all, the inequity remained. And it extended to photography work.

A few weeks after the Waveland retreat, Matt Herron wrote Julian Bond that he was training King and Hayden in New Orleans. "Both show great talent and interest in photography and could make a very considerable contribution to SNCC as photographers, but neither of them has a scrap of decent equipment."[129] Less than a month later, King would tender her resignation as longtime communications secretary in order to "develop a Mississippi Documentary-Photography project" with Casey Hayden. King cited a number of programmatic and practical reasons for creating such a project, including the need for a darkroom in Mississippi to better service the number of projects in the state, as well as the "enormous" usefulness of "visual aids . . . to political organizing."[130] Among her reasons for starting her own photography project was her exclusion from SNCC Photo. "One of the problems with people who do photography now (and the movement as a whole it seems) is that people who know things are reluctant to teach others. Without being personally critical, there seems to be considerable hesitation on the part of Cliff [Vaughs] and Tom [Wakayama] for instance to share technical knowledge and lend equipment. Perhaps this is because they consider themselves porfessionals [sic]."[131]

Explicit in King's memo is a critique of the "professional" (photographer, administrator, organizer) who jealously guard his skills and knowledge in order to create and maintain hierarchy. For King, it was precisely this hierarchy, whether imposed on women within SNCC or on local people, that was antithetical to the ideal of the beloved community and could only serve to deter "the slow process of changing values and ideas."[132] Just as Frank Smith had questioned his fellow organizers' commitment to class equality through the "One Man One Vote" poster, King similarly began to reread gender relations through the prism of photography. The camera placed in the hands of nonprofessionals, here defined as the women and southern black folks not of SNCC Photo's inner circle, could function to truly tell the story, not solely of SNCC, but of black life in Mississippi. "I see making photography accessible to people as a way of forcing a kind of documentary writing. . . . Perhaps the most exciting part of this whole thing, is that

we may finally be able to do what a lot of us have been talking about for so long—to get Mississippians writing about Mississippi."[133] The Mississippi Documentary-Photography project, then, offered King and Hayden a means to withdraw from the hotbox of Atlanta headquarters with its sole darkroom, while exercising administrative control and creative direction over a project of their own design. It allowed them to remain connected to the organization, fulfilling its mission and commitment to empowering local people, while working to empower themselves as well. For King, the focused, high-quality work of Lyon and later Francis Mitchell had been necessary to "legitimize" photography within SNCC and to legitimize SNCC's program of radical democracy. Now, cameras needed to be placed in more hands, and photography needed to be put to new uses. In deemphasizing the professional, such a project aimed to both revive and extend SNCC's commitment to grassroots organizing.[134]

What emerged was not the Mississippi Documentary-Photography Project, as King had originally proposed, but the Southern Visual Education Service, a project that produced visual materials as pedagogical tools. King and Emmie Schrader along with Mary Varela and Bob Fletcher became extremely excited about the potential of film strips.[135] Invented around the 1930s, filmstrips consisted of about thirty to fifty images mounted onto a spool of 35mm film, which could then be played through a filmstrip projector. They were also extremely inexpensive to produce. Filmstrips told stories, passed on information, and offered direction.

As a crude form of filmmaking, filmstrips also facilitated the construction of new SNCC narratives. "ANYONE CAN MAKE A FILMSTRIP," Varela declared to SNCC staff in no uncertain terms. "It's no big thing!! Just decide what you want to make a strip on and we'll (Fletcher/Varela) help you lay it out and shoot it . . . We can either get you film—if you have cameras in your county—or we can come over and shoot whatever pictures you want in your strip."[136] She added that she was planning a filmstrip-making workshop open to anyone. And with the addition of a negative copier (in which photo negatives are exposed onto a positive film strip) built by a New York volunteer, "one could make twenty-five filmstrips in a short day."[137] Filmstrips, as produced in the photography outpost in Tougaloo, Mississippi, largely utilized by women (including Emmie Schrader, Kathy Amatniek, King, and Hayden), offered a space for SNCC women and local people to create their narratives of the movement. More than just their accessibility, filmstrips proved useful as tools for organizing, political education, and literacy programs. Mary Varela and Bob Fletcher hitched their photographic skills to

their own educational project work and, of all SNCC staffers, were the most successful in their creation and deployment of filmstrips. By November 1965, Varela reported to funders that three strips were nearly completed, and by March 1966, that number had increased to eight, including one on elections in Holmes County, another on the United Farm Workers Organizing Committee "done for those up in the Delta wanting to organize a farm workers' union" (a precursor to Varela's subsequent career as an organizer in the Hispanic land rights movement in the Southwest), and two strips about the Vietnam War.[138]

The filmstrip *Something of Our Own* perfected the format and effect Varela had learned through previous strips.[139] It relied almost exclusively on photographs, which she noted, "are the best in getting the message across."[140] Varela, Fletcher, photographer and volunteer Bennie Jackson of the Child Development Group of Mississippi (CDGM), and coproducer Marilyn Lowen mostly drew from Varela and Fletcher's black-and-white images made especially for the strip, as well as utilizing photographs from SNCC files. The strip incorporated text taken from the recorded narrative of several members of the original West Batesville Farmer's Cooperative. In their own words, the members communicated their story and process to other interested farmers and approved the final version. Such a collaborative approach guided all of Varela's media work for SNCC, including Fannie Lou Hamer's first autobiography, *To Praise Our Bridges* (1967). Photography here served as an adjunct to Varela's work as an activist and educator. The practice of making filmstrips disrupted the professional-amateur hierarchy that was crystallizing around SNCC Photo and worked to solidify and re-articulate the organization's commitment to grassroots empowerment.

The opening image of *Something of Our Own* (part 1) is in many ways indicative of this visual shift (figure 2.8). Taken most likely by either Varela or Fletcher, the photograph tightly frames a black man wearing jeans and a clean, long-sleeved shirt in a field of nearly waist-high okra. As the strip was meant to be instructive, it shows the man facing the camera directly as he cuts an okra pod to place in the bin he holds in his other hand. He looks out from under the brim of his hat and is simultaneously demonstrating and addressing his audience. Significantly, we see a farmer bearing the tools of this trade: shears, a collection bin, long sleeves, and heavy work gloves to protect him from the plant's irritant hairs. The farmer's authority is underscored by the slightly low camera angle. Instead of the camera looking down at the idle black man seated in front of his ramshackle home offered to us in the "One Man One Vote" poster, here we look up at a competent

Figure 2.8. Photograph of black farmer for cover of *Something of Our Own,
Part One* (1965), by Mary E. Varela and the West Batesville Farmer's Cooperative,
Labadie Collection, University of Michigan. (Courtesy of Maria Varela)

working farmer surrounded by the lush white flowers of the okra plant and
a wide open sky behind him. While the photograph borders the pictur-
esque—echoing the romanticization of rural black southerners to which
some SNCC members succumbed—the image asserts the subject's knowl-
edge and announces its invitation to dialogue through the man's direct look
at the camera as he carefully and deliberately wields his tools. Followed by
photographs of African Americans running meetings and of black hands

sorting okra, signing petitions, keeping records, and directing heavy equipment (cotton-pickers, combines, and trucks), these images aver that "amateurs," whether farmers or photographers, are fully capable of performing and producing quality work.

The photographs made by Varela and Fletcher also reflect a growing trend toward focusing more on single subjects, rather than groups, as well as more on the physical terrain. Even as the energy around the movement seemed to be unquantifiable in this period, the images seem to slow down, to be less urgent, and to invite contemplation. Filmstrips depended upon clarity of image and the willingness of the viewer to study them if they were to work as educational tools. But we also might see in these photographs an effort at observation rather than documentation, an effort that suggests a "subjective exchange" between photographer and subjects.[141] It is as if SNCC members were attempting to make sense of both the transforming social and physical landscapes of the South, its breadth and its uncertainties, and their own place within.

For Schrader, Kathy Amatniek, and Varela, photography enabled the production of politically engaged art. Elizabeth Martinez, who during the 1960s went by the name Sutherland, also employed photography in the service of SNCC politics and programs, but through formal publications and gallery exhibits, exploring and expanding SNCC's photographic sites. From 1964 through 1966, Martinez worked as the head of SNCC's New York office, a key source of publicity and fund-raising for the organization. Photographs were an essential component of Martinez's efforts, for they enabled funders and other supporters to visualize SNCC's work in the South, a place that for many New Yorkers was a foreign land. While still working as an editor at Simon and Schuster, Martinez came up with the idea to publish books in collaboration with SNCC as fund-raisers. *Letters from Mississippi: Personal Reports from Volunteers in the Summer Freedom Project, 1964, to Their Parents and Friends* and, especially, *The Movement: Documentary of a Struggle for Equality*, both published in 1965, relied on photographic images. In conceiving and executing the latter project, Martinez brought to bear her prior experiences as a United Nations analyst of anticolonial struggles in Africa and Latin America, as assistant to Museum of Modern Art director of photography Edward Steichen (curator of the popular and controversial *Family of Man* exhibit), and as Art and Books Editor of the *Nation*.[142] *The Movement* is distinguished by its broad mapping of the civil rights struggle, incorporating Lyon's and others' images of the southern front, with photographs from rent strikes and other demonstrations in the North. Combined

with the words of Hansberry, a chronicler of urban black life predominantly, *The Movement* visualizes the expansiveness of the civil rights movement in a way that would not be recognized so explicitly until some of the most recent waves of movement historiography. The book helped translate the movement to a wider, northern audience.

Soon after the project was completed, Martinez left the publishing house to head up SNCC's New York City office full time. Her extensive connections within the New York literary and art worlds would prove to be a great boon to the organization, especially as SNCC planned *Now*, the first of two traveling photography exhibits. But these contacts also proved to be a source of contention when Martinez, emerging as the arbiter of SNCC's image in New York City, became vulnerable to accusations of favoring one photographer over another or of being unfair in her complaints about the photography department's "lack of service."[143] The image-text combination of the Simon and Schuster publication *The Movement* shares similarities with *Something of Our Own*. However, the book, like *Now*, explicitly reached out to non-southern audiences, translating the movement for them rather than inviting them in. And as a formal publication, beholden both to questions of aesthetics and copyright in a way that filmstrips were not, *The Movement* cemented the professional/amateur divide.

As the organization as a whole struggled to identify and chart a new direction, SNCC and its photo unit wrestled with the questions, what are SNCC stories, and who is authorized to tell them? In this moment, there were fewer mass protests to be documented, and though violence still pervaded the lives of impoverished African Americans especially, such violence proved more difficult to record. Indeed, national audiences began to grow weary of such images. SNCC photographers in turn explored increasingly the expressive and affective possibilities of photography, engaging both the high art world and the vernacular quotidian. In many ways, between 1964 and 1965 SNCC found itself imprisoned in its own luminous glare, and the camera for many in the organization offered a means of escape and redefinition.

SNCC and the Aesthetics of Black Power, 1966–1967

Through mid-1966, SNCC continued to seek a political platform that addressed the black zeitgeist, the needs and moods of African Americans caught between the passage of the Voting Rights Act and the catharsis of Watts, Newark, and the urban uprisings of more than one hundred inner

cities by 1968.[144] SNCC found its ideological, if not programmatic, direction with the emergence and embrace of black power. At its most fundamental level, black power made space for the expression of black anger rather than the performance of conciliation. It sought black control over de facto segregated institutions, "something of our own," rather than integration. And it acknowledged black humanity through a celebration of black culture. "Black power" gave name and loose structure to an emergent consciousness among African Americans. For black SNCC staff members, lost in the fog of their own prior successes, black power was like a compass that both helped them to pinpoint their current location and to chart a future direction.[145]

Since the Waveland retreat, members had struggled with a deepening sense of political frustration over how best to aid marginalized black communities access political power. A fair amount of this frustration focused on the question of black leadership and white staffers within SNCC and a belief held by more and more members that SNCC could not advocate local community control if it did not model that control itself. Conversations came and went, tensions rose and fell, but conflict became unavoidable when the members of the Atlanta Project insisted that SNCC must "emphasize racial identity" if it wanted to remain relevant to black communities. Growing out of their efforts to organize Atlanta's urban black communities, the Atlanta Project maintained "that the form of white participation, as practiced in the past, [was] now over," and SNCC needed to function as an all-black institution.[146] Though many in the organization recognized the necessity of new policies that built upon, practiced, and fostered a new racial consciousness, many were put off by the Atlanta Project's disruptive and disrespectful approach. For their part, the Executive Committee largely tabled the issue of the continued efficacy of an interracial movement in favor of clarifying direction and strengthening declining programs.

These concerns began to collide in early May 1966 at the Kingston Springs retreat, near Nashville, during which staffers critically interrogated the goals and beliefs that had guided them previously. They began to put forward a revised set of policies that would embrace a new mode of organizing black folks. As longtime SNCC activist Ivanhoe Donaldson averred, "Nationalism helps organize in the black community."[147] SNCC members agreed to chart a direction that was decidedly more militant, that moved away from an interracial and toward a black-oriented structure, and that would cultivate Third World alliances. Most significantly, SNCC members voted out longtime chairman John Lewis and replaced him with the younger and more strident Stokely Carmichael in a highly contentious elec-

tion. Lewis, Julian Bond, and others would resign from the organization soon after. Carmichael had garnered success in organizing the Lowndes County Freedom Organization—the original Black Panther Party—an all-black movement for meaningful participation in the Democratic Party that advocated armed self-defense if necessary.[148] His election as chair signaled a decisive shift in SNCC away from the interracial model of nonviolent participation embodied by Lewis, an original Freedom Rider, to an embrace of black power in all its emerging manifestations—political, cultural, and economic.

A month later, Carmichael would truly come into view as black power spokesman and "architect." During the Meredith March against Fear, initiated by James Meredith to demonstrate to other African Americans that they could exercise political rights without fear, Carmichael and others were arrested for attempting to set up tents in violation of a dubious police order. That night, June 16, 1966, released from jail, Carmichael told a crowd of about six hundred people gathered in Greenwood, Mississippi, "This is the 27th time I've been arrested. I ain't going to jail no more . . . What we gonna start saying now is black power!"[149] Carmichael engaged the audience in a call-and-response of the catchphrase "black power" until it escalated into a collective chant. SNCC had used the slogan before, a shortened version of "black power for black people" that SNCC organizer Willie Ricks and others had found successful in meetings, organizing conversations, and local speeches, primarily in Alabama. But here, within the context of the march, with both Martin Luther King and Floyd McKissick of CORE present, "black power" captured national media attention and black imagination. The event brought a new influx of activists to SNCC, mostly northern African Americans, many of whom had never participated in SNCC's early efforts nor held much respect for the organization's nonviolent origins. In the charged atmosphere of both Greenwood and the growing urban unrest throughout the United States, "black power" became both a rallying cry and a declaration of war.

Carmichael's cry of "black power" also served to give shape to the unfocused political sentiments swirling in and around SNCC in this period of unique transition for both the organization and its modes of representation. The brutal confrontation at the Edmund Pettus Bridge in Alabama, known as Bloody Sunday, marked the end of the visual age of marches and demonstrations and served notice that the unself-conscious acts of Bull Connor and George Wallace were coming to a close. Images of angry African Americans at the center of urban riots replaced images of angry whites harass-

ing nonviolent protesters on the front pages of newspapers and on nightly television news reports. With the change of lead visuals came a change of national sentiment. And with the pronouncement of black power, general sympathy gave way to a barrage of baffled questions belying white fear. Is SNCC still nonviolent? Is SNCC antiwhite? In their demand for answers, the mainstream media identified and turned to charismatic leadership. For the first time, SNCC obliged, and Carmichael often found himself the sole subject of articles and interviews, representing the organization as both its increasingly militant voice and its handsome young black face.[150]

Field worker Fay Bellamy, for one, lamented that SNCC seemed too preoccupied with "the press," and that rather than focusing attention on the work of the movement, Chairman Carmichael was spending his time and energy doing interviews. Moreover, in these interviews, Carmichael was placed on the defensive, "explaining" SNCC's programs and move toward black power, "Even though we know in advance that everything Stokely or anyone else from this organization says will be completely turned around."[151] Articles like "The New Snick," "New Racism," and "Two Veteran Rights Leaders Ousted by SNCC" accentuated schisms in the leadership and a new extremism that would only lead to "isolation" and "defeat."[152] In response, SNCC's New York office produced "What's Happening in SNCC?" in order to address the many misconceptions circulating about the organization.[153] As a result of this back and forth, Bellamy feared that SNCC was enabling the *New York Times* and *Meet the Press* to define the organization as violent and militant. "It makes one wonder if we are addicted to the press. That maybe it's a habit we can't kick." Bellamy linked Carmichael's emergence as spokesman and face of SNCC to a move away from the consensus model of democracy that marked SNCC's early years. That is, no longer was SNCC empowering people to speak for themselves, but instead beginning to function as representative, standing in for those who must be represented. A "liaison" delegated by the mainstream media detracted from SNCC's careful organizing work and indeed signaled the organization's fixation on ideology to the detriment of programming. Moreover, Carmichael's sharp and captivating words, filtered through the dominant press, could be and often were misinterpreted by the very constituents SNCC hoped to reach. For example, Bellamy recounts an incident when a cadre of armed black men showed up at Atlanta headquarters, emboldened by Carmichael's passionate language, amplified through the mainstream press. Looking to "enlist," the men were disappointed when staff turned them away.[154] If SNCC wanted to be representative then it needed to take its job more seriously. "It is my hope that

we will refrain from letting the press or anyone else bind us into thinking or feeling what they want us to," Bellamy concluded. "I would argue for a little more talking to black people and less talking to the press. We know how to manipulate. Let us begin to do just that, but in the black communities, not to the white press who will distort everything we say."[155]

The photographs SNCC produced and the forms of their dissemination keenly and delicately navigate the tension between the temptation and necessity of representing the organization to the media and representing black people to themselves. Even as SNCC leaders returned to the spotlight, SNCC Photo under Julius Lester's direction continued its move away from producing images for "the white press" and turned its attention to black audiences as both subjects and spectators. SNCC Photo (mostly) resisted the temptation to visually lionize and iconize SNCC leadership in a way similar to the imagery that would become the hallmark of the Black Panther Party, discussed in the next chapter. Indeed, the photographs visualize SNCC's ongoing commitment to black empowerment, as opposed to the specific program of black power. SNCC Photo created calendars, engagement books, and postcards destined for the walls of African American homes, as well as a photographic-autobiography of Fannie Lou Hamer, as a means of extending cultural and visual recognition to marginalized black communities, now that political recognition had been (theoretically) achieved.

SNCC Photo might be understood as the cultural wing of SNCC's developing black power program. But we must simultaneously consider SNCC Photo as a reflection of Julius Lester's own deeply conflicted stance on black power. Lester, a southerner and graduate of Fisk University, had worked for SNCC before, first performing as a folk singer in benefits in New York City between 1961 and 1963, as part of his work at the Highlander Freedom School under musical director Guy Carawan. He then worked as a volunteer in the Mississippi Summer Project in 1964. In all his endeavors, Lester constantly searched for ways of making a meaningful and unique impact on the movement. In his estimation, "Anybody can demonstrate, anybody can go to jail."[156] He returned to the South in 1965 to pursue a project "to search out indigenous musicians and organize festivals in connection with SNCC in local communities" with funding from the Newport Folk Foundation, of which he was a board member.[157] It was while working with SNCC photographer Bob Fletcher, a classmate from Fisk whom Lester had hired onto the project, that Lester first took up the camera. Reticent at first—"there were · enough photographers in the world, and what could I add?"—he realized that he and Fletcher approached their subjects very differently. "Well, what

I discovered was that Bob did not see a thing that I saw." After going back to New York, Lester returned to the South in February and March 1966 not as a folk singer but as a photographer. For two months he, along with Worth Long, a SNCC member who was a central player in Lewis's unseating, followed David Garr, a key photographer of the folk singing scene, learning the camera and developing himself as "a human eye." When Lester rejoined SNCC in June following Carmichael's declaration of black power, it was as a photographer. He assumed the role of director of SNCC Photo working out of the Atlanta headquarters.

As he combed through and reorganized the SNCC Photo files, contributed his own photographs, and found new uses for all images, Lester simultaneously committed his ideas about black power to paper. In strident articles such as "The Angry Children of Malcolm X" (1966) and the highly circulated tract, *Look Out Whitey! Black Power's Gon' Get Your Mama!* (1968), Lester decried the early idealism of SNCC and welcomed what he saw as an inevitable race war. "Now it is over. The days of singing freedom songs and the days of combating bullets and billy clubs with Love," he wrote. "Trash has to be thrown out. Garbage dumped and everything unfit, burned."[158] Yet the photographs he made in this period, or the photographs he selected for inclusion in SNCC publications, reflect little of the acerbic animus of his published texts. Absent also are photographs of SNCC leadership, of Carmichael or H. Rap Brown. Lester chose instead to capture the proud faces of rural black southerners, examples of folk ingenuity, and the wide open spaces of southern fields. While his writing may have been influenced by the later work of Frantz Fanon, Lester identifies the FSA work of Walker Evans as a key inspiration for his photography. He embraced photography as a means "to document the lives of the people for whom the civil rights movement had been for [*sic*]."[159] Significantly, it is his photographic work that in later years Lester has chosen to emphasize for its subjective and affective visual embrace of blackness, over the vitriolic antiwhite rhetoric that gained him notoriety during the late 1960s and for which he would express deep regret as early as 1976. SNCC Photo then should also be understood as Lester's attempt to navigate his own "reservations about Black Power and black consciousness," which in his estimation had set "SNCC . . . in a mass of confusion." Photography offered Lester, by 1966 the only one left willing to work in SNCC's Atlanta darkroom, the opportunity to "participate in the most important summer of black America's political history . . . watching with . . . dispassion so that I could see that which the more passionate might not see."[160]

When Julius Lester took over SNCC Photo in early summer 1966, his first task was to reorganize the unit, a task he accomplished through publishing manifestoes, clarifying job descriptions, and laying out future plans. He felt that SNCC Photo no longer needed to supply images for the mainstream press releases or provide documentation of movement demonstrations. Rather, photography must serve new purposes and audiences. As Lester wrote in the January 1967 SNCC *Photo News*, "We in SNCC say they [black Americans] should be allowed the opportunity to know their own images. . . . We are going to look at ourselves with our own eyes and define ourselves (if we must) after we've taken a good long look and found out that we're a beautiful people."[161]

Under Lester's direction, SNCC Photo engaged in visual dialogues with black people, locally, nationally, and internationally. SNCC Photo turned away from reportage and toward the articulation of a black aesthetic, creating images of black people for themselves. He deemphasized the work of supplying photographs to the mainstream press and instead sought to cultivate relationships with African news outlets in particular. Though reticent to impose a definition of a black identity on a people still discovering themselves, Lester believed that such self-reflection and self-consideration were integral to SNCC's work. As he would later aver, "power is not only political, power is also self-confidence. And so you can't have self-confidence if the images you see reflect somebody else's world . . . how somebody else looks. How can you have confidence in yourself?"[162]

This attention manifested in a number of sources. Lester began to develop black history postcards, children's books (some to be used as preschool teaching tools), a photography exhibit entitled *US* that opened at Harlem's Countee Cullen Library, and most interestingly, engagement and wall calendars (figure 2.9). According to Lester, "Black power to us is exemplified by these calendars."[163] The purpose of the calendars in particular was fourfold. First, they identified and attempted to address a black desire for art and imagery for decoration. Lester recalled that "You could go into people's houses on plantations and . . . their walls would be covered, you know, with calendars. And it could be from four years ago, and it was clear to me that they wanted something to look at." Lester then combed through the SNCC files and collected photographs for five thousand calendars, some of which were sold and many that were given away for free to impoverished African Americans in both the North and South, primarily throughout Mississippi.[164]

Second, like the use of black images in preschool teaching tools, the

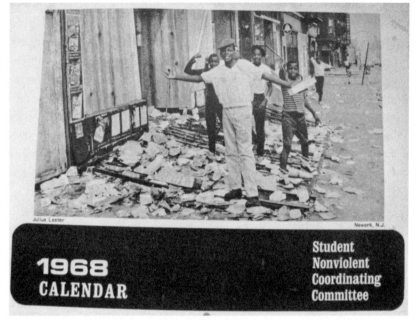

Julius Lester

Newark, N.J.

1968 CALENDAR

Student Nonviolent Coordinating Committee

Figure 2.9. Cover of SNCC 1968 wall calendar. Photograph by Julius Lester. (Collection of Julius Lester)

calendars and engagement books offered African Americans an opportunity to "see themselves" not as objects of derision or of pity, but as subjects worthy of portraiture and reflection. Again, Lester remembered, "When I went on a plantation and stuff, you know, they'd never had their picture taken, because . . . you didn't have Instamatics then . . . you didn't have Polaroids. . . . And so when I would ask to take their picture, some of the old people, especially, would just draw themselves up with such dignity. And it was a big event that they were important enough that somebody wanted to take their picture. . . . We want you to see what you look like."[165] Significantly, the calendars included images from Varela's *Something of Our Own*, of Fannie Lou Hamer's husband, Pap Hamer, as well as Lester's portraits (figure 2.10). Indeed, images of SNCC leadership are almost entirely absent from the calendars. Lester remembers a trip to Cuba, where for three weeks he worked as Carmichael's administrative assistant. In his autobiography, Lester recalls tensions with Carmichael, who Lester described as a "revolutionary celebrity," who "fed on attention . . . and . . . seemed to think that I'd brought my cameras to Cuba to photograph his every step."[166] Yet for Lester, there was so much more to see and to photograph, especially

SEPTEMBER 1968

Sunday	1963—Addie Mae Collins, 14; Denise McNair, 11; Carol Robertson, 14; and Cynthia Wesley, 15, murdered in bombing of church in Birmingham, Ala.	**15**	Sunday
Monday		**16**	Monday
Tuesday		**17**	Tuesday
Wednesday	1909—Kwame Nkrumah born.	**18**	Wednesday
Thursday		**19**	Thursday
Friday		**20**	Friday
Saturday		**21**	Saturday

1968—Observance of the 349th Year of Black Resistance to Oppression—SNCC

Figure 2.10. Sample page of SNCC 1968 engagement calendar.
Photograph by Julius Lester. (Collection of Julius Lester)

the faces of everyday people, rather than the overly photographed face of Stokely Carmichael. Rather than foregrounding photographs of famous figures, by drawing on SNCC's own photo files, the calendar made local people the subjects.

Third, the calendars situated African Americans within time and space. The engagement calendars included important events in black history that both celebrated African American achievements such as the date of the first Pan-African Congress (February 19, 1919) and the opening of the African Free School in New York City (November 1, 1787); and also commemorated loss, including the anniversary of the Sixteenth Street Baptist Church bombing (September 15, 1963); and the date of each of the recent urban uprisings (Omaha, Nebraska, April 2, 1967; Cincinnati, Ohio, June 17, 1967; Brooklyn, New York, August 2, 1967). They also noted significant upcoming events, reminding their users the date of the Mississippi primary, for example. Further, Lester included images from his travels throughout the United States and Vietnam (figure 2.11). He photographed SNCC delegations, the aftermath of urban rebellions and the people and landscapes of these various locales. Such images visualized the nationalizing of the movement and the international connections that SNCC aggressively pursued in this period. Through portraiture especially, Lester connected the faces and

Figure 2.11. Sample page of SNCC 1968 wall calendar. Photograph by Julius Lester. (Collection of Julius Lester)

struggles of the black belt to Newark and to the decolonizing Third World. And through the format of the calendar, Lester literally summons "nation time," a sense that African Americans are no longer outside of history but at its center, and that the fullest expression of resistance has arrived.[167] "In our very souls we resisted," reads the back of the calendar, "biding our time, waiting for the day when we could strike the final blow for our liberty."[168] Black people (and their allies) though separated by geography, are here articulated as a people through the utopian simultaneity invoked by the calendar.[169]

Finally, the calendars served as fund-raisers, billed as "Freedom Gifts," alongside posters, postcards made from photographs by Lester, Fletcher and Clark, poetry books, children's books, and albums. Aside from the calendars and postcards, Lester also produced a booklet on the 1966 Atlanta rebellion and another on the Lowndes County Freedom Organization, both designed for publicity and propagandizing. And he made images of SNCC leadership, including Carmichael, also for promotional purposes. Clearly,

photography continued to play a central role in SNCC's publicity and pro-paganda as well as fund-raising efforts. But these were not Lester's primary interests or goals. Rather, he most wanted to visualize to African American audiences, especially of the rural South, a narrative of themselves as strong black people in a world of their own making.

Conclusion

SNCC's increasing employment of and evolving relationship to photography during the eight-year tenure of the organization reveals an ever-changing "grammar of interaction" between movement and medium. This bond proved at different times ideal, unwieldy, aporetic, yet always irresistible. It first attests to the necessity of photography as a tool of documentation for social movements in a televisual age of increasing media scrutiny. For SNCC in its early years, between 1960 and 1964, documentary photography proved a powerful tool in the organization's efforts to control its own image and to advance its projects. SNCC utilized photography as a public opportunity to challenge black disfranchisement and the fear of integration imbued by centuries of white domination. These early photographs literally envision "the beloved community," "the band of brothers and sisters within a circle of trust" that up until 1964 served as SNCC's model for organizing, pro-testing, living, and working together. Photographs gave a face to the young vanguard organization. And more than that, the photographs gave form to the multiracial, integrated, and just society SNCC participants were risking their lives to create. In this sense, then, SNCC photographs served as both performances of liberatory possibility and as documents of democracy in action. The images functioned as both idealized vision of the redeemed and healing community SNCC participants were working to actualize and evidence of the kinship the organization had already achieved. In this mo-ment, camera, photographer, and movement worked to produce affective and effective documents for social change.

Not simply an indexical tool, photography of course is also an aesthetic instrument. And as SNCC expanded from 1964 to 1966, so too did its em-ployment of the camera, utilized increasingly as an apparatus of personal exploration and individual expression. Danny Lyon's desire to be free of the obligations of political representation, and later Julius Lester's retreat into the solitude of the darkroom, both expose the tension between photog-raphy's capacity for political mobilization and an emphasis on the photog-rapher as artist and auteur. They intimate the challenges of being a "move-

ment photographer," of producing images that are at once formally and politically compelling, that convey a personal vision while communicating the needs of the movement. What emerged in the wake of Lyon's departure was an increasing strain between "photographer" and "activist." Even as SNCC Photo grew, the revolving door of photographic workers that passed through the unit suggests that few could fulfill the demands of that hyphenated role of photographer-activist. This tension within the photo unit over the place of photography and role of photographers in the movement illuminates the factional divisions within SNCC in the years after the success of Freedom Summer. As we will see with the Black Panther Party, the example of SNCC Photo was not reproduced, and photographers increasingly operated outside of the movement. While there were still photographers within the movement, there were no longer movement photographers.

Yet such an expansion of the roles of and spaces for photographers suggest what we might call the "heteroscopic" nature of photography in SNCC. By heteroscopic, I refer to the range of visions and diversity of photographic expressions of a movement that from the outside appeared uniform and unified.[170] It allows us to consider photography within SNCC not as a homogeneous expression within the organization, though that may have been its intention. Rather, photography communicated the inherent diversity and internal differentiations that were prevalent and unavoidable, destabilizing and enriching to the organization. SNCC's early engagement with and mobilization of photography constituted a conversation between the movement and a larger white audience, a vehicle offering a view from the frontlines. In the period between late 1964 and early 1966, the photographic archive reveals SNCC's struggle with the multitude of voices and visions attempting to tell a range of SNCC stories to a host of different interlocutors. The period from 1966 through 1968 is marked by photographs that attempt a conversation between black folks about the multiplicity of black identities in the context of an emergent black power movement that more often than not sought to flatten out and idealize "blackness." Photography offers a way of not only understanding how SNCC intervened in dominant media structures but also how it elaborated its self-making and expressed its own internal differentiation. These still photographs hand down to us what corporate-controlled television cannot: visions of utopia as seen from the frontlines.

Attacked First by Sight

In early May 1967, Huey P. Newton, cofounder and minister of defense of the six-month-old Black Panther Party (BPP), assembled with Bobby Seale, the party's cofounder and chairman; Eldridge Cleaver, the recently named minister of information; Kathleen Cleaver, former SNCC member and now BPP communications secretary; and a photographer named Brent Jones. The group met in the San Francisco apartment of Eldridge Cleaver's white attorney, Beverly Axelrod.[1] The primary purpose for this gathering was to make a photograph of Newton that could then be transformed into a poster to raise funds for and awareness about the nascent BPP. The party had already begun to garner recognition from African Americans in the San Francisco Bay Area through its structured patrols of black ghetto communities and observations of police activities. These organized young black men and women carrying guns, cameras, and law books were gaining a regional reputation as defenders of black communities. Only a few days before the meeting at Axelrod's home, the Panthers achieved national attention when on May 2, 1967, a cadre of twenty-four men and six women brought the organization's Ten Point Platform to Sacramento, California's capital. The action at the Capitol contesting the Mulford Act—which was designed to outlaw the display of loaded weapons and deliberately aimed to weaken the Panthers' community patrols—drew local and national press coverage. By way of photographs and film footage, the dominant media confronted national audiences with images of armed black men striding confidently past an aghast Governor Ronald Reagan and into the halls of the Capitol building. As their reputation grew, Eldridge Cleaver urged the Panthers to begin fashioning and projecting an image entirely of their own making.

Cleaver came to the party in February 1967 with his own spotlight. Released from prison in December 1966 after serving nine years of a one-to-fourteen-year sentence for rape, Cleaver's writings from his time in Soledad Prison were published in the New Left publication *Ramparts*. Later published in 1968 as *Soul on Ice*, the essays would stir the literary world. With the national media turning their attention to the Black Panthers in Oak-

land, author and journalist Cleaver felt it necessary to orchestrate a publicity photograph of Newton. Keenly aware of the power of image and the power of personality, Cleaver posed Newton in an elaborate wicker chair on top of a zebra rug in Axelrod's living room. Newton wore the Panther uniform of black beret (modeled after those worn by French Nazi resisters Newton and Seale had once seen in a movie), black leather jacket, crisp powder-blue shirt, and pressed black slacks. Cleaver gathered a number of African objects to serve as props. He stood a rifle in Newton's right hand and placed one of Axelrod's African spears in his left. He leaned two of Axelrod's African shields against the walls, one on either side of Newton. Bobby Seale later wrote of the significance of the spear and shields, "Huey would say many times that long, long time ago, there was a man who invented a spear, and he frightened a whole lot of people. But, Huey said, the people invented a shield against the spear. . . . So this is what Huey P. Newton symbolized with the Black Panther Party—he represented a shield for black people against all the imperialism, the decadence, the aggression, and the racism in this country."[2] Jones took several shots of a still and stern Newton, his face partially obscured in shadow (figure 3.1).

Through the visual dramaturgy of what has become the most iconic of the photographs taken that day, Newton seemed to capture and clarify many of the ambiguities and competing strains of "black power" that had emerged around the discourse. The African artifacts symbolized cultural nationalism, a philosophy defined by a glorified African past and the unifying force of a monolithic black culture. The rifle and the shells collected at Newton's feet signified revolutionary nationalism, an ideology culled from the influential writings of Frantz Fanon, an identity that emerges from armed active struggle against a group's oppressor. Newton himself, minister of defense of the self-proclaimed vanguard organization of the black movement in the United States, personified black nationalism, a conviction that only black people can best lead black communities. The photograph also revealed more than the authors perhaps intended. A sort of black capitalism, a breed of black power vociferously eschewed by the Panthers, can be inferred from the polished attire and expensive settings. To purchase such furnishings suggests financial means beyond those of the average inner-city dweller and an Afrocentric "taste" that can be commodified and consumed.

Like the shields surrounding him, Newton marked a necessary invention of "the people," the physical manifestation of their anger and frustration into a structured and creative force mobilized to counter the oppression of the state. This photograph came to exemplify black American revolu-

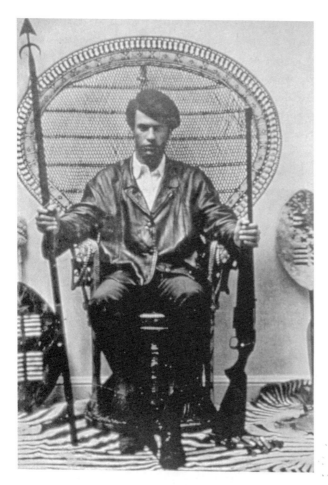

Figure 3.1. Huey Newton, Black Panthers' minister of defense, seated in a wicker chair, San Francisco, 1967. Photograph by Eldridge Cleaver. (*The Black Panther/* It's About Time)

tion and to embody the black American revolutionary. Transformed into a poster, it emerged as wildly popular with rank and file Panther membership, as well as radicals of other groups. Simultaneously, the image proved alluring to the dominant media. This photograph is perhaps the most well-known and most reproduced image of Huey Newton and, by extension, of the Black Panther Party to date.

The production and dissemination of this image raises a number of important questions and illuminates several contradictions about the BPP and the various ways in which it chose to represent itself and be represented by those around it. First, by focusing the camera on Huey Newton alone, Cleaver and those who circulated the poster placed an emphasis on the leadership of the party rather than the rank and file membership (still very few by this time) or the communities the Panthers served. This focus

would later prove crucial in the years 1968 to 1970 when the party's work centered on freeing Newton from jail and the real threat of his going to the gas chamber for the murder of white Oakland police officer John Frey in October 1967. Newton, with spear, rifle, and uniform, projects and defines a militarized, hypermasculine leadership seemingly willing to give up his life for the revolution and for the people he served. Yet here the leader is seated, enthroned like a monarch, with his back to an undecorated wall. Rather than appearing in active defense of the people, Newton looks as though he is waiting for the people to come to him. Moreover, with his face partially shrouded in shadow, he figures not as open and approachable but as mysterious and inaccessible. The credence surrendered to leadership in this photograph reveals a tension between the power of the vanguard, chosen to both serve and lead the people, and the power of the people themselves.

In many ways, the poster, as part of a concerted effort to raise awareness and support for the "Free Huey" campaign, did bring the people to Huey, or as close to his words and image as they could come to the imprisoned leader. The party's membership grew from a couple hundred to thousands during the period of Newton's incarceration, due in large part to the tireless organizing efforts of the party for Huey's release. Officially, the BPP viewed cultural forms and the media as little more than tools to be harnessed if the Panthers, as individuals and as an organization, were to survive. When Kathleen Cleaver began working with the party officially in November 1967, she found herself thrust into the maelstrom created by Newton's incarceration. From her experience working with SNCC, Cleaver "created the position of Communications Secretary based on what I had seen Julian Bond do. . . . I sent out press releases, I got photographers and journalists to publish stories about us . . . I designed posters."[3] The photographs and posters, though popular and significant in mobilizing interest in the BPP, were understood in strictly quotidian terms—generating awareness and fund-raising—as opposed to the higher purpose of revolution and liberation.

The image projected around the country and around the world was one Newton himself did not like. According to Kathleen Cleaver, Newton often complained that the photograph misrepresented both the party and himself.[4] Others, like Stew Albert, a white radical and early friend of both Eldridge Cleaver and the party, felt similarly ambivalent about the image. Albert recalls, "Cleaver showed up at my pad and wanted to put a large personality poster of Huey seated in a wicker chair . . . up on my wall. Because Eldridge was so happy with his new friends, I agreed." Albert's alac-

rity, however, quickly changed to diffidence: "But when he gave me a bunch of posters for my 'associates,' I felt unspoken reservations about their corniness. Besides, personality posters were relatively new. Even our new San Francisco rock stars hadn't as yet made use of them. They seemed narcissistic and quasi-cultic, not really ideal food for egalitarian revolutionaries."[5] Despite Newton's protests, Cleaver, along with countless others who possessed and displayed the poster, remained enthusiastic about it. According to Albert, "the Newton trial made the spear poster chic."[6]

The "spear poster" demonstrates the power of the image to supersede even a leader's wishes. It further elucidates the struggle between Newton and Cleaver over the meaning and direction of the Black Panther Party, a struggle that would result in a break by 1971. Additionally, if we consider how "chic" the poster would become with Newton's incarceration, we can begin to understand the struggle that took place on the broader terrain of visual representation. The poster functions as a snapshot of a clash between the images that various constituencies wanted to see or hoped to project.

These various constituencies—Newton, Cleaver, branches around the country, rank and file membership, the media, the state, everyday people who supported or opposed the Panthers or wrestled with something in between—each infused the image of Newton with their own meanings, political or otherwise. This is evidenced by the appearance of the photograph in many forms and locations. The poster could be found in the front windows of Panther offices from Oakland to Harlem to Algiers. The party's newspaper, *The Black Panther Community News Service*, reproduced the photograph a number of times on the cover and within the publication. Protesters attached the poster to sticks and raised it above their heads at "Free Huey" demonstrations. College students of all races and ethnicities hung it on their dorm room walls. The image traveled internationally as well: the Organization of Solidarity of the Peoples of Africa, Asia, and Latin America (OSPAAAL), for example, known for a pioneering revolutionary aesthetic, incorporated the poster into posters and postcards of their own (figures 3.2–3).[7] Likewise, the dominant media replicated the image. The *New York Times* in particular would reproduce the photograph at least twice, in 1967 and 1968, accompanying articles that simultaneously made light of the Panthers' absurd theatricality while playing up their violent threat.[8] *Esquire*, the men's magazine at the forefront of the self-reflexive New Journalism trend, dissected the image in a wry "guide" to understanding the Panthers.[9] Bay Area–based freelance photographer Ted Streshinsky, partially restaged the image not long after the Panthers' eruption onto the national stage: in Stre-

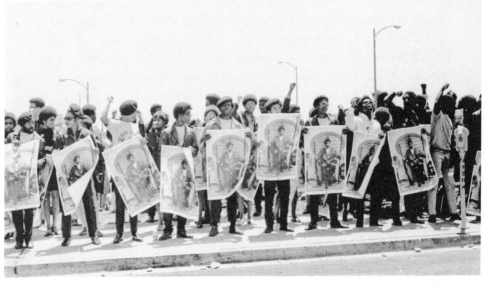

Figure 3.2. "Free Huey" rally, Alameda County (Calif.) Courthouse, September 1968. Photograph by Stephen Shames. (Polaris)

shinsky's image, Newton sits beatifically, cigarette in hand, with the poster affixed to the wall behind him. Dressed in the same clothes, it's not clear which is the image and which its referent (figure 3.4). And the FBI remarked upon the photograph in reports on the Panthers.[10] Many observers and participants viewed the Panthers' style, rhetoric, and image circulated through photography as the outward manifestation and best representation of the party's political platform.

Perhaps one of the most striking and most compelling contexts in which the image signified is its reproduction in a 1968 photograph taken of the poster in the window of the Oakland BPP office (figure 3.5).[11] Made by Stephen Shames, a young white man from Berkeley, California, and a close ally of the Panthers, the photograph shows the poster of Newton in the cracked window of BPP headquarters, shot full of bullet holes by two drunken Oakland police not long after Newton's conviction on charges of voluntary manslaughter in September 1968. Behind the fractured but not quite broken glass, the minister of defense sits full frame in the wicker chair. As the front page of the February 21, 1970, special issue of the *Black Panther* on "Evidence and Intimidation of Fascist Crimes by U.S.A." attests, the tattered poster represents, and literally covers, an extensive written and visual list of murdered and incarcerated Panthers, as well as attacked

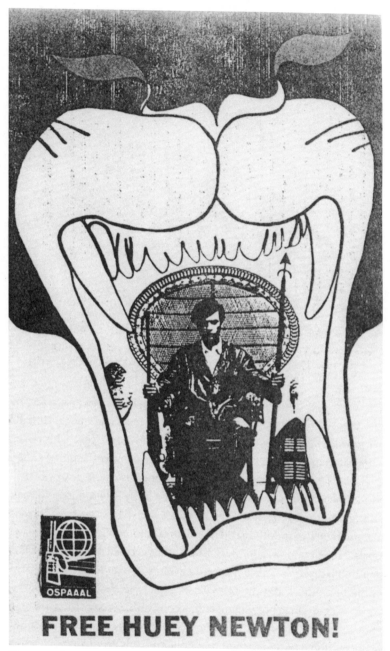

Figure 3.3. "Free Huey Newton" postcard, c. 1968, by Alfrédo Rostgaard and OSPAAAL. (Wisconsin Historical Society, image ID 73879)

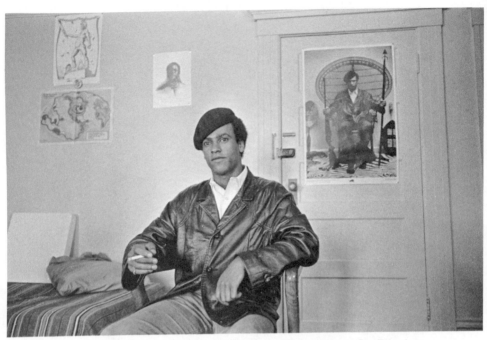

Figure 3.4. Huey Newton at Black Panther Party headquarters in San Francisco, California, July 1967. Photograph by Ted Streshinsky. (© Ted Streshinsky/Corbis)

and destroyed BPP offices (figure 3.6). The cover is particularly arresting when juxtaposed to the prior week's front page: the same image, tinted a Panther powder blue, without text, and completely unscathed. This cover, which appeared on Newton's birthday, reminds readers of the incarcerated leader. The second cover, toned an alarming orange, is an image of violence perpetrated first against an individual: by 1970 both Newton and Cleaver were facing trial for police shootouts in which each had sustained gunshot wounds, and only two months earlier, leaders of Illinois chapters in Chicago and Peoria, Fred Hampton and Mark Clark, were gunned down by police as they slept in Hampton's Chicago apartment. It is also an image of violence against the BPP offices and the party itself. Finally, as the full cover of the newspaper, it is an image of violence that confronts readers with life-size bullet holes, impressing upon them their own proximity and vulnerability to state aggression. Despite the FBI and police assault on the BPP, Newton and the party he led remained stoic and resolute. The reproduction of this photograph of a photograph reveals that the Panthers understood that their ideas, their image, as well as their physical persons were under attack (figure 3.7). As such, they staged their opposition not only through rhetoric,

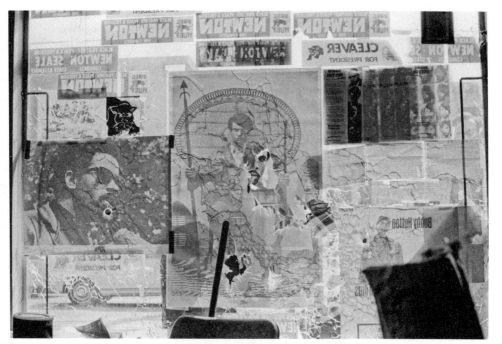

Figure 3.5. Black Panthers' Oakland office window shot full of bullet holes, September 1968. Photograph by Stephen Shames. (Polaris)

through their programming, and through public actions, but through spectacle as well. The realm of the visual, of image, of performance, of culture here emerges as a significant battleground in the field of politics.

The BPP often categorically dismissed "culture," as practiced by cultural nationalist groups like Maulana Ron Karenga's United Slaves (US) organization, as frivolous and insignificant; the return to an imagined African past through clothing, naming, and the affirmation of patriarchal family structures was a mere diversion from the task of bringing about a transformed future. Yet "culture," the rhythms and rituals of identity created by shared experiences of ghetto marginalization, as well as the often countercultural and necessarily dissident forms produced to elaborate that identity, were key to mounting and sustaining revolution. Newton, Seale, and the BPP at large drew on the notion of revolutionary culture expounded by Frantz Fanon—"we must discuss . . . we must invent and make new discoveries"— a culture that emerges out of struggle and is constantly changing in order to adapt to the needs of a people in the midst of radical transformation.[12] Culture, then, is a necessary component of the process of decolonization, one that aids in a community's remaking and revisioning of itself. Indeed,

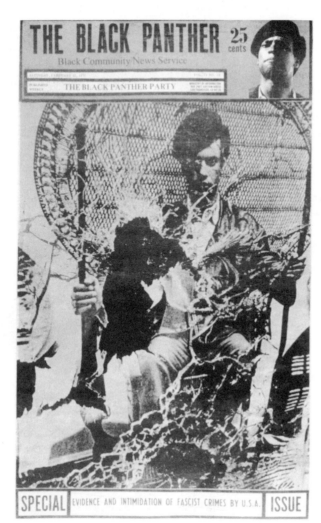

Figure 3.6. Cover, *Black Panther*, February 21, 1970. Photograph by Stephen Shames. (*Black Panther/* Polaris)

perhaps the Panthers' greatest and most lasting achievement lay in cultural transformation, most especially the ways in which African Americans viewed themselves and perceived their power and powerlessness vis-à-vis the state. Not only did the Panthers' community work spark the imagination and fear of all who chose to look and listen, but also the group's self-presentation and representation offered a charged model of political engagement.

This chapter traces the battle over the Black Panther Party's meaning, direction, and ultimately its legacy, as mapped through the Panthers' own use of visual images and the struggle over those images that took place be-

Figure 3.7. Sand bags fortify walls of Panther office (with Newton poster),
May 1970. Photograph by Stephen Shames. (Polaris)

tween the dominant culture, the state, the party, and "the people." As many
scholars and former Panthers have worked to reconstitute and indeed re-
deem the party's history and legacy through conferences, scholarly texts,
Web sites, and exhibits, photography as illustration has gained in impor-
tance.[13] Yet photography and the question of "image" more broadly as fun-
damental component of Panther organizational strategy have presented a
shifting, unsteady ground that many attempt to downplay or sidestep for
fear of replicating the original media framing (and frame up) of the BPP.[14]
Yet Panther visuality and photography as political practices not only have
much to tell us about the party itself but about the elaboration of blackness
in the global revolution of 1968. We can neither dismiss the Panthers' media
savvy and images of excess, nor can we exonerate the dominant media for
its very real collusion with the FBI to discredit and undo the BPP. There are
no "innocents" here. Rather, we must situate the Black Panther Party within
its media moment, one marked by the proliferation of media technologies
among both consolidating media conglomerates and decolonizing nations;
the rise of New Journalism and the radicalization of the underground press;

a moment in which the Society of the Spectacle meets the rising tide of the Third World.

"Dialectics of Seeing"

It is clear what is at stake for the field of Panther historiography around the question of visual culture: such attention paid to what lies on the surface can be dangerous. It can, and in the case of the "established press" during the Panthers' heyday, did lead to a misreading of the BPP's goals and reveal a willingness to see only what one wants or chooses to see. Tom Wolfe's 1970 *Radical Chic and Mau-Mauing the Flak Catchers*, for example, exposes the author's fascination with the cultural elite's fascination with afroed hair and svelte black bodies, with black leather jackets and street speak. Describing a fund-raiser in the Upper East Side penthouse of Leonard and Felicia Bernstein, Wolfe writes how one of the culturati admitted breathlessly, "I've never met a Panther—this is a first for me!" She is not the only Panther virgin in the room:

> She is not alone in her thrill as the Black Panthers come trucking on in, into Lenny's house, Robert Bay, Don Cox the Panthers' Field Mar-, shal from Oakland, Henry Miller the Harlem Panther defense captain, the Panther women—Christ, if the Panthers don't know how to get it all together, as they say, the tight pants, the tight turtlenecks, the leather coats, Cuban shades, Afros. But real Afros, not the ones that have been shaped and trimmed like a topiary hedge and sprayed until they have a sheen like acrylic wall-to-wall—but like funky, natural, scraggly . . . wild.[15]

Truly a sight to behold, the Panthers, Wolfe tells us emphatically, stand in stark contrast to black activists of the early 1960s: "*These are no civil-rights* Negroes *wearing gray suits three sizes too big—these are* real men! Shoot-outs, revolutions, pictures in *Life* magazine of policemen grabbing Black Panthers like they were Vietcong—somehow it all runs together in the head with the whole thing of how *beautiful* they are." Their beauty and virility cut through and penetrate the crowd, "*Sharp as a blade.*"[16]

Wolfe's lengthy descriptions of clothing and speech—the "status detail" typical of the New Journalism that Wolfe helped name—reveal both a spark of recognition and an ignorant dismissal of the party's community service work and broader political impact. For Wolfe, ventriloquizing the Radical Chic set, the Panthers and the political style they represent amount to noth-

ing more than their image: sexy, threatening, and purely superficial, a series of documentary photographs in *Life* meet fashion spreads in *Vogue*. Yet the Panthers signify as undeniably authentic—primitive, virile, their clothes and hair laying bare their hypermasculine essence—as if directly from the pages of *National Geographic*. Or for southerner Wolfe, steeped in one hundred years of black brute/rapist iconography, the Panthers as "sharp," "penetrating," and "too big," may leap from the pages of a Thomas Dixon novel. The allure of the Panther image derives in part from their physical distinction from earlier civil rights activists, who themselves played a role, seen as poor imitations of the white bourgeoisie whose society they so desperately wanted to enter. Primal and wild, potent and exotic, Wolfe tells us, the Panthers, the new "pet primitives," offer the cultural revitalization of high society (and the sexual rehabilitation of black men) rather than the revolutionary transformation of society at large (figure 3.8). The celebrities and society mavens are only, can only be, enticed and enchanted, beguiled and seduced by image, because, according to Wolfe, there is no substance to the party, or to their admirers for that matter.

Yet in his voyeuristic concern with Panther image, Wolfe hints that the Panthers constitute only one side of a mirror. On the other lies the gaze and reflection of the elite would-be radicals who rally to the Panthers' defense. Looking at the Panthers, confronting them in image and in flesh, forces the Bernsteins, the Lumets, the Stantons, and the like to begin to examine themselves, to consider their language, their dress, the color of their servants, even the food served at their parties. Indeed, both *Radical Chic* and the original *New York* magazine article focus primarily on the ways in which this group of white elites come into view through their encounters with radical politics. What Wolfe uncovers is that these uneasy if titillating encounters with Black Panther politics in particular begin to disrupt and undo the smooth fantasies whites have of themselves. "Who the hell was this Negro," Wolfe imagines Bernstein wondering in a dream at the essay's open, "rising up from the piano and informing the world what an ass Leonard Bernstein was making of himself? It didn't make sense, this superego Negro by the concert grand."[17] Not only are the Panthers on display in "the Bernsteins' Chinese yellow duplex, amid the sconces, silver bowls full of white and lavender anemones, and uniformed servants serving drinks and Roquefort cheese morsels rolled in crushed nuts." But also laid bare is elite whiteness and its dependence on the primal black subject as "status detail." Suddenly, through highly visual language, Wolfe indicates a changing mode of racial seeing in which fear and derision is now accompanied

Figure 3.8. Photograph that appeared on the cover of *New York* magazine, June 8, 1970. Photograph by Carl Fischer. (© Carl Fischer. All rights reserved.) For the full cover, see <http://nymag.com/news/features/46170/>.

by *open* fascination and attraction, the emergence of a dialectic in which a reified blackness no longer shores up a universal whiteness but asserts itself at the most inopportune moments.

With Wolfe observing the interaction of the two groups from a presumably "outside" vantage point, concerned with "the delicious status contradictions and incongruities that provide much of the electricity for the Radical Chic," he suggests what we might call a "dialectics of seeing" between the Panthers and their privileged and, in many cases, glamorous supporters. While *Radical Chic* belies its own status anxieties, it offers a useful framework for considering the active relationship between the Panthers and their various observers, a relationship that centers in the visual field and crystallizes around the Panthers specifically. Wolfe indicates an emergent mode of racial seeing in which fear and derision sit side by side with exposed fascination and attraction, a relationship that is as informed by historical encounters as by the prominence of mass media, that is, as much by fact as by image. Wolfe's indictment of the Bernsteins and their radical chic set is an acknowledgement of the power of the Panther image, a cry in a sense to these elites to stop looking.

I borrow the phrase "dialectics of seeing" from the title of Susan Buck-Morss's book on Walter Benjamin's "Arcades Project." By dialectics of seeing, Buck-Morss refers to Benjamin's philosophical approach to history and culture, "one that relies . . . on the interpretive power of images that make conceptual points concretely, with reference to the world outside the text."[18] Like Benjamin's concept of "dialectics at a standstill," the dialectics of seeing describes the process by which one can better understand history through its condensation and assemblage in the material, visual object. Here, I would like to expand the term's meaning to consider not just the engagement of a viewer with the visual object, specifically the photograph, but to the engagement of the viewer with another visual or viewing subject. Moreover, I want to consider a series of dialectical engagements that place the Panthers, as both subject and commodity, at the center of a constellation of visual conversations in the late 1960s and early 1970s with multiple constituencies. How do various actors make and create meaning about themselves and others through visual and visible referents?[19] How does this dialectic of seeing both depend upon and transcend the visible? What exactly is the relationship between the Black Panther image and the Black Panther Party?

The dialectics of seeing that coalesced around the Black Panther Party from its inception in October 1966 through the split of the Newton and

Cleaver factions in 1971 can best be viewed as a complex process of emergence and incorporation, a cycle of call and response in which visuality, and photography in particular, played a key role. The first arena examines what I call an emergent visibility, "a visible form of insurgency," in which the Panthers announced themselves and their rebellion in dominant and marginalized public spheres through a visible presence in the urban black communities they hoped to liberate and transform.[20] Through a coming to political, racial, and class consciousness, the Panthers produced "a source of emergent cultural practice." As Raymond Williams describes, in such an emergent culture, "new meanings and values, new practices, new relationships and kinds of relationships are continually being created."[21] From the founding of the organization in October 1966 through early 1969, "spectacular" activities like the Panther police patrols, the sortie into the Sacramento legislature, and the first few in a series of very public trials gained the Panthers increasing visibility and recognition within local, regional, national, and international communities. Their presence on the streets and in the papers (their own and mainstream publications), bearing arms and wearing self-styled uniforms, enticed and frightened viewers with new ways of conceiving black politics, black efficacy, and black subjectivity.

Emergent visibility encompasses the various theaters in which the BPP publicly performed their political agenda, the various sites where the party made itself visible in hopes of setting a revolutionary example for black people. It is significant that Panther leadership emphasized the necessity of remaining "above ground," that is choosing to wage ideological and material battle in plain view, rather than underground, and vehemently taking credit for their actions. In contrast to the earlier activists of the civil rights movement working in the hostile South, the Panthers did not make furtive walks down long roads under cover of night to mobilize constituents, nor did they hold clandestine meetings in the back of churches. Rather, the BPP committed itself to remaining within the purview of all of its observers. Wrote Newton, "The vanguard party is never underground in the beginning of its existence, because this would limit its effectiveness and educational processes. How can you teach people if the people do not know and respect you? The party must exist above ground as long as the dog power structure will allow."[22] Further, the Panthers did not demonstrate with song and prayer, appealing to moral character and a higher power. Even when BPP activism remained nonviolent, it hinted at and exploited the threat of violence to get its point across. The Panthers' primary activities considered in this section—police observation, public protest, and political disruption—

revealed a commitment to establish a visible presence in black communities, to produce new knowledge about the capacity of black people to control black communities, and to announce an alternative model of political action by putting those actions on ostentatious display.

The Panther presence in this period was both physical and virtual. That is, the Panthers' emergent visibility was broadcast as much through photographic images as it was practiced in the flesh, if not more so. Photographs made and/or utilized by the BPP, including Newton in the wicker chair, Newton and Seale standing armed guard in front of party offices, and Kathleen Cleaver standing armed guard in the doorway of her home, announced and circulated new meanings, values, practices, and relationships to the state. And with photography present from nearly the organization's very inception doing iconographic rather than simply documentary work, the Panthers proclaimed a new relationship to the dominant media, one in which they hoped to set the terms of engagement. Like the earlier civil rights movement, the Black Panther Party proved itself to be incredibly photogenic. What marks Panther engagement with photography as insurgent is the party's explicit and self-conscious use of spectacle to announce itself and its goals. Whereas the civil rights movement enlisted the dominant and alternative media as witnesses, the Panthers indicted the media for their complicity with capitalism. They achieved this in part by showing themselves camera-friendly, picturesque even, trading on and transposing fantasy and desire, fear and rage that blacks and whites specifically held for each other. Through use of posters and guns, rhetoric and style, the Panthers attempted to expropriate spectacle, not only the state's power to shock and awe, but also the visual excesses projected onto blackness. Newton recognized that "we're going up against a highly technical country, and we realize that they are not only paper tigers, as Mao says, but real tigers too because they have the ability to slaughter many people."[23] More than this though, Newton knew the BPP would "have to work out new solutions to offset the power of the country's technology and communication; its ability to communicate very rapidly by telephone and teletype and so forth." With deep political commitment and burgeoning media-savvy, the Panthers called to the public's imagination by way of the established press, and the public responded.

The Panthers came into view largely through the lens of the camera and would find it difficult to free themselves from its viewfinder. Just as photography expanded the Panthers' emergent visibility it also was fundamental to the process of the party's iconization, the focus of the second section of

this chapter. This iconization took two forms: incorporation and institutionalization. As Williams reminds us: "To the degree that [a new culture] emerges, and especially to the degree that it is oppositional rather than alternative, the process of attempted incorporation significantly begins."[24] Starting in 1967 with the shock of the Panthers' "invasion" of the Capitol in Sacramento, dominant media actively and willingly circulated and codified the "Panther image," using the signs and symbols introduced by the party to mock, aggrandize, and ultimately isolate the group. What images popular culture could not incorporate, the FBI sought to aggressively and literally destroy.

The second form of iconization emerged from the Panthers themselves and might best be called a process of institutionalization. On the one hand, institutionalization refers to the BPP's attempt, beginning in early 1969, to formalize the organization and put into practice service programs that countered the state and media backlash against a now-amplified militant image. In Newton's own estimation, a focus on guns had taken the party too far away from the original commitment to "serve the people." *Black Panther*, the party's official newspaper, worked to provide stability and consistency to the BPP by disrupting the media's business-as-usual and presenting the Panther platform "unfiltered." Its use of photographs deliberately countered and discredited the "angle of refraction" of the established press.[25]

The newspaper also offered a stage for the "revolutionary art" of Minister of Culture Emory Douglas who, through his cartoons and collages, developed a new visual iconography. This second form of institutionalized vision became shorthand to signify and convey complex political ideas, a means by which the party could contain its contradictions and enable a broad constituency to lay claim to the BPP. Significantly, Douglas's collage work created a distinct visual aesthetic that at once used and refuted the status of the photograph. His work in the service of the movement marked a "new solution," in Newton's words, to the harnessing of media technologies to imperialism in the Society of the Spectacle.

Through this cycle of iconization, this dialectics of seeing, I am concerned here with the manner in which the photographic image came to dominate the way movement participants and outside observers alike imagined and interpreted the Black Panther Party, a group deeply preoccupied with the power and currency of the image. How did photography contribute to the crystallization and fragmentation of the BPP? Photography offered a means through which a range of audiences worked to frame, contain, capture, and gain access to the Panthers. As such, photography hastened the

"process of attempted incorporation" of this emergent (and especially oppo-
sitional) culture, "an incorporation," as Williams tells us, "which already
conditions and limits the emergence."[26] To return to Newton in the wicker
chair as a prime example, how did a photograph so laden with contradic-
tion and so rife with paradox become representative of the Black Panther
Party specifically, and black resistance more generally? What can the Black
Panther Party's selective, even haphazard, use of photography and uneven
relationship to photographers tell us about the incongruities, fissures, and
evolution of the organization? How did the many indexical registers of the
photograph, as document of truth, as construction of desire, as that which
brings viewers intimately close and yet keeps them permanently at arm's
length, intermingle to create an image both fascinating and repulsive, both
specific to a particular moment and historically transcendent?

While earlier uses of photography by African American social move-
ments were distinctly focused on dismantling stereotypes and undoing
myths about the unfitness of black people for citizenship, this chapter be-
gins with the assumption that mythmaking along with myth breaking—
narrativizing and symbology—were and are fundamental components of
the work the Panthers carried out and of the legacy they have left behind.
Like social movements before them, the Panthers were concerned with
offering a revised definition of black bodies, with addressing black people
as looking subjects, and with situating their version of black power as part
of a longer continuum of movements for social justice. What marks the BPP
as distinct is a shift in the cultural politics of the photographic image. I hope
to show how the party found itself struggling within and against an image,
a visual language it collectively and dialectically created with both its advo-
cates and its enemies.

It is necessary also to place the BPP within its historical "mediascape." In
the late 1960s, the French Situationist Guy Debord theorized "spectacle" as
a way in which capitalism and the state worked together, primarily through
mass-produced images, to promote an ideology that perpetuates their con-
trol.[27] In the "society of the spectacle," visual technologies ("the most stul-
tifying superficial manifestation," but not the only apparatuses) are mobi-
lized to reify and commodify all human relationships.[28] Reality becomes a
series of representations, and society exists through the spectacle. Rather
than unifying, however, spectacle alienates and isolates people from them-
selves and one another, from the "real" experiences of everyday life, ren-
dering them complicit and politically impotent. Spectacle is a means of
maintaining hegemony, in Gramsci's terms, or the cultural logic of late

capital, to borrow from Fredric Jameson; it works in a variety of ways, all of which seem to advance the interests of the dominant class. We might consider Black Panther public "performances" as examples of "situations," "constructed encounters and creatively lived moments in specific urban settings, instances of a critically transformed everyday life" that, the Situationists argued, were a means of challenging alienation and oppression by the system.[29]

But more than "anti-art art," the Panthers' insurgent visibility signals the longer, complex history of black recalcitrance announced publicly, not just as hidden transcript. In a sense, black bodies have always been part of a capitalist spectacle that maintained its power through representation. The space between black subjectivity and the black imago—the imagined mental image of blacks—secured by the reification and commodification of black bodies had long resulted in a black experience of alienation and double consciousness. The heightened encounter with the spectacle that marked the cultural condition of postmodernity articulated by Debord, Jameson, and other postwar philosophers bore striking resemblance to the black experience of modernity.[30] Put another way, the "surplus symbolic value" of racialized bodies functions as a necessary component of the society of the spectacle.[31]

Yet, if as Debord tells us, "spectacle is the self-portrait of power in the age of power's totalitarian rule over the conditions of existence," then the BPP's engagement in and use of spectacle becomes carnivalesque, a derisive inversion of power's projected image of itself.[32] Even more so, rather than being the tool of power alone, spectacle proves necessary to negate the negation of life, in Debord's words, to repudiate the ideology perpetuated by the state. More than simply being seen to be free and revolutionary within black communities, throughout the country and the world, the Panthers offered up the visual as a stage or battleground in and of itself. In this sense then, "insurgent visibility" proved itself not merely an unspoken tactic of the Panthers, but emerged from a negotiated set of historical processes, from a lengthy past of state counterinsurgency that worked to eviscerate black subjectivity by controlling its visibility while also erasing its own performative or spectacular work to render black communities voiceless, powerless, and marginalized. Spectacle, like whiteness, derives much of its power from its own "naturalness." As Debord tells us, "the stronger the class, the more forcefully it proclaims it does not exist, and its strength serves first and foremost to assert its nonexistence."[33] For the state, spectacle functions as the façade, the smoke and mirrors, behind which it hides its manipulation and

brawn. Through the exploitation of spectacle, through political presence, and through their harnessing of photography, the Panthers undertook the important task of making those traces of force, strength, and power materialize.

The French writer and Panther sympathizer Jean Genet suggested that the Panthers "attacked first by sight." Genet observed of the group during the months he traveled with Chief of Staff David Hilliard in 1970 that the BPP "was one of many revolutionary outcrops. What made it stand out in white America was its black skin, its frizzy hair and . . . an extravagant but elegant way of dressing. They wore multicolored caps only just resting on their springy hair; scraggy moustaches, sometimes beards; blue or pink or gold trousers made of satin or velvet, and cut so that even the most short-sighted passer-by couldn't miss their manly vigor." Like Tom Wolfe, Genet was taken by the Panthers' dress, their style, and the image they projected in public space. Like Wolfe, Genet noted the bulging eyes, turning heads, and breathless gasps that the Panthers left in their wake. But unlike Wolfe, Genet recognized the Panthers' own attention to image as a means of visualizing themselves into existence, if not on their own terms, then on terms they actively negotiated and challenged. The significance placed on appearance becomes not only one of an arsenal of weapons "to endow the black race with form" by any means necessary, but emerges as the first strike. "The above few," Genet continued, "are but a few hasty points about the appearance of a group of people who instead of hiding showed themselves off. The Black Panthers attacked first by sight."[34] Indeed, to do justice to the Panthers we must consider the influence and success they achieved in the cultural arena, how they attacked first by sight. Ultimately, we can better understand how the political importance of the BPP is inseparable from its cultural legacy.

Emergent Visibility

When Huey Newton and Bobby Seale sat down in October 1966 in the office of the North Oakland Neighborhood Anti-Poverty Center, where Seale worked, to write up the Black Panther Party Platform and Program, or Ten Point Platform, they had already evaluated and taken part in numerous local and national black power efforts. Long and intense conversations revolved around determining "why no Black political organization had succeeded" and "what freedom ought to mean to Black people" and, above all, what action Seale and Newton could take in order to liberate the

black masses successfully.[35] Believing the best course was through existing groups, the two friends participated first in the Afro-American Association of Oakland, then the Oakland City College group, Soul Students Advisory Council (SSAC), and its "underground" offshoot, the Revolutionary Action Movement (RAM), during 1965 and 1966. Through mobilization for an Afro-American Studies program at the college, Seale and Newton believed they could sway SSAC toward the more visceral and seemingly less abstract goal of black self-defense. Taking up guns, they contended, would prove the best way to articulate the "defense for the survival of Black people in general and in particular for the cultural program we were trying to establish."[36] When they had no takers from either SSAC or from RAM, they decided a new path was needed.

As Seale and Newton talked, they read political tomes from Third World revolutions, paying close attention to Frantz Fanon's *Wretched of the Earth*, Che Guevara's *Guerrilla Warfare*, and the works of Mao Tse-tung (Mao Zedong). These texts offered a global context in which to situate their local efforts. They viewed West Oakland as an internal colony rather than an urban outpost, and their work as not merely a ghetto uprising but as part of an international revolution. Newton and Seale also studied domestic efforts, including Robert Williams's *Negroes with Guns* and the words of Malcolm X, to better understand how their predecessors invoked and imagined African American armed self-defense. And the two men chose as their organization's name the black panther symbol of the Lowndes County Freedom Organization (LCFO), activated by the people of Lowndes County, Alabama, and SNCC organizers, with Stokeley Carmichael at the helm. Though they viewed the reliance on and ultimate faith in the federal government and American democracy to be fatal flaws, Newton and Seale lauded the ability of the LCFO and Williams to discern creative and effective ways of representing the people to themselves and to activate latent political power. In the spring of 1966 Newton and Seale began in earnest organizing conversations with "the brothers on the street" as a way of gauging the will of the people and "testing ideas that would capture the imagination of the community."[37] By the fall of that year, Newton and Seale felt more than ready to formalize their political education and interactions into a tangible program.

From the consideration of multiple sources and influences through a self-described dialectical method—evaluating what worked and what did not, for what reasons, and under what historic and geographic circumstances—Newton and Seale assembled the Ten Point Platform and officially inaugurated the Black Panther Party for Self-Defense on October 15,

1966. Concerned with material items such as land, food, housing, education, clothing, as well as securing concrete manifestations of justice and peace, the platform stressed action rather than just talk, praxis ("what we want") alongside theory and ideology ("what we believe"). With its concluding paragraph invoking the Declaration of Independence, the platform and the party set out to advocate for "what the people want and not what some intellectual personally wants or some cultural nationalists . . . want, or some jive-ass underground RAM motherfucker wants, or what some jive motherfucker in some college studying bullshit says, talking esoteric shit about the basic social-economic structure, and the adverse conditions that we're subjected to so that no black man even understands."[38] Newton and Seale wanted black men and women not only to understand, but also to believe, to organize, to act. For this reason, the platform itself did not take long to compose and was followed almost immediately by the Panther community patrols.[39]

Believing that "people respect the expression of strength and dignity displayed by men who refuse to bow to the weapons of oppression," Newton and Seale wanted to demonstrate rather than describe their agenda to the communities they hoped to liberate and transform.[40] The newly formed BPP developed a program and practice of an emergent visibility. Through highly visible street presence, challenges to the authority of the state, and later through successful community programs, the Panthers helped change the way African American communities saw themselves and their own power to change the everyday conditions of their lives. At the same time, they gave notice to the government, the media, and watching audiences that black people would no longer bow readily or easily to the will of the state.

Initially, these challenges took place in the theater of the street, a space in which the Panthers were visible simultaneously to passersby and to the police who kept watch over them. African American communities of Oakland, San Francisco, Berkeley, Richmond, and soon thereafter, Los Angeles first became aware of the BPP by way of the Panthers' police patrols. Newton and Seale believed the best way to begin the work of "educating and revolutionizing the community" was by addressing point seven of the Ten Point Platform: "We want an immediate end to police brutality and murder of black people."[41] In the riot-torn urban centers of the mid- to late 1960s, the police tended to operate as an external occupation force, coercing and containing these populations, rather than fulfilling its duty to protect and serve. Communities in the Bay Area, Los Angeles, New York, and elsewhere

had struggled to establish outside and independent civilian review boards but met resistance and ultimately failure.

Newton and Seale recognized the limitations of these earlier black patrols in monitoring police activities with notepads, tape recorders, and cameras alone, and then bringing their findings to the authorities, primarily the police themselves. Now Newton and Seale hoped to "raise the encounters to a higher level" by adding firearms and law books to the arsenal of oral, written, and visual recording equipment.[42] The small Panther patrols no longer simply recorded police-civilian encounters for a higher or outside authority to take action at a later date. Rather, the patrols actively performed their duties in the very moment that police intimidation and violence occurred, even preventing it from taking place at all.

Initially, the patrols simply caught the police off-guard and for this reason proved successful. Patrolling throughout the Bay Area, day or night, in unsystematic patterns, the Panthers might appear anywhere, and the police could not accurately anticipate where or when. The watch consisted of stopping at and monitoring police actions, with weapons in full view, from a designated "safe" distance, lest they be charged with obstructing justice. Eventually, the police responded to the patrols by turning their attention from stopping and detaining community members to questioning and investigating the Panthers themselves. Some of these interrogations escalated to armed standoffs. Newton noted the panic on the part of the police, and he implored his comrades to remain calm. By displaying a cool, composed, self-restraint on police turf, the Panthers would prove themselves to be equal, even superior to their oppressors.

Throughout *Seize the Time*, Bobby Seale conveys the exuberance Panthers experienced during community patrols and demonstrations at being seen by the police and black communities alike as angry and unafraid, while simultaneously placing the police in positions of visible fear and confusion. In April 1967, the deputy sheriff of Contra Costa County murdered Richmond, California, resident Denzil Dowell. Dowell's family called on the Panthers to aid their investigation into Denzil's death. Seale recalls a confrontation in Martinez, the county seat, between the Contra Costa police and a few carloads of Panthers and Richmond community members. When Huey and six other armed men got out of the car in front of the sheriff's office, "The sheriff's car came up directly across the street, right at the corner. The pig jumped out of the car, took his key out, and unlocked that little thing that holds the shotgun in it. He got his shotgun out and jacked a round off into the chamber of the shotgun. When he did that, Huey just

stopped and looked at him, and the brothers were kind of in line, right be-
hind him, doing the same thing that Huey was doing, looking at the pig."[43]
The steady looking escalated quickly to a show of force: Huey responded
by "jacking a round off" into the chamber of his own shotgun. The other
brothers followed suit, and according to Seale the sheriff retreated. "The
sheriff looked at these Panthers jacking these rounds off, took his shotgun,
ejected his round out of the chamber . . . got back in his car and drove away.
That was the baddest set on the scene. I don't know who he thought he was.
Those other sheriffs standing at the door were amazed and surprised."[44]

Seale recounted many such moments as this in which police and Pan-
thers challenged each other visually, staring and scrutinizing, where reck-
less eyeballing escalated to the level of forceful confrontation. The Pan-
thers' own gaze, coupled with firearms, became the first stage of defiance,
a weapon of its own. Historically, whites expected blacks to avert their eyes
when in the presence of "superiors." Indeed, racialized hierarchies relied
upon this seemingly minor interaction. By looking baldly into the eyes of
white authority, the Panthers announced not only their equality but their
power and virility. In this confrontation between black men and white men,
between "pigs" and "brothers," police and Panthers face off while holding
their pistols and shotguns in their hands and holding each other's gaze.
They perform their strength and manhood, their mastery over their weap-
onry, over each other, for one another. They masturbate, "jacking off" and
"ejecting," in Seale's words, while never losing eye contact. In this highly
charged context, the black male gaze, then, becomes a weapon no less
threatening, no less deadly, than the black phallus.

If we imagine governmental neglect, in the form of poverty and blight,
and sanctioned violence, as manifested in police harassment and brutality,
as performances of the state's power over its urban black citizens, then we
can see how the Panthers' stylistic, verbal, and specular bravado further
emerges as a direct challenge and intervention to the political play directed
by the state, though one predicated on the correlation of power with mascu-
linity. The Panthers stepped onto this stage playing the part of the fearsome
(male) revolutionary dreaded and longed-for by the state, but they played it
in such a way as to reveal the state's investment in the spectacle. In Seale's
and others' descriptions of police/Panther confrontations, "the State shows
itself like a revelation," curtailing democracy and showing both the excesses
and the limits of its own power.[45]

The Panthers even gave a name to their performances that exposed the
state's performativity: "shock-a-buku." Newton defined shock-a-buku as "a

tactic of keeping the enemy off balance through sudden and unexpected maneuvers that push him toward his opponent's position."[46] Like Japanese Kabuki theater—"kabuku means 'to be off balance'"—the Panthers engaged in a performance that left its audiences and interlocutors unsure and unsteady.[47] In other words, the Panthers stunned or shocked "the enemy" aplenty (*beaucoup*) by deviating from the designated and decided-upon script of state-subject interaction. The BPP could draw attention to the theatricality of the state without becoming subordinate to the state's power at the same time. In the very act of illuminating the performativity of the state, the command those performances yield and wield over black communities was rendered inoperative. Cops "who had always been cocky and sure of themselves as long as they had the weapons to intimidate the unarmed community" were revealed as cowards when confronted with "armed Black men coming to the support of the community," men who returned police insults with calls of "swine" and "pigs."[48] So while the state's very real power over life and death, the power to achieve consent by way of coercion, terror, and violence, still remained, the Panthers simultaneously exposed the mechanisms by which government forces maintained control. They effectively laid bare the fissures and frailties of such power to the controlled and dispossessed.

Throughout the Panthers' police patrols, black community members, the party's other audience, observed and learned. Intimidated by uniformed and armed police, African American witnesses to the patrols saw uniformed and armed black men who met the police "no longer [as] . . . subjects but [as] equals."[49] Moreover, the Panthers studied carefully the laws governing the carriage of guns as well as grounds and conditions for arrest. In this way, they matched the legal knowledge of the police as well as their dress and weaponry. African American witnesses to Panther/police encounters began to overcome their fear of police reign over their neighborhoods through watching intrepid black men wield guns in addition to the law. Traditionally, African Americans deemed the brandishing of firearms in particular by other African Americans reckless and dangerous, especially when up against a more strongly fortified police force, backed by a white political structure that prefers its black citizens compliant and docile. The very thought was unimaginable, at best fantasy or science fiction; at worst, terrifying and suicidal.

Initially, even the BPP's own minister of information, Eldridge Cleaver, found it difficult to envision African Americans sporting guns in public self-defense. According to Bobby Seale,

Eldridge just couldn't understand how it could happen—h
pulled this shit off or why niggers would be crazy enough to
there in the streets [with guns]. It looked unbelievable. Eldr
it scared him, that's what it did. Scared Eldridge! He said t
Malcolm [X] was teaching, he was just dealing with rheto...
how we had to organize a gun club, we had to do this, we had to have
these guns, etc. He said it was abstract and he couldn't visualize it.
Or if he did visualize it, he visualized a whole army, the black race
armed. But then, when he saw us out there in the process of organiz-
ing, he saw about ten, twelve dudes with some guns, and he saw all
those pigs. It looked like we didn't have a chance, it looked hopeless,
but then many times it looked so beautiful and inspiring, that he just
had to relate to it.[50]

The Panther police patrols offered Cleaver and other African Americans
the ability to *see* in practice the provocative ideas of Malcolm X, whose
spirit pervaded the Black Panther Party. What had once been "abstract" and
"unbelievable" was now clear as day. Theory transformed into action, the
Panthers made visible the promise and potential of black power.

What made the Panthers' public display of firepower all the more threat-
ening was its legality, being perfectly within the bounds of the law. In their
writings and speeches, Seale and Newton consistently emphasized the con-
stitutionality of the Panther patrols. In their encounters with police, Newton
and Seale could be found reciting again and again the Second Amendment,
pertaining to the right to keep and bear arms, and California state law re-
garding the proper way of carrying weapons. Though the Panthers fright-
ened other blacks, whites, and police alike, part of their challenge to the
system was to flaunt the laws that had flouted them, ultimately the laws
that should protect them. The Panthers brandished the law as boldly as they
brandished their shotguns.

The Panthers did not set out to be a ghetto police force. Rather, they
set out to show people what a ghetto force might look like. They aimed
to model a form of community self-defense that ghetto residents could
adopt and emulate, with the ultimate goal of aiding black communities'
self-liberation. "We knew that the law was not prepared for what we were
doing and policemen were so shocked that they didn't know what to do.
We saw that the people felt a new pride and strength because of the ex-
ample we set for them; and they began to look toward the vehicle we were
building for answers."[51] Returning the gaze of the law, surveying and scru-

tinizing police activities, together with a show of arms, emerged as a visible form of insurgency to police and black communities alike. The Panthers not only attacked the police first by sight; but they simultaneously attacked the police's fearful grip on black urban residents.

The patrols proved an effective form of recruitment. Emboldened by the Panther presence, residents would often come out to observe police activity themselves. Panthers used these occasions to pass out the Ten Point Platform and other materials, hold political discussions, and invite people to join the BPP. And many people for whom the Panthers posted bail "came right of jail and into the Party."[52] Newton and Seale brought the Black Panther Party into being with the police patrols, which were intended to "get [the community's] attention and give them something to identify with."[53] The first public announcement of the Panthers' arrival, the Panther patrols set out deliberately to capture community attention through capturing the attention of the authorities.

Despite the attention paid to visibility, there are few, if any, photographs that document BPP activities during the organization's first six months. The camera would come full force with Cleaver's arrival and his assertion that the party needed to produce and control its own image. Photographs were enlisted to bear witness to the Panthers' emergent visibility and to extend the reach of public performances. The party sought out visual media to announce itself.

It became clear that to reach as broad a community audience as possible, the Panthers would have to do more than just be visible to black people, or even visible to white people. They would have to render themselves visible to white audiences on their own terms. Like other underground or radical presses, the *Black Panther* newspaper afforded the party the opportunity to disseminate its own ideas while challenging the mainstream media that supported the established political order and cultural hegemony.[54] Through the encouragement of Eldridge Cleaver, himself a journalist, the party produced and distributed small leaflets, flyers, and posters. A full-blown newspaper, however, seemed to Newton a waste of time and resources, the antithesis of an organization dedicated to concrete action. "We had never thought of putting out a newspaper before. Words on paper had always seemed futile," Newton later wrote of the emergence of the *Black Panther*. But in an effort to raise Bay Area residents' awareness around the case of Denzil Dowell, the BPP produced a short newsletter. According to Newton, "the Dowell case prompted us to find a way to inform the community about the facts and mobilize them to action. Lacking access to radio, television,

or any of the other mass media, we needed an alternative means of cc munication. No one would do it for us.[55] Only four pages long, with words, "Why Was Denzil Dowell Killed" crudely handwritten above a high contrast photograph of Dowell, "five or six thousand copies" of the first issue of the *Black Panther Community News Service*, dated April 25, 1967, was distributed to surrounding communities in return for a donation of ten cents.[56]

This first issue drew notice from the *San Francisco Chronicle and Examiner*. Only a few days later, the Sunday edition published a feature entitled, "It's All Legal: Oakland's Black Panthers Wear Guns, Talk Revolution," which included "perhaps the first [photograph of the BPP] to appear in a major newspaper," an image of Newton and Seale standing armed and dressed in uniform, in front of the party's Oakland headquarters.[57] The newspaper's pull-quote for the photograph's caption announced the two young leaders' brazen racism and violence, emphasizing the threat the Panthers posed to the paper's largely white readership: "They make no bones about being anti-white or about being revolutionaries."[58] Yet while the photograph, credited only to AP/World Wide, illustrated a black threat both frightening and "melodramatic" only three miles away across the bay, for Newton and Seale, the image offered a wealth of possibilities (figure 3.9).

The BPP's founders pose calmly, even casually, before the Grove Street storefront window for an Associated Press photographer. Newton, adorned with ammunition, holds his shotgun in front of him pointed at the sky, as Seale's hangs barrel downward from a shoulder strap, both proper legal positions for brandishing weapons in public view. Draped in the window is a large banner bearing the original name of the newly formed organization: The Black Panther Party for Self-Defense. The men look in opposite directions, simultaneously surveying the street before them, partially reflected in the office window, and guarding the BPP office at their backs. The image portrays the Panther leaders as ready and willing to defend their ideals and their community. They are positioned in a public space that they have claimed as their own. The photograph demonstrates effectively how Panthers situated themselves between the people and the state, with the camera functioning as the witnessing medium between the two.

Through the police patrols, Newton and Seale recognized "the street" both as public space in general and as the embodiment of an inner-city geographic and cultural imaginary, as the primary and perhaps most significant arena for the BPP. They enabled the party's multiple audiences to witness firsthand Panther insurgency and to observe different audiences' reactions

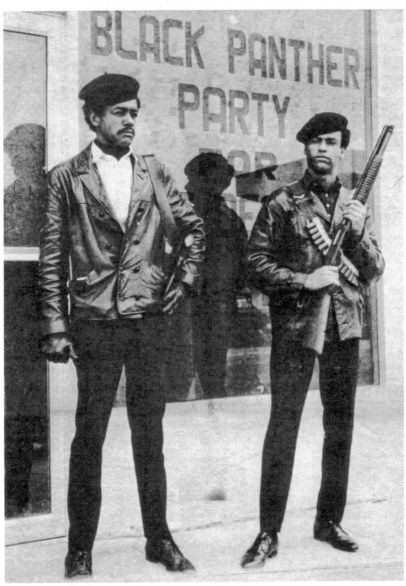

Figure 3.9. Bobby Seale and Huey Newton in front of BPP Headquarters, Oakland, California, April 1967. Photographer unknown. (Courtesy of It's About Time)

to each other. By inserting themselves within, between, and outside of the scripted interactions of the state and its subjects, the Panthers utilized the street as a theater to suggest alternative possibilities for black communities. By positioning themselves at the center of the street, Newton and Seale asserted their own credibility: they are of the street, know its codes, and are prepared to defend it. In this location where the majority of police-community encounters occurred, they reminded audiences of its public nature, recalled and replayed the threat to authority of mass (black) bodies assembled in such public spaces, and ultimately reclaimed the street from the state and delivered it to the people. As Deputy Communications Secretary Judi Douglas editorialized, "the pigs are in the streets now but THE STREETS BELONG TO THE PEOPLE."[59]

Through its careful though relaxed composition of subjects and setting, the photograph both hints at its constructedness while, at the same time, because neither man addresses the camera directly, denies its own invention. It signifies as the document of a deadly serious self-styled performance, rather than mere show for the camera. This image of "insurgent visibility" is meant as an exhibition of the young organization's power.[60] But it is also a display of a true lack of power as well. When juxtaposed to a color snapshot taken of six of the first members of the BPP, the AP photograph reveals a presentation in which both the press and the Panthers were invested to varying degrees. In the November 1966 snapshot, a bright sun shines on Elbert "Big Man" Howard, Sherman Forte, Reggie Forte, and Bobby Hutton along with Newton and Seale. Between the six, there are two leather jackets, one beret, a Panther button, and a single pair of sunglasses, but no weaponry. Most of the Panther iconography is present in this image but not uniformly so. Similarly, the men's faces bear a range of expressions, and no single affect permeates the group. Newton stands in the front, sharing the center of the frame with Sherman Forte. Newton's face is stern, his eyes narrowed, and he fixes a withering look toward the camera. Coupled with his erect posture and casual short sleeves, however, his demeanor seems contrived, especially as both Fortes offer delicate smiles. Seale, in a blazer and collared shirt, stands in the background, his hands thrust in his pants pockets. Though he is parallel to Howard, also in the third line, the slouching Seale seems to fade further into the background in comparison to the larger Howard. Over the course of the next few years, many photographs of Seale imaged a similar impatience or skepticism, capturing a man at ease in front of an audience but not as comfortable in front of a camera. Despite the attention to placement, this photograph then is a backyard snap-

shot of a bunch of brothers on the block, not quite the publicity still of a vanguard paramilitary unit. The AP photograph, in contrast, suggests the need to present a consistent visual message, to streamline the public face of leadership, and to underscore a sense of crisis. Ultimately no match for the state's boundless resources, the Panthers' insurgent visibility embodied the best and perhaps most desperate acts of powerless people looking to achieve a large-scale transformation of society. "And the spectacle would work," Genet tells us, "because it was the product of despair. The tragedy of their situation . . . taught them how to exaggerate that despair. . . . Excess in display, in words and in attitude swept the Panthers to ever new and greater excess."[61]

The photograph of Newton and Seale in uniform offered visual impact and as such was often replicated or disassembled and reassembled in a variety of different contexts. Emory Douglas in particular, as the party's primary visual propagandist, made great use of the image. During Newton's and Seale's concurrent trials in Oakland, Chicago, and New Haven (1968–70), the image appeared in ubiquitous posters declaring the men "POLITICAL PRISONERS OF USA FASCISM" (figure 3.10). Newton's image alone was further circulated as part of "Free Huey" campaign literature and paraphernalia, including back-page versions of the Ten Point Platform. In a circa 1970 poster in support of the Panther 21 (twenty-one New York City Panthers facing imprisonment for allegedly conspiring to bomb department stores and parks), Newton no longer stands in front of BPP headquarters but instead commands a cut-and-paste army of white activists (figure 3.11). "White Brothers and Sisters," the poster hails, "The Revolution Wants You!" With the original background removed, effectively extracting them from the street, these reproductions repositioned Newton, Seale, and the Panthers within numerous theaters but always in a triangulated relationship with the state and the people.

Two days after Bay Area readers got a first photographic look at the Panthers, the BPP took its bold performance to Sacramento. It soon became clear that though the organization could draw all eyes in its direction it would have less command over the ways in which it would be framed. Yet the Panthers counted on the audacity of the image and the antiblack bias of the reports to speak precisely to the marginalized, inner-city black poor they hoped to recruit. The strategy counted on the ability of such audiences, already alienated by media partiality, to read through such reports with an "oppositional gaze."[62] And it recognized that not only could photography and journalism be harnessed in the service of oppositional politics through

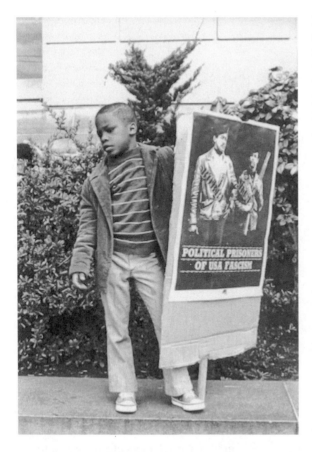

Figure 3.10. Child at a Black Panther Party rally in front of the Federal Building, San Francisco, California, February 11, 1970. Photograph by Ilka Hartmann. (© Ilka Hartmann, 2010)

alternative sources like the underground press but that dominant outlets themselves could unwittingly provide a platform for oppositional views.

Seale would later call the Panther action on May 2, 1967, "the colossal event," an event so massive in scale and larger than life that it heralded a critical shift in the party's direction (figure 3.12). The BPP planned the action specifically to increase its visibility. When Panther political performance met the established press, the images produced would be seared into the visual landscape, and the camera was permanently embedded in all future encounters.

The Mulford Act, dubbed the "Panther Bill," was introduced into the California state legislature by Republican assemblyman Donald Mulford from Piedmont, a wealthy and predominantly white city entirely surrounded by darker, poorer, Oakland. The bill sought to ban the possession and display of loaded weapons, effectively circumventing the constitutional right to bear arms and rendering the Panthers' police patrols illegal. In an

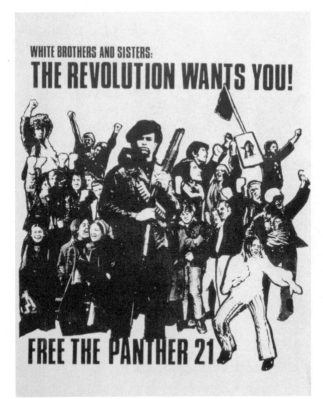

Figure 3.11. Poster in support of New York Black Panthers facing conspiracy charges, c. 1970. (Tamiment/Wagner Poster Collection, Tamiment Library, New York University)

effort to counter the Mulford Act and broaden the BPP constituency, thirty Panthers and Panther supporters led by Bobby Seale traveled to the state capital to deliver "Executive Mandate number one," admonishing African Americans to recognize that the Panther bill was nothing more than the most recent attempt to silence black communities and render them defenseless. Striding past an alarmed Governor Ronald Reagan speaking to schoolchildren on the lawn, and in through the doors of the Capitol, many of the Panthers carried guns (always held in the proper legal position) and created space for Seale to read. "The Black Panther Party for Self-Defense believes that the time has come for Black people to arm themselves against this terror before it is too late. The pending Mulford Act brings the hour of doom one step nearer," declared the mandate in its final paragraph. "We believe that the Black communities of America must rise up as one man to halt the progression of a trend that leads inevitably to their total destruction."[63]

If audiences were unsure of what they were hearing on their radios or seeing on their televisions, they gained another opportunity for clarification

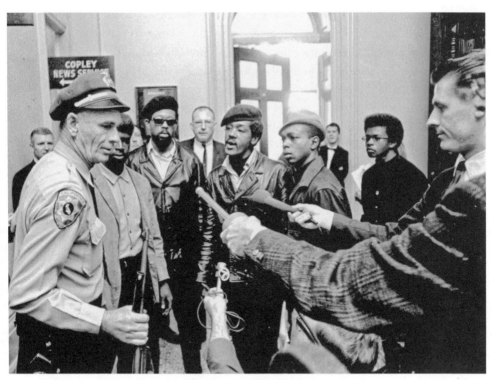

Figure 3.12. Eldridge Cleaver, Bobby Seale, and Bobby Hutton in Sacramento, May 2, 1967. Photographer unknown. (AP Photo)

when Seale read the mandate a second time to the dozens of reporters and cameras "haunt[ing] the capitol waiting for a story."[64] Indeed, the principal purpose of the event was to bring the BPP platform to the attention of the widest audience possible, "to use the mass media as a means of conveying the message to the American people and to black people in particular."[65] Whether the legislators heard and heeded was of secondary concern. Most important, the Panthers wanted everyday observers to know who the Panthers were and what they were about.

In actuality, many politicians, reporters, and laypeople alike did not hear the "Executive Mandate" despite Seale's multiple deliveries. Most found themselves "so amazed at the Black Panthers' presence," by the sight of "niggers with guns," to listen truly and closely to the words spoken by the Panther chairman.[66] According to Newton, "They were concentrating on the weapons."[67] Sol Stern reported in the *New York Times* that "secretaries and tourists gaped and then moved quickly out of the way."[68] Photographs depict Panthers lining the halls or moving through the building, always

surrounded by onlookers, especially photographers and reporters. Indeed images from the event are as much about the incongruity of armed African Americans in the state house as they narrate an immediate media response. The Panthers produced a spectacle that revealed both the state and the dominant media's own deep investment in spectacle.

The armed Panthers proved to be such a spectacle that they were inundated "by many cameramen in front of us, backing up and taking pictures of us walking down the hall. Movie cameramen, still cameramen, regular cameras. Bulbs were flashing all over the place."[69] Unsure where to go, the media literally cleared a path for Seale and his cadre to the floor of the Assembly where the bill was being discussed, leading the group to the political space and constituency to which the BPP previously had no access. The reporters even made it somewhat difficult for the police to apprehend the Panthers. The press, and the visual media in particular, forged new and more expansive channels of contact, communication, and conflict between the BPP, its observers, and the state, a more concentrated dialectics of seeing. This heightened visibility brought the Panthers hundreds of new recruits locally and nationally, leading to the formation of BPP branches across the country. It resulted in increased government surveillance and harassment. And indeed only a few months later, in July 1967, the California legislature passed the act, demonstrating that the state would rather change its own laws rather than having them applied in a way that worked against its own authority. The convergence of the BPP and the press in the Capitol rotunda illuminated the fear and fascination that would shape dominant media coverage of the BPP. The encounter suggests that the mainstream press would offer both a path to political recognition and a source of public condemnation. The press could provide a route through political invisibility while also immuring the BPP within the prison house of prior representations.

Making Icons out of Iconoclasts

The Panthers projected, articulated, manifested, and performed an insurgent visuality. As Jean Genet observed, "They deliberately set out to create a dramatic image. The image was a theatre both for enacting a tragedy and for stamping it out."[70] Even as this emergent culture offered "new meanings and values and new practices," the Panthers' "dramatic image" lent itself readily to mechanical reproduction, to being captured, circulated, and fetishized in photographic form especially. Genet continued that the Pan-

thers "aimed to project their image in the press and on the screen until the Whites were haunted by it."[71]

Haunted, indeed. Terrified. Bewildered. Angered. And moved to swift and often draconian action. Beginning with the *San Francisco Chronicle and Examiner* article and immediately following Sacramento, the Panthers became the subject of national news stories. In the *New York Times, U.S. News and World Report,* and *Time* magazine, articles claimed expertise on the group, particularly its penchant for violence, and through quotes from law enforcement, suggested that the organization needed to be put down. Simultaneously, these articles framed the BPP as "Media Age revolution-aries," mostly bark and little bite.[72] Concepts central to BPP ideology, like "U.S. imperialism," "white power structure," and "political assassination," for example, were placed in quotation marks, implying both the foreign-ness of the terms to mainstream newspapers' readership and their improper usage by the Panthers themselves.[73] Similarly, political analysis was written off as "catechism" or the "Panther line." Articles patronized the Panthers in order to minimize their perceived threat; they infantilized in order to dis-miss the political platform. Not unlike Wolfe's radical chic set, newspaper coverage's vacillation between fear and delight portrayed the Panthers as pet primitives.

Alternatively, the Panthers appeared as the villains in a Hollywood West-ern whose treachery must be overstated to make their defeat that much more satisfying and to aggrandize the valor of the hero—in this case, local and federal law enforcement. Newspaper journalists, like their counterparts in the more literary New Journalism, rendered their descriptions of the BPP in highly visual, even cinematic terms. "If a Hollywood director were to choose them as stars of a movie melodrama of revolution," Jerry Belcher began his *San Francisco Chronicle and Examiner* article, "he would be ac-cused of type casting."[74] "Huey Newton toyed with a foot-long stiletto that he said he had taken from an American Nazi party officer in a scuffle last weekend" was the image that Wallace Turner chose to open his piece on the BPP.[75] Such vivid language suggests the inconceivability of the Panthers' political platform and public performances (not unlike Eldridge's Cleaver's enthusiastic incredulity), while it also reveals the need to characterize the party in recognizable terms. And the terms most readily available came from the shared cultural imaginary. Even without accompanying photo-graphs, text replayed images—imagoes—that were already seared in the mind's eye of American national consciousness.

Both enticingly new and painfully familiar, the Panthers presented an-

other form of excess beyond the rhetoric of violence. "They are guerrilla theater masterfully done—so masterfully that, at a point, everybody began to believe them and to be frightened of them," *Newsweek* lamented. "They are Media Age revolutionaries, gifted with words, good at sloganeering . . . irresistibly photogenic, scary on television, masterful at poster art."[76] While much of the coverage of the BPP relied on melodramatic framing for legibility and mobilized imagery that presented the Panthers as spectacle, the coverage simultaneously dismissed and punished the Panthers for their own exploitation of media.

The dominant media became invested in a certain type of Panther image. The *Newsweek* cover of the February 23, 1970, issue features three Panthers wearing the de rigueur uniform of black leather jacket, sunglasses, and beret on top of an afro, who mug seriously in front of a poster of the then-incarcerated Bobby Seale (figure 3.13). The image relies upon and recycles a specific brand, tested and approved, of Panther iconography. This image was demanded even as the Panthers themselves strived to replace and remake their public persona. According to Stephen Shames, a key photographer of the BPP and one of the creators of the cover photograph along with Alan Copeland, the original picture submitted to *Newsweek* depicted the three Panthers wearing sports jackets and ties. In the context of amplified political persecution and police harassment, the BPP wanted to project a more professional image. Moreover, black men wearing leather jackets, whether they were Panthers or not, increasingly had become police targets. *Newsweek* editors objected to these "unrecognizable" Panthers and "insisted they wear leather jackets. . . . They told us to go out and buy leather jackets." The Panthers were given the ultimatum, "If you don't wear the leather jackets, you won't be on the cover." *Newsweek*, so beholden to an image that in their hands was often used to vilify rather than idolize, even went so far as to "hold the cover for a day and it cost them a hundred thousand dollars," Shames later discovered.[77] And the BPP were so beholden to the need for media coverage that they were willing to capitulate. This constructed image of the BPP and its leaders proved to be one that the Panthers themselves both capitalized on and struggled against. As the Panthers were "branding" their iconoclastic platform, writing themselves into visibility through the mechanisms and frameworks available to them, the establishment press saw only icons—empty symbols—and manipulation. Not only is the use of violence legitimate only when wielded by the state, these articles informed audiences, but so too is the use of the mass media.

The state did indeed employ mass media in its war against the BPP. The

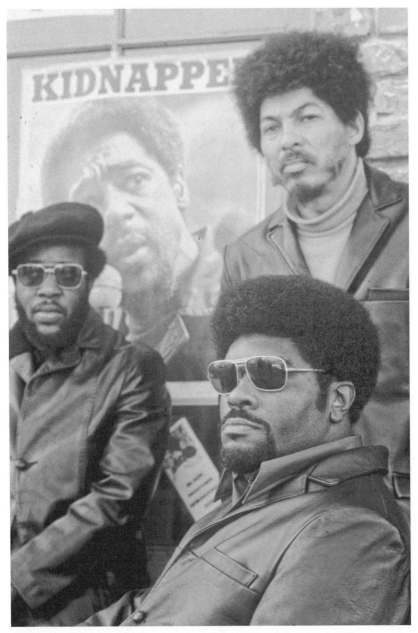

Figure 3.13. Photograph of David Hilliard, Elbert Howard (Big Man), and
Donald Cox that appeared on the cover of *Newsweek*, February 23, 1970.
Photograph by Stephen Shames and Alan Copeland. (Polaris)

party drew the acute attention of the FBI, which stepped up its counter-intelligence campaign against "black nationalist-hate groups" in August 1967, expanded it in February 1968, and "accelerated" its campaign against the Panthers specifically in September 1968.[78] Up to that point, the FBI had simply expanded its anti-Communist and anti–civil rights movement programs, opening new or continuing files on BPP leadership. The Panthers were one group among many, and initially the FBI set its sights on preventing coalitions between organizations. But by 1968, FBI Director J. Edgar Hoover pronounced the Panthers "the greatest internal threat to the internal security of the country" and launched a campaign that included party infiltration, wiretapping and surveillance, orchestrating tensions between the BPP and other nationalist groups (most notably SNCC and the US organization), creating internal dissension, conducting "harassment arrestments," and carrying out assassinations.[79]

Through his investigations of the FBI and COINTELPRO papers, Ward Churchill uncovered an official "Mass Media Program," "'wherein derogatory information on prominent radicals was leaked to the news media.'"[80] Exploiting "an already developed network of some three hundred 'cooperating journalists,'" the FBI efficiently circulated stories and images of the BPP as nothing more than violence-prone hoodlums through the mainstream press.[81] The repetition of this illustration led it to be firmly established in the public's perception to the extent that, according to writer and Panther supporter Donald Freed, "even when individual reporters began to awaken and see things differently . . . the angle of refraction of 'the news' was [already] set."[82]

Mainstream newspapers also proved an important COINTELPRO resource. "Consideration should be given," Hoover wrote in his August 1967 memo regarding black nationalist groups, ". . . to preclude violence-prone rabble-rouser leaders of these hate groups from spreading their philosophy publicly or through the mass communications media." Hoover directed his operatives to cultivate and exploit "the cooperation of local news media contacts" and to design proposals that would "insure the targeted group is disrupted, ridiculed, or discredited through the publicity and not merely publicized."[83] To insure derision and disorder rather than free publicity, FBI operatives filtered their own crafted disinformation, or "gray propaganda," through the "mass communications media." Fraudulent quotes and fabricated stories of organizational rivalry leaked to newspapers helped fix in the minds of mainstream readers an image of the Panthers as delusional renegades and violent thugs waging a war against local police, average (white)

citizenry, and other political "gangs." The goal was to "isolate" the BPP from "the moderate black and white community which may support it."[84]

Such media infiltration extended to visual forms as well. The FBI produced and circulated violent cartoons to exacerbate internecine rivalries or as "evidence" of sadistic intentions. An FBI countersubversive creation, "The Black Panther Coloring Book," which circulated around 1968, utilized Emory Douglas's police-as-pig iconography in a children's book filled with graphic images that advocated children's violence against police and the white power structure. In Miami, agents worked with local television to guarantee that the Panthers received detrimental publicity. Not only did an editor cut a talk show with black nationalists in such a way as to highlight their "extremism," but producers also paid attention to the visual presentation of their guests: "The interview of black nationalist leaders on the show had leaders seated, ill at ease, in hard chairs. Full-length camera shots showed each movement as they squirmed about in their chairs, resembling rats trapped under scientific observation."[85]

Far more mercurial, photographs did not necessarily require doctoring. Instead extant photographs could be captioned and repurposed to fit a frame of excess and disrepute, a narrative already in place in dominant news coverage by 1968 that was ready to be exploited by the FBI. The photograph of an armed Newton in the wicker chair might suggest the theatricality and romance of revolution, but the use of Panthers handcuffed and stripped naked in a police round-up functioned as confirmations of common criminality.[86]

The state also exerted pressure on various media about the types of photographs that could be reproduced and in what venues. Stephen Shames recalls a potential Panther photo book in the works around 1971. Macmillan Publishing Company planned to issue a collaboration using Shames's images and Newton's words and had already advanced the photographer and the BPP ten thousand dollars on the project. But, according to Shames, Vice President Spiro Agnew got wind of the book, along with four other radical ventures also being undertaken by Macmillan at the time, and compelled the publishing house to drop the Panther project.[87]

Images emerged as their own sites of struggle in other more material ways. FBI invasion and destruction of Panther offices included very concerted efforts to ruin posters and films as well as office equipment. FBI agents ordered infiltrators to steal "at every opportunity" visual materials along with financial records and administrative papers.[88] A photograph made of a 1970 police raid on a Philadelphia party headquarters depicts a

"face off" between an image of Huey Newton propped up on a chair and a police officer who kneels before it.[89] The government worked to destroy the BPP; and when the party eluded the state, the state sought to destroy Panther images.

But by the time of Newton's and Seale's trials and the nationwide protests calling for their release, there were simply too many images to be destroyed. Theatrical and photogenic, the Panthers drew photographers to them with the same allure and magnetism by which they attracted community support and government opposition. Professional photojournalists, amateur documentarians, commercial photographers, studio portraitists, artists, and freelancers were all drawn to the revolutionary spirit pervading the era, to the opportunities for visual storytelling presented at nearly every turn, and to the Panthers in particular. A brief survey of the Panther photographic archive reveals a host of familiar and not so familiar names of those who attempted to capture the group on film and Newton in particular: Annie Leibovitz, Gordon Parks, Ted Streshinsky, Jeffrey Blankfort, Ruth-Marion Baruch and Pirkle Jones, Howard Bingham, Ilka Hartmann, Jonathan Eubanks, Hank Lebo, Eve Crane, W. G. Jackson, Lizzie Lennard, and Candice Bergen. The Panthers often employed photographs of themselves that came from or first appeared in sources external to the party, and the majority of these photographers were not official members of the BPP. By 1972, likely as part of Elaine Brown's and Ericka Huggins's political campaigns for city council seats and Bobby Seale's run for mayor, the BPP had its own photo agency in place. The names of BPP members Melanie King, Donald Cunningham, and Lauryn Williams (who was trained by Stephen Shames before he ended his affiliation with the party in 1973) appear consistently, stamped on the back of 8- x 9-inch black-and-white publicity photos and other shots.[90] However, before this time, the BPP proved unwilling to utilize "their most talented people" as photographers. For example, Masai Hewitt worked as a commercial photographer before joining the BPP, but as a Panther he served as the party's minister of education.[91] Some BPP members, including Billy X Jennings and Ducho Dennis, did take photographs for the party, but only as time and conditions permitted. Whether mainstream or alternative, politically radical or radically apolitical, making pictures for the party or just of the party, those who photographed the Panthers revealed themselves as deeply invested in the politics of the insurgent black image in U.S. public space. And they all contributed to and occasionally resisted the institutionalized vision of the party.

Stephen Shames, a white University of California at Berkeley student,

was only a college sophomore when he began photographing the Panthers in 1967. Up until then, he had done some organizing in the earlier free speech movement and had only shot a few rolls of film. Considered by many West Coast Panther veterans to be the official photographer for the party, Shames first saw the Panthers in April or May 1967, "selling red books [at] the first big peace march in Berkeley. They caught my eye."[92] From then until 1972, Shames photographed the BPP almost exclusively. Likewise, Jonathan Eubanks had been "mainly a commercial photographer, weddings and portraits," when in 1969, "working in my lab, making prints to exhibit in the [Berkeley] Arts Festival, a news flash came on the radio said the Black Panthers were demonstrating downtown. I put everything aside and said that was where I needed to be. It was pretty dramatic."[93]

Many photographers of the BPP considered themselves artists and radicals, the camera their weapon of choice. Though many were new to the medium of photography, the artists I interviewed had all found themselves drawn inexorably to careers in documentary photography after taking their first pictures of the Panthers. Carroll Parrott Blue, one of the few African American women to photograph the BPP, recalls that "In those days if you had a camera you could take pictures. And so I simply walked the streets of Boston, SF/Bay Area, and Los Angeles to photograph every rally, protest and gathering that I could find."[94] Photography—for photographers and viewers alike—offered a means of getting closer to and making sense of the movement and the Panthers especially, "documenting this exciting America evolving right before my very eyes."[95] Roz Payne, a white female founding member of the Newsreel Collective based initially in New York, regards as her greatest achievement from that period a sequence of photographs of Curtis Powell of the Panther 21 getting busted by the police in his home. These images are the "most meaningful because I thought Curtis Powell or I could've died."[96]

In Shames's words, "part of being a photographer is wanting to be there."[97] For Shames, who could never be a Panther officially because of his race, the camera brought him closer to the activities and spirit of the radical movements happening in Berkeley and throughout the country. But when the BPP invited Shames to be its official photographer, he gained greater access to the organization as well. As Bill X Jennings, a rank and file member and occasional BPP photographer, offered, Shames was "the closest [outside] person we would let take our pictures. He could see the other nature of the Panthers," the side the mainstream media chose to ignore and suppress.[98]

In addition to being influenced by the likes of Margaret Bourke White, Dorothea Lange, Gordon Parks, and Roy DeCarava, photographers of the BPP cite Charles Moore and Danny Lyon. Inspired and moved by the "images of . . . police dogs and the water and the heroism" of the civil rights movement of the early 1960s, Shames possessed a keen personal sense of the affect of photographs.[99] "I wanted to take pictures like those other pictures [of the civil rights movement]. What can I do?" he asked himself. Photography "is what I can do that is unique, use the camera as a weapon. That was my gun."[100] Similarly, husband-and-wife team Ruth-Marion Baruch and Pirkle Jones made intimate portraits of Panthers and their supporters to counter the blustering, swaggering images circulating in the mainstream. These photographs would appear as part of an exhibit to raise money for organizational programs and legal funds. Keeping with the Panthers' invocation of the gun and militant dissidence, photographers often viewed their role as an extension of the Panthers' visible insurgency and insurgent visibility. According to Roz Payne, the work of taking pictures lay exclusively in the moment. Films and photographs, she says, "were weapons for organizing. We didn't think we were making history. We were doing it to build a movement. We weren't making archives."[101]

Photographers donated their work to the BPP. Indeed Eubanks, for one, never granted copyright permission to the BPP. Instead, he gave his images to a UC-Berkeley campus group called "The Black Family" for use in its publication. Some of its members were Panthers. Eubanks laughs when he comments that the Panthers "didn't get them directly from me." Others had more direct contact with the party. Carroll Parrott Blue traveled to the party office in Berkeley where she "volunteered" her first photographs of Panther rallies to the editor of the *Black Panther*, "Big Man" Howard. From there, and as the result of a friendship struck up with a Panther named Shirley Feeley, Blue was asked to take pictures of the Free Breakfast Program for the paper. "It was my first real assignment from them or anyone! Of course I did not get any money for doing this."[102] Big Man contacted Blue on a freelance basis, choosing what he liked from her contact sheets.

Many of the photographers remained on the periphery of the BPP. Despite the closeness and intimacy portrayed in Eubanks's Panther photographs, the artist opted to keep his distance: "I just photographed what I saw without making it personal. No contact, no interviews."[103] Blue had friends in the party and even developed a crush on a Panther man. Like "many, many other bright young Black women . . . [I was] seduced by the macho energy of it all."[104] But then she discovered that her crush had "talked

disrespectfully about me behind my back. That incident helped to distance me from the romance of it all."[105] Though she continued to photograph and support the party, she recognized that "We were simply not a mix for each other. So my reception was that I was one of many of 'the photographers' that were out there. I was treated in a non-descript manner. Because they knew me, they didn't stop me from doing anything. I moved pretty freely around when and where I wanted to move."[106] While photography brought Blue closer to the Panthers, it also helped maintain distance, as Julius Lester learned in his work for SNCC. The camera could capture the Panthers' work and also convey the desire their onlookers might feel for them. Simultaneously, it could distill that desire into something more professional. The camera occupied the interstices of the society of the spectacle such that in the hands of these radical artists it could both reify and humanize.

Shames and the BPP proved to be a prolific mix for one another. After assuming the position of official photographer, extended by Bobby Seale, Shames journeyed throughout the country visiting and photographing every party chapter. He traveled with "a letter from Huey or Bobby saying, 'This is our guy. Give him what he wants.'"[107] This introduction provided him entrance and afforded a level of trust that he might not otherwise have received as a white photographer appearing on BPP office doorsteps. Indeed, Shames was the only photographer invited inside the church at the 1970 funeral for slain Panther Jonathan Jackson at which Huey Newton delivered the eulogy. Shames gave the Panthers carte blanche to use the photographs as they saw fit. In turn, Shames who also worked for *Ramparts* and the Associated Press, could peddle his pictures to other publications: "Bobby didn't care if I sold pictures to *Newsweek* or whatever because he realized I had to eat too."[108]

Other photographers, including Ted Streshinsky and Jeffrey Blankfort, maintained similar, open working relationships with the party, shooting images that would appear in mainstream, alternative, and Panther press outlets. Such a relationship indicates the fluidity of photographic circulation at the same time that loop of representational call-and-response was tight. Through the specific instance of photographer as intermediary, we can see how mainstream media and the Panthers shared a visual repertoire of the party that at some moments they created simultaneously. With competing interests not only utilizing the same images but taking a hand in their creation, the high stakes and difficult struggles over framing come into sharp relief.

In its November 1970 issue, *Esquire* magazine published a "pictured

essay" entitled, "Is It Too Late for You to Be Pals with a Black Panther?" The seven-page spread, organized as a series of quizzes, diagrams, cartoons, and cleverly captioned photographs, wryly attempted to navigate its "gentlemen" readership through the confusing landscape of Black Panther politics and presentation. To be "pals" with a Panther, one must first know how to "identify" a Panther: the essay opens with a high-angle, full-page, color photograph by premiere *Esquire* photographer Carl Fischer, of seven African Americans wearing sunglasses and variously arranged on the front stoop of a somewhat dilapidated apartment building (figure 3.14). The five men sport berets, the two women have large afros, and two in the group raise black power salutes to the camera. The reader is invited to "Test yourself. Take a sharp pencil and cross out those who are not Panthers. Then turn the page for some bad news." The "bad news" is that despite the sunglasses, berets, afros, fists, and a smattering of Black Panther buttons, none of "the friendly and respectable seven" are actually Panthers but instead a gathering of contemporary African American musicians, writers, and one "ad salesman for *The Village Voice*."[109]

This first bit of subterfuge, this bait-and-switch, sets the tone for the remainder of the essay; one that situates the problem of visual identification at the core of whether one can or should affiliate with the Panthers. The essay seeks to sharpen its viewers' eyes to the vicissitudes of black identity in order to better survey the political scene. How is one supposed to know the difference between jazz pianist Les McCann and New York Panther Michael Tabor, between Kathleen Cleaver and singer-songwriter Roberta Flack? Even with a "discriminating eye" the Panthers prove elusive. Earlier that year, *Newsweek* tried to assert Panther iconography in order to clearly mark their cover subjects as "authentic" Black Panthers and therefore dangerous. But *Esquire* reveals that by the end of 1970, Panther iconoclasm has been thoroughly reduced to a series of icons that any African American can don. The figure of "the Black Panther," with *his* recognizable dress, hair, and swagger, has stepped in as the late 1960s articulation of the universal black subject. "Blackness" and black identity itself remains identifiable but persistently misrecognized.

This terrain is so confounding for *Esquire*'s urbane gentleman because, as the magazine informs us, the Panthers themselves cannot decipher the imposters from the real deal. Dismissive of COINTELPRO infiltration that often made the necessity of such distinctions within the BPP matters of life and death, *Esquire* lays this conundrum at the feet of other mass media and at the doorstep of the Panthers themselves. "More than any other previ-

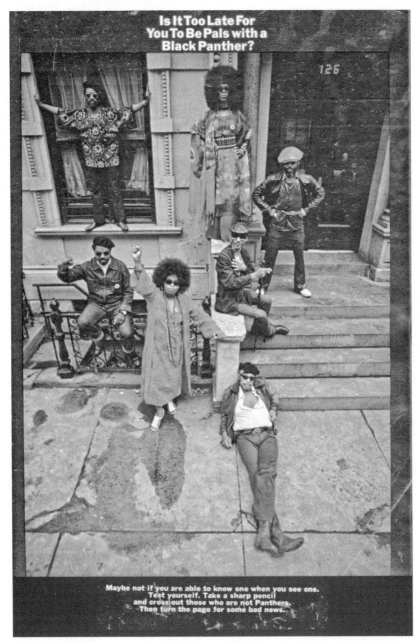

Figure 3.14. *Esquire*, November 1970, asking, "Is It Too Late for You to Be Pals with a Black Panther?" Photograph by Carl Fischer. (© Carl Fischer. All rights reserved)

ous black image, the Panther has been created by television. The medium is a Panther-lover."[110] The Panthers are nothing more than a media creation, the next in a long line of black representations and stereotypes. Even as *Esquire* presents this pictured essay under the guise of "penetrating" a "media-influenced" image in order to "understand his [a Black Panther's] reality," the magazine is invested in institutionalizing and capitalizing on "the Panther image." It simultaneously acknowledges its complicity in creating such an elusive commodity—not unlike the Hathaway Man or the Grants 8 Scotch Man whose ads throughout the magazine interpellate the sophisticated reader the publication hopes to reach—while ultimately placing blame on the deceitful yet clumsy Panthers. Publicity-hungry ideologues, stylish yet without substance, Panthers are nothing more than a series of symbols and icons that stand in for blackness itself.

Esquire even performs the labor of identifying and deciphering Panther iconography for its readers. The essay's second page offers a dissection of the poster of Newton in the wicker chair (figure 3.15). Sardonically, *Esquire* reads the mise-en-scène, unpacks the symbolism of the various components—"The Official Beret/Leathers/Gun/Afro/Shades/Roots/Shoes"— and notes the contradictions embedded within the photograph ("So what if the throne looks like Hong Kong wicker?"). It concludes that not only is this image created for "the media" but it is constructed for an ideal white male spectator and therefore can only invoke fear and derision. Of "The Official Shades," the diagram notes, "Although Huey doesn't need them, a Panther wears shades to scare you. They hide what he's thinking and make him look cool and mean. A cool, mean, scary black can give even the best of liberals, even you, sleepless nights."[111] As Genet averred, *Esquire* recognizes that the Panthers "deliberately . . . creat[ed] a dramatic image," one that would "haunt the whites."[112]

But this is where *Esquire*'s understanding of Panther visuality ends: it ends (where it begins) with the white subject, rather than with the transformation of society at large. For the magazine, the dialectics of seeing involve only two parties rather than a constellation of engagements, a series of encounters that the Panthers staged between themselves and *multiple* constituencies. Fortunately for its readers, *Esquire* is able to translate the Panthers within a complicated visual terrain, confining the BPP to a single frame and dismissing it when it attempts to exceed those bounds.

Genet attempted to understand the Panthers on their own terms, engendered by his own outcast lifestyle as well as the months he spent traveling with David Hilliard. Conversely, *Esquire* is concerned with what the

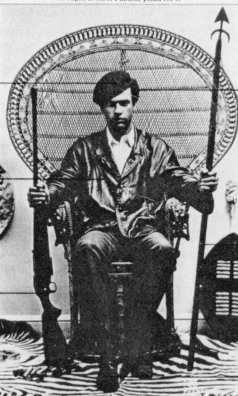

This is closer to the real Panther
It ought to be. A Panther posed for it

The Official Beret
The Black Panthers wear berets because berets are the prominent trademarks of military elitists — hotshot British Commandos, Nazi tank gunners, etc. Ché Guevara also wore one. The beret may be colored for camouflage in alien environments. American Special Forces wear green ones over in the jungles of Southeast Asia while the Panthers wear black ones in the streets of America.

The Official Leathers
Leather is primeval. To a flabby suburbanite like you, it means a tough outer skin. That's why the Panther wears leather. What would you think of a Panther in a jacket made out of permanent-press polyester?

The Official Gun
An unarmed Black Panther is not as newsy to newsmen as an armed one. As Minister of Defense, Newton recommends these guns for the neighborhood arsenal: an Army 45, the dependable M-16, a 12-gauge High Standard Magnum shotgun with an 18-inch barrel, the P-38. An unarmed Panther is not as groovy on a poster either.

The Official Afro
Long hair is now on everyone, of course, but when you started to let yours grow it didn't have anything to do with racial pride. Letting it all hang out is, to black psychiatrists Grier and Cobbs, "psychologically redemptive." In other words, the Afro is good for the Panther's head. What's your excuse?

The Official Shades
Although Huey doesn't need them, a Panther wears shades to scare you. They hide what he's thinking and make him look cool and mean. A cool, mean, scary black can give even the best of liberals, even you, sleepless nights.

The Official Roots
African trappings—spear, shields, a zebra rug, and throne—underline the Panther's identification with The Great Worldwide Revolutionary Struggle Against Oppression and Colonialism. So what if the throne looks like Hong Kong wicker?

The Official Shoes
Many Panthers prefer combat boots but the sharper ones can be seen tearing down the walls in knobs, footwear defined by Bobby Seale as "soft, alligator and expensive."

Figure 3.15. Huey Newton poster dissection, *Esquire*, November 1970.

Panthers-as-cynosure mean for its readership. Indeed, if the BPP is so frivolous and laughable, why devote so much energy to mocking a group on the verge of implosion? For *Esquire*, like Tom Wolfe, the Panthers signaled a displacement of (media) attention away from a white male subject toward the more alluring black male subject embodied by the figure of "the Panther." The essay even quotes Marshall McLuhan, doyen of the emergent media studies, foretelling of such a shift: "It is apparently unknown to the Negro . . . that his TV image is enormously superior to that of the white person—especially on color TV. . . . It is simply that the TV image is itself iconic. It favors the contour, the mask, the sculptured form . . . the white person [is rendered] hopelessly inferior on the TV medium."[113] Here the white male readership of *Esquire* is witnessing, experiencing, and even contributing to

its own decentering. Not only is the Panther image meant to invoke fear and loathing in a white male audience, it also signals that audience's loss of power. The "Panther Image" may be just the "latest" in a long line of black stereotypes, from Uncle Tom to Staggerlee, from Stepin Fetchit to Sidney Poitier, shorthand for compartmentalizing and containing African American masculinity. But through their engagement with the society of the spectacle, this "image" has placed into sharp relief "a new lovable stereotype," that of white masculinity, whether "Ghetto Merchant," or "Honkey."[114] *Esquire* sounds the alarm that the Panthers have rendered white men, "the new Invisible Man." Haunting, indeed.

Institutionalizing Vision

With so many different constituencies attempting to lay claim to the Panther image, the BPP found it difficult yet imperative to wrest control over the party's representation. Before Sacramento, the BPP had consisted of a hundred or so members. But the publicity garnered by the event caused the group's numbers to swell and new chapters to sprout around the country. Through a focus on the image of "niggers with guns," the response of mass media and the state worked to alienate the BPP from as many potential supporters as possible. The party responded by building its infrastructure and creating programs and outlets that demonstrated a commitment to black community control; as its image was spectacularized through national exposure, the organization refocused some of its own attention on the local. The *Black Panther* newspaper as well as the survival programs functioned as recruiting tools that enabled a broad range of people to find solidarity with the BPP, to find common goals within the Panther image. Rather than being "showcases" or publicity stunts in response to intense media scrutiny and government pressure, the paper and community services provided programmatic structure, reaffirmed a commitment to black communities, and in the case of the newspaper, provided a steady source of income. These modes of institutionalization also mark a different relationship to the question of spectacle, one that sought to disrupt the commodification of human relationships by mass mediation and reestablish a sense of individual and collective efficacy. The BPP reasserted the iconoclasm of the Panther "icon" by expanding the group's public works and providing institutional structure to the organization. "Panther" had to be made to stand for more than "niggers with guns."

Like other underground or radical presses, the *Black Panther* offered

the BPP a form of protection against the attacks of the dominant media and provided the party the opportunity to disseminate its own ideas to a national audience of black readers. The FBI's Mass Media Program coupled with general reportage proved extremely effective in not only alienating the BPP from the wider American public but isolating them from black communities as well. David Hilliard, BPP chief of staff, asserted in 1969 that "the press has animalized the Black Panther Party . . . with their vilification of the Party . . . [and] that the public or the people would accept that shit because they see us as a deadly threat to the communities." The *Black Panther* afforded the Panthers a means of "cultural self-defense."[115]

Initially, the organization produced the newspaper by hand, utilizing the most rudimentary equipment and any space available, including other alternative press offices and the home of Beverly Axelrod.[116] Soon the paper's political and economic significance became apparent, leading the central committee to upgrade the equipment and increase the staff. With the aid of Emory Douglas, an advertising art student at San Francisco City College named BPP minister of culture, the *Black Panther* went from a mimeographed broadsheet to a fully laid out, multipage newspaper.

Eventually, a newspaper cadre was formed, led by Masai Hewitt, a former commercial photographer, named minister of information after the expulsion of Eldridge Cleaver in 1971. This group was in charge of all aspects of producing and distributing the paper, from investigating and writing stories, to gathering and taking photographs, to designing layout for the thirty-two-page paper each week, all in time for it to go to press on Thursday nights. Graduating from scissors, press-down type, and border tape, the cadre utilized "drafting tables, desks and typewriters, two Linotype machines, a mimeograph machine, and several tape recorders to take testimony from people harassed by the police" set up in the transformed second floor front room of the Shattuck Avenue BPP office in Oakland.[117] In turn, the paper provided a continual source of revenue for the besieged organization. Sold for twenty-five cents, ten cents went into production, five cents was turned over to the BPP general fund, and the remaining ten cents remained in the hands of the seller, the only income for Panthers who received no salary from their full-time commitment to the party.

The paper, like the police patrols, became an organizing tool. It offered a means of talking with potential customers, local communities, and everyday folk and getting closer to them through selling. Hilliard, recalling his early work with the BPP, maintained that hawking the paper inevitably opened up conversations, especially if the potential buyer refused to pur-

chase the paper. Additionally, selling the *Black Panther* presented a means of recruitment. According to Hilliard, "The paper . . . helps us organize new chapters." Selling the paper on the streets introduced new comrades to the work of on-the-ground organizing, familiarizing them with the party's beliefs and rhetoric through their own teaching of Panther philosophy. "This is the stuff revolution is made of," Hilliard pronounces effusively, as he remembers selling the *Black Panther* for the first time. "Just like they did it in Cuba: speaking to people, hearing what they think, getting them to question their assumptions, telling them your ideas."[118] The *Black Panther*, like newspapers in Cuba, offered a tool for building a revolution.

The *Black Panther* appeared monthly until January 1968, when the party began to produce the paper on a weekly basis. As the "Black Community News Service," the paper reported news of the BPP and its activities and services, provided contact with political prisoners, offered legal advice, printed letters from readers, published poetry by leadership and rank and file alike, and showcased visual art, including cartoons by Douglas and J. Tarika Lewis, who went by the moniker Matilaba. The news and opinions were presented and disseminated in a style that could not be found in the mainstream press. Above all, the *Black Panther* provided and presented news of significance to working-class African Americans, other oppressed peoples of color, and the radical poor in an unflinching, in-your-face manner.[119]

The *Black Panther*, as one of the alternative media, an organizing tool, and a source of income, proved especially important during the "Free Huey" campaign of 1967 through 1970 as the BPP's membership rapidly increased and branches opened up around the United States. "In short time," Hilliard later recalled, "the paper becomes the most visible, most constant symbol of the Party, its front page a familiar sight at every demonstration and in every storefront-window organizing project throughout the country."[120] By 1970, over 125,000 copies of the *Black Panther* circulated weekly throughout the United States and the globe. Though the style and rhetoric of different chapters throughout the country may have evolved in a slightly different manner, the paper provided cohesion for the party as the BPP expanded. Journalist, political prisoner, and former Philadelphia Panther Mumia Abu-Jamal has remarked that each emergent branch of the party had diverse "tempos, rhythms and feels." Indeed, he suggests, "there was no single BPP; there were many, unified in one national organization . . . but separated by the various regional and cultural influences that form and inform consciousness." Through the paper, the party's goals and agenda, as handed

down from Oakland headquarters, remained clear, constant, and consistent.[121]

"Every week this paper exposes to the people the truth about the ruling class of America," one *Black Panther* writer declared in 1969. "Circulation of this paper has increased by the thousands in the last months and more people are seeing through the lies put out by the imperialist newspapers." As readers' political consciousness and media literacy grew, the paper, according to Newton, proved no less than another weapon in the battle for a voice and a presence in the political arena. Emory Douglas recalled that, "Huey compared the Party's need for a publication with the armed struggle of the Vietnamese. He said that the Vietnamese carried mimeograph machines wherever they went to produce flyers and other literature to spread the word about their fight to free their country. The Party needed to have a newspaper so we could tell our own story."[122]

Photography occupied an important place in the *Black Panther*. Each issue was laden with images of BPP activities and members. These photographs helped construct and extend the Panthers' theater and expand their audiences. According to Bill X Jennings, the BPP considered photography a means to "indirectly educate and organize the people, to bring contradictions right to them, show bad conditions and the correct way to deal with contradictions, with situations in the community." Jennings concurred with Newton's belief that African Americans are not a reading people, therefore visual images, both photography and graphic art, serve a pedagogical function: "For people who don't read [photographs are] the way we teach people in our community."[123]

The September 6, 1969, issue of the paper, for example, features a 5 ½- × 8-inch photograph of Harlem Panther Al Carroll, who "gives correct info. to parent in community" (figure 3.16).[124] Carroll stands in the doorway of the storefront office, framed by posters of Panthers, political prisoners, international political leaders, and announcements of events. Carroll speaks to a black woman with a short afro who presumably has just received some written literature from the papers Carroll holds folded behind his back. Likewise, a photograph in the following week's issue depicts a Panther in the doorway of the Berkeley office joking and smiling with a large group of children gathered outside (figure 3.17). The image accompanies an article admonishing "false" free breakfast programs, those that purported to feed children but in actuality fed only themselves and their pockets, that is, state-funded poverty programs that did not offer the Panthers' serving of political

AL CARROLL OF HARLEM GIVES CORRECT INFO. TO PARENT IN COMMUNITY

Figure 3.16. Panther Al Carroll "gives correct info. to parent in community,"
from the *Black Panther*, September 6, 1969. (*Black Panther*/It's About Time)

ideology.[125] These photographs portray the office as a place of information
and advice, where community members, especially children, could always
turn for help.

Photographs published in the *Black Panther* bear witness to the Panthers'
emergent visibility and its effect on community and police audiences. In an
early issue of the paper, Stephen Shames, Jonathan Eubanks, Ruth-Marion
Baruch, and Pirkle Jones lent their photographs for a collage of "Free Huey"
campaign activities.[126] Under the heading, "World Awaits Verdict," images
of rallies and demonstrations portray uniformed Panthers in formation,
bearing "Free Huey" signs and Newton posters, waving banners, or verbally
and aggressively challenging the workings of the state. Some photographs
offer careful compositions of militarized marching, others more haphaz-
ard crowd shots, as well as portraits of individuals or small groups. They
also capture more intimate moments, many taken by Baruch and Jones
who sought to "express the feeling" of the movement: a uniformed Pan-
ther man feeds a baby on his lap, children laugh, a woman embraces her
man who adjusts his own tripod-mounted camera. Taken on separate days
from a range of events by different photographers, the images promote the
numbers of the gathered masses who came to demand Newton's immedi-
ate release. Importantly, they also reveal the age and gender diversity of the

Figure 3.17. Black Panther in doorway of Berkeley office visits with a group of children from the community, from the *Black Panther*, September 13, 1969. (*Black Panther*/It's About Time)

Panthers' African American supporters. Other photographs in the same issue, of a meeting and collaboration between Los Angeles Panthers and Brown Berets, similarly visualize the profound impact the organization had on other marginalized peoples and its growing cross-racial alliances. Taken together, the collage impresses upon viewers the density of the movement. These photographs document the public actions of angry, yet organized, groups to oppose governmental injustices.[127]

Photographs of Newton and other leaders surrounded by and address-ing predominantly African American crowds bespeak the power of their leadership. The photographic treatment of Newton in particular reveals efforts to address the simultaneous if conflicting needs of the BPP; that is, both to free the party leadership and to empower black communities. In effect, the imaging of Newton marks continuing efforts to contain the

contradictions introduced by the "spear poster," which intensified during the "Free Huey" campaign and were exacerbated by mass media coverage: the problems of creating an image of collective action through the portrait of an individual.

The August 15, 1970, issue highlights this tension. The cover advertises a "photo supplement" of "Huey P. Newton, Back on the Streets with the People," following his release on bail after serving two years on the manslaughter conviction. The case had been thrown out and a new trial ordered. In the images on the cover and the large centerfold, a victorious Newton stands on a car outside of the Alameda County Courthouse greeting the diverse crowd of nearly ten thousand people who came to cheer his return. Imprisoned during the campaign that raised his profile and cultivated his celebrity, Newton appears elated though overwhelmed in images in which he speaks to the crowd and even seems to attempt to calm them as many hands reach for him. In other photographs of the event not reproduced in the *Black Panther*, we see Newton rip off his shirt, raise a black power fist, smile, grimace, and be shuttled away as the crowds press in on him. "Although people received me warmly, I was at first a symbol," Newton recalled in the 1973 publication *Revolutionary Suicide*. "Our relationship had changed. There was now an element of hero worship that had not existed before I got busted. . . . The earlier close family tie has been enlarged by an image of me created through publicity and the media."[128] The photo supplement attempted to contain these contradictions by displaying a leader beloved by the people but also a leader more comfortable with selling newspapers and embracing youth than addressing a crowd. The images walk a fine line between aggrandizing the already larger-than-life, internationally known figure and recognizing the community commitment of a local activist.

While the *Black Panther* newspaper struggled to define the BPP image on a national level as a centrally orchestrated party, the paper also helped publicize the Panthers' local initiatives, especially their survival programs. Alongside the newspaper, the survival programs provided institutional structure and challenged the dominant press's violent framing of the BPP. Newton himself recognized that the rhetoric of armed struggle may be useful, "a tool to be used in our strategy; it is not an end in itself." He began to see "picking up the gun" as "reactionary simply because the community was not prepared to do that at that point. Instead of being a cultural cult group [like cultural nationalist organizations] we became . . . a revolutionary cult group."[129] For Newton, the survival programs became a means to

reconnect with black communities through service, while rearticulating a commitment to revolution.

The most expansive, recognizable, and arguably the most important of these survival programs was the Panther's free breakfast for inner-city children, started in Oakland in January 1969 and implemented by all party branches two months later. Churches often provided space, local businesses donated food—sometimes under threat of boycott—and community members, including "welfare mothers, grandmothers and guardians in the Black community" who were uncertain about the Panthers or unwilling to commit full-time, volunteered their energies to the program.[130] The success of the free breakfast program lead to the development of other programs, such as free sickle cell testing, ambulance services, and health clinics; these in turn spurred the recruitment of doctors, nurses, and other trained professionals.[131] As community service, the survival programs expanded the Panthers' constituency and enhanced the party's reputation by offering a new, competing image of the BPP.

Perhaps most significantly, the survival programs challenged the dominant image of the Panthers as wholly violent, hostile, and aggressively masculine. Soon after the institution of the free breakfast program, the *Black Panther* was laden with photographs of happy children eating, smiling, learning, and even raising their fists to posters of Newton. Children became the focus of the party's work, indeed one of its new public faces, and impressed upon audiences a sense of shared purpose. Rather than being perceived as hopelessly solipsistic and nihilistic, the Panthers were seen to be invested in a redeeming future.

With men and women required to serve in any and all capacities, through their community service the Panthers began simultaneously to disrupt some of the sexualized gender roles both they and the media worked to project. "All Party Work Is Political" announces a caption beneath the photo of a woman preparing meals.[132] Other photographs in the *Black Panther* affirm this sentiment in their depiction of young black men wearing frilly aprons and serving paper plates of grits and sausage to young boys and girls. In the July 19, 1969, issue, for example, appears a large photograph of burly Panther Charles Bursey lovingly placing breakfast before eager children (figure 3.18).[133] On trial at the time of publication on charges of attempted murder of a police officer and assault with a deadly weapon, the image of Bursey specifically and of other black men doing traditional "women's work" offered a counterbalance to popular notions of the Panthers as violence-prone thugs.

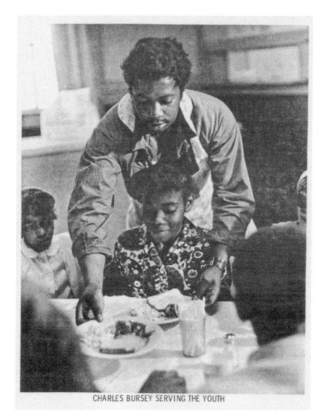

Figure 3.18. Charles Bursey serving breakfast, from the *Black Panther*, July 19, 1969. Photograph by Ruth-Marion Baruch and Pirkle Jones. (Survivors Trust for the Benefit of Pirkle Jones)

CHARLES BURSEY SERVING THE YOUTH

Moreover the photograph of Bursey is juxtaposed in the same issue with photographs of serious-minded black women like Connie Matthews addressing the Socialist Party in Denmark, or political prisoners Ericka Huggins of the New Haven 14 and women of the Illinois 16 raising their fists in the air, at the forefront of the Panther struggle (figure 3.19). In other issues, we see black women expertly carrying shotguns, most notably, the full page image of Kathleen Cleaver bearing a rifle as she guards the entrance to the apartment she shared with her husband (figure 3.20).[134] Many have noted the masculinist dimensions of the BPP and specifically the ways in which these images of armed women at once overly sexualized female subjects and, at the same time, ungendered them under the banner of a black manhood regenerated through violence. Panther women became at once fetish objects bearing other fetish objects; and they become invisible mimics in the iconography of revolutionary (male) blackness. "We'll just have to get guns and be men," sang Elaine Brown. These photographs and the practices they document, however, also demonstrate that a traditional gendered

HANDS OFF ILLINOIS 16

The sixteen indictments returned against the Black Panther Party were a concerted effort by the Federal Government to destroy the leadership of the peoples vanguard. But like their efforts in the past, these reactionaries have proven themselves to be paper tigers. The racist pigs have redoubled their efforts to destroy the Party since their frame-up of Deputy Chairman Fred Hampton they failed to stop the Party and its programs.

The pigs have shown us all that their only duty in the oppressed community.

vice in this country.

The Federal Government of this capitalist society is the real criminal. These capitalist fools are murdering, victimizing; and taxing the people to death. All part of this decadent (decaying) capitalist society. If the government was really representative of the people then it would support the Black Panther Party's Breakfast for Children Program, help the Party to institute the nationwide Free Medical Centers, and force its pig agents to withdraw from the community.

volutionaries, guides who, are helping the masses liberate themselves from the hands of the oppressor.

They work from can't see in the morning to can't see at night establishing socialistic programs. The fascist police agencies throughout the country are intensifying the terror, brutalizing, murdering and visciously repressing people; the 16 were helping the people to resist this genocidal (mass destruction of a people) activity by the government.

The Illinois 16 believes that it is

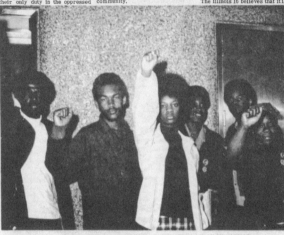

peoples communities is to repress the Vanguard and brutalize and murder the people. "WE WANT AN IMMEDIATE END TO THE POLICE BRUTALITY AND MURDER OF BLACK PEOPLE." The Vanguard has committed no crimes only fed the hungry, clothed the needy, provided medical attention for the sick - while the federal government has sat back on its hind legs, allowing our children to starve to death, to freeze in the winter because of the lack of clothing, and to remain sickly because of the racist medical ser-

The Ku Klux Klan are racist murderers, why haven't they been indicted? The Minute-men are right-wing capitalist fascist, why haven't they been indicted? Black capitalism is a scheme to exploit the masses of the people, why haven't Nixon and his lackies been indicted? The Black Panther Party and the people have exposed these criminals and this is why we are being repressed. The Illinois 16 followed the political ideology of the Party. They are servants of the people; "oxen to be ridden by the people." They are tested re-

time for us as oppressed people to arm ourselves against this terrorism, "We must rise up as one man to halt the progression of a trend that leads inevitably to our total destruction". -- Huey P. Newton

We must declare what Fred Hampton declared "Let all tests of revolution confront me, Those that I am not ready for, I will become ready for. PEOPLE UNITE"
Illinois Chapter
Black Panther Party

Figure 3.19. Article supporting indicted Panthers known as the Illinois 16, from the *Black Panther*, July 19, 1969. (*Black Panther*/ It's About Time)

division of labor, or broader gender relations, within the party were not fixed.[135] Indeed, some of the inspiration for imaging black women with guns came from international posters and photographs, especially from China and Vietnam, which foregrounded women as key to the success of anti-colonial struggles. The photograph of Cleaver likewise signals the necessity of women on the frontlines: because Eldridge was still on parole, he could not carry guns, therefore Kathleen appears as the defender not only of the hearth but the right of black people to defend themselves. The BPP was "not a hotbed of critical inquiry on gender issues in the academic sense"; rather, as historian Tracye Matthews suggests, "gender politics and power dynam-

1968: BALLOT OR THE BULLET

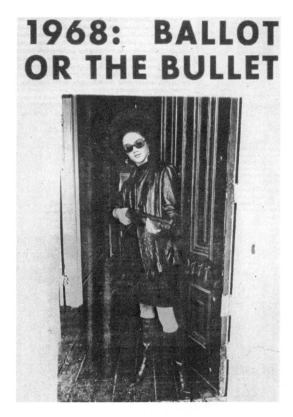

Figure 3.20. Kathleen Cleaver holding a shotgun, from the *Black Panther*, 1968. Photograph by Alan Copeland. (Alan Copeland)

ics" were constantly negotiated, challenged, struggled over on a daily basis by women and men alike.[136] Furthermore, that men and women both performed duties traditionally identified with leadership, such as public speaking, or "true" political activity, such as standing trial and enduring imprisonment, or service or support work, such as the free breakfast and other survival programs, impels audiences, both then and now, to redefine and reconsider gendered notions of leadership, service, and political participation.[137] Competing, often contradictory, visual images of black manhood and womanhood reveal that photography was one terrain on which these negotiations took place.

Through their full-time work within black communities, the Panthers believed they performed a model of revolution for the people they served and hoped to lead, while also acting out their resistance to those who perpetuated an oppressive system. In the words of Al Carroll of the Harlem Panthers, "The BPP is doing what we want to *see* done and that is *to show* the people the way out of this nonsense, that we have not been completely

THE BLACK PANTHER, SATURDAY SEPTEMBER 13, 1969 PAGE 14

INTERNATIONAL NEWS

CONTINUED FROM LAST WEEK

THE POWER OF ARMS

From Tricontinental May - June 1969
by Amilcar Cabral Secretary-General PAIGC

After the Party was created in leaders in order to create the meas-
1956, there was another important ures necessary to help the struggle.
moment in 1959 when the Portu- This enabled us to create a political
guese committed the Pijiguiti mas- school to prepare political activists.
sacre, which caused indignation This was decisive for our struggle.
among the entire population of

Figure 3.21. The *Black Panther* "International News" masthead,
September 13, 1969. (*Black Panther*/It's About Time)

jammed yet, and if we choose the revolutionary path and resist this dog,
we'll bring about just what the Party is teaching and *showing* by example,
and that is change."[138] Photographs illustrated the work of the party and
documented its revolutionary example.

In turn, black folks saw an organized group of young African Ameri-
can men and women protecting black communities, disseminating infor-
mation, feeding hungry children, and providing much-needed access to
health care. Even more than this, the Panthers conducted their work out
in the open in the absence of state and local governments who had for the
most part ignored and dismissed ghetto communities and residents, deny-
ing them the very services that the state had a duty to provide. Panther
visibility proved striking, in both practice and in photographic reproduc-
tion, because its models of black community activism stood out against or
in contradistinction to "white" state neglect. "In white America the Blacks
are the characters in which history is written," wrote Genet, himself "read-
ing" America through the Black Panthers and their struggle. "They are the
ink that gives the white page a meaning."[139] Like Genet's metaphor, the
"white" state acted as the blank field upon which black political presence
emerged.

Photographs in the newspaper also revealed more explicitly interna-
tional influences. The *Black Panther* included an "International News"
segment, the banner for which served as a platform for the revolutionary
triumvirate of Patrice Lumumba, Ho Chi Minh, and Che Guevara (figure
3.21), and by 1970 expanded to include Kim Il Sung and Mao Tse-tung. The

banner utilized cut-and-paste iconic headshots of the three martyred Third World liberators next to the section's title, superimposed over the silhouette of a Kalashnikov rifle, the hardware of anticolonial fighters across three continents. Indebted to and inspired by the struggles of these men and their countries' fights against colonialism and imperialism in Zaire, Vietnam, Cuba, and Bolivia (as well as North Korea and China), the heading of the International News section echoed the headshot of Newton, which appeared on the cover of each issue of the newspaper, especially when Newton himself was facing his own potential martyrdom. The BPP's use of photography visually traced the Panthers' influences while situating them firmly within a global war.

While Eldridge and Kathleen Cleaver lived in exile in postcolonial Algeria, beginning in 1969, the newspaper functioned as a means of maintaining public ties to the BPP. Through various articles, letters, and statements, the Cleavers publicized their activities and the work of the International Section of the BPP, established in 1970, but eliminated when Newton (prompted by COINTELPRO machinations), expelled the Cleavers from the party. Photographs from the First Pan-African Cultural Festival in Algiers in July 1969 sent a powerful message of diasporic possibility. "Panthers in Kasbah" announces the cover of the August 9, 1969, issue as Cleaver, along with Masai Hewitt and novelist Richard Wright's daughter, Julia Wright Hervé, walks through the narrow stone-stepped alleys of the former native quarters of Algiers, surrounded by Algerian children (figure 3.22). Significantly, this marked Cleaver's "resurfacing" after eight months underground, the moment in which he publicly announced his whereabouts. The photographs depict a "hero's welcome," even if the conditions of his stay were slightly more complicated. In the issue's centerfold, devoted to the Afro-American/ Black Panther Party Cultural Center at the festival, crowds of visitors press against the windows and into Panther offices in Algiers and carefully consider Emory Douglas's artwork. According to one caption, "Black Panthers Are Center of Attention," and their offices were "visited by thousands daily."[140]

Photographs of the opening of the International Office in October–November 1970 likewise reveal the potency of the Cleavers' work. In a series of images, Eldridge meets with Chinese and Korean ambassadors, while Donald Cox, also in exile, greets members of the African National Congress.[141] In a country that maintained no diplomatic ties with the United States, the small International Section in many ways constituted a U.S. embassy in Algeria.[142] The Algerian government provided refuge for Cleaver,

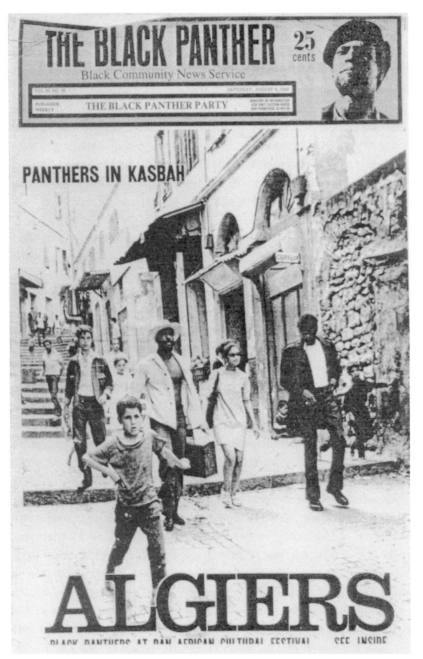

Figure 3.22. Eldridge Cleaver and Panthers in Algeria to attend Pan-African Cultural Festival, from the *Black Panther*, August 9, 1969. (*Black Panther*/It's About Time)

facing imprisonment in California, and in these images we see the Panthers here recognized as both a legitimate political organization and as a cultural force. In 1970, Newton's own ideas about transnationalism and decolonization crystallized into a theory of "revolutionary intercommunalism," a concept that saw the world's oppressed peoples as "a dispersed collection of communities," which if properly networked could overthrow U.S. imperialism and global capitalism.[143] For stateside readers of the *Black Panther*, familiar posters of Newton and Seale photographed in unfamiliar locales made the concept of revolutionary intercommunalism visible and the diasporic project of the BPP tangible. Such photographic work aided in connecting the BPP to international struggles, a counter to their political isolation within the United States.

Photographs could be used to show the coming to consciousness of black communities, the strength of party leadership, and the developing networks of connections beyond African American communities. Yet photographs also documented and imaged state violence against the Panthers as well as African Americans at large. Here photographs provided a visual shorthand for undermining the FBI and mass media representations of the BPP, articulating and framing the inverse of state depictions of the party, its members, and activities. Even as Panther offices are meant to be inviting, offering a community sanctuary, we can also detect from images of party offices how photographs also offered a form of countersurveillance, a visual wall to block the prying eyes of the state.[144] Published photographs rarely depicted the interior of Panther offices. Most BPP photographers were not granted access to these sensitive spaces. Indeed, what outside viewers or passersby learned about the Panthers' interior they gleaned from the assortment of posters and flyers that covered nearly every available inch of window space. The window display projected the Panthers' image outward, providing information and educating interested community members. Furthermore, such attention paid to the exterior space suggested that the office inside provided a safe haven from the charged and often dangerous theater of the street. The photographs intimated that what lay behind the window's façade was for those who wanted to see, learn, and do more than bear witness or function as audience member alone. Images projected outward were not only for community members but for the police as well. The photographs manifested what we might call a visual "culture of dissemblance," to borrow historian Darlene Clark Hine's term, one that offers up a particular public face of openness and disclosure while rendering what is private, in this case the workings of the Panther office, not readily visible.[145] As police

assaults on BPP offices and Panthers themselves increased, for example, the *Black Panther* reproduced numerous photographs of destroyed workplaces and doorways riddled with bullet holes, rather than intact and functioning office spaces. Panther offices that had been attacked or destroyed by the police indicated that the interiors had already been penetrated and violated by the state gaze, and by extension, that crimes had been committed for which justice must be sought.[146]

Photographs revealed the workings of the state and its penetration of black communities in other ways. The March 7, 1970, issue featured a story on police "run amuck" in the African American neighborhood of Hunter's Point in San Francisco, exemplifying a wave of incidents of "pigs . . . actively search[ing] for a reason to come into the community with guns drawn."[147] The cover photograph depicts a confrontation between police and members of the community in which at least twenty police officers, many in riot gear, are positioned in the middle of the street and have trained their weapons on a target to the left of the picture frame (figure 3.23). Black onlookers are pressed together in the background, lining the street and standing in doorways. Notably, a man with a movie camera crouches down next to a police officer not quite in the center of the photograph. He too aims his "weapon" at the action that we cannot see. Both the police and mass media wield weapons that attempt to capture and contain an unseen black threat. Together they enlarge a black specter that haunts the edges of the photograph to the level of black spectacle. Here on the cover of the *Black Panther*, the police and the press become both audience members and actors in this street drama; they are both "occupying forces" within African American inner-city neighborhoods, a key feature that marks African Americans as an "internal colony" within the United States. The readers of the newspaper are able to take in the entire scene, to visualize the collusion of the camera and the gun, the mass media and the state, that represses black communities generally and the Panthers in particular.

The BPP reproduced images of African American men bloodied in police attacks, even of corpses of victims of police brutality. Similarly, police photographs of incarcerated members could be found in every issue. Coupled with captions about infiltrating pigs and innocent Panthers, these latter photographs no longer signified identifiable and apprehended criminality (figure 3.24). Rather, images of Rory Hithe of the Denver BPP, Peggy Hudgins of the New Haven branch, and others were rendered, like Newton himself, identifiable revolutionaries marked for containment by an oppressive state: mug shots function to pluck alleged offenders from the obscurity

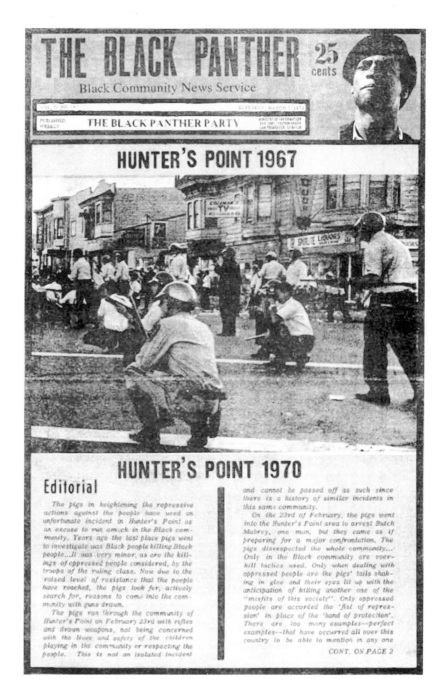

Figure 3.23. Heavily armed riot police invade Hunter's Point neighborhood of San Francisco, 1967, on the cover of the *Black Panther*, March 7, 1970. (*Black Panther*/It's About Time)

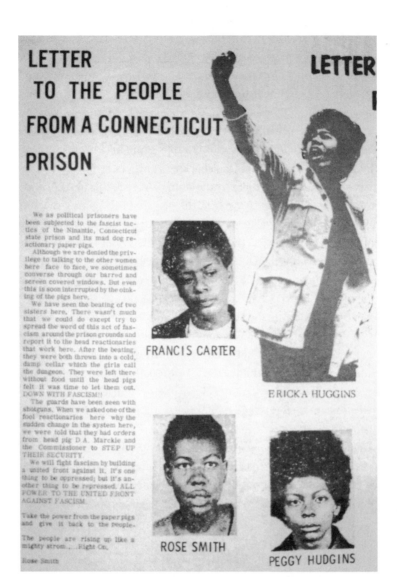

LETTER
TO THE PEOPLE
FROM A CONNECTICUT
PRISON

LETTER

We as political prisoners have been subjected to the fascist tactics of the Niantic, Connecticut state prison and its mad dog reactionary paper pigs.

Although we are denied the privilege to talking to the other women here face to face, we sometimes converse through our barred and screen covered windows. But even this is soon interrupted by the oinking of the pigs here.

We have seen the beating of two sisters here. There wasn't much that we could do except try to spread the word of this act of fascism around the prison grounds and report it to the head reactionaries that work here. After the beating, they were both thrown into a cold, damp cellar which the girls call the dungeon. They were left there without food until the head pigs felt it was time to let them out. DOWN WITH FASCISM!!

The guards have been seen with shotguns. When we asked one of the fool reactionaries here why the sudden change in the system here, we were told that they had orders from head pig D.A. Marckle and the Commissioner to STEP UP THEIR SECURITY.

We will fight fascism by building a united front against it. It's one thing to be oppressed; but it's another thing to be repressed. ALL POWER TO THE UNITED FRONT AGAINST FASCISM.

Take the power from the paper pigs and give it back to the people.

The people are rising up like a mighty strom..,..Right On,

Rose Smith

FRANCIS CARTER

ERICKA HUGGINS

ROSE SMITH

PEGGY HUDGINS

Figure 3.24. "Letter to the People from a Connecticut Prison," in the *Black Panther*, September 13, 1969. (*The Black Panther*/It's About Time)

that left them invisible to the eyes of the law, only to relocate and categorize them in generic police files. When reproduced in the mainstream media, these images reinstate and doubly mark the criminality of their subjects, alerting the general public to the threat these individuals pose.[148] Included in the BPP newspaper, surrounded by accounts of their cases and what they have endured in police custody, the personalities and humanity of these persecuted Panthers emerge. These photographs stand in contrast to those in the mainstream media of naked and shackled Panthers, stripped down to the bare essence imagined for them by the state.[149] Within this new context, photographs in the *Black Panther* recast the players in the state's theater: government agencies materialize as the perpetrators of excessive violence against innocent community activists. Further, this visual transvaluation exposes the state's own reliance on coercive media discourse and disproportionate force when citizens fail to behave or perform their proscribed roles. In effect, the Panthers' theater as illustrated by such photography made perceptible to viewers the state's investment in a theater of its own.

But these documents of brutality and incarceration are also images of extreme vulnerability. Indeed, between 1968 and 1970, there are far more photographs of armed police than armed Panthers. The paper is also filled with photographs of the decaying interiors of ghetto slum apartments, substandard health care facilities, and defenseless children. And photographs of slain Panthers become portraits of martyrdom. These are not the fearsome Panthers depicted in *Newsweek*, the glamorous emblems of the *New York Times* and *New York* magazine, or the cartoon menace of *Esquire*. These are impoverished and besieged black folks. Neglected and anonymous, brutalized and marginalized, these are decidedly unspectacular subjects.

The Panthers' emergent visibility then represents not only an exhibition of power but a display of a true lack of power as well. As the party battled increasing political retaliation and isolation, the collection of photographs in the *Black Panther* suggest competing if not contradictory modes of representation. The editors of the newspaper were motivated by the need to demonstrate strength amid true vulnerability, to garner support for programs and legal defense funds while not undermining the respect created through earlier images of seeming invincibility. The juxtaposition of photographs reveals a party at once trying to establish its positions and programs while defending itself from outside assault. Hence the power of the bullet-ridden poster of Newton that aims to bring these two modes of image-making into a single frame. Even if, for the Panthers, "the paper [was] syn-

ònymous with our invincibility . . . our lifeline to the chapters and a visible sign of our defiance of the pigs,"[150] it was also a testament to their susceptibility and exposure, one that itself became a target.[151] The *Black Panther* emerged as a battleground in which a struggle for political control was waged between the BPP and the state, a dialectics of seeing staged on the terrain of media over the production and circulation of meaning.

Making Icons Iconoclastic

The artwork of Emory Douglas proved critical to the emergent visibility of the BPP, visually translating the party's ideology and rhetoric into single-frame cartoons. He created a new set of Panther icons through a combination of cartoons and photographs that fashioned an identifiable visual tone for the party while simultaneously containing visual and ideological contradictions. Douglas's powerful thick-lined drawings of determined black children, stern-faced black men, armed black women, and, most iconically, avaricious pigs clothed in police uniform, stripped down even the most complex concepts to readily accessible images.[152] Courses in advertising art at City College of San Francisco sharpened Douglas's sense of how to deliver a message quickly through the juxtaposition of image and text and also how to evaluate strong work. "Strong work" meant not solely, or even primarily, technical proficiency, but work that conveyed political meaning and had "social impact," that audiences could see, feel, understand, and act upon. Pictures that "cut through the chase." As Douglas put it, "sometimes you have a lot of art that even though it's brilliant, it's for the intellect to look through, break it down and deal with all the different symbolism. Whereas this art cut through the chase, just comes to the point of what we were talking about."[153]

Douglas drew inspiration from a host of sources, including international poster work from China, Vietnam, the Middle East, and Cuba. These posters circulated through OSPAAAL and offered Douglas another vocabulary for revolution, most significantly in the inclusion of women and children as subjects for his work.

Douglas's work, seen throughout the *Black Panther* and reproduced as posters, was not confined to his pen and typeset, but incorporated photographs as well. In the newspaper headquarters, Douglas maintained an image file, composed of artwork, including that by Harlem Renaissance artists Aaron Douglas and Romare Bearden, and photographs cut from newspapers and magazines, from art books, and from the Panthers' own

portfolio. Douglas drew on this file not only for inspiration as he developed his pieces, but for inclusion in his artwork as well. Many posters and newspaper issues showcase the interplay of ink and photograph: photographs of Newton, Seale, or Elaine Brown adorn hand-drawn images of weeping children or rejoicing women in the form of buttons; photographic posters of party leadership decorated the walls of dilapidated homes and neglected ghetto streets; photographs of children appear as reminders of the stakes of Panther programs.

For Douglas, photography was important to the mission of the paper, not simply as document but for illustration; that is, to show and teach through observation. Though the paper aimed to include as many photographs as possible, according to Douglas, this did not always happen for a number of reasons, usually lack of space or lack of images. Most significantly, Douglas notes that sometimes photographs on their own did not always perform the way Douglas wanted them to. Instead he pursued a combination, "an integration of creative design elements along with the photography, to enhance the photography or the image, the artwork of the photograph itself. That's what I was inspired to do. In the image, the photograph that was being used, whatever the design element was, composition-wise [I would] add other elements to it to give it an impact."[154]

Here I would like to highlight two of the distinct ways that Douglas employed photographs, as he put it, "to show the contrast of what can and should be done."[155] On one hand, photographs were assembled as documentary litanies of the bleak conditions and the brutalities faced by impoverished black communities. Photographs of contemporary police brutality and past lynchings appear in the helmet of a hand-drawn African American soldier on the cover of the September 20, 1969, issue of the *Black Panther*, discussed in the introduction (figure i.8). A collage that appeared in the newspaper a year later features a large drawing of a man injecting heroin. The drawing is surrounded by photographs of a black soldier in combat gear, a woman crying out in agony, and at the bottom (both literally and figuratively) lies a black man passed out in the gutter. In the background hangs an American flag, echoing the stamp on the addict's shirt: "U.S. Govt. Approved," signaling state complicity with black death (figure 3.25). In each of these collages forlorn black children feature prominently, beseeching both the images' subjects and its viewers to act and rescue these youth. Photography is deployed here for its "truth-telling" capacity, imaging the harsh realities of African American life. Sedimented in the stark black-and-

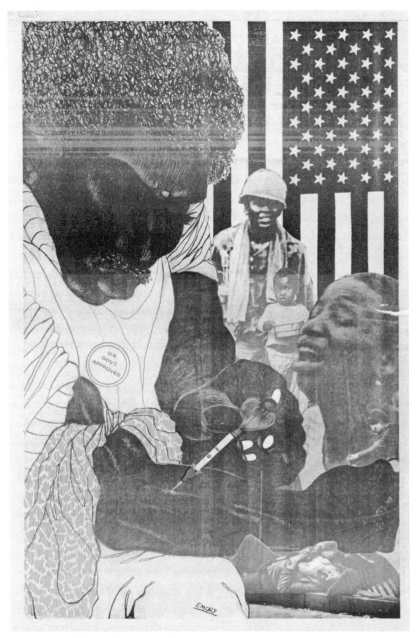

Figure 3.25. Collage of photographic images and drawings of problems besetting the black community, by Emory Douglas, from the *Black Panther*, September 1970. (© 2010 Emory Douglas/Artists Rights Society [ARS], New York)

white image photographs function as images seared into black individual and collective consciousness.

In a different though related use of photography, photographs of party leadership or activities form a backdrop for Douglas's image of a representative though nameless black figure. For example, in a collage printed April 10, 1971, Douglas has drawn a clear-eyed black woman, clothed in a red dress with matching house slippers, indicating impoverishment and the narrow confines of her world (figure 3.26). She carries a mop and pail as well as full grocery bags in each arm. One bag's label informs us that the items come from the "People's Free Store." Each bag also features a photograph of an imprisoned Panther, with the words "Free Bobby" and "Free Ericka" above, reminding the viewer of the ongoing trials of Ericka Huggins and Bobby Seale in New Haven. The photographs themselves would have been familiar to readers of the newspaper because they had appeared in previous issues and had been used in other Douglas posters. Fed and provided for by the BPP—"Thanks to the People's Free Store," the caption reads, "I can go home and mop my floors and feed my children"—it is now the community's turn to nourish and support the party.

In another collage, appearing in an issue commemorating the third anniversary of "Lil" Bobby Hutton's death (and what would have been Hutton's twentieth birthday), a hand-drawn young man wearing a cap and a blue Panther insignia button stands atop an overflowing garbage can (figure 3.27). The trash can functions as his ghetto soapbox as he addresses both another man and the viewer. His body is in motion, a finger of one hand pointing toward a newspaper in his other that reads "Community Control of Police," practically leaping out from the solid brick wall filling the background of the image that threatens to immure the young Panther. Breaking the monotony of the tight brick pattern is a poster with a photographic image of Bobby Hutton, the Panthers' first recruit who would die at the age of seventeen, in a hail of police gunfire in a shoot out that prompted Eldridge Cleaver's period of exile. In Douglas's collage the poster is tattered, peeling off the wall and perforated with giant bullet holes. Douglas's hand-drawn young man at the center, barely contained by his surroundings or by Douglas's ink, is the artistically rendered echo of the real-life Hutton, whose two-dimensional likeness hangs martyred on the wall behind. As the cover of the issue states, "He was the beginning not the end . . . Community Control of Police." With his organizational zeal and his matching cap, the cartoon figure bursts forth from Hutton's memory, his mutilated image, and carries on his legacy and the work of the party.

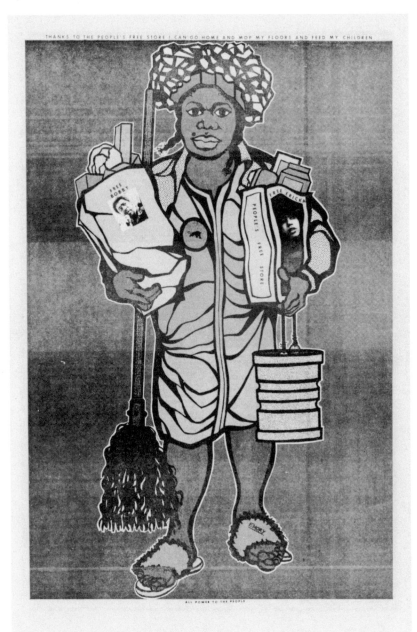

Figure 3.26. Drawing of a black woman carrying a mop and pail and grocery bags after visiting the People's Free Store, by Emory Douglas, from the *Black Panther*, April 10, 1971. (© 2010 Emory Douglas/Artists Rights Society [ARS], New York)

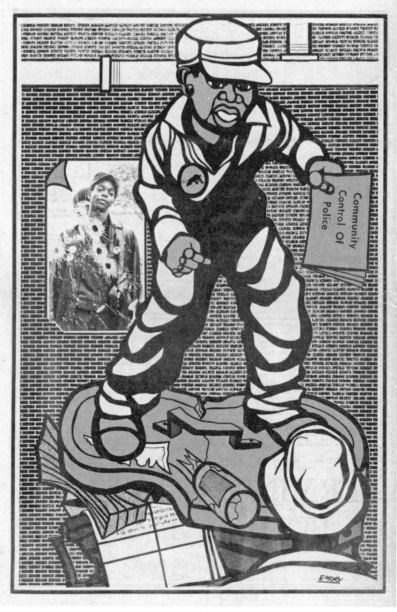

Figure 3.27. Drawing of a young Black Panther (Bobby Hutton) using an overstuffed garbage can for a soapbox, by Emory Douglas, from the *Black Panther*, April 3, 1971. (© 2010 Emory Douglas/Artists Rights Society [ARS], New York)

In both of these posters, the photograph offers the model of the Panthers' revolutionary program in action while the drawing seeks to project an image of everyday folks motivated by their oppressive conditions and mobilized by the example of BPP activity. Douglas's work initiates a careful choreography between the present and the future, between harsh realities and revolutionary fantasies. Photography here functions as a documentation of desire, not as documentation of despair.

In each example of integration of design elements, we see the logics of advertising at work. Douglas worked to highlight the relationship between hope and misery, ongoing struggle within dilapidated surroundings. Through relations of scale that situate photographs as spectacles that loom large over black individual and collective life, as assembled memories contained within one's mind, or as small badges of future possibility, Douglas's collages exemplify a practice that offers viewers images of a better life, a future improved self promised not only by the consumption but the activation of the Panther "brand."

Not only a practice that attempts to align multiple temporalities, Douglas's collages also exhibit a practice in which photography is knowingly utilized for its multiple valences. In the collage of the young speaker, the image of Hutton, like the image of Newton in the wicker chair, began as a photograph that was transformed into a poster, later damaged by gunfire, and then rephotographed to be incorporated as a poster in this constructed, back alley landscape. This long chain of reproductions (in a relatively short period of time) suggests an awareness of the photograph as excess and as deficit; a constant reproducibility in which meaning atrophies and accumulates. It indicates a relationship to the photograph that not only recognizes the medium's limits and its possibilities, but actively works in the break between restriction and opportunity. By juxtaposing photography with other two-dimensional forms—text, cartoons—Douglas produces highly textured yet accessible pieces in which both meaning and image are layered.

Photography provided a space of imagination, documentation, and creativity, one in which "evidence" could be refigured and recontextualized to tell an alternative tale of repression and terrorism. Douglas's work concedes and even appreciates photography as crucial to the successful mobilization and expansion of a social movement. But his pieces also demonstrate irreverence toward photography's truth-bearing claims: meaning is neither fixed nor static, photographs bear unreliable witness, and their impact must be, in Douglas's estimation, "enhanced." Of course, Ida B. Wells understood that context and framing were key. Yet she still believed in photography's

veracity, especially as compared to the written word. But for Douglas, the photograph is incapable of signifying on its own, hence the need for its constant manipulation and emplacement. The photograph can neither bear the full burden of representation on its own nor can it be ignored altogether.

Here we witness Berger's "alternative practice of photography," a practice that begins to defy and undermine the society of the spectacle, even as it makes use of its protocols.[156] The employment of segments of the Newton/Seale photograph in front of the Oakland office reassembled as part of a poster for the Chicago or New York offices, for example, enabled different and often divergent chapters of the BPP to lay claim to Panther leadership, to extend the protection of ghetto streets throughout the country, while imagining and performing the version of the Panthers they wanted. Such collage through the use of quotes by Ho Chi Minh, or photographs of Panthers less well known nationally, also rendered visual international influences and gave voice to important local figures beyond Newton and Seale.[157] They linked the local to the national to the global. Posters made use of eidetic images in order to compile, assemble, arrange, and ultimately create the organization they hoped to bring together and bring into being.

Conclusion: The RPCC and the End of Innocence

Perhaps no poster makes all of this more evident than one created for the Revolutionary People's Constitutional Convention (RPCC). Heeding the call of the BPP, between eight and fifteen thousand delegates from domestic and international liberation organizations came to Philadelphia to radically rewrite the United States Constitution over the weekend of September 5, 1970.[158] According to journalist Nora Sayre, whose report on the convention was published in *Esquire*, about half of the attendees were white and about half black, and in all, "it was a powerfully grass-roots audience."[159] The RPCC documents, accepted by the five to six thousand people present at the final plenary session, called for an international bill of rights, international reparations, the abolishment of capitalism, the renunciation of U.S. nationhood, the destruction of nuclear weapons and the United States army, support for gay and women's liberation, a demand for socialized medicine, and an end to genocide. While broad and lofty in scope, the goals of the RPCC and the convention itself "shed light on . . . the aspirations of the 1960s [New Left] movement."[160] Specifically, it revealed the Panthers' attempts to build anticapitalist, anti-imperialist, multiracial coalitions rather than engage in a national strategy of racial separatism.

A poster made for a second RPCC gathering reveals the breadth of domestic and international politics that the convention responded to and hoped to change or build upon (figure 3.28). An Emory Douglas drawing of a male revolutionary wearing a peasant hat and fatigues, raising a Kalashnikov in one hand and a grenade in the other, stands in the foreground. Behind him are cut-and-paste photographs that would have been familiar to BPP members and supporters: slain Panther Fred Hampton, the bullet-riddled poster of Newton in the fan chair, another of Newton with rifle, Bobby Seale, honorary Panther Jonathan Jackson. There are photographs that would have been recognizable to audiences of 1970: the young woman who screams over the body of a fellow student murdered by National Guardsmen at Kent State University earlier that year, a Vietnamese man holding a child severely burned by napalm. And there are photographs depicting general conditions of poverty and hunger, police brutality and lynchings, forlorn and weeping children, and anonymous black faces and white faces consumed with anger and frustration, many of whom look directly out at the viewer from the chaos of the page. As Newton intoned during the convention, "[U.S. history] leads us to the conclusion that our sufferance is basic to the functioning of the government."[161] These photographs are interspersed with images of Panther rallies, examples of resistance, and, at the center in the protective space forged by the hand-drawn Kalashnikov, a child raising a black fist. As in his other works, Douglas mixes forms to enhance impact and to reveal hope and possibility in the midst of even the most abject suffering. Such assemblage illumines the dialectic between power and resistance.

These photographs are not merely compiled. Rather, all the components interact, witness, and even respond to each other's struggles. A young black child mourns over the body of the Kent State student. In the top right corner of the poster are two photographs of "Black August," Jonathan Jackson's takeover of a Marin County courtroom on August 7, 1970, in which he demanded the release of the Soledad Brothers: William Christmas holds a revolver to the back of a woman's head while James McClain trains a handgun and rifle on Judge Harold Haley. Between the two images of the dramatic event, caught so extensively on film by a photojournalist, is a cutout of two shackled Panthers, a reminder that at the literal center of this event was a demand for freedom for black prisoners, a political platform missed in the spectacular images and sensational reporting. It is the communication between these juxtaposed figures that lends the poster its power, that suggests a broader context for the individual components. The poster visualizes the interconnectedness of each of these struggles and articulates the

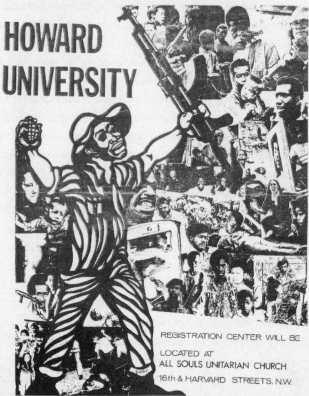

Figure 3.28. Poster promoting the Revolutionary People's Constitutional Convention in Washington, D.C., November 1970, by Emory Douglas. (© 2010 Emory Douglas/Artists Rights Society [ARS], New York)

political collage that is the RPCC; the images cascade and present global revolution as the best and final solution. Its assemblage constructs the crucial "living context" for these images for which John Berger advocates; they are presented within "a radial system . . . so that [each] photograph . . . may be seen in terms which are simultaneously personal, political, economic, dramatic, everyday and historic."[162] Moreover, if spectacle is "conceived of as an ensemble of independent representations" that operate to isolate and divide, then the collage work of the Panthers offers a reunification of ideas, events, and images.[163]

The RPCC poster epitomizes the production of a radical form of photography that recorded and expanded the emergent visibility and insurgent visuality of the BPP, while preserving the urgency and efficacy of these practices. But the techniques of disaggregation and reassembling, collage and bricolage, also suggest something beyond a changing relationship to photography. They mark a profound transition in conceptualizing black subjectivity and collectivity. They indicate a shift away from what Stuart Hall has described as "a struggle over the relations of representation," a struggle defined by countering black invisibility and exclusion with mere presence, replacing derogatory images with "positive" ones; and a move toward "a politics of representation itself" that must contend with the increasing hypervisibility of black bodies, that challenges not merely the fear and loathing of black subjects but their fetishization as well, and that seeks to read blackness as a series of signs rather than as essence.[164] A transition, in short, from black visual modernity to black visual postmodernity. Blackness emerges here as once cartoon and photograph, as impoverished and enriched, in agony and in joy, black subjects in conflict with one another and in solidarity with nonblack peoples. Not only is the photograph being deployed for its constructive rather than documentary capabilities, but its performative labor is to imagine/envision a new black revolutionary subject.

Hall called this "the end of the innocent notion of the essential black subject," an awakening from an ardent faith in the singularly defined black representation that would challenge and overthrow a sordid and oppressive history of media marginalization.[165] Certainly, the Panthers had their own distinct ideas about ideal representatives and representations: consider Newton's enthusiastic review of Melvin Van Peebles's controversial film *Sweet Sweetback's BaadAsssss Song* as "the first truly revolutionary Black film," or one need only look to the premium placed on male leadership.[166] But Douglas's art in its form suggests a new mode of engagement; so too does the awareness that a "positive" image—whether of middle-

class respectability or of patient suffering—will not radically transform black communities. Eldridge Cleaver admitted as much when pressed by an interviewer as to why the Panthers do not emphasize the survival programs to dominant media, presenting a more sympathetic image: "I don't think we have to put on a positive image," an image he viewed as "apologetic."[167] The visuality of a new form of black subjectivity, rooted in the "deadly serious" play of cultural politics, Nikhil Pal Singh tells us, emerged as the literal negative, inversion, or "antithesis of national subjectivity in the United States."[168] All of the assumptions or "common sense" upon which the state maintained its hegemony were now being opposed with impudence and impunity. Rather than being repulsive, black is beautiful. Rather than serving and protecting, the police intimidate and brutalize. Instead of informing, the dominant media misleads. Rather than providing for its most destitute citizens, the state neglects and denigrates them. We see how each of the Panthers' programs recast the roles of the state and its many agents in light of their actions within ghetto communities. In language, style, and deed, the police patrols, the survival programs, the newspaper, the Panthers themselves practiced and attempted to effect a transfiguration or transvaluation, to use Nietzsche's term signifying a shift in meaning, a term that Huey Newton was fond of, in this case a shift of the meaning of black bodies in public space in the United States. Even as the Panthers sought a revised black image, redefining what was deemed "negative" as "positive," they began to destabilize these very categories.

Or Was It the Pictures That Made Her Unrecognizable?

Each Tuesday through Sunday for nearly two months in the winter of 2000, multiracial and multigenerational crowds lined up in the bitter cold of Manhattan's tony upper East Side to witness a lynching. On January 13 of that year, *Witness: Photographs of Lynchings from the Collection of James Allen and John Littlefield*, opened at the very small, some might even say intimate, Roth Horowitz Gallery, an art space usually dedicated to the display of antiquarian books. The Roth Horowitz selected some seventy-five images supplemented by a few literary volumes, including first editions of Paul Lawrence Dunbar's *Oak and Ivy*, Oscar Micheaux's novel *The Conquest*, and other "historical ephemera" from their own collection.[1] The photographs of silent and silenced black men and women were hung on the gallery's bright white walls with limited or no text. The images included in the show, however, constituted only a partial selection of the one hundred and forty postcards and cabinet cards, photographs and stereographs that Atlanta-based antiques dealer James Allen and his partner, John Littlefield, had been gathering, tentatively at first and then quite aggressively, even obsessively, over the course of a decade.[2] Allen has continued collecting, and at last count the archive numbered some 225 photographs and 11 boxes of pamphlets, broadsides, letters, and newspaper clippings. Ninety-nine photographs appeared in the limited edition hardcover art book *Without Sanctuary: Lynching Photography in America*, published by noted fine art press Twin Palms, available for sale first at the Roth Horowitz and eventually at many bookstores and of course online.

Seen by hundreds of visitors each day, from major news media to high school groups, most waiting an hour or more in freezing temperatures, *Witness* was celebrated by critics as "essential viewing," "strange and beautiful," and a window to "one of the more complicated public secrets of this nation's past."[3] *Witness* provoked an abrupt awakening for some and tendered a painful confirmation for others. So popular was the exhibit that it was extended at the Roth Horowitz for an additional month, and then restaged across town at the New-York Historical Society as *Without Sanc-*

tuary: Lynching Photography in America from March 14 to July 9, 2000. *Without Sanctuary* then traveled to the Andy Warhol Museum in Pittsburgh, Pennsylvania (September 22, 2001, to January 21, 2002) before arriving in Atlanta, surrounded by conflict and controversy, at the Martin Luther King Jr. National Historical Site on May 1, 2002. There the show, cosponsored by Emory University, remained until December 31 of that year, drawing some 176,000 visitors. Since then, *Without Sanctuary* has been shown in Jackson, Mississippi, Detroit, Chicago, and Arles, France. In October 2008, it became part of the permanent collection of Atlanta's Center for Civil and Human Rights (CCHR), set to open in 2010. *Without Sanctuary* has pried open a space for the history of lynching to be told and retold, not only through the exhibits and the book, currently in its sixth printing, but significantly through a host of national and international public programs, conferences, and Web sites. It is a strange century that opens and closes with images of dead black bodies at center stage of our national imaginary.

The first decade of the twenty-first century saw a number of photographic exhibits commemorating African American struggle, periods both dark and triumphant, mounted at major museums, small galleries, local libraries, and university campuses.[4] In June 2008, the High Museum in Atlanta mounted *Road to Freedom: Photographs of the Civil Rights Movement, 1956–1968* to commemorate the fortieth anniversary of Martin Luther King's assassination, showcasing nearly two hundred images made by photojournalists, activists, and laypeople, largely from the museum's recently expanded permanent collection. It was a powerful coincidence that *Road to Freedom* would open in Washington, D.C., within days of the historic election of Barack Obama and remain on display through his inauguration as the first black president of the United States. *Road to Freedom* would offer up images of "the buses in Montgomery, the hoses in Birmingham, a bridge in Selma, and a preacher from Atlanta who told a people that 'We Shall Overcome'" that the new president-elect conjured in his election night speech.[5] With the new image of Barack Obama taking the oath of office, it would seem as if the road to freedom ended triumphantly on the steps of the Capitol, January 20, 2009.

By the time of the 2008 presidential election, the civil rights movement had been safely incorporated into United States history and memory, an often-triumphant tale of heroes, both well-known and unsung who through acts of bravery forced a nation to confront and better itself; this is certainly the inspirational narrative upon which the president-elect drew. But the legacy of the Black Panther Party has proved more difficult to tame, due

in part to the conundrum presented by the performative photographs now looked to as historical documents. In 2006, the fortieth anniversary of the founding of the BPP in nearby Oakland, San Francisco's Yerba Buena Center for the Arts (YBCA) worked with curator Claude Simard, and former Panther, photographer, and BPP archivist Billy X Jennings to produce the show *Black Panther Rank and File*. The exhibit brought photographs of the Panthers by a host of professional and amateur photographers, Emory Douglas's newspaper covers, and assorted Panther ephemera, together with contemporary post-Panther artwork "inspired by the Black Panther movement and reflecting its liberating ideals."[6] The nonprofit YBCA, with its mission to promote civic engagement and social justice through showcasing contemporary art, organized a series of public programs on topics ranging from revolutionary art, to the history of the BPP, to immigrant rights. Over the course of its four-month run, *Black Panther Rank and File* drew the largest crowds YBCA had seen to that date.

The journeys of lynching, civil rights, and black power photographs and the popularity of the exhibits in which they were displayed raise important questions at once political, historiographic, and ethical for the study of social movement photography, its intersection with the construction of history, and the shaping of memory. What happens when these images travel through time? Why and how does social movement photography resurge in particular moments? What messages and meanings does it carry in these new contexts, specifically on the clean white walls of museums? The exhibits, centered as they are on photography, are dependent on photographs to simultaneously narrate history, shape a legacy, and in the case of the civil rights and Black Panther shows, "elevate" photojournalists and photographer-activists to the status of artists. As Susan Sontag observed, "The memory museum is now mostly a visual one."[7] My goal is not to roundly condemn such a move from the frontlines of the African American freedom struggle to the safer spaces of the museum; for certainly the antilynching movement of the 1930s, SNCC, and the BPP all sought out art galleries to display their movements' imagery as a means of reaching new audiences in spaces that encouraged contemplation and conversation, rather than just shock and urgency. Instead, I am concerned with how photography in the context of these contemporary exhibits mobilizes racial and national memory. What narratives emerge about the movements and their legacies? And what is revealed about photography itself? Finally, to return to the paradox of the "movement photograph," does such mobilization necessarily lead to an ossification of the past, or can these images born out of

political struggle be offered a "living context," in the words of author and critic John Berger, in which we "incorporate [photography] . . . into social and political memory, instead of using it as a substitute which encourages the atrophy of any such memory?"[8] Through an examination of the traveling exhibits *Without Sanctuary, Road to Freedom: Photographs of the Civil Rights Movement, 1956–1968* and its companion show *After 1968: Contemporary Artists and the Civil Rights Legacy,* and *Black Panther Rank and File,* I explore how contemporary artists, activists, and curators wrestle with these questions of race, memory, and photography.

We must return then to the concept of critical black memory introduced in the first chapter, a mode of critically evaluating the past as a means of forging identity and organizing for future struggles that lies outside of the formal disciplines of history. Memory has been a fundamentally central and salient aspect of black life, history, and culture. Indeed, African Americans have been described as "a watchful people, a people who could not not know: a people of long memory."[9] We need to consider memory as a mode of criticism "that makes visible what has been obscured, what has been excluded and what has been forgotten."[10] Critical black memory functions as a mode of historical interpretation and political critique that has functioned as an important resource for framing and mobilizing African American social movements and political identities. This practice is one of many tools New World blacks and African Americans in particular have employed as a response to the dislocation, subjection, and dehumanization that has marked their experience of modernity.

Occupying an awkward place on the edge of history's archives, photography as historical resource is at once neutral and partisan, transparent and elusive, ideological, authentic yet unreliable. It is precisely in these interstices that photography has presented itself not only as a means of critiquing racial logics, but also as a technology of memory that attempts to speak back to formal history.

The Cultural Life of Black Corpses

Certainly, the *Without Sanctuary* collection has occupied such a discomfiting space, an archive that has proven difficult to curate yet hard to resist. Between 2000, when *Witness* opened, and 2009, *Without Sanctuary* was exhibited eight times and drew record crowds at nearly every location.[11] The evolution of the first four shows in particular reveals the challenges curators, intellectuals, and audiences faced in framing these photographs:

Should they be displayed with or without text? What sort of other images or objects, if any, should accompany the photographs in the exhibit? Who are the audiences for the shows: the consumer of modern art, the school group learning about civil rights, the professional historian? How will the space of the gallery and museum (which encourage "unfettered looking") or the library and historical site (which promote studious deliberation) influence the ways audiences see the photographs? Are the photographs to be understood as relics from the past, as aesthetic objects, as memorials, or as rallying cry? *Without Sanctuary* expanded with each move, and its narrative focus sharpened as Allen, along with exhibit committees established in each locale, wrestled with the meaning of the archive for each city and each exhibition context. It was only through an ongoing struggle with the photographs themselves and contending with the various kinds of memory work the images perform that such a framing could be established.

The Roth Horowitz show exploded into national consciousness like a repressed memory spontaneously recovered—traumatic, vivid, and almost incomprehensible. Though the accompanying book included important historical and personal essays that provided a guide to understanding the history of lynching, the photographs' origins, and their complex impact on African Americans, the exhibit itself was almost wholly wordless. Indeed, the show's title, *Witness*, offered almost the only text in the entire exhibition. *Witness* commanded its viewers to look and remember but gave them little or no indication of what or, more importantly, who they were beholding. Without display cards, the photographs became less than art objects and hung as images of horror outside of time, bespeaking a history without place, depicting subjects—black and white—without agency. Present at the gallery almost every day of the show's run to provide the missing narrative to interested visitors, Allen declared, "these are not universal images [but] individual personalities."[12]

Allen expressed great disapproval with the structure of the Roth Horowitz exhibit, leading him to take a greater hand in the show's next presentation at the New-York Historical Society. A white southerner, Allen enlisted the help of African American art curator Julia Hotton to produce *Without Sanctuary* at the NYHS. In an extremely large presentation, descriptive labels and lengthy exhibition text accompanied the photographs. Allen and Hotton further supplemented the photographs with "material from the Historical Society's collections . . . added to provide a fuller picture of the anti-lynching movement's activities in New York," including "books, pamphlets and placards." Finally, "public programs at the Historical Society [in-

cluding symposia, film showings, and roundtable discussions] . . . also en-
courage[d] a dialogue with the public about modern New Yorkers' reaction
to these harrowing images."[13] Where *Witness* unearthed the photographs to
let them float unanchored on the gallery's walls, the NYHS exhibit seemed
to bury the images in a sea of facts and figures. Books available on tables,
computer banks, and bright lights hanging from the space's vaulted ceil-
ings encouraged research—indeed NYHS is a library as well as a museum.
Such a design worked to reassert the individuality and historical specificity
of the victims imaged in the show's ninety-eight photographs. But it also
proscribed viewers' affective responses, as the amount of text to be read
proved daunting. No longer mounted as aesthetic objects, the photographs
were designated as historical documents. Yet neither the photographs nor
the viewers were allowed to speak for themselves.

Overall, these additions composed a "very contextualized format" for
the photographs and followed the exhibit in each incarnation.[14] The Andy
Warhol Museum in Pittsburgh, *Without Sanctuary*'s next location, placed
the exhibit at the center of a community "Project." With the aid of a com-
munity advisory board, the Warhol Museum hosted daily public symposia
and "dialogues," musical performances, and a short film series. While the
photographs themselves were displayed chronologically by date of lynch-
ing, with short identifying labels, the galleries surrounding *Without Sanc-
tuary* aimed to provide a larger historical context through a timeline of
African American history, and exhibits on Billie Holiday and the historic
African American newspaper *Pittsburgh Courier*. There were also separate
spaces for reflection, commentary, and conversation. The photographs then
were provided space for contemplation as well as a context for historical
comprehension.

The presentation at the Warhol Museum forced the curators to explicitly
engage the question of viewing space. Devoted to contemporary art, popu-
lar culture, and the work of pop artist and innovator Andy Warhol, which
revels in the reproducibility of cultural signs, the museum would seem an
odd choice for the display of lynching photography. The museum's cura-
tors were all too aware of this seeming incongruity, but according to Jessica
Gogan, assistant director of education, they saw in *Without Sanctuary* an
opportunity to engage in civic dialogue against the backdrop of two racially
motivated killings that took place in Pittsburgh in 2000, as well as in the
immediate aftermath of the September 11 terrorist attacks in New York and
Washington, D.C. The organizers of the show began to think explicitly and

critically about how to *use* the photographs; that is, what work they might do for contemporary local audiences.

By the time *Without Sanctuary* arrived in Atlanta, framing the relevance of the collection was not merely a concern but an imperative and a source of conflict. The Atlanta exhibition of *Without Sanctuary* marked the first time these profound images would be shown in the South. The first time, that is, since their birth at the sites of lynchings throughout the region. One could say lynching photography had returned home, but not without struggle and controversy. In spring 2000, initial discussions about bringing the collection to the Atlanta History Center ended in bitter acrimony when Rick Beard, executive director of the AHC, expressed extreme hesitation and decided to put the exhibit off for at least four years. Beard continually posed the question to James Allen, "Is Atlanta ready for this?" "Put bluntly," Beard would later write in a letter to Randall Burkett, head archivist of Emory's African American collections, "the city that's 'too busy to hate' is also the city too busy to think deeply about the painful aspects of its past until somebody foreign tells them it's okay."[15] Allen responded to this concern by averring that the "rich white people" who serve on the AHC's board "did not want it here. They shouldn't call it a history center. They should call it the Atlanta Heritage Society."[16] At the beginning of the twenty-first century, lynching images would emerge as a battleground over the meanings and place of history.

Even Emory University, which sought to house the collection in its library, expressed deep reservations about the public display of lynching photography. After more than six months of public and private forums to assess whether "such a show [might] foster understanding and healing, or would exacerbate racial tensions around Emory and Atlanta," an advisory committee determined that the photographs must be exhibited.[17] "We [at Emory] are so beyond ready for it. Why are we even still asking? We are overdue it, in my mind," commented advisory member Deborah Lipstadt, Dorot Professor of Modern Jewish History and Holocaust Studies at Emory.[18] Like its previous northern incarnations, *Without Sanctuary* in Atlanta hosted thousands of visitors. The popularity and profound impact of the exhibit proved that lynching still held sway on viewing audiences and that lynching photography could map and define the boundaries of new imagined communities, including those of a "raceless," "classless," post–civil rights America. That these horrific events occurred was not in question. At stake in the successive rebirths of *Without Sanctuary* was the very memory of

both lynching's history and the legacy of the antilynching movement that mob violence precipitated.

With the 2002 show at Atlanta's King Center, a presentation format and narrative structure was established that provided the model for subsequent exhibitions, including the proposed design for the permanent exhibition of the CCHR. In this structure, and specifically within subsequent sites devoted to African American history, lynching photography is placed within the larger African American freedom struggle, and in the case of the CCHR, as "anchor [for] the first chapter" of the story of the road to civil rights. Emory University sponsored a four-day international conference entitled "Lynching and Racial Violence: Histories and Legacies." At the exhibit's location within Atlanta's historic black Auburn Avenue neighborhood and across the street from the Ebenezer Baptist Church, Reverend King's home congregation, the photographs and their descriptions were mounted on the walls of a black room with a bold red line painted just beneath the images, literally underlining the bloody history on display—a color design that was replicated in subsequent editions of the Twin Palms book. The lynching photographs themselves constituted about half of the items in the exhibit. Antilynching propaganda—from Ida B. Wells's pamphlets to Soviet posters to French broadsides—were featured prominently throughout the room in display cases made from Georgia oak. Trees whose branches may have once borne the dead weight of Sam Hose or Leo Frank now enshrined local, national, and international efforts to bring their murderers to justice. Regarding this distributive choice, the curator of the exhibit and director of the Sonja Haynes Stone Black Cultural Center at the University of North Carolina at Chapel Hill, Joseph P. Jordan, commented, "These images and texts document one of America's more brutal, violent, and racist periods, which subsequently gave birth to an equally powerful and resolute set of forces dedicated to justice, humanism, and dignity."[19] Indeed, when visitors exited the display room, they entered the wider presentation of photographs, sculptures, and timelines that constitute the King Center's permanent exhibit of the 1960s civil rights movement. Lynching and antilynching are meant to be understood as but one component of the ongoing African American freedom struggle.

The visual material of *Without Sanctuary* at the King Center display were situated within a general soundscape of black work songs and sounds of the southern night, meant to evoke the spaces in which lynchings took place and a structure of feeling of black life in the South. Billie Holiday's voice, singing the popular and haunting "Strange Fruit," greeted visitors to

the exhibit in an anteroom devoid of images. Visitors were invited to read the lyrics, written by Abel Meeropol, also known as Lewis Allan, a Jewish schoolteacher and Communist sympathizer, transcribed in white letters against the black backdrop. This aural introduction to the exhibit prepared guests for what they were about to behold, letting them hear first a description of "black bodies swinging in the Southern breeze." It also informed viewers that like Holiday's first performance of "Strange Fruit" at New York City's integrated and politically progressive nightclub, Café Society, in 1939, the images to be seen are at once disturbing and moving, "a declaration of war . . . the beginning of the civil rights movement."[20]

As curator, as well as an academic and community activist, Jordan worked carefully to historically contextualize the photographs, to politically inform the exhibit's audiences while also providing a respectful memorial for the victims themselves—not a simple task. After the photographs' circulation on Web sites, in the early exhibits, and through the Twin Palms publication, enfolding *Without Sanctuary* into a critical black memory would prove difficult. Many responses by Web site and museum visitors engaged the photographs in a process of public memory in at least two distinct yet similar ways, though there are a host of articulations. First the photographs were maneuvered to reanimate certain forms of political struggle through resuscitation of the icons that have come to signal such struggles. Conversely, the photographs encouraged the curtailment of political struggle and the reification of past social movements. Or, as Natasha Barnes, a professor of English and member of the Emory advisory board, expressed her reservations about displaying lynching photographs in Atlanta: "[One of the dangers is] cheap conversations about race relations, whether it's a 'We're being lynched today' narrative or a 'We're really past that now, it's history.'"[21] Photography can readily aid and abet either "narrative," indeed reducing the complex axis of violence, communal belonging, and social disorder to an easy black-white dyad under the rubric "race relations."

In the first scenario, the reawakening of political engagement was achieved through acknowledgement and activation of what we might call the *spatiality* of the photograph, literally what inhabits the picture's frame. This spatiality is similar to Roland Barthes's definition of the "studium," "the general enthusiastic commitment" on the part of the viewer for what the photographer has framed.[22] Here we pay attention to the fact of the image's subjects, the weight of their photographic presence across time, their intractability. Employed as document, the photograph can further be called upon to illustrate the persistence and *unchanging* nature of black oppres-

sion: African Americans suffered then, at the hands of white Americans, as they do now. After viewing images on the *Without Sanctuary* Web site, Wiley J. Huff, a police trainer in Miami, Florida, lamented, "Our society is still involved in the lynching of innocent people. We have not moved one iota toward a more civilized society in the United States of America . . . Unfortuantely [*sic*], I don't expect change in our collective national character. What a shame."[23]

By considering the spatiality of the photograph, its subject, its studium only, viewers serve to resituate African American freedom struggles within or upon the skin alone. Viewers are to take the political solutions represented within the space of the photograph, quite literally, at face value: black people alone can mount movements for social justice, movements whose strategies replicate those that proved successful in a previous social formation. Strategies for struggle often remain imprisoned within the past of the image itself. Likewise, lynching photographs can further entrench lynching iconography despite radically different social landscapes. The seeming public insatiability for tales of racial violence and transgression has kept the tale of the black male rapist/criminal (O. J. Simpson, Washington, D.C.-area sniper John Muhammad, racial profiling) alive and well and circulating in our cultural and political imaginary. This narrative finds its "antithesis" in the image of "the lynched black man," which has emerged and evolved as visual shorthand, as a powerful icon paradigmatic of the suffering of all African Americans understood only through the abject black male body. This is the highly vivid and visual discursive framework through which conservative African American Supreme Court nominee Clarence Thomas could cry "legal lynching" in the face of accusations of sexual harassment made by equally conservative African American lawyer Anita Hill.[24] Attentiveness to a photograph's spatiality without regard to its role as artifact can often facilitate such narrow and incomplete responses.

Likewise, a focus on a photograph's *temporality*, its pastness, its signification as artifact, can engender the limitation of political activity. This is a second mode through which photographic memory operates. Here, curators, politicians, popular culture makers, to name only a few groups, employ social movement photography to inform us that the black people who populate such images as victims (or revolutionaries, as in the case of Panther imagery; or both, as we have with SNCC photographs) no longer exist. Likewise, their white oppressors are gone as well. Also vanished is the America that enabled such crimes or created the conditions for radical dissent.

(black body)

In these ways, social movement photography may provide solace and a pretext for inaction. Angel L. Fox, another Web site commentator, reflected that the *Without Sanctuary* photographs caused him/her to "think about all the evil and the harm that a group of people can actually do. It also makes me thankful that things have changed somewhat, and justice will be served by the courts, or on Judgement Day."[25] For Fox, the photographs evoked a moment of contemplation. Yet, immediately following, they also caused Fox to absent himself/herself from them and all they might imply. In this context and for this observer, lynching photographs became "arrested moments," John Berger's term that refers to the way public photographs first seize viewers and then in the next moment alienate them through the image's discontinuity with the viewers' present moment.[26] In this moment of alienation, the image and its subject become relics, old news. The lynching images Fox viewed are public photographs from a long ago past made even more distant and abstract through the technology of the Internet and a Web site format. Through a sort of double mediation, Fox is absolved from any connection with lynching's history and therefore cannot be personally implicated in any drive for justice. That is reserved for a higher power, whether that is the government or God. Through an emphasis on the photograph's temporality, its Medusalike break from the flow of time, viewers are encouraged to see the "then and now" as wholly separate and distinct. The photograph as document serves as a fixed point in time— though floating in cyberspace—one by which we can measure our progress as a society.

But photography, when placed in a broader context, can also encourage a critical evaluation of the past. The various incarnations of *Without Sanctuary* searched for an acceptable framework, a means of situating the photographs so as to be able to truly "articulate the past historically," recognizing both the persistence of racism even as it takes on new guises. M. G. Moore, another visitor to the *Without Sanctuary* Web site, commented similarly, "How can we as Black Americans go to fight Iraq, because their people have been persecuted, when the same thing is happening to Black Americans today . . . Blacks in American [*sic*] are still being lynch [*sic*] under the Bush Administration."[27]

M. G. Moore's response also suggests that the photographs may provide a framework for making sense of one's own moment and shaping future actions: "How can we as Black Americans go to fight Iraq." As Walter Benjamin informs us, "to articulate the past historically does not mean to recognize it 'the way it really was.' It means to seize hold of a memory

as it flashes up at a moment of danger."[28] Benjamin's assertion compels us to ask: Why these images now? What do they tell us about our contemporary crises? In many contexts, the photographs are maneuvered to inform us that the past is not over. Rather than a complete loss of historical specificity and the total collapse of time, "then" and "now" are linked, albeit in a distinctly linear fashion. Such connections, moreover, can offer a charged political language through which to voice dissent. In an Emory course on lynching, a young black male student from Atlanta "argued that lynchings never really stopped, given police brutality, racial profiling and the lopsided number of African-Americans sentenced to death."[29] Lynching photographs may encourage viewers to look for lynching's present-day manifestations. In turn, through the present angle of refraction, the crime of lynching in its own moment is rendered legible to contemporary viewers, especially those generations not personally touched by mob violence.

While Allen himself recognized the significance of the archive "as a blunt instrument for starting a discussion about race in America," he struggled to place the collection in what he deemed a suitable permanent home.[30] Even as the exhibit traveled widely, the Twin Palms book went into multiple printings, and the Web sites hosted scores of visitors each day, framing the images in order to perform the educational and political work that Allen hoped for still proved difficult. After working to sell the collection to Emory University's Woodruff Library in 2002, by January 2003 Allen was "disappointed" with the library's handling of the material.[31] For the next few years, Allen housed the still-growing *Without Sanctuary* in his own home and nearly sold it to Cornell University in upstate New York. He remained committed, however, to keeping the collection in the South, forcing larger conversations about the history of race and violence in the region. In October 2008, Atlanta's newly founded Center for Civil and Human Rights announced it had acquired the archive, with substantial support from Mayor Shirley Franklin and the city. Here as part of the Martin Luther King National Historical Site, *Without Sanctuary* would be inserted into a longer civil rights history. And while civil rights veteran and CCHR advisory board member C. T. Vivian opined, "I'm not clear on the purpose of showing these pictures," his fellow board member, Lonnie King, contended that the lynching archive is "as important as the King papers. . . . They show the mindset the movement had to fight against."[32] With the purchase by the CCHR, the lynching archive and its place in collective memory now have an established narrative.

Though these photographs may have found a permanent home and a

convincing place within the larger narrative of the black freedom struggle, their meaning may never become anything close to stable, but will by necessity continue to evolve over time. This inability to fix the meaning of these images is both necessary and unsettling. For what should be more painfully objective than a photograph of such forensic value: an image of a murder victim surrounded by his or her killers? Yet, across the long twentieth century, the meaning of these images has been a site of struggle, as evidence of white supremacy or white barbarism, as something inescapably present or decidedly rendered into the past, as ghostly apparition or legal forensic document—the meaning of these most arresting images refused to remain still.

"Interested in Moments I Didn't Exist In": Photography and Postmemory

Whether seeking connections with the past or distancing oneself from it, all visitors to the *Without Sanctuary* Web site or exhibits found the corpus of lynching photography unsettling. Perhaps these images that had been buried for so long in the deep possession of white owners coming out into the light of day signaled that a new battle for an engaged critical black memory was now well underway. Joseph Jordan understood this battle when many asked him, "'Why bring up this era of U.S. history when we've worked so hard to overcome the history of terror and hatred that plagued us in those dark years?'"[33] The very fact of the photographs' existence and the history of mob violence they described could not be denied at the turn of the twenty-first century. Indeed, the concern among Atlanta's elite—the Atlanta History Center, Emory University—was not whether the veracity of the photographs would be questioned but in what meaning viewers, southern viewers, would make of a truth that seemed equally likely to "foster understanding and healing" as it did to "exacerbate racial tensions." And the exhibit's proponents, including Jordan and the Emory advisory board, feared that the presentation of lynching images would occasion simple conversations that eventually devolved into "a short-cut to false reconciliation."[34] Though this is not what Jordan wanted, he averred, "Yet, for me, above all, this exhibit underscores the need for truth as a way to reconciliation. Truth, relentlessly pursued, suggests that justice cannot be far behind."[35] For most involved in bringing *Without Sanctuary* to public view, the greater crime would be to keep the photographs hidden, to disavow and disallow their role in shaping American memory.

There has been little such debate about photographs of the civil rights movement. Images that effected a national moral transformation, documents that aided the passage of some of the most important legislation in this country's history, and photographs that garnered Pulitzers and other prizes for their makers have hardly ever been out of national sight since their inception. Moreover, with the passage of the Civil Rights Act of 1964 and the Voting Rights Act of 1965, these photographs quickly became "history" and marked the "end" of the civil rights movement. By emphasizing the temporality of these particular photographs, their "pastness," a simple ending can be found for a history whose end is still being written, while earlier struggles and their attendant traumas can be safely ensconced in the past. Certainly, in our present moment a multiplicity of political standpoints compete to claim their place as heir apparent to Martin Luther King and legatees of the movement's righteous outrage. The photographs, for example, of Project C—reproduced as bronze statues in Birmingham's Kelly Ingram Park—or images from the March on Washington—incorporated into television and print advertisements—work to produce what Renee Romano and I have elsewhere described as a "consensus memory" of the civil rights movement that provides a safe touchstone to mark how far we have come as a nation from the dark times of Jim Crow.[36]

Indeed, the challenge for the High Museum's 2008 exhibit *Road to Freedom: Photographs of the Civil Rights Movement, 1956–1968*, and other similar though smaller exhibits, has been where to find new and unseen photographs of the civil rights movement, and how to look beyond the iconic to the hidden, the local, the untold. Yet the iconic photos are included by necessity, leading to questions of what new insight could be gleaned from reviewing such well-known pictures. What would draw audiences to see images already seared into the national imaginary?

For the High Museum's curator of photography, Julian Cox, presenting the archive of civil rights photography offered both a set of challenges but also a series of opportunities. Mounting such an exhibit in commemoration of the fortieth anniversary of Atlanta native Martin Luther King's assassination almost guaranteed a broad audience while creating space for Cox to develop the Atlanta museum's photography collection. *Road to Freedom's* 250 photographs include well-known images of Rosa Parks being fingerprinted in 1956, Charles Moore's Birmingham photographs, and various shots of Martin Luther King. The exhibit is also comprised of newly discovered photographs of the 1961 bombing of a Freedom Rider bus in Anniston, Alabama, held in a law firm "for decades as potential evidence"; other

views of Project C made by a Birmingham Police Department detective; and photographs by SNCC worker and Free Southern Theater founder Doris Derby. Derby's images, in particular, from the Mississippi delta depict the quiet and hard work of individuals engaged in collective work and community life amid the chaos and turmoil of civil rights organizing: activists listening intently at community meetings, black nurses and doctors serving in health clinics, well-dressed African American women working at a food cooperative. All of these black and white images made by professionals, amateurs, and unknowns, were successfully enfolded into a narrative of triumph, signposts on "the road to freedom," and indeed Cox hopes the collection will "have a presence" at the nearby CCHR.[37] The mix of the familiar and the newly found underscore photography's central role in the making of the civil rights movement; the importance of the camera to both participants and observers for making sense of these events; and the continued attraction such images hold for contemporary audiences to narrativize both the history of the civil rights movement and its legacy.

Separated by a wall from *Road to Freedom* at the High Museum, an accompanying exhibit was mounted that placed contemporary artists in conversation with these iconic photographs and began the work of questioning its own narrative. Organized by Jeffrey Grove, the High Museum's Wieland Family Curator of Modern and Contemporary Art, *After 1968* showcases the work of seven artists born in or after 1968 who were sent previews of *Road to Freedom* and commissioned to create work in response. Though *After 1968* might be described as "homage," most of the works are neither entirely reverent nor wholly uncritical of either the earlier photographs or the legacy of the movement. It is telling as well that while the artists were commissioned to produce new work, much of what emerged was either work that was already in progress or that fit into themes already consistently explored by each of these artists, including the commodification of black life and political ideals, the struggle to test the meanings of blackness against the backdrop of history and its received narratives, and new modes of interpreting and representing the past.

After 1968 offers an example of a postmemory project. "Postmemory" is Marianne Hirsch's term for second-generation understandings of the Holocaust, experiences of cultural or collective trauma that were not actually lived through by younger generations of Jews, but ones "powerful, so monumental, as to constitute memories in their own right."[38] Postmemory straddles the line between overidentification with the photograph's original subjects, in this case Holocaust victims or survivors, and complete displace-

ment and distancing. It also acknowledges how memory is largely "mediated not through recollection but through representation, projection and creation," and the events themselves are often experienced and comprehended through repetition.[39] Photographs in particular offer a shared terrain and aid the transmission of Holocaust history and memory; moreover, "compulsive and traumatic repetition connects the second generation to the first."[40] Postmemory applies equally well to photographs of lynching or Project C as it does to images of the Holocaust. Through their engagement with the civil rights archive and its attendant narrative, the artists in *After 1968*, like so many of their generation, contend with a history that has shaped their life choices and set the terms of their self-fashioning, but with which they have neither direct experience nor personal memory.

Born in 1977, Leslie Hewitt, in a series titled *riffs on real time* (2002–9), attempts to locate the artist within a signal moment of history though there are obviously no documents of her existence. She takes old family photographs and found images and frames them first on cloth book covers, magazine covers, or loose-leaf notebook paper, and then places them atop vibrant-colored shag carpets or wood-paneled flooring before photographing them in natural light (figure c.1). Such layering gives the work a three-dimensional, sculptural effect, suggesting a "liveness" and proximity that is tempered by the tattered edges of the books, the uneven knots of rugs in hues long out of favor, and the washed-out colors of the original photographs. She moves very public history from the streets to the home; domestic images of earlier periods offer a space to signal closeness and absence. For Hewitt, "When it comes to the black power movement, there is so much documentation of violence, discontent and aggression. . . . I didn't always see my personal story."[41] Employing the photograph as public document, Hewitt marks her own absence from the past; employing the photograph as family portrait, she makes known her desire for connectivity. In this way, *riffs on real time* is her own temporally and spatially present improvisation on history's well-known verses. As she comments, "I'm really interested in moments I didn't exist in."[42] History, Hewitt informs us, is both daunting and intimate, tactile yet elusive.

In Deborah Grant's artwork, history accumulates. Her twenty-four-panel installation included in *After 1968*, *The Flaming Fury of Bayard Rustin the Queen at the End of the Bar*, rearranges photographs cut from civil rights era newspapers and combines them with hand-drawn images and text set against a rich red background to provoke new meanings and associations.

Figure c.1. Leslie Hewitt, *riffs on real time* (1 of 10), 2002–5, chromogenic print, 30 × 24 inches (76.2 × 61 cm). (Collection of the artist)

Arranged in a grid, the uniform, 24- × 18-inch pieces together appear as a comic book or stills from a 35mm film (moving at twenty-four frames per second). In a process she calls "Random Select," Grant's aim is "for the viewer is to get an experience but then to make their own decision based on . . . recognizable images or sourced imagery." In her reassembly, "images that . . . translate into our mind" now compel the viewer to ask, "how can we then correlate these images back to a present when they're re-presented in another context?"[43] In the piece, a white policeman embraces—or arrests—a black woman, while Jean-Michel Basquiat's graffiti crown (itself appropriated from a New York street gang) hovers over them; in another panel an arm reaches into the frame holding a photograph of Cynthia Wesley, one of four young black girls murdered at Birmingham's Sixteenth Street Baptist Church on September 15, 1963; below her dangling portrait, beer bottles fashioned into Molotov cocktails are lined up neatly. And in another, Fannie Lou Hamer opens her mouth and sings Arabic phrases written neatly in gold (figure c.2). Though somewhat irreverent, Grant's collages are not as random as they might seem, as she mines words and images for their multiple meanings: "flaming" for example refers to church bombings and urban riots, to uncontrollable anger and "excessive" queerness, referenced in the person of Bayard Rustin, a key architect of nonviolent self-defense and close adviser of Martin Luther King, who was nonetheless marginalized and eventually silenced by the movement for his open homosexuality.

Indeed, Grant refuses to be imprisoned by photographs or in turn affix to them any single meaning. This comes in part from a refusal to be nostalgic: in her estimation, the photographs she collects are "not hard to cut up at all."[44] On one hand, Grant's method suggests a total evisceration of the civil rights movement and its legacy. While taking for granted the "blackness" of its subjects, social movement photography in Grant's work simultaneously defamiliarizes iconic images while spectacularizing the contexts and events the photographs depict. In doing so, a form of colorblindness is advanced, one in which what we see—black bodies in struggle—no longer matters. All we are asked or encouraged to see is the two-dimensional, black image that at once hails an earlier period, but whose meaning and signification are rewritten for the present. In this way, the blackness of the subject becomes a vestige of the past, an article of clothing, adorning the eternal present. Social movement photography becomes reified, used not to forget the past, but mostly to recall those elements that can be easily and readily consumed. Or, as with the portrait of Fannie Lou Hamer, these images can show how hegemonic black bodies have become as icons of protest, suggesting that

Figure c.2. Deborah Grant, *The Flaming Fury of Bayard Rustin the Queen at the End of the Bar*, 2008, mixed media on 24 enamel-painted birch panels, 24 × 18 inches each. Photograph by Mike Jensen. (Courtesy of the artist)

in a post-9/11 world blackness as sign continues to stand in opposition to injustice.

Yet such a disembowelment of history may be necessary if it affords opportunities to tell new stories woven from both individual and collective memories. For Grant, born in 1968 in Toronto, Ontario, to Barbadian parents who moved the family first to the desiccated South Bronx of the 1970s and then to diverse and fraught Coney Island, these memories are as much about histories of colonialism and migration as they are histories of Jean-Michel Basquiat and Nan Goldin. Grant's work reflects a range of experiences, a wealth of cultural and historical encounters, and a process of mixing common to a generation accustomed to navigating a diverse so-

cial landscape, terrain that has been opened up by the 1960s movements. Grant's use of civil rights photographs first eviscerate and then re-create blackness and the meanings of struggle for social justice right before our eyes in ways that are at once attentive to history but attuned to the multiple visions that inhabit the present.

Black Panther Rank and File:
Was It the Pictures That Made Them Unrecognizable?

The fraught legacy of the Black Panther Party has inevitably invited more ambivalent visual responses than has the civil rights movement. From blaxploitation films of the 1970s to hip-hop culture of the 1990s, to the 2008 presidential election, the iconography of black power, and of the Black Panthers in particular, has been the staging ground for articulations of both cartoonish radicalism and dangerous resistance.[45] The deployment of BPP imagery has also opened a space in which to consider how such memory continues to shape or foreclose contemporary activism.

In her compelling video *a/k/a Mrs. George Gilbert* (2004), Coco Fusco combines archival footage, press clippings, trial transcripts, and FBI records with "simulated surveillance footage" and fictionalized dialogue to consider the investments of those both on the left and on the right in the image of Angela Davis. Included as part of the expansive *Black Panther Rank and File* exhibit, the thirty-one-minute, grainy, black-and-white piece chronicles Davis's emergence as a political figure in the late 1960s when she was fired from her professorship at the University of California by then-governor Ronald Reagan for her public affiliation with the BPP and the Communist Party; her support of prisoner and philosopher George Jackson; her placement on the FBI's "Ten Most Wanted" list for her alleged involvement in Jonathan Jackson's tragic takeover of the Marin County Courthouse; the harrowing two-month period she spent underground; and following her eventual capture, the international campaign calling for her release. Finding that both the politically progressive artist and the FBI agent assigned to trail the fugitive are drawn to Davis as elusive icon, Fusco examines how multiple uses of photography—as tool of surveillance, as criminal mug shot, and as celebratory portrait—converge to render a subject at once desirable and fearsome, accessible and inscrutable. Davis's ubiquitous image as FBI "Wanted" poster and political campaign poster, as well as in a host of newspapers and magazines, served to vilify and venerate her. It also served as

the "pretext for something akin to a reign of terror," a justification for the racial-gender profiling of hundreds of black women who were followed, detained, and even jailed while police forces searched for the elusive Davis.[46] Davis in the meantime donned a number of disguises and aliases, including "Mrs. George Gilbert," to escape detection. The video's female narrator asks in a voice-over, "Was it the Afro, the glasses, . . . or was it the pictures that made her unrecognizable?" Photography as a technology of surveillance functions as both vehicle and synecdoche for the ways in which desire, containment, and scopophilia converge in dominant modes of looking at black bodies.

A/k/a Mrs. George Gilbert raises two important, interrelated questions: first, how might photographs, rather than offering easy access to history, instead render the past unrecognizable? And by constructing this video as a compilation and at times a conversation between disparate parties, Fusco compels us to ask, what is the relationship between the memories of individuals and the memories of groups as these memories congregate around a set of shared images? What visions of the collective emerge from these contrasting individuals and their different relationships to the past? In its form *a/k/a Mrs. George Gilbert*, like the *Black Panther Rank and File* exhibit in which it was included, suggests a kind of "collected memory," a need to draw on multiple positionalities and a range of forms to best comprehend the breadth of collective memory.

The organizers of *Black Panther Rank and File* were faced with the task of how to project a fraught political legacy within the space of the art museum. The sprawling exhibit mixed art and artifact and incorporated the work of more than fifty artists, photographers, documentarians, journalists, and movement participants and activists from across a two-hundred-year period, the bulk of the work being from the last forty years. As curator René de Guzman writes in his introduction to the show, "By putting historical records next to works of art, *Black Panther Rank and File* offers an exhibition experience that grows out of the poetic association between the two."

At times the curatorial selections seemed unwieldy and only marginally connected to the theme of the show. Indeed we must ask, how expansive was the Panther's ideology and style that they could incorporate so many disparate pieces? Why are they at the center of our memories of black power? Why do they serve as entry point for so many divergent artistic statements and explorations? On one hand these choices say less about the Panthers specifically than the turn of a particular way of seeing black-

ness, initiated in part by the Panthers but indicative of the movement more broadly. At times throughout the multi-room exhibit, the BPP faded into the backdrop, and the Party itself became "unrecognizable."

However in its breadth, in the exhibit's very unwieldiness, we can see the workings of a practice of critical black memory. We can see an attempt to engage the range of the Panther archive, with an emphasis and reliance on the photographic archive. The exhibit offered a material and physical space in which the artwork of Emory Douglas and the photographs of Ruth Marion-Baruch and Pirkle Jones came face to face with the experimental film of Coco Fusco and Michael Britto and the conceptual work of Carrie Mae Weems and Kerry James Marshall. *Black Panther Rank and File* articulated—joined up and expressed—a collected memory of the BPP.

By "collected memory," I refer to sociologist Jeffrey Olick's call to clarify our usage of the term "collective memory," itself an idiom caught between "two cultures." One concept treats culture as the terrain of the individual, "a subjective category of meanings contained in people's minds," and collective memory is thus the sum of individual remembrances; while the other concept imagines a collective memory expressed through the group as articulated through commemorations, rituals, and other "publicly available symbols and narratives."[47] The difficulty in the concept of collective memory arises in deciphering the relationship between its various forms: do the memories of the group—the race, the class, the nation—fundamentally shape what and how individuals remember or is collective memory composed of and by the memories of individuals? By thinking of culture as the province of both individuals and groups, and as a site in which we struggle as individuals *and* groups, however, we can recognize memory's circularity rather than a unidirectionality. To quote Olick, "It is not just that we remember as members of groups, but that we constitute those groups and their members simultaneously in the act (thus re-member-ing)."[48]

The concept of collected memory is an important provocation. Here I would like to emphasize the notion of collection, of aggregation. Surveys and oral histories constitute the most common tools of collected memory for their capacity to "give voice" to individuals. But we might broaden these tools to consider the assemblage of the archive and the role of the collector, or the curator. In this way, memory work becomes, in anthropologist David Scott's estimation, a form of archeology, a process of assembly, and re-membering. Collecting is "at once an art and a mode of intelligibility."[49] Imagining *Black Panther Rank and File* as an example of collected memory gives space for individuals and groups to speak back to one another.

Collected memory does not assume a falsely universalizing or monolithic group but recognizes that within the "collective" members remember differently. Or choose not to remember at all. That is, attention to collected memory can allow for a freer play of difference across the many intersecting identities of a group: gender, sexuality, generation, geography, class. It also suggests the possibilities of a critical black memory that allows for a reactivation of activism in the present through an engagement with the past, one that provides a living context rather than a reified set of fossils.

While a number of the works were explicitly celebratory, bordering on hagiography, like Sam Durant's "Model for a Monument to Huey Newton" which stood in the Yerba Buena lobby, others were more mournful and elegiac, ironic, and most interestingly, deeply ambivalent. Pieces like Jonathan Seliger's African American flag shopping bag (X, 2004), for example; or Satch Hoyt's large black power fist Afro-pick inlaid with cubic zirconium resting in a velvet lined wood case (*From Mau Mau to Bling Bling*, 2003); or Hank Willis Thomas's disembodied arm, dressed in a suit sleeve and wearing a gold watch, raised high in a black power fist (*It's About Time*, 2005), each evaluate the status of African American liberation movements one and two generations later (figure c.3). Each of the artists seem to lament that the "success" of black power is measured in access to consumer products—a gold watch, a shopping bag, jewelry—suggesting that the process of incorporation has gone corporate and the movement has been commodified. This is certainly an interpretation encouraged by the exhibit curators, who placed Willis-Thomas's fist alongside a framed print of Newton's spear poster in a small room facing busy Mission Street. Yet these works offer wry commentary about a political struggle that has always been pressed into the spaces between capitalism and cultural representation. At the turn of the twenty-first century, the avenues for black political expression are intimately tied to the marketplace.

The site of the exhibit mimicked the site of memory itself: a space in which documents of historical events are not unitary or cohesive, but rather where "memories" become engrams, "bits and pieces channeled to different places in the brain and stored in different ways." As Olick writes, "The process of remembering does not involve the 'reappearance' or 'reproduction' of an experience in its original form, but the cobbling together of a new memory."[50] *Black Panther Rank and File* overall did not attempt to "condense history" or offer a consensus memory of the Panthers.[51] Rather, through aggregation and juxtaposition, *Black Panther: Rank and File* as an example of collected memory was attuned to the individual and the collec-

Figure c.3.
Hank Willis-
Thomas,
*It's About
Time* (2005).
Photograph by
Leigh Raiford.
(Courtesy of
the artist)

tive, to the multigenerational and the multigendered. As more than the sum
of its parts, it revealed the complexities of both the Black Panthers and of
the practices of critical black memory.

From the scattered incompleteness of the exhibit, of the original images
of the Panthers and of the Panther project itself, expanded visions of col-
lected memory emerge. There is unfinished business here, which holds an
opportunity for contemporary urban grassroots activism. Just outside the
exhibit proper in the Resource Room, *Black Panther Rank and File* included

a multimedia installation by Oakland-based artist collective Soul Salon 10. *10 Mo'* extends the original call of the Panther Ten Point Platform, adding "We Want Fresh Shit," addressing the lack of healthy food options and the damaging proliferation of liquor stores, corner markets selling junk food, as well as violence in present-day West Oakland (figures c.4a and c.4b). One wall features a gray stencil of a local convenience store, a neon "Open" sign shines brightly. The original Ten Point Platform is reproduced below. At the center of the installation, a large outline of a bottle is cluttered with empty liquor bottles, old photographs, a discarded shoe and deep red roses, ephemera from the artists' own lives. The bottle pours its contents onto a modest table set for two; prepackaged pork rinds, Slim Jims, and assorted candy packs pile up in the table's center. Above the table on the shocking orange wall, a black hooded sweatshirt bearing a memorial photograph to a young black man is partially framed. An empty gilded frame is nearby, perhaps waiting to memorialize another young black man, or bespeaking the absence of a frameable past or the lack of a memory worth preserving. Painted oversized silhouettes of men loom like specters and aim fingers clenched into guns at both frames; the violence of the present murders both the past and future. Oakland's black homes, *10 Mo'* tells us in no uncertain terms, are being fed and consuming a steady diet of bad food, addiction, and loss. Forty years after Newton and Seale called for an "immediate end to . . . murder of black people," black life remains expendable. In addition to police brutality, drug and alcohol addiction, gang violence, and poverty, Soul Salon 10 draws attention to the slow death caused by poor nutrition and environmental racism. "The tradition of the oppressed," as manifest in this installation, reminds us, "that the 'state of emergency' in which we live is not the exception but the rule," a crisis that is at once domestic and public, personal and political, economic, cultural, and physical.[52] To bring about a "real state of emergency" means to recognize that such conditions, though persistent, are not the natural order of things.

Through its invocation of the BPP Ten Point Platform and its inclusion as part of the larger exhibit, Soul Salon 10 offers both the BPP and the young victims of West Oakland a living context. As Berger tells us, "Photographs are relics of the past, traces of what has happened. If the living take that past upon themselves, if the past becomes an integral part of the process of people making their own history, then all photographs would reacquire a living context, they would continue to exist in time, instead of being arrested moments."[53] As a whole, *Black Panther Rank and File* attempts to create a living context for these photographs, one in which these

Figures c.4a and c.4b. Artist collective Soul Salon 10, *10 Mo'* (install view, 2006). Photographs by Leigh Raiford. (Courtesy of Soul Salon 10: Andrea Ali, April Banks, Bridget Goodman, Kaya Fortune, Woody Johnson, Keba Konte, Rosalind McGary, Eesuu Orundide, Bryan Keith Thomas, Githinji Wa Mbire, Amanda Williams, Keith "K-Dub" Williams)

many images can continue to educate and empower us, to encourage and enlist us.

PHOTOGRAPHY STANDS AT THE crossroads of history and memory. This intersection is certainly not uncomplicated or unvexed. As Shirley Wajda has suggested, "Photographs confound historians; history confounds photography."[54] Such a location alerts us to the ways that we as scholars, particularly historians, engage photographs in our work. We tend to use photographs as illustrations, as evidence, as a mirror that accurately reflects the past. But we do not "apprehend photography as a social practice," fully exploring the practices of looking or the historicity of the photograph itself. Such an engagement requires a different kind of interpretive act. And indeed it challenges the way we interpret and interrogate other kinds of archival sources. This is certainly the case of African Americans' engagement with photography. Long refused access to honorific depiction, black bodies were confined to the frames of the criminal, the pornographic, the ethnographic, the comedic photograph, or to the margins of the sentimental portraits of whites.[55] As demonstrated by "photography's other histories," the multitude of photographic practices engaged by subaltern groups, African Americans too have used the technology to reconstruct not merely individual and collective selves, but also racial and national histories.[56]

Can social movement photography be situated or enlisted in such a way that takes both the photograph's spaciality and its temporality into account, aware and self-conscious of the tension between its situatedness and its transcendence? Can such photography offer itself as both a document of past struggles and as a utopian vision or performance of what might be? Can there be a "political race" of the image? Critical race theorists Lani Guinier and Gerald Torres advance the rubric of "political race" not as "a theory of racial group membership, skin color, or other individual attributes traditionally associated with race."[57] Rather, political race is imagined as a site in which those "raced black"—the impoverished, the marginalized of any racial or ethnic background—recognize their linked fate and begin to organize collectively for social justice. How might we produce, view, or frame social movement photography in such a way that acknowledges its black subjects at the forefront of these movements while simultaneously recognizing how blackness has signified variously across time? Indeed, the visual field counts as one of the most difficult places to dislodge the relation between the biological "fact" of race, the cultural "truths" those bodies possess, and the technologies of vision that bind these two together in ways

that erase their own labor. I have attempted to begin to destabilize this bond by addressing it in its most entrenched location: the visual episteme, specifically the photograph.

A political race of the image calls for a renewed acknowledgement of the visual field "as itself a racial formation, an episteme hegemonic and forceful," an articulation of the economic and historical processes from which images emerge.[58] A political race of the image also demands a continued and vigilant recognition of the limitations of the medium. Photography is well suited to capturing demonstrations, confrontations, action. Yet by the very nature of its production and dissemination, the medium often cannot so easily capture long-term organizing, growth, development, process. Likewise, photography fails to capture evolving subjectivities. A political race of the image would begin to demonstrate Berger's "alternative practice of photography," one that "incorporates photography into social and political memory, instead of using it as a substitute which encourages the atrophy of any such memory."[59]

One last photograph. In Maria Varela's "We Marched," demonstrators in the 1966 Mississippi March against Fear move away from us as their reflections progress in our direction (figure c.5). Of this photograph, Varela writes, "We marched through valleys of dread, reflections in two centuries of tears . . . not knowing where we would sleep or if morning would come . . . not knowing, would it do any good?"[60] This is an elusive photograph, one that defies easy assignment to a particular place or time. Framed slightly off-center, the march continues beyond the photograph's edge; what remains is mostly empty space and empty time. The image's aqueous mirroring is further destabilizing, at once in motion and still, both in ascension and already inherited. We are offered a reflection, a backward gaze at forward motion, not unlike Benjamin's angel of history propelled "irresistibly . . . into the future to which his back is turned" by the "storm . . . we call progress."[61] In the absence of a human face, Varela does not countenance the movement, she does not fix its image in endangered black bodies or white faces twisted in anger. Rather the movement is expressed through its own motion and human effort; the movement's ability to grow beyond what we see is suggested by the continual echo of reflections; and an unknown future, both its perils and rewards, is imagined in the long shadows that exceed the picture's frame. A radical decontextualization of a historic event, Varela's photograph attempts to capture what will always remain fugitive and out of reach of King's "gigantic circling spotlights." This photograph reminds us, as we look back with the benefit of nearly a half-century of history, of the

Figure c.5. Maria Varela, "We Marched," 1966. (Maria Varela/Take Stock Photos)

uncertainty of civil rights work, that protesters risked their lives for unsure and indeterminate rewards.

Activists and artists considered in this study have engaged photography by mobilizing in its interstices: by emphasizing the structures of inequity that are captured within the photograph's frame while acknowledging that what remains fugitive is what fosters the emergence of new insights and new futures. Not only did these individuals and collectives fight to end lynching, to gain civil rights, and to assert human rights, but they also sought to reconstruct the meaning of black bodies in the United States. They remade racial formations through photography, in turn offering us an alternative lens through which to view the medium itself. As Berger tells us, these visions, "This future is a hope which we need now, if we are to maintain a struggle, a resistance, against the societies and culture of capitalism."[62]

Introduction

1. Martin Luther King Jr., *Why We Can't Wait*, 30.

2. See Rogin, *Blackface, White Noise*.

3. See Kelley, "Birmingham's Untouchables: The Black Poor in the Age of Civil Rights," chap. 1 in *Race Rebels*.

4. See Tagg, *Disciplinary Frame*.

5. See Wexler, *Tender Violence*.

6. Sekula, "The Body and the Archive," 347.

7. Ibid., 10.

8. Quoted in Mirzoeff, "The Shadow and the Substance," 114.

9. Tagg, "Currency of the Photograph," 117.

10. Tagg, *Burden of Representation*, 63.

11. Fusco, "Racial Times," 60.

12. See especially Shawn Michelle Smith, *American Archives*.

13. Holmes, "The Stereoscope and the Stereograph," 80, 81.

14. See Alan Trachtenberg's discussion of the series of daguerreotypes made of African-born slaves taken by Columbia, S.C., daguerreotypist J. T. Zealy in 1850, in *Reading American Photographs*. These images were commissioned by Harvard natural scientist Louis Agassiz to corroborate his notion of the "separate creation" of the races. Trachtenberg also provides an excellent analysis of Matthew Brady's Rogue Gallery that, in contrast to his portraits of "illustrious Americans," imaged "undeveloped types" who menaced America's public, primarily urban spaces. See also Painter, *Sojourner Truth*; and Shawn Michelle Smith, *American Archives*.

15. See Willis, *Reflections in Black*.

16. Ibid.; Sligh, "Reliving My Mother's Struggle"; hooks, "In Our Glory," 50. For discussions of the role of portrait photography in nineteenth-century, white, middle-class life, see Trachtenberg, *Reading American Photographs*; Newhall, *History of Photography*; and Gillian Brown, *Domestic Individualism*. For arguments that further complicate the existing scholarship, see Shawn Michelle Smith, *American Archives*; and Wexler, "Seeing Sentiment."

17. Gates, "Trope of the New Negro"; hooks, *Black Looks*.

18. Hartman, *Scenes of Subjection*, 22.

19. Raiford, "Restaging Revolution."

20. See, for example, Kasher, *Civil Rights Movement*; Telfair Museum of Art, *Freedom's March*; and Shames, *Black Panthers*. Exhibits include *We Shall Overcome: Photographs from the American Civil Rights Era*, Lyndon Baines Johnson Library and Museum, Austin, Tex. (a Smithsonian Institute traveling exhibit, 1998–2004); *The Black Panthers, 1968: Photographs by Ruth-Marion Baruch and Pirkle Jones*, Berkeley (Calif.) Art Museum, March 26–June 23, 2003; *Serving the People—Body and Soul*, Berkeley (Calif.) Public Library, February 18–March 19, 2005; *The Black Panther Party: Making Sense of History*, Center for Documentary Studies, Duke University, January 23–April 9, 2006; *Oh*

Freedom Over Me, Center for Documentary Studies, Duke University, August 16–November 7, 2004; *Radicals in Black and Brown: Palante, People's Power, and Common Cause in the Black Panthers and the Young Lords Organization*, Sonja Haynes Stone Center for Black Culture and History, University of North Carolina, 2007; *Black Panther: The Revolutionary Art of Emory Douglas*, Museum of Contemporary Art Pacific Design Center, Los Angeles, October 21, 2007–February 24, 2008; *"Most Daring Dream": The Photography of Robert Houston and the 1968 Poor People's Campaign*, Montgomery College (Md.), April 16–May 12, 2009; *Emory Douglas: Black Panther*, New Museum for Contemporary Art, New York City, July 22–October 18, 2009; *Dr. Martin Luther King and the Chicago Freedom Movement, 1965–1966*, McClean County (Ind.) Museum, January 18–March 20, 2010.

21. Benjamin, "Theses on the Philosophy of History," 255.

22. Ibid., 257.

23. Nora, "Between Memory and History," 284.

24. David Scott, "Introduction," vi.

25. Goldsby, *Spectacular Secret*, 281.

26. Alexander, "'Can you be BLACK and look at this?,'" 92; Goldsby, *Spectacular Secret*, 287.

27. Agamben, *Homo Sacer*; and JanMohamed, *The Death-Bound-Subject*.

28. See especially Trudier Harris, *Exorcising Blackness*; Jackson, "Re-Living Memories"; and Apel, *Imagery of Lynching*.

29. Harris, *Exorcising Blackness*; Goldsby, *Spectacular Secret*; JanMohamed, *Death-Bound-Subject*; and Jackson, "Re-Living Memories."

30. Foster, *Vision and Visuality*, ix.

31. Gilroy, *Black Atlantic*, 118.

32. Gitlin, *The Whole World Is Watching*.

33. It has also produced a host of new scholarship. I am particularly indebted to the recent work of Goldsby, *Spectacular Secret*; Shawn Michelle Smith, *Photography on the Color Line*; Apel and Smith, *Lynching Photographs*; Apel, *Imagery of Lynching*; Moten, *In the Break*; and Rushdy, "The Exquisite Corpse." On scopic regimes, see Martin Jay, "Scopic Regimes of Modernity."

34. McAdam, *Freedom Summer*; Nina Simone, "Mississippi Goddam" (1964), *Nina Simone in Concert*, Philips Records.

35. It is not my belief that the most significant or sole element of social movements is its engagement with culture. Rather, I am asserting that the transformation of consciousness is one key component.

Chapter One

1. From the text of the bill, see House Resolution 13, quoted in James Weldon Johnson, *Along This Way*, 362, 370, 371; James Weldon Johnson to Walter White, November 30, 1922, NAACP Anti-Lynching Campaign files on microfilm (hereafter cited as NAACP-ALC). See also Chadbourn, *Lynching and the Law*.

2. Walter White to James Weldon Johnson, November 23, 1922, NAACP-ALC.

3. NAACP, "The Shame of America" (advertisement), *New York Times*, November 22, 1922, NAACP-ALC; James Weldon Johnson, "Lynching," 6, and *Along This Way*, 370.

4. Walter White to James Weldon Johnson, November 23, 29, 1922, NAACP-ALC. On the *New York Times Mid-Week Pictorial*, see Newhall, *History of Photography*.

5. Johnson to White, November 30, 1922, NAACP-ALC.

6. Diawara, "Black Spectatorship."

7. Marriott, *On Black Men*, 5.

8. Zangrando, *NAACP Crusade against Lynching*.

9. Hale, *Making Whiteness*; Patterson, *Rituals of Blood*; Wood, *Lynching and Spectacle*; White, *Rope and Faggot*; and Dray, *At the Hands of Persons Unknown*.

10. Walter Johnson, *Soul by Soul*, 149.

11. Reproduced in Allen et al., *Without Sanctuary*.

12. NAACP Anti-Lynching Campaign Files, Series A, Group I, Container C, box 370, Library of Congress, Washington, D.C.

13. Trudier Harris, *Exorcising Blackness*.

14. Text from the *Without Sanctuary* exhibition at the New-York Historical Society, May 12, 2000.

15. Brundage, *Lynching in the New South*, 48.

16. Shawn Michelle Smith, *Photography on the Color Line*, 138.

17. Foucault, *Discipline and Punish*, 34. For an analysis of white male anxiety about white women in public in the context of lynching, see Jacquelyn Dowd Hall, *Revolt against Chivalry*. See also chapter 2, "The Anatomy of Lynching," in Wiegman, *American Anatomies*.

18. Allen-Littlefield Collection, Emory University; Allen et al., *Without Sanctuary*; Brundage, *Lynching in the New South*. Both Shawn Michelle Smith, *Photography on the Color Line*, and Goldsby, *Spectacular Secret*, discuss the "cultural riches," in Goldsby's words, employed to disseminate and "reproduce" lynching.

19. Fanon, *Black Skin, White Masks*, 109.

20. Maurice O. Wallace, *Constructing the Black Masculine*, 8.

21. Wells and Duster, *Crusade for Justice*, 129. *Habeas corpus* means literally to "have the body." The writ of *habeas corpus* requires that a person or evidence be brought before a judge or court to determine if there is sufficient cause to prosecute, detain, or imprison. It is important to note that to show the body, in this case through the use of lynching photographs, antilynching activists needed to *have* the body, to usurp ownership of these images from the hands of the white communities and individuals who claimed them previously.

22. Ibid., 139.

23. Ibid., 186.

24. Gunning, *Race, Rape and Lynching*, 85.

25. Schecter, *Ida B. Wells-Barnett*, 25, 34, 35.

26. Wells and Duster, *Crusade for Justice*, 116.

27. Ida B. Wells, *Red Record*, 82.

28. Barthes, *Image—Music—Text*, 25, 26. For further discussions of the relationship between image and text, see Hunter, *Image and Word*; and Mitchell, *Picture Theory*.

29. Wells, *Red Record*, 117, 119.

30. Collins, *Domestic Slave Trade*.

31. White women and children of course also participated in lynchings. Lynching, most usually framed as necessary to protect white women from the sexual threat posed

by black men, remained an expression of white supremacist patriarchy. See Jacquelyn Dowd Hall, *Revolt against Chivalry*; and Shawn Michelle Smith, *Photography on the Color Line*.

32. Collins, *Truth about Lynching*, 60.

33. Ibid.

34. Fanon, *Black Skin, White Masks*, 212, 111.

35. Collins, *Truth about Lynching*, 61.

36. See Diawara, "Black Spectatorship"; hooks, "The Oppositional Gaze," in *Black Looks*; Snead, *White Screens, Black Images*; Bobo, *Black Women as Cultural Readers*; Michele Wallace, "Race, Gender and Psychoanalysis in Forties Film"; Reid, *Redefining Black Film*; and Jacqueline N. Stewart, *Migrating to the Movies*.

37. Jacqueline N. Stewart, *Migrating to the Movies*, 101. On "interpellation," see Althusser, "Ideology and Ideological State Apparatuses."

38. Jacqueline N. Stewart, *Migrating to the Movies*, 94.

39. See Stuart Hall, "Gramsci's Relevance."

40. Claude Neal was lynched between Greenwood and Marianna, Florida, on October 26, 1934, according to McGovern, *Anatomy of a Lynching*. Laura Nelson and her son, L. W. Nelson, were hanged from a bridge in Okemah, Oklahoma, on May 25, 1911. A tinted lithographed postcard of "Commercial Avenue, Southeast from 9th Street, Cairo, Ill." is hand-marked by an "x" denoting the spot on a town landmark, Hustler's Arch, "where they hung the Coon," referring to the November 11, 1909, lynching of Will James. See Allen et al., *Without Sanctuary*.

41. For discussions of the heterogeneity of the black masses following World War I, see Carby, *Reconstructing Womanhood*; Lewis, introduction to *Portable Harlem Renaissance Reader*; and Winston James, *Holding Aloft*.

42. James Weldon Johnson, "WAKE UP COLORED MEN! WAKE UP!," *New York Age*, November 2, 1916, James Weldon Johnson Scrapbooks, Beinecke Rare Book and Manuscript Collection, Yale University.

43. Roach, *Cities of the Dead*, 2.

44. See Shawn Michelle Smith, *Photography on the Color Line*; and Apel and Smith, *Lynching Photographs*.

45. See Feimster, *Southern Horrors*. See also Wiegman, *American Anatomies*; Joy James, *Resisting State Violence*; Carby, *Reconstructing Womanhood*; and Gunning, *Race, Rape and Lynching*.

46. Spillers, "Mama's Baby, Papa's Maybe."

47. Gunning, *Race, Rape and Lynching*, 78.

48. Higginbotham, *Righteous Discontent*.

49. See Allen et al., *Without Sanctuary*; and Dray, *At the Hands of Persons Unknown*.

50. On the Scottsboro Boys, see Goodman, *Stories of Scottsboro*; Cunard, *Negro*, 153–77. On Emmett Till, see Whitfield, *Death in the Delta*; Pollack and Metress, *Emmett Till in Literary Memory*; and Metress, *Emmett Till*. For an analysis of the role of photography in the Till story, see Goldsby, "The High and Low Tech of It"; and Courtney Baker, "Emmett Till." For an examination of the trope of the grieving black mother in photography, see McDowell, "Viewing the Remains."

51. McDowell, "Viewing the Remains," 170.

52. Wells, "Lynch Law," in Rydell, *The Reason Why*, 31.

53. "Father and Three Sons Assassinated for Raising the First Cotton, News Never Reached World from Texas," *Chicago Defender*, October 30, 1915, 1.

54. Ula Y. Taylor, *Veiled Garvey*, 85.

55. "Father and Three Sons Assassinated for Raising the First Cotton, News Never Reached World from Texas," *Chicago Defender*, October 30, 1915, 1.

56. Homi K. Bhabha defines fixity "as the sign of cultural/historical/racial difference in the discourse of colonialism, [that] is a paradoxical mode of representation: it connotes rigidity and an unchanging order *as well as* disorder, degeneracy and demonic repetition." Bhabha, "Other Question," 370.

57. For discussions of the relationship between African American identity and photographic portraiture, see Willis, *Reflections in Black*; Holloway, *Portraiture and the Harlem Renaissance*; and Powell, *Cutting a Figure*. See also Gates, "Trope of the New Negro."

58. W. E. B. Du Bois, "Opinion," *Crisis* 23, no. 6 (April 1922), 238.

59. "The Looking Glass," *Crisis* 25, no. 1 (November 1922), 16.

60. James Weldon Johnson, *Along This Way*, 361–62.

61. Higham, *Strangers in the Land*, 207.

62. Between 1882 and 1924, the U.S. Congress passed a series of immigration acts that fixed quotas for all immigrants, primarily those from Eastern and Southern Europe, and denied admittance altogether to immigrants from Asia, especially those from China and Japan. In the context of World War I and the Red Scare, immigrants could be barred from entry based on political—Communist, anarchist—beliefs. As Matthew Frye Jacobson writes, "threats posed by immigration were threats to national sovereignty." Jacobson, *Barbarian Virtues*, 93. See also Lowe, *Immigrant Acts*; and Higham, *Strangers in the Land*.

63. Higginbotham, *Righteous Discontent*.

64. Du Bois, *Dusk of Dawn*, 67.

65. James Weldon Johnson, *Along This Way*, 318.

66. Johnson to White, November 30, 1922, NAACP-ALC.

67. The Dyer Bill was to be reintroduced in the next session of Congress, the 67th, meaning that it would have to go through the entire process in the House again. See Zangrando, *NAACP Crusade against Lynching*; and Dray, *At the Hands of Persons Unknown*.

68. W. E. B. Du Bois, draft of *Crisis* editorial, February 1923, 5, NAACP-ALC.

69. James Weldon Johnson, "Statement re political reaction of Colored People on abandonment of Dyer Anti-Lynching Bill," n.d., NAACP-ALC.

70. Ibid.; Du Bois, draft of *Crisis* editorial, February 1923, 1.

71. William E. Borah to W. E. B. Du Bois, July 15, 1926, quoted in Lewis, *W. E. B. Du Bois*, 193.

72. W. E. B. Du Bois, "Opinion," *Crisis* 23, no. 6 (April 1922), 238, and draft of *Crisis* editorial, February 1923, 5.

73. W. E. B. Du Bois, "Opinion," *Crisis* 25, no. 4 (February 1923), 152.

74. "Our Future Political Action: A Symposium," *Crisis* 25, no. 4 (February 1923), 55–156.

75. Du Bois, draft of *Crisis* editorial, February 1923, 1.

76. James Weldon Johnson, "American Nation Roused to Lynching Danger Says N.A.A.C.P. Report for 1922," press release, December 29, 1922, NAACP-ALC.

77. Benjamin, "Theses on the Philosophy of History"; Houston A. Baker, "Critical Memory and the Black Public Sphere," 7.

78. Gilroy, *Black Atlantic*, chapter 6.

79. Brundage, *Southern Past*, 10.

80. John Berger, "Uses of Photography," in *About Looking*, 58.

81. Maurice Stevens, Opening Address, "Imagining Bodies: Visions of the Nation through Race, Gender and Space" symposium, University of Illinois, Urbana-Champaign, March 16, 2006.

82. Cameron, *Time of Terror*; Marriott, *On Black Men*, 3.

83. Trudier Harris, *Exorcising Blackness*, 187.

84. Hartman, *Scenes of Subjection*, 7.

85. Visual artists who have reproduced or incorporated lynching photography into their work are too numerous to consider here. For studies that take up such artists' work in more detail, see, Apel, *Imagery of Lynching*; Jackson, "Re-Living Memories"; Apel and Smith, *Lynching Photographs*; and Raiford, "Consumption of Lynching Images."

86. Park, "Lynching and Antilynching"; Vendryes, "Hanging on Their Walls"; and Langa, "Two Antilynching Art Exhibitions."

87. Hale, *Making Whiteness*, 225.

88. Ibid., 226.

89. Benjamin, "Work of Art"; Cadava, *Words of Light*, 53.

90. "Father and Three Sons Assassinated for Raising the First Cotton, News Never Reached World from Texas," *Chicago Defender*, October 30, 1915, 1.

91. Als, "GWTW," 42.

Chapter Two

1. When Lyon joined up with SNCC in 1962, the organization had a small number of white student field workers, including Bob Zellner, Casey Hayden, and Jim Monsonis, each of whom had ties to the predominantly white and northern Students for a Democratic Society (SDS). Carson, *In Struggle*. See also Lyon, *Memories of the Southern Civil Rights Movement*; and Hogan, *Many Minds, One Heart*.

2. For a version of this image, see Raiford, "'Come Let Us Build a New World Together,'" <http://muse.jhu.edu/journals/american_quarterly/v059/59.4raiford.pdf>.

3. Lyon, *Memories of the Southern Civil Rights Movement*, 26; Lewis and D'Orso, *Walking with the Wind*, 192.

4. See Payne, "The Rough Draft of History," in *I've Got the Light of Freedom*.

5. Ransby, *Ella Baker and the Black Freedom Movement*.

6. Ella Baker, "Bigger than a Hamburger," 4.

7. Forman, *The Making of Black Revolutionaries*, 245.

8. I am indebted to Rick Powell and Michael Cohen for highlighting this connection.

9. Hayden, "Fields of Blue," 342.

10. Diane Nash, a founding member of SNCC, defines the beloved community as one "that gave to its citizens all that it could give and allowed its members to then give back to the community all that they could. Our goal was to reconcile, to heal and to rehabilitate, to solve problems rather than to simply gain power over the opposition." Quoted in Greenberg, *Circle of Trust*, 18–19.

11. Hansberry and Lyon, *The Movement*, 118.

12. Lyon, *Memories of the Southern Civil Rights Movement*, 26.

13. Bruce Nelson, conversation with author, April 27, 2001, Los Angeles, Calif.

14. Forman, *The Making of Black Revolutionaries*, 241, 244.

15. Courtland Cox, "Executive Minutes," May 10, 1964, SNCC Papers on Microfilm, AII4 (336), hereafter cited as SNCC-Mf.

16. Julian Bond, "A Remarkable Time," in Lyon, *Photo Film 1959–1990*, 10.

17. This phrase is Tamio Wakayama's, SNCC photographer and staff member, 1963–65, from a telephone interview with the author, July 17, 2001.

18. Herron moved with his family to Mississippi in 1964 where he conceived and directed the Southern Documentary Project. The SDP worked with SNCC during 1964 to produce a visual record of the movement in the spirit of the Farm Securities Administration (FSA) images of the Depression era. FSA photographer Dorothea Lange offered some small critique of the project. Matt Herron, interview with the author, August 29, 2007, San Rafael, Calif., and email correspondence with the author, July 13, 2007.

19. Open letter from Harvey Zucker (New York photographer and filmmaker), n.d., SNCC-Mf. Herron says of Forscher, "Marty did the repair work and the special installations for all of the top advertising and photo people. . . . Marty got most of the studio photographers in New York to give him their Pentax since they were switching to Nikons. He fixed them up and sent them south to SNCC. And when a camera got busted, either in the line of duty or because it got smashed, we'd put it in a box and mail it back to Marty, and Marty would fix it and send it back. Not a penny changed hands. Single-handedly he kept photography in the South moving." Herron interview, August 29, 2007.

20. Matt Herron to Julian Bond, November 19, 1964, SNCC-Mf, Axi1–20 (36).

21. Forman, *The Making of Black Revolutionaries*, 359.

22. "A Conversation between Daniel Jesse Wolff and Daniel Joseph Lyon, 1989," in Lyon, *Photo Film*, 6; Greenberg, *A Circle of Trust*, 37.

23. For more on SNCC's harnessing of music, particularly its relationship to jazz performers of the day, see Monson, "Monk Meets SNCC."

24. Fabre, "Free Southern Theatre." See also Free Southern Theatre poster, n.d., Social Action Collection vertical files, State Historical Society of Wisconsin.

25. There were Friends of SNCC chapters in Canada. And, ironically, through the United States Information Agency's anticommunist program, photographs of SNCC successes were distributed throughout many newly independent African nations. See Social Action Collection vertical files, State Historical Society of Wisconsin; Carson, *In Struggle*, 134–35; and Forman, *The Making of Black Revolutionaries*, 406. See also Hayes, *Diasporic Underground*.

26. Gitlin, *The Whole World Is Watching*, 22.

27. Ibid., 1.

28. "Media frames," according to Gitlin, are "persistent patterns of cognition, interpretation, and presentation, of selection, emphasis, and exclusion, by which symbol handlers routinely organize discourse, whether verbal or visual." Ibid., 7. See also Roberts and Klibanoff's excellent study of media and the civil rights movement, *The Race Beat*.

29. Student Nonviolent Coordinating Committee to the editors of the *Atlanta Journal*, August 11, 1960, SNCC-Mf.

30. Student Nonviolent Coordinating Committee to the editors of the *Atlanta Inquirer*, August 11, 1960; Sandra Hayden to Henry Schwarzschild, Anti-Defamation League, July 17, 1963, SNCC-Mf.

31. Good, *The Trouble I've Seen*, 43, 41.

32. Ibid., 49, 44, 42.

33. See Morris, *Origins of the Civil Rights Movement*; Charron, *Freedom's Teacher*; and Hamlin, *Story Isn't Finished*.

34. Roberts and Klibanoff, *The Race Beat*, 308.

35. Ibid., 167.

36. Good, *The Trouble I've Seen*, 60.

37. Matt Herron interview, August 29, 2007.

38. Roberts and Klibanoff, *The Race Beat*, 262.

39. Dee Gorton, email correspondence with the author, July 6, 2001.

40. Roberts and Klibanoff, *The Race Beat*, 256.

41. Walter Benjamin, "N [Theoretics of Knowledge, Theory of Progress]," in Gary Smith, *Benjamin: Philosophy, History, Aesthetics*, 50. See also Benjamin, *Arcades Project*, 463.

42. See Jameson, *The Political Unconscious*.

43. Fred Shuttlesworth quoted in Branch, *Parting the Waters*, 790.

44. See Garrow, *Protest at Selma*.

45. Roberts and Klibanoff, *The Race Beat*, 317, 318; Moore and Durham, *Powerful Days*.

46. James C. Scott, *Domination and the Arts of Resistance*.

47. For work on the roles of African American women in the civil rights movement, see especially Robnett, *How Long? How Long?*, in which she introduces the notion of women as "bridge leaders"; Crawford, Rouse, and Woods, *Women in the Civil Rights Movement*; Collier-Thomas and Franklin, *Sisters in the Struggle*; and Nasstrom, "Down to Now."

48. "They Fight a Fire That Won't Go Out," *Life*, May 17, 1963. See Kasher, *Civil Rights Movement*, 96. For more on multiple and opposing readings of a single visual image, see Butler, "Endangered/Endangering."

49. See Kasher, *Civil Rights Movement*, 95; Branch, *Parting the Waters*; and Garrow, *Protest at Selma*, 162. For Garrow, the "audience" that mattered for civil rights images were elected officials and international officials of standing who had access to U.S. officials.

50. Carmichael quoted in Michael T. Kaufman, Obituary, *New York Times*, Monday, November 16, 1998.

51. Bob Moses quoted in *Freedom on My Mind*, documentary film by Connie Field and Marilyn Mulford (1997). Also in his memoir, *A Way Out of No Way*, Andrew Young recounts the impact the images had on him: "As my family watched, we could literally feel God calling us back to the South." Young, quoted in Torres, *Black White, and in Color*, 42.

52. Julius Lester, "SNCC Photo News," January 1967, SNCC-Mf.

53. Whitfield, *Death in the Delta*; Goldsby, "The High and Low Tech of It"; Pollack and Metress, *Emmett Till in Literary Memory*; and Metress, *Emmett Till*.

54. See Goldsby, "The High and Low Tech of It."

55. Moody, *Coming of Age in Mississippi*; Hunter-Gault, *In My Place*; Ali, *The Greatest*; Julian Bond, Calhoun College Master's Tea, Yale University, February 1999; Whitfield, *Death in the Delta*; Sellers, *River of No Return*; and Steele, *Content of Our Character*. For a provocative discussion of the role of the Emmett Till murder on black identity formation, see Alexander, "'Can you be BLACK and look at this?'"

56. Steele, *Content of Our Character*.

57. Mary King, *Freedom Song*, 431 (emphasis added).

58. Jane Stembridge, "Report of the Publication of the First Newsletter—June 1960," August 5, 1960, SNCC-Mf.

59. Freedom School teachers can be seen using *Ebony* during their lessons. See "Mississippi Freedom Project," SNCC Pamphlet, c. 1964, Social Action Collection vertical file, Wisconsin Historical Society.

60. Roberts and Klibanoff, *The Race Beat*, 54; Torres, *Black, White, and in Color*.

61. Greenberg, *Circle of Trust*, 38.

62. Torres, *Black, White, and in Color*.

63. The national television news occasionally produced stories sympathetic to the movement, most notably the NBC profile of the Nashville movement, "Sit-In," (1960). As Sasha Torres argues, even while the film served networks needs, movement participants, including SNCC, also readily appropriated it, using it as an educational and recruitment tool. Torres, "The Double Life of 'Sit-In,'" in *Black, White, and in Color*.

64. See Payne, "Debating the Civil Rights Movement: The View from the Trenches," in Lawson and Payne, *Debating the Civil Rights Movement*.

65. Forman, *The Making of Black Revolutionaries*, 299.

66. Hansberry and Lyon, *The Movement*, 127.

67. Ibid., 81.

68. Lyon, *Memories of the Southern Civil Rights Movement*, 78.

69. Ibid., 80. For more on the protective role of photographs and photographers, see Mary King, *Freedom Song*.

70. Forman, *The Making of Black Revolutionaries*, 105.

71. Carol A. Wells, "Have Posters, Will Travel," 5. See also the Center for the Study of Political Graphics, <www.politicalgraphics.org>.

72. See *Visions of Peace and Justice*; and Durant, *Black Panther*.

73. John Berger, "Uses of Photography," in *About Looking*; see also Batchen, "Vernacular Photography," in *Each Wild Idea*.

74. Lyon, *Memories of the Southern Civil Rights Movement*, 61. For a version of this image, see Raiford, "'Come Let Us Build a New World Together,'" <http://muse.jhu.edu/journals/american_quarterly/v059/59.4raiford.pdf>.

75. Roberts and Klibanoff, *The Race Beat*, 291–92.

76. "Testimony of the Student Nonviolent Coordinating Committee before the House Judiciary Committee, Tuesday, May 28, 1963," 2. SNCC Files, Schomburg Center for Research in Black Culture, New York Public Library.

77. For a version of this image, see Raiford, "'Come Let Us Build a New World Together,'" <http://muse.jhu.edu/journals/american_quarterly/v059/59.4raiford.pdf>.

78. Lyon, *Memories of the Southern Civil Rights Movement*, 108.

79. Wakayama interview, July 17, 2001.

80. In a letter to "Mitch," most likely Francis Mitchell, working in communications, Mary King notes that she's ordered an 11- × 14-inch print of this photograph and that it "can thus be used for posters and also for the exhibit Mike [Miller] wants put together." The photograph was included as part of *Now*, a traveling photo exhibit, 1965–66. Mary King to Mitch, May 25, 1964, SNCC-Mf.

81. For a version of this image, see Raiford, "'Come Let Us Build a New World Together,'" <http://muse.jhu.edu/journals/american_quarterly/v059/59.4raiford.pdf>.

82. Nancy, "Finite History," 170.

83. For a version of this image, see Raiford, "'Come Let Us Build a New World Together,'" <http://muse.jhu.edu/journals/american_quarterly/v059/59.4raiford.pdf>.

84. James Baldwin, *The Fire Next Time*.

85. Forman, *The Making of Black Revolutionaries*, 420.

86. See Carson, *In Struggle*; Mary King, *Freedom Song*; Lyon, *Memories of the Southern Civil Rights Movement*; Fleming, *Soon We Will Not Cry*.

87. Herron, correspondence with the author, July 13, 2007.

88. For a version of this image, see Raiford, "'Come Let Us Build a New World Together,'" <http://muse.jhu.edu/journals/american_quarterly/v059/59.4raiford.pdf>.

89. Frank Smith, untitled position paper, SNCC Conference, 1964, Social Action Collection vertical files, Wisconsin Historical Society.

90. Ibid.

91. Sekula, "On the Invention of Photographic Meaning," 473. See also Raeburn, *Staggering Revolution*; Stange, *Symbols of Ideal Life*; and Trachtenberg, *Reading American Photographs*.

92. Lyon, *Memories of the Southern Civil Rights Movement*.

93. See Greenberg, ed. *A Circle of Trust*.

94. Lyon, *Memories of the Southern Civil Rights Movement*, 71.

95. Wendell Hoffman quoted in Raines, *My Soul Is Rested*, 377.

96. Charles Moore quoted in Kasher, *Civil Rights Movement*, 62.

97. For a version of this image, see <http://www.magnumphotos.com/Archive/C.aspx?VP3=ViewBox_VPage&VBID=2K1HZOWRKN3B4&IT=ZoomImage01_VForm&IID=2K7O3R8JROAT&PN=16&CT=Search>.

98. Danny Lyon, public lecture, Poughkeepsie, N.Y., February 17, 2001.

99. Matt Herron interview, August 29, 2007. Herron describes himself as "wearing three hats" as a photographer in the 1960s, a useful distinction to describe the not always well-articulated boundaries between modes of photography in this moment.

100. Student Nonviolent Coordinating Committee, "SNCC Photo," n.d. (c. 1965), box 47, Social Action Collection vertical files, Wisconsin Historical Society.

101. Gitlin, *The Whole World Is Watching*, 1.

102. There were thirty-seven position papers mimeographed in advance of the meeting, according to a document included in the packet, though other papers may have been added at the time of the retreat. "Papers That Should Be in Your Packets, 11/6/64, SNCC Retreat," SNCC Papers, Social Action Collection, Wisconsin Historical Society; Mary King, *Freedom Song*, 563.

103. Forman, *The Making of Black Revolutionaries*, 420.

104. Mary King, *Freedom Song*, 447, 563; Carson, *In Struggle*, 140; Hogan, *Many Minds, One Heart*.

105. For more on SNCC "experiment[s] in white community organizing," especially the White Folk's Project, see Carson, *In Struggle*.

106. SNCC staffers, including Charlie Cobb and Mary King, also produced poetry chapbooks.

107. Memo from Tom Wakayama to Executive Committee Re: SNCC Photo, n.d. (c. early fall 1964), SNCC-Mf.

108. Student Nonviolent Coordinating Committee, "SNCC Photo," n.d. (c. 1965), box 47, Social Action Collection vertical file, Wisconsin Historical Society.

109. Ibid.

110. Daniel Jesse Wolff, "Arc of Hope," in Lyon, *Photo Film*, 125.

111. Danny Lyon to Jim Forman, April 7, 1964, quoted in Ute Eskildsen, "Social Commitment as Personal Adventure," in Lyon, *Photo Film*, 38. Lyon was persuaded to return south to photograph for the Mississippi Summer Project but left again as soon as the summer was over.

112. For more on the conflict between "hardliners" and "floaters," see Carson, *In Struggle*, especially chapter 11; and Sellars, *River of No Return*.

113. Minutes, Executive Committee Meeting, April 12–14, 1965, Holly Springs, Miss., reel 26, SNCC-Mf.

114. "A Conversation between Daniel Jesse Wolff and Daniel Joseph Lyon, 1989," in Lyon, *Photo Film*, 7.

115. Bob Fletcher to Clifford A. Vaughs, December 6, 1964, reel 5, SNCC-Mf.

116. Clifford A. Vaughs, "Field Report for Period of November 10 thru 17, 1964," December 1, 1964, SNCC-Mf. See also Vaughs to Ruby Doris Smith Robinson and Erin Simms, n.d. (c. December 1964); and Vaughs to Bob Fletcher, December 1, 1964, reel 36, SNCC-Mf.

117. Francis Mitchell, for example, was raised as a contentious case during meetings in both March and April 1965:

Betty [Garman, Atlanta office manager]: Francis said he was going off to write a book.

Foremon [*sic*]: What happens to his checks?

Ruby: We hold them in Atlanta until he hollers for them.

Cleve[land Sellers]: Well, he should holler long and loud the next time. . . .

Ralph: We should think about whether or not we want to keep him on the payroll while he writes this book.

Foremon [*sic*]: My recommendation is that we write a strong letter to Mitch and inform him that until we hear from him and know what he is doing, a [*sic*] that he will be temporarily suspended from the staff.

"A Short Summary of the Executive Committee Meeting, March 5 and 6 1965 in Atlanta, Ga"; "Minutes, Executive Committee Meeting, April 12–14, 1965, Holly Springs, Mississippi," reels 4, 13, SNCC-Mf.

118. Julian Bond to Matt Herron, November 16, 1964, SNCC-Mf.

119. Herron to Bond, November 19, 1964, SNCC-Mf.

120. Wakayama, *Signs of Life*, inside cover.

121. Tom [Tamio] Wakayama to SNCC Executive Committee, April 23, 1965, SNCC-Mf.

122. Ibid.

123. Wakayama conversation with author, July 17, 2001.

124. "Minutes, Executive Committee Meeting, April 12–14, 1965, Holly Springs, Mississippi," reels 8, 20, SNCC-Mf.

125. Clifford A. Vaughs to Ethel Jean Breaker, SNCC Photo, July 3, 1965; Elizabeth

Sutherland to Jim Forman and Cynthia Washington, January 31, 1966; Marilyn Lowen to Clifford A. Vaughs, February 21, 1966, SNCC-Mf.

126. "Film Job Numbers and Disposition," n.d., SNCC-Mf. The recent exhibit *Road to Freedom: Photographs of the Civil Rights Movement, 1956–1968*, at the High Museum in Atlanta, included a number of photographs by SNCC staffer and Free Southern Theatre founder Doris Derby. According to Danny Lyon, during the opening of the exhibit, when Derby "was presented as one of the photographers, John [Lewis] said, 'I didn't know she took pictures.'" Danny Lyon, "Time Will Tell, Part Two," June 14, 2008, <www.dektol .wordpress.com>, January 12, 2009.

127. Clifford A. Vaughs to Ruby Doris Smith Robinson, November 27, 1964; Vaughs to Richard Avedon and Sue Moselle, December 2, 1964, reel 36, SNCC-Mf.

128. Anonymous [Mary King and Casey Hayden], "Women in the Movement," position paper, 1964. <http://www2.iath.virginia.edu/sixties/HTML_docs/Sixties.html>, January 14, 2009.

129. Matt Herron to Julian Bond, November 19, 1964, reel 36, SNCC-Mf.

130. Mary King to Julian Bond, Jim Forman, Ivanhoe Donaldson and Ruby Doris Smith Robinson, December 12, 1964, SNCC-Mf.

131. Ibid.

132. [King and Hayden], "Women in the Movement."

133. Mary King to Julian Bond et al., December 12, 1964, SNCC-Mf.

134. Julius Lester offered a similar critique of those who wanted to be "photographers" and those who "took pictures," that is, those who demanded recognition for their work, and those who wanted to observe and put their images in service of something else. Lester interview, November 5, 2007, Belcherville, Mass.

135. Filmstrips became popular in American schools in the 1940s and were used in classrooms extensively until video cassettes proved more accessible and convenient in the 1980s. They could be made easily using photographs, charts, text, or even simply with stick figure drawings, or any materials available. Around 1965–66, they cost less than one dollar a copy, and projectors could be purchased for a nominal cost, around $30.

136. Mary [Maria] Varela to the Staff, Memo Re: Filmstrips, November 11, 1965, SNCC-Mf.

137. Maria Varela, email correspondence with the author, January 14, 2010.

138. Varela, Memo Re: Filmstrips, November 11, 1965, SNCC-Mf; Mary Varela, "Report on Adult Education Activities Funded by the Aaron E. Norman Fund," February 20, 1966, Maria Varela Papers, Wisconsin Historical Society. While Varela was not a spokesperson for any "group," she did raise grant money for the projects she was affiliated with. Varela, email correspondence. Kathy Amatniek, later Kathy Sarachild and an early theorist of women's liberation, also produced an antiwar filmstrip. See "Information for Friends of SNCC and Campus Groups on Filmstrips," March 1966, Wisconsin Historical Society.

139. Mary E. Varela, *Something of Our Own, Parts One and Two* (Jackson, Miss.: H. J. K. Publishing, 1965), Labadie Collection, University of Michigan, Ann Arbor.

140. Varela, "Report on Adult Education," Varela Papers, 6.

141. See Duganne, *The Self in Black and White*.

142. Elizabeth Martinez, interview with the author, November 17, 2008, San Francisco, Calif.

143. Cliff Vaughs to Elizabeth Sutherland, July 28, 1965; Elizabeth Sutherland, NY SNCC, to Photo Department, April 20, 1965, reel 36, SNCC-Mf.

144. "Report of the National Advisory Commission on Civil Disorders" (1968), <http://www.eisenhowerfoundation.org/docs/kerner.pdf>, March 5, 2009.

145. SNCC's shift from "civil rights to black power" has been examined extensively. See especially Carson, *In Struggle*; and Payne, *I've Got the Light of Freedom*. For studies that expand the periodization and our concept of this shift, see Jacquelyn Dowd Hall, "Long Civil Rights Movement"; Singh, *Black Is a Country*; and Hamlin, *The Story Isn't Finished*.

146. The Atlanta Project, quoted in Carson, *In Struggle*, 196.

147. Ivanhoe Donaldson, "A Review of the Direction of SNCC—Past and Future," quoted in Carson, *In Struggle*, 201.

148. Hasan K. Jeffries, *Bloody Lowndes*.

149. Quoted in Carson, *In Struggle*, 209–210.

150. See, for example, Bennett, "Stokely Carmichael"; Price, "SNCC Charts a Course"; and "'We Don't Need or Want Moderation,' Says SNCC Leader," *Afro-American*, May 20, 1966.

151. Fay Bellamy, "A Little Old Report," n.d. (c. 1967), Robert "Bob" Fletcher Papers, Schomburg Center for Research in Black Culture, New York Public Library.

152. Rowland Evans and Robert Novak, "The New Snick," *Washington Post*, May 25, 1966; "New Racism," *Time*, July 1, 1966; Jack Nelson, "Two Veteran Rights Leaders Ousted by SNCC," *Los Angeles Times*, May 17, 1966; Gene Roberts, "New Leaders and New Course for 'Snick,'" *New York Times*, May 22, 1966.

153. "What's Happening in SNCC?" special bulletin from New York office, June 3, 1966, quoted in Carson, *In Struggle*, 205.

154. Bellamy, "A Little Old Report," Fletcher Papers.

155. Ibid.

156. Julius Lester interview with the author, November 5, 2007, Belcherville, Mass.

157. Ibid.

158. Julius Lester, "The Angry Children of Malcolm X," *Sing Out!* October/November 1966, <http://nationalhumanitiescenter.org/pds/maai3/overcome/overcome.html>, March 13, 2009.

159. Lester interview.

160. Lester, *All Is Well*, 128, 129.

161. Julius Lester, *SNCC Photo News*, January 1967.

162. Lester interview.

163. Lester, "SNCC Photo News," January 1967.

164. Lester interview. See also Lester, "SNCC Photo News," January 1967.

165. Lester interview.

166. Lester, *All Is Well*, 140, 141.

167. "Time to get / together / time to be one strong fast black energy space / one pulsating positive magnetism, rising." Amiri Baraka, "It's Nation Time" (1970), in Harris, *LeRoi Jones/Amiri Baraka Reader*, 240–42.

168. SNCC wall calendar, 1968, back page. Personal collection of Julius Lester.

169. See especially Anderson, *Imagined Communities*.

170. I use "heteroscopic" as a visual companion to Mikhail Bakhtin's concept of

"heteroglossia" as described in *Dialogic Imagination*; and Holquist, *Dialogism: Bakhtin and His World.*

Chapter Three

1. Roz Payne, telephone interview with the author, April 2, 2002. For other accounts of this photo shoot, see Beverly Axelrod's video interview with Roz Payne, in Roz Payne archives, Richmond, Vt.; and Seale, *Seize the Time.*

2. Seale, *Seize the Time*, 182.

3. Kathleen Cleaver, "Women, Power, and Revolution," 124–25.

4. Kathleen Neal Cleaver, interview with the author, October 7, 1998, New Haven, Conn. See also Peebles, Taylor, and Lewis, *Panther*, 158.

5. Albert, "White Radicals, Black Panthers," 189.

6. Ibid.

7. See Doss, "'Revolutionary Art Is a Tool for Liberation.'"

8. Rhodes, *Framing the Panthers*, 83, 120. See also Sol Stern, "The Call of the Black Panthers," *New York Times*, August 6, 1967; and Wallace Turner, "Negroes Press Nomination of Indicted Militant," *New York Times*, February 5, 1970.

9. "Is It Too Late?"

10. U.S. House of Representatives Staff Study by the Committee on Internal Security, *The Black Panther Party: Its Origin and Development as Reflected in Its Official Weekly Newspaper*, "The Black Panther Black Community News Service," 91st Cong., 2d sess., October 6, 1970, Labadie Collection, University of Michigan, Ann Arbor.

11. *Black Panther*, February 21, 1970.

12. Fanon, *Wretched of the Earth*, 315. The Third Cinema movement, "the cinema of liberation," as articulated in Solanas and Getino's manifesto, "Towards a Third Cinema," utilized Fanon's words as a starting point.

13. Rhodes, *Framing the Panthers*; Shames, *Black Panthers*; *Black Panther Rank and File* exhibit at Yerba Buena Center for the Arts, San Francisco, Calif., March 18–July 2, 2006; Lazerow and Williams, *In Search of the Black Panther Party*, especially contributions by Edward Morgan and Tim Lake, as well as Davarian L. Baldwin's excellent introductory comments.

14. See especially Jones, *Black Panther Party Reconsidered*; and Cleaver and Katsiaficas, *Liberation, Imagination*. While both collections consider the visual, the essays tend to argue that images and imagery are a weapon wielded against the Panthers rather than one they themselves used. Two exceptions are Singh, "Black Panthers and the 'Undeveloped Country' of the Left"; and Doss, "'Revolutionary Art Is a Tool for Liberation.'"

15. Wolfe, *Radical Chic*, 7–8. See also Charlotte Curtis, "Black Panther Philosophy Is Debated at the Bernsteins," *New York Times*, January 15, 1970.

16. Wolfe, *Radical Chic*, 7–8, emphasis in the original.

17. Tom Wolfe, "Radical Chic," <http://nymag.com/news/features/46170/>.

18. Buck-Morss, *Dialectics of Seeing*, 6.

19. See also Lacan's description of the "mirror stage," in *Écrits*; as well as Fanon's discussion of Hegel's master-slave dialectic in terms of the visual field, in *Black Skin, White Masks.*

20. Singh, "Black Panthers and the 'Undeveloped Country' of the Left," 83.

21. Raymond Williams, *Marxism and Literature*, 124, 123.

22. Huey P. Newton, "The Correct Handling of a Revolution," *Black Panther*, May 18, 1968, quoted in Phillip S. Foner, *Black Panthers Speak*, 43. On being forced underground, see also *Huey Newton Talks to* "The Movement" (pamphlet), n.d., Labadie Collection, University of Michigan, Ann Arbor. Following his break with the BPP, Cleaver would begin to call for the development of armed underground cells, from which the Republic of New Afrika would emerge.

23. *Huey Newton Talks to* "The Movement," 12, 13.

24. Raymond Williams, *Marxism and Literature*, 124.

25. Freed, *Agony in New Haven*, 6.

26. Raymond Williams, *Marxism and Literature*, 124.

27. Debord, *Society of the Spectacle*. On the Situationists, see Wollen, *Raiding the Icebox*, chapter 4; Knabb, *Situationist International Anthology*; and Sussman, *On the Passage of a Few People*.

28. Debord, *Society of the Spectacle*, 19.

29. Wollen, "Bitter Victory," 22.

30. Gilroy, *Black Atlantic*.

31. Rogin, *Blackface, White Noise*.

32. Debord, *Society of the Spectacle*, 19. On the carnivalesque, see Bakhtin, *Rabelais and His World*; and Roach, *Cities of the Dead*.

33. Debord, *Society of the Spectacle*, 74.

34. Genet, *Prisoner of Love*, 213, 214.

35. Newton, *Revolutionary Suicide*, 107.

36. Ibid., 109.

37. Ibid., 114.

38. Seale, *Seize the Time*, 63–64.

39. Newton notes that he and Seale sat down and "took about twenty minutes to write" the Ten Point Platform, while Seale writes that it took the first two weeks of October 1966 to produce the document. See Newton, *Revolutionary Suicide*, 116; and Seale, *Seize the Time*, 59.

40. Newton, *Revolutionary Suicide*, 112.

41. Ibid., 120. For other accounts of the Panther police patrols see Seale, *Seize the Time*; and Abron, "'Serving the People.'"

42. Newton, *Revolutionary Suicide*, 120.

43. Seale, *Seize the Time*, 144.

44. Ibid.

45. Chris Marker, director, *A Grin without a Cat*, 1993.

46. Newton, *Revolutionary Suicide*, 122.

47. Davarian L. Baldwin, "'Culture Is a Weapon,'" 300.

48. Newton, *Revolutionary Suicide*, 122.

49. Ibid., 120.

50. Seale, *Seize the Time*, 133–34.

51. Huey P. Newton, "On the Defection of Eldridge Cleaver from the Black Panther Party and the Defection of the Black Panther Party from the Black Community: April 17, 1971" in *The Original Vision of the Black Panther Party* (pamphlet), n.d., Labadie Collection, University of Michigan, Ann Arbor.

52. Newton, *Revolutionary Suicide*, 121.

53. Ibid., 120.

54. For more on *Black Panther* as an example of the underground press or "dissident media," see Davenport, "Reading the 'Voice of the Vanguard'"; Abron, "'Raising the Consciousness'"; and Rhodes, *Framing the Panthers*.

55. Newton, *Revolutionary Suicide*, 142.

56. Rhodes, *Framing the Panthers*, 99.

57. Ibid., 70.

58. Belcher, "It's All Legal."

59. Judi Douglas, "Editorial: Hunter's Point, 1970," *Black Panther*, March 7, 1970, 2.

60. Singh, "Black Panthers and the 'Undeveloped Country' of the Left."

61. For a version of this image, see <http://www.bobbyseale.com/phototour>; Genet, *Prisoner of Love*, 85.

62. bell hooks, "The Oppositional Gaze," in *Black Looks*.

63. Quoted in Newton, *Revolutionary Suicide*, 148–49.

64. Ibid., 147.

65. Seale, *Seize the Time*, 162–63.

66. Ibid., 157.

67. Newton, *Revolutionary Suicide*, 149.

68. Sol Stern, "The Call of the Black Panthers," *New York Times*, August 6, 1967.

69. Seale, *Seize the Time*, 157–58.

70. Genet, *Prisoner of Love*, 83.

71. Ibid.

72. "The Panthers and the Law," *Newsweek*, February 23, 1970.

73. Belcher, "It's All Legal," 4; "Panthers and the Law"; Lawrence E. Davies, "Black Panthers Denounce Policemen," *New York Times*, April 13, 1968, 12.

74. Belcher, "It's All Legal," 1.

75. Wallace Turner, "A Gun Is Power, Black Panther Says," *New York Times*, May 21, 1967, 66.

76. "The Panthers and the Law."

77. Stephen Shames, telephone interview with the author, May 2, 2002.

78. Memo, G. C. Moore to W. C. Sullivan, "Subject: Counterintelligence Program/ Black Nationalist—Hate Groups/Racial Intelligence (Black Panther Party)," September 27, 1968, reprinted in Churchill and Vander Wall, *COINTELPRO Papers*, 124.

79. J. Edgar Hoover quoted in Churchill and Vander Wall, *Agents of Repression*, 77. For firsthand accounts of the work of Panther infiltrators, see Roz Payne Archives, Richmond, Vt.; and Donald Freed, *The Glass House Tapes*, Huey P. Newton Microfilm Collection, Stanford University Special Collections.

80. U.S. Senate Select Committee to Study Government Operations with Respect to Intelligence Activities, *Hearings on Intelligence Activities, vol. 6: The Federal Bureau of Investigation*, 94th Cong., 1st sess., 1975, 30, 605, quoted in Churchill, "'To Disrupt, Discredit and Destroy,'" 81.

81. Churchill, "'To Disrupt, Discredit and Destroy,'" 84. For more on the FBI's COINTELPRO campaign against the Panthers, see Churchill and Vander Wall, *COINTELPRO Papers*, and *Agents of Repression*.

82. Freed, *Agony in New Haven*, 6.

83. Memo, FBI Director J. Edgar Hoover to SAC Albany, August 25, 1967, reprinted in Churchill and Vander Wall, *COINTELPRO Papers*, 109–10.

84. Memo, FBI Director Hoover to SAC, San Francisco, May 27, 1969, reprinted in ibid., 145.

85. Memo, FBI Director Hoover to SAC, Albany, August 5, 1968, reprinted in ibid., 119.

86. See Elwood Smith photograph, *Philadelphia Daily News*, August 31, 1970, 1; and Maurantonio, "Crisis, Race, and Journalistic Authority."

87. Shames interview. See also Shames, *Black Panthers*.

88. Churchill and Vander Wall, *Agents of Repression*, 68.

89. Peebles, Taylor, and Lewis, *Panther*, 82.

90. See Dr. Huey P. Newton Papers, Series 5, Photograph Collection, Stanford University. On Williams, see Bobby Seale, foreword to Shames, *Black Panthers*, 12.

91. Shames interview. See also Elaine Brown, *Taste of Power*.

92. Shames interview.

93. Jonathan Eubanks, telephone interview with the author, June 4, 2002.

94. Carroll Parrott Blue, email correspondence with the author, June 5, 2002.

95. Blue correspondence.

96. Roz Payne, telephone interview with the author, April 2, 2002.

97. Shames interview.

98. Bill Jennings, telephone conversation with the author, March 29, 2002.

99. Shames interview.

100. Ibid.

101. Payne interview. The Newsreel Collective even modeled its own structure after the militancy of the Panthers, organizing into various cadres and taking disciplinary action against errant members. See also Young, *Soul Power*.

102. Blue correspondence.

103. Eubanks interview.

104. Blue correspondence.

105. Ibid.

106. Ibid.

107. Shames interview.

108. Ibid.

109. "Is It Too Late?," 142, 143.

110. Ibid., 144.

111. Ibid., 143.

112. Genet, *Prisoner of Love*, 213.

113. McLuhan quoted in "Is It Too Late?," 144.

114. Ibid., 146.

115. David Hilliard, "Enemies 'Within,' Enemies 'Without,'" *Black Panther*, September 6, 1969, 2; Chomsky and Herman, *Manufacturing Consent*.

116. See Abron, "'Raising the Consciousness'"; Peebles, Taylor, and Lewis, *Panther*; Davenport, "Reading the 'Voice of the Vanguard'"; and Payne interview.

117. Hilliard and Cole, *This Side of Glory*, 224.

118. Ibid., 154, 149.

119. *Basta Ya!*, the publication of Los Siete de la Raza, the seven imprisoned leaders of the Chicano Brown Liberation Movement, appeared twice a month on the flip side of the *Black Panther*.

120. Hilliard and Cole, *This Side of Glory*, 149.

121. Abu-Jamal, "Life in the Party," 46; Cox, "Split in the Party."

122. "The Black Panther Party under Attack," *Black Panther*, September 6, 1969, 9; Douglas quoted in Abron, "'Raising the Consciousness,'" 348.

123. Bill Jennings, telephone interview with the author, March 29, 2002. Newton declared that "the Black community is basically not a reading community." Quoted in Brad Brewer, "Revolutionary Art," *Black Panther*, October 24, 1970, 17.

124. *The Black Panther*, Saturday, September 6, 1969.

125. Shirley Hewitt, "Free Food or Fairy Tales???," *Black Panther*, September 13, 1969.

126. *Black Panther*, September 7, 1968, 8–9.

127. See Peebles, Taylor, and Lewis, *Panther*; and Baruch and Jones, *Vanguard*.

128. Newton, *Revolutionary Suicide*, 291–92.

129. Newton, "On the Defection of Eldridge Cleaver," Labadie Collection.

130. Matthews, "'No One Ever Asks,'" 245.

131. See especially Abron, "'Serving the People'"; Monges, "I Got a Right"; Lincoln Webster Sheffield, "People's Medical Care Center," *Daily World*, May 16, 1970, in Phillip S. Foner, *Black Panthers Speak*, 173–75; and Nelson, *Body and Soul*.

132. *Black Panther*, April 27, 1969, 4.

133. "Breakfast Programs," *Black Panther*, July 19, 1969, 16.

134. The July 19, 1969, issue of the *Black Panther* contains a drawing of a Vietnamese peasant woman carrying a rifle with a fixed bayonet. See also *Black Panther*, September 13, 1969, which includes the image of Kathleen Cleaver. The photograph was earlier made into a poster with the caption "1968: Ballot or the Bullet." See Joy James, *Shadowboxing*; and Keeling, *Witch's Flight*.

135. Elaine Brown, "The End of Silence," *Seize the Time*, Vault Records/BMI, 1970. For descriptions of sexism and masculinism within the BPP and black nationalism more broadly, see Kathleen Neal Cleaver, "Women, Power, and Revolution"; Michele Wallace, *Black Macho*; Davis, "Black Nationalism"; and Springer, *Living for the Revolution*.

136. Matthews, "'No One Ever Asks,'" 242.

137. In addition to Matthews, "'No One Ever Asks,'" and the other essays collected in Collier-Thomas and Franklin, *Sisters in the Struggle*, see also Fleming, *Soon We Will Not Cry*; and Robnett, *How Long? How Long?*

138. "'Contradictions between the Old and New,'" *Black Panther*, September 6, 1969, 9 (emphasis mine).

139. Genet, *Prisoner of Love*, 213.

140. *Black Panther*, August 9, 1969, 14–15. The next week's issue would announce the birth of the Cleavers' first child, Maceo, born in a "free" African country. *Black Panther*, August 16, 1969.

141. *Black Panther*, September 6, 1969, and October 31, 1970.

142. Kathleen N. Cleaver, "Back to Africa," and Address to "Photography, Memory and the Black Panther Party's Visit to the People's Republic of the Congo, 1971," symposium, Yale University, May 1, 2009.

143. "Huey's Message to the Revolutionary People's Constitutional Convention Plenary Session, September 5, 1970, Philadelphia, PA" (broadside), in the author's possession.

144. This is not to suggest that Panther offices remained impervious and impenetrable to the state. See especially Churchill and Vander Wall, *COINTELPRO Papers* and *Agents of Repression*.

145. Hine, "Rape and the Inner Lives," 292–97.

146. See especially "Special Issue: Evidence and Intimidation of Fascist Crimes by U.S.A.," *Black Panther*, February 21, 1970.

147. *Black Panther*, March 7, 1970, 1.

148. See Tagg, *Burden of Representation*.

149. See Elwood Smith photograph, *Philadelphia Daily News*, August 31, 1970, 1; and Churchill, "'To Disrupt, Discredit and Destroy,'" 99.

150. Hilliard and Cole, *This Side of Glory*, 223–4.

151. Hoover pronounced the *Black Panther* "one of the most effective propaganda operations of the BPP. . . . The BPP newspaper has a circulation of . . . 139,000. It is the voice of the BPP and if it could be effectively hindered, it would result in helping to cripple the BPP." The bureau employed numerous tactics to achieve their desired goal. At first, police were instructed to arrest Panthers selling the paper, on the grounds that they were circulating incendiary material. In the course of arrest, police were able to confiscate any unsold papers. As circulation of the *Black Panther* grew, so too did FBI devices. These methods included contaminating the printing facility with a chemical called Skatol to render the paper foul-smelling and therefore unsellable; compelling airline carriers to raise shipping rates, stretching already limited BPP finances; and suggesting that the Internal Revenue Service conduct an investigation into the paper's and the party's finances. See memo, FBI Headquarters to Chicago and seven other field offices, May 15, 1970, quoted in Churchill and Vander Wall, *COINTELPRO Papers*, 159–61; and Churchill, "To Disrupt, Discredit and Destroy," 85–87.

152. For more on the uses of cartoons as part of political movements, see Cohen, "'Cartooning Capitalism,'" and "Imagining Militarism."

153. Emory Douglas, interview with the author, San Francisco, Calif., July 24, 2007.

154. Ibid.

155. Emory Douglas, public lecture, "Louder than Words: Portraits and Expressions of the Black Panther Party" symposium, University of California–Berkeley, February 14, 2008.

156. John Berger, "Uses of Photography," in *About Looking*.

157. See, for example, "Black Power—Black Panther Party," Poster and Broadside Collection, Tamiment Library/Wagner Labor Archives, New York University.

158. For more on the RPCC, see Katsiaficas, "Organization and Movement"; and Sayre, "Politics."

159. Sayre, "Politics," 38.

160. Katsiaficas, "Organization and Movement," 142.

161. Newton quoted in Sayre, "Politics," 38.

162. Berger, *About Looking*, 67.

163. Jappe, *Guy Debord*, 6.

164. Stuart Hall, "New Ethnicities," 442.

165. Ibid., 443.

166. Huey Newton, "He Won't Bleed Me: A Revolutionary Analysis of 'Sweet Sweetback's Baadasssss Song,'" *Black Panther*, January 19, 1971.

167. Eldridge Cleaver in *Eldridge Cleaver*, dir. William Klein, 1970.

168. Singh, "Black Panthers and the 'Undeveloped Country' of the Left," 83.

Conclusion

1. Roth Horowitz, "Witness," press release, n.d. [2000], document in author's possession.

2. Prior to the release of *Without Sanctuary*, Allen solicited lynching photographs to add to the collection as well as information about photographs already in his possession through the Web site <www.willbuy.com>, through mass mailings to antique dealers, and through the maintenance of a toll-free phone number. James Allen, interview with the author, February 9, 2000, New York, N.Y.

3. Schwarz, "Killing Fields"; Patricia Williams, "Diary of a Mad Law Professor."

4. For a short list of such exhibits, see note 20 of the introduction, above.

5. Obama, "Victory Speech."

6. Yerba Buena Center for the Arts, "Risk and Response," 10.

7. Sontag, "Regarding the Torture of Others," in *At the Same Time*, 128.

8. Berger, *About Looking*, 62.

9. Fabre and O'Meally, "Introduction," in *History and Memory in African-American Culture*, 5.

10. David Scott, "Introduction," vi.

11. According to New-York Historical Society director Jan Ramirez, some fifty thousand people attended the show during the course of its four-month run, making it the most popular exhibit at the historical society to that date. Fears, "Civil Society." The Andy Warhol Museum also states that *Without Sanctuary* "resulted in the highest attendance for any exhibition since the Museum opened in 1994." Grogan, "Warhol Museum," 4.

12. Allen interview.

13. New-York Historical Society, "Without Sanctuary."

14. *Journal E: Without Sanctuary: Lynching Photography in America*, January 30, 2003, <http://www.withoutsanctuary.org>.

15. Quoted in Fears, "Civil Society."

16. Ibid.

17. A.O.A., "History, Horror, Healing."

18. Ibid.

19. "Without Sanctuary: Lynching Photography in America, Atlanta Exhibition" (pamphlet), document in the author's possession.

20. Ahmet Ertegun, quoted in Margolick, *Strange Fruit*, 5.

21. A.O.A., "History, Horror, Healing."

22. Barthes, *Camera Lucida*, 26.

23. Wiley J. Huff, quoted in *Jounal E: Without Sanctuary*, January 23, 2003.

24. See especially Morrison, *Race-ing Justice, En-gendering Power*.

25. Angel L. Fox, quoted in *Jounal E: Without Sanctuary*, January 20, 2003.

26. Berger, *About Looking*.

27. M. G. Moore, quoted in *Jounal E: Without Sanctuary*, January 20, 2003.

28. Benjamin, "Theses on the Philosophy of History," 255.

29. Auchmutey, "Lynching Exhibit Confronts South's Ugly Past."

30. Auchmutey, "Reminders of a Cruel Past."

31. Ibid.

32. Quoted in ibid.

33. Jordan, "'Truth as a Way to Reconciliation.'"

34. Ibid.

35. Ibid.

36. See Romano and Raiford, *The Civil Rights Movement in American Memory*.

37. Lichtendorf, "Road to Freedom."

38. Hirsch, "Surviving Images," 9. See also Hirsch, *Family Frames*.

39. Hirsch, "Surviving Images," 9.

40. Ibid., 8.

41. Leslie Hewitt quoted in Dorothy Spears, "'60s Legacy, Personal Histories," *New York Times*, June 1, 2008, <http://www.nytimes.com/2008/06/01/arts/design/01spea .html>, 17 August 2009. See also, Grove, *After 1968*; Martin, "Leslie Hewitt," 48–49; and Beckwith, *New Intuitions*.

42. Hewitt quoted in Spears, "'60s Legacy, Personal Histories."

43. Deborah Grant in "Deborah Grant" (2007), <www.newarttv.com/Deborah+Grant>, 28 August 2009. See also, Grove, *After 1968*; and Sirmans, "Deborah Grant," 32–33.

44. Deborah Grant quoted in Spears, "'60s Legacy, Personal Histories."

45. See Raiford, "Restaging Revolution."

46. Davis, "Afro Images," 177.

47. Olick, "Collective Memory," 335.

48. Ibid., 342.

49. David Scott, "Introduction," vii, fn 5.

50. Olick, "Collective Memory," 340.

51. Jessica Dawson, "'Black Panther: Rank and File': Rallying Its Own Art Movement," *Washington Post*, November 23, 2007, C2.

52. Benjamin, "Theses on the Philosophy of History," 257.

53. Berger, *About Looking*, 61.

54. Wajda, "History Writing, with Light," 567.

55. Wexler, *Tender Violence*, and Wexler, "Seeing Sentiment."

56. Pinney and Peterson, *Photography's Other Histories*.

57. Guinier and Torres, *Miner's Canary*, 16.

58. Butler, "Endangered/Endangering," 17.

59. Berger, *About Looking*, 58.

60. Worth Long, *We'll Never Turn Back*, 17.

61. Benjamin, "Theses on the Philosophy of History," 258.

62. Berger, *About Looking*, 60.

Archives and Collections

Ann Arbor, Michigan
 University of Michigan Library
 The Labadie Collection
Berkeley, California
 University of California, Berkeley
 Bancroft Library
 Black Panthers photographs
 Stephen Shames Black Panther photograph collection
Madison, Wisconsin
 State Historical Society of Wisconsin
 Photograph Collections
 Poster Collections
 Social Action Collection
New Haven, Connecticut
 New Haven Public Library
 Yale University
 Beinecke Rare Book and Manuscript Collection
 James Weldon Johnson Collection
 Manuscripts and Archives
New York, New York
 New York Public Library
 Schomburg Center for Research in Black Culture
 New York University
 Tamiment Library/Wagner Labor Archives
 Poster and Broadside Collection
Stanford, California
 Stanford University Special Collections
 Dr. Huey P. Newton Foundation Collection
Washington, D.C.
 Library of Congress
 National Association for the Advancement of Colored People Papers
 Visual Materials from the NAACP Records
 Pamphlet Collection

Interviews

James Allen, New York, New York, February 9, 2000
Carroll Parrott Blue, email correspondence, June 5, 2002
Kathleen Neal Cleaver, New Haven, Connecticut, October 7, 1998

Emory Douglas, San Francisco, California, July 24, 2007
Jonathan Eubanks, telephone, June 4, 2002
Dee Gorton, email correspondence, July 6, 2001
Matt Herron, San Rafael, California, August 29, 2007
Billy X Jennings, telephone, March 29, 2002
Julius Lester, Belcherville, Massachusetts, November 5, 2007
Elizabeth Martinez, San Francisco, California, November 17, 2008
Bruce Nelson, conversation, Los Angeles, California, April 27, 2001
Roz Payne, telephone, April 2, 2002
Stephen Shames, telephone, May 2, 2002
Maria Varela, email correspondence, January 14, 2010
Tamio Wakayama, telephone, July 17, 2001

Microfilm Collections

Dr. Huey P. Newton Foundation, Inc., collection, Mo864. Department of Special
 Collections, Stanford University Libraries, Stanford, Calif.
Papers of the NAACP. Part 7, The Anti-Lynching Campaign, 1912–1955. Edited by
 Robert L. Zangrando. Frederick, Md.: University Publications of America, 1987.
Student Nonviolent Coordinating Committee Papers, 1959–1972. Sanford, N.C.:
 Microfilming Corp. of America, 1982.

Newspapers and Periodicals

Atlanta Journal-Constitution	New York Times Mid-Week Pictorial
Black Panther	Philadelphia Daily News
Crisis	San Francisco Chronicle and Examiner
Chicago Defender	Student Voice (Atlanta, Ga.)
Los Angeles Times	Washington Post
New York Times	

Films

Eldridge Cleaver, dir. William Klein, 1970. O. N. C. I. C.
Freedom on My Mind, dir. Connie Field and Marilyn Mulford, 1994.
A Grin without a Cat, dir. Chris Marker, 1993 [1977]. Davidis/Icarus Films.

Articles, Books, Dissertations, Manuscripts

Abel, Elizabeth. Signs of the Times: The Visual Politics of Jim Crow. Berkeley: University
 of California Press, 2010.
Abron, JoNina. "'Raising the Consciousness of the People': The Black
 Panther Intercommunal News Service, 1967–1980." In Voices from the Underground:
 Insider Histories of the Vietnam Era Underground Press, edited by Ken Waschberger.
 Tempe, Ariz.: Mica Press, 1993.
──────. "'Serving the People': The Survival Programs of the Black Panther Party." In

The Black Panther Party Reconsidered, edited by Charles E. Jones. Baltimore: Black Classic Press, 1998.

Abu-Jamal, Mumia. "A Life in the Party: An Historical and Retrospective Examination of the Projections and Legacies of the Black Panther Party." In *Liberation, Imagination, and the Black Panther Party: A New Look at the Panthers and Their Legacy*, edited by Kathleen Neal Cleaver and George Katsiaficas. New York: Routledge, 2001.

Agamben, Giorgio. *Homo Sacer: Sovereign Power and Bare Life*. Translated by Daniel Heller-Roazen. Stanford, Calif.: Stanford University Press, 1998.

Albert, Stew. "White Radicals, Black Panthers and a Sense of Fulfillment." In *Liberation, Imagination, and the Black Panther Party: A New Look at the Panthers and Their Legacy*, edited by Kathleen Neal Cleaver and George Katsiaficas. New York: Routledge, 2001.

Alexander, Elizabeth. "'Can you be BLACK and look at this?': Reading the Rodney King Video(s)." In *Black Male: Representations of Masculinity in Contemporary American Art*, edited by Thelma Golden. New York: Whitney Museum of Art, 1994.

Ali, Muhammad. *The Greatest*. New York: Random House, 1975.

Allen, James, et al. *Without Sanctuary: Lynching Photography in America*. Santa Fe: Twin Palms, 2000.

Allen, Robert. *Black Awakening in Capitalist America: An Analytic History*. Trenton, N.J.: Africa World Press, 1990. (Originally published in 1970)

Als, Hilton. "GWTW." In *Without Sanctuary: Lynching Photography in America*, edited by James Allen et al. Santa Fe: Twin Palms, 2000.

Althusser, Louis. "Ideology and Ideological State Apparatuses (Notes Towards an Investigation)." In *Lenin and Philosophy*, translated by Ben Brewster. New York: Monthly Review Press, 1971.

Anderson, Benedict. *Imagined Communities: Reflections on the Origins and Spread of Nationalism*. London: Verso, 1991. (Originally published in 1983)

Anner, John, ed. *Beyond Identity Politics: Emerging Social Justice Movements in Communities of Color*. Boston: South End Press, 1996.

A. O. A. "History, Horror, Healing: Faculty Deliberations on Lynching Photography Examine Racial and Historical Understanding." *Academic Exchange* [Emory University]. April/May 2001.

Apel, Dora. *Imagery of Lynching: Black Men, White Women, and the Mob*. New Brunswick, N.J.: Rutgers University Press, 2004.

Apel, Dora, and Shawn Michelle Smith. *Lynching Photographs*. Berkeley: University of California Press, 2008.

Auchmutey, Jim. "Lynching Exhibit Confronts South's Ugly Past." *Atlanta Journal-Constitution*, April 28, 2002, <http://www.ajc.com>. January 25, 2003.

———. "Reminders of a Cruel Past." *Atlanta Journal-Constitution*, October 19, 2008, <http://www.ajc.com>. August 12, 2009.

Avedon, Richard. *Evidence, 1944–1994*. New York: Random House, 1994.

Avedon, Richard, and James Baldwin. *Nothing Personal*. New York: Atheneum, 1964.

Bailey, Ronald W., and Michele Furst, eds. *Let Us March On! Selected Civil Rights Photographs of Ernest C. Withers, 1955–1968*. Boston: Massachusetts College of Art, 1992.

Baker, Courtney. "Emmett Till, Justice and the Task of Recognition." *Journal of American Culture* 29, no. 2 (June 2006): 111–24.

Baker, Ella. "Bigger than a Hamburger." *Southern Patriot*, May 1960.

Baker, Houston A., Jr. "Critical Memory and the Black Public Sphere." In *The Black Public Sphere*, edited by the Black Public Sphere Collective. Chicago: University of Chicago Press, 1995.

Bakhtin, Mikhail. *The Dialogic Imagination*. Austin: University of Texas Press, 1982.

———. *Rabelais and His World*. Bloomington: Indiana University Press, 1984. (Originally published in 1968)

Baldwin, Davarian L. "'Culture Is a Weapon in Our Struggle for Liberation': The Black Panther Party and the Cultural Politics of Decolonization." In *In Search of the Black Panther Party: New Perspectives on a Revolutionary Movement*, edited by Jama Lazerow and Yohuru Williams. Durham, N.C.: Duke University Press, 2006.

Baldwin, James. *The Fire Next Time*. New York: Dial Press, 1963.

Barthes, Roland. *Camera Lucida: Reflections on Photography*. Translated by Richard Howard. New York: Hill and Wang, 1981.

———. *Image—Music—Text*. New York: Noonday Press, 1977.

Baruch, Ruth-Marion, and Pirkle Jones. *Panthers 1968*. Los Angeles: Greybull Press, 2002.

———. *The Vanguard: A Photographic Essay on the Black Panthers*. Boston: Beacon Press, 1970.

Batchen, Geoffrey. *Each Wild Idea: Writing, Photography, History*. Cambridge, Mass.: MIT Press, 2001.

Beckwith, Naomi, ed. *New Intuitions: Artists-in-Residence 2007–08*. New York: Studio Museum in Harlem, 2007.

Bederman, Gail. *Manliness and Civilization: A Cultural History of Gender and Race in the United States, 1880–1917*. Chicago: University of Chicago Press, 1995.

Belcher, Jerry. "It's All Legal: Oakland's Black Panthers Wear Guns, Talk Revolution." *San Francisco Sunday Chronicle and Examiner*, April 30, 1967.

Belfrage, Sally. *Freedom Summer*. Charlottesville and London: University Press of Virginia, 1990.

Benjamin, Walter. *The Arcades Project*. Translated by Howard Eiland and Kevin McLaughlin. Cambridge, Mass.: Harvard University Press, 1999.

———. *Illuminations*. Translated by Harry Zohn, edited by Hannah Arendt. New York: Schocken Books, 1969.

———. "A Small History of Photography." In *One-Way Street and Other Writings*. London: NLB, 1979.

———. "Theses on the Philosophy of History." In *Illuminations*, translated by Harry Zohn, edited by Hannah Arendt. New York: Schocken Books, 1969.

———. "The Work of Art in the Age of Mechanical Reproduction." In *Illuminations*, translated by Harry Zohn, edited by Hannah Arendt. New York: Schocken Books, 1969.

Bennett, Lerone, Jr. "Stokely Carmichael: Architect of Black Power." *Ebony*, September 1966.

Berger, John. *About Looking*. New York: Pantheon Books, 1980.

Berger, John, and Jean Mohr. *Another Way of Telling*. New York: Pantheon Books, 1982.

Bhabha, Homi. "The Other Question: The Stereotype and Colonial Discourse." In *Visual Culture*, edited by Jessica Evans and Stuart Hall. London: Sage Publications, 1999.

Black Public Sphere Collective, ed. *The Black Public Sphere*. Chicago and London: University of Chicago Press, 1995.

Bobo, Jacqueline. *Black Women as Cultural Readers*. New York: Columbia University Press, 1995.

Bolton, Richard, ed. *Contest of Meaning: A Critical History of Photography*. Cambridge, Mass.: MIT Press, 1992.

Bond, Julian. "A Remarkable Time." In *Photo Film, 1959–1990*, edited by Danny Lyon. [Heidelberg], Germany: Edition Braus, 1991.

Boyd, Herb, and Lance Tooks. *Black Panthers for Beginners*. New York: Writers and Readers 1995.

Branch, Taylor. *Parting the Waters: America in the King Years*. New York: Touchstone, Simon and Schuster, 1988.

Brennen, Bonnie, and Hanno Hardt, eds. *Picturing the Past: Media, History and Photography*. Urbana: University of Illinois Press, 1999.

Brown, Elaine. *A Taste of Power: A Black Woman's Story*. New York: Anchor Books, Doubleday, 1993.

Brown, Gillian. *Domestic Individualism: Imaging the Self in Nineteenth-Century America*. Berkeley: University of California Press, 1990.

Brundage, W. Fitzhugh. *Lynching in the New South: Georgia and Virginia, 1880–1930*. Urbana and Chicago: University of Illinois Press, 1993.

———. *The Southern Past: A Clash of Race and Memory*. Cambridge, Mass.: Harvard University Press, 2005.

Buck-Morss, Susan. "Aesthetics and Anaesthetics: Walter Benjamin's Artwork Essay Reconsidered." *October* 16 (Autumn 1992): 3–41.

———. *Dialectics of Seeing: Walter Benjamin and the Arcades Project*. Cambridge, Mass.: MIT Press, 1987.

Burawoy, Michael, et al. *Ethnography Unbound: Power and Resistance in the Modern Metropolis*. Berkeley: University of California Press, 1991.

Butler, Judith. "Endangered/Endangering: Schematic Racism and White Paranoia." In *Reading Rodney King/Reading Urban Uprising*, edited by Robert Gooding-Williams. New York: Routledge, 1993.

———. *Gender Trouble: Feminism and the Subversion of Identity*. New York: Routledge, 1990.

Cadava, Eduardo. *Words of Light: Theses on the Photography of History*. Princeton, N.J: Princeton University Press, 1997.

Cameron, James. *A Time of Terror: A Survivor's Story*. Baltimore, Md.: Black Classic Press, 1982.

Carby, Hazel V. *Cultures in Babylon: Black Britain and African America*. New York: Verso, 1999.

———. *Race Men*. Cambridge, Mass.: Harvard University Press, 1998.

———. *Reconstructing Womanhood: The Emergence of the Afro-American Woman Novelist*. New York: Oxford University Press, 1987.

Carmichael, Stokely, and Charles Hamilton. *Black Power: The Politics of Liberation in America*. New York: Random House, 1971.

Carson, Clayborne. *In Struggle: SNCC and the Black Awakening of the 1960's.*
Cambridge, Mass.: Harvard University Press, 1995. (Originally published in 1981)

Carson, Clayborne, David J. Garrow, Vincent Harding, and Darlene Clark Hine, eds.
Eyes on the Prize: A Reader and Guide. New York: Penguin Books, 1987.

Chadbourn, James Harmon. *Lynching and the Law.* Chapel Hill: University of North
Carolina Press, 1933.

Charron, Katherine Mellen. *Freedom's Teacher: The Life of Septima Clark.* Chapel Hill:
University of North Carolina Press, 2009.

Chomsky, Noam, and Edward S. Herman. *Manufacturing Consent: The Political
Economy of the Mass Media.* New York: Pantheon Books, 1988.

Churchill, Ward. "'To Disrupt, Discredit and Destroy': The FBI's Secret War against
the Black Panther Party." In *Liberation, Imagination, and the Black Panther Party:
A New Look at the Panthers and Their Legacy,* edited by Kathleen Neal Cleaver and
George Katsiaficas. New York: Routledge, 2001.

Churchill, Ward, and Jim Vander Wall. *Agents of Repression: The FBI's Secret War
against the Black Panther Party and the American Indian Movement.* Boston: South
End Press, 1988.

———. *The COINTELPRO Papers: Documents from the FBI's Secret Wars against Dissent
in the United States.* Boston: South End Press, 1990.

Cleaver, Eldridge. *Soul on Ice.* New York: Dell, 1968.

Cleaver, Kathleen Neal. "Back to Africa: The Evolution of the International Section
of the Black Panther Party (1969–1972)." In *The Black Panther Party Reconsidered,*
edited by Charles E. Jones. Baltimore: Black Classic Press, 1998.

———. "Women, Power, and Revolution." In *Liberation, Imagination, and the Black
Panther Party: A New Look at the Panthers and Their Legacy,* edited by Kathleen
Neal Cleaver and George Katsiaficas. New York: Routledge, 2001.

Cleaver, Kathleen Neal and George Katsiaficas, eds. *Liberation, Imagination, and the
Black Panther Party: A New Look at the Panthers and Their Legacy.* New York:
Routledge, 2001.

Coar, Valencia Hollins, ed. *A Century of Black Photographers, 1840–1960.* Providence,
R.I.: Museum of Art, Rhode Island School of Design, 1983.

Cohen, Michael. "'Cartooning Capitalism': Radical Cartooning and the Making of
American Popular Radicalism in the Early Twentieth Century." *International Review
of Social History* 52 (Winter 2007): 35–58.

———. "Imagining Militarism: Art Young and *The Masses* Face the Enemy." *Radical
History Review* 106 (Winter 2010): 87–108.

Collier-Thomas, Bettye, and V. P. Franklin, eds. *Sisters in the Struggle: African American
Women in the Civil Rights–Black Power Movement.* New York: New York University
Press, 2001.

Collins, Winfield Hazlitt. *The Domestic Slave Trade in the Southern States.* Port
Washington, N.Y.: Kennikat Press, 1969. (Originally published in 1904)

———. *The Truth about Lynching and the Negro in the South in Which the Author
Pleads That the South Be Made Safe for the White Race.* New York: Neale, 1918.

Cox, Donald. "The Split in the Party." In *Liberation, Imagination, and the Black Panther
Party: A New Look at the Panthers and Their Legacy,* edited by Kathleen Neal
Cleaver and George Katsiaficas. New York: Routledge, 2001.

Crawford, Vicki L., Jacqueline Anne Rouse, and Barbara Woods, eds. *Women in the Civil Rights Movement: Trailblazers and Torchbearers, 1941–1965*. Bloomington and Indianapolis: Indiana University Press, 1993.

Cunard, Nancy, ed. *Negro: An Anthology*. New York: Continuum, 1996. (Originally published in 1933)

Curry, Constance, ed. *Deep in Our Hearts: Nine White Women in the Freedom Movement*. Athens: University of Georgia Press, 2000.

Cutler, James E. *Lynch-law: An Investigation into the History of Lynching in the United States*. New York: Longmans, Green, and Co., 1905.

Darnovsky, Marcy, Barbara Epstein, and Richard Flacks, eds. *Cultural Politics and Social Movements*. Philadelphia: Temple University Press, 1995.

Davenport, Christian A. "Reading the 'Voice of the Vanguard': A Content Analysis of the Black Panther Party Intercommunal News Service, 1969–1973." In *The Black Panther Party Reconsidered*, edited by Charles E. Jones. Baltimore: Black Classic Press, 1998.

Davidov, Judith Freyer. *Women's Camera Work: Self/Body/Other in American Visual Culture*. Durham, N.C.: Duke University Press, 1998.

Davis, Angela Y. "Afro Images: Politics, Fashion, and Nostalgia." In *Picturing Us: African American Identity in Photography*, edited by Deborah Willis. New York: New Press, 1994.

———. *An Autobiography*. New York: International Publishers, 1974.

———. "Black Nationalism: The Sixties and the Nineties." In *Black Popular Culture*, edited by Gina Dent. Seattle: Bay Press, 1992.

Debord, Guy. *The Society of the Spectacle*. New York: Zone Books, 1995. (Originally published in 1967)

Denning, Michael. *The Cultural Front: The Laboring of American Culture in the Twentieth Century*. London: Verso, 1996.

———. *Culture in the Age of Three Worlds*. New York: Verso, 2004.

Dent, Gina, ed. *Black Popular Culture*. Seattle: Bay Press, 1992.

Diawara, Manthia. "Black Spectatorship: Problems of Identification and Resistance." In *Black American Cinema*, edited by Manthia Diawara. New York: Routledge, 1993.

Dittmer, John. *Local People: The Struggle for Civil Rights in Mississippi*. Urbana: University of Illinois Press, 1994.

Doss, Erika. "'Revolutionary Art Is a Tool for Liberation': Emory Douglas and Protest Aesthetics at the *Black Panther*." In *Liberation, Imagination, and the Black Panther Party: A New Look at the Panthers and Their Legacy*, edited by Kathleen Neal Cleaver and George Katsiaficas. New York: Routledge, 2001.

Dray, Philip. *At the Hands of Persons Unknown: The Lynching of Black America*. New York: Modern Library, 2002.

Du Bois, W. E. B. *Dusk of Dawn: An Essay toward an Autobiography of a Race Concept*. New Brunswick, N.J.: Transaction, 1984. (Originally published in 1940)

Duganne, Erina. *The Self in Black and White: Race and Subjectivity in Postwar American Photography*. Dartmouth, N.H.: University Press of New England, 2010.

Durant, Sam, ed. *Black Panther: The Revolutionary Art of Emory Douglas*. New York: Rizzoli, 2007.

Eagleton, Terry. *Literary Theory: An Introduction*. Minneapolis: University of Minnesota Press, 1983.

Ebony Pictorial History of Black America. Vol. 3, *Civil Rights to Black Revolution.* Chicago: Johnson Publishing, 1971.

Edwards, Erica R. "Moses, Monster of the Mountain: Gendered Violence in Black Leadership's Gothic Tale." *Callaloo* 31, no. 4 (Fall 2008): 1084–102.

Fabre, Geneviève. "The Free Southern Theatre, 1963–1979." *Black American Literature Forum* 17, no. 2 (Summer 1983): 55–59.

Fabre, Geneviève, and Robert O'Meally, eds. *History and Memory in African-American Culture.* New York: Oxford University Press, 1994.

Fanon, Frantz. *Black Skin, White Masks.* Translated by Charles Lam Markmann. New York: Grove Weidenfeld, 1967. (Originally published in 1952)

———. *Wretched of the Earth.* New York: Grove Press, 1963.

Fantasia, Rick. *Cultures of Solidarity: Consciousness, Action, and Contemporary American Workers.* Berkeley: University of California Press, 1988.

Fax, Elton C. *Black Artists of the New Generation.* New York: Dodd, Mead, 1977.

Fears, Darryl. "Civil Society: *Without Sanctuary.*" *Washington Post,* January 28, 2002.

Feimster, Crystal. *Southern Horrors: Women and the Politics of Rape and Lynching in the American South.* Cambridge, Mass.: Harvard University Press, 2009.

Fleming, Cynthia Griggs. *Soon We Will Not Cry: The Liberation of Ruby Doris Smith Robinson.* Lanham, Md.: Rowman and Littlefield, 1998.

Fletcher, Jim, Tanaquil Jones, and Sylvere Lotringer, eds. *Still Black, Still Strong.* New York: Semiotext(E), 1993.

Foner, Eric. *Nothing but Freedom.* Baton Rouge: Louisiana State University Press, 1983.

Foner, Phillip S., ed. *The Black Panthers Speak.* New York: Da Capo Press, 1995.

Forman, James. *The Making of Black Revolutionaries.* New York: Macmillan, 1972.

Foster, Hal, ed. *Vision and Visuality.* Seattle: Bay Press, 1988.

Foucault, Michel. *Discipline and Punish: The Birth of the Prison.* Translated by Alan Sheridan. New York: Vintage Books, 1977.

———. *The History of Sexuality, Volume One: An Introduction.* Translated by Robert Hurley. New York: Vintage Books, 1978.

Frederickson, George M. *The Black Image in the White Mind: The Debate on Afro-American Character and Destiny, 1817–1914.* New York: Harper and Row, 1971.

"Free Angela: Actress Cynda Williams as Angela Davis, a Fashion Revolutionary." *Vibe,* March 1994.

Freed, Donald. *Agony in New Haven: The Trial of Bobby Seale, Ericka Huggins and the Black Panther Party.* New York: Simon and Schuster, 1973.

Fulton, Marianne, ed. *Eyes of Time: Photojournalism in America.* Boston: Little, Brown and Company, 1988.

Fusco, Coco. "Racial Times, Racial Marks, Racial Metaphors." In *Only Skin Deep: Changing Visions of the American Self,* edited by Coco Fusco and Brian Wallis. New York: Harry N. Abrams, 2003.

Gaines, Kevin K. *Uplifting the Race: Black Leadership, Politics, and Culture in the Twentieth Century.* Chapel Hill: University of North Carolina Press, 1996.

Garrow, David J. *Protest at Selma: Martin Luther King Jr. and the Voting Rights Act of 1965.* New Haven and London: Yale University Press, 1978.

Gates, Henry Louis, Jr. "The Trope of the New Negro and the Reconstruction of the Image of the Black." *Representations* 24 (Fall 1988): 129–56.

Genet, Jean. *Prisoner of Love*. Translated by Barbara Bray. Hanover, N.H.: Wesleyan University Press, 1992.

Genovese, Eugene. *Roll, Jordan, Roll: The World the Slaves Made*. New York: Vintage Books, 1972.

Giddings, Paula. "Missing in Action: Ida B. Wells, the NAACP, and the Historical Record." *Meridians: feminism, race, transnationalism* 1, no. 2 (Spring 2001): 1–17.

Gilmore, Glenda Elizabeth. *Gender and Jim Crow: Women and the Politics of White Supremacy in North Carolina, 1896–1920*. Chapel Hill: University of North Carolina Press, 1996.

Gilroy, Paul. "'After the Love Has Gone': Bio-Politics and Etho-Poetics in the Black Public Sphere." In *The Black Public Sphere*, edited by the Black Public Sphere Collective. Chicago: University of Chicago Press, 1995.

———. *Against Race: Imagining Political Culture beyond the Color Line*. Cambridge, Mass.: Harvard University Press, 2000.

———. *The Black Atlantic: Modernity and Double Consciousness*. Cambridge, Mass.: Harvard University Press, 1993.

———. *Small Acts: Thoughts on the Politics of Black Cultures*. London: Serpent's Tail, 1993.

———. *"There Ain't No Black in the Union Jack": The Cultural Politics of Race and Nation*. Chicago: University of Chicago Press, 1987.

Ginzburg, Ralph. *One Hundred Years of Lynchings*. Baltimore: Black Classic Press, 1988. (Originally published in 1962)

Gitlin, Todd. *The Whole World Is Watching: Mass Media in the Making and Unmaking of the New Left*. Berkeley and Los Angeles: University of California Press, 1980.

Gogan, Jessica. "The Warhol: Museum as Artist: Creative, Dialogic, and Civic Practice." *Americans for the Arts*, <http://www.AmericansForTheArts.org>. August 22, 2009.

Goldberg, Vicki. *The Power of Photography: How Photographs Changed Our Lives*. New York: Abbeville Publishing Group, 1991.

Golden, Thelma, ed. *Black Male: Representations of Masculinity in Contemporary American Art*. New York: Whitney Museum of Art, 1994.

Goldsby, Jacqueline. "The High and Low Tech of It: The Meaning of Lynching and the Death of Emmett Till." *Yale Journal of Criticism* 9, no. 2 (1996): 245–82.

———. *A Spectacular Secret: Lynching in American Life and Literature*. Chicago: University of Chicago Press, 2006.

Good, Paul. *The Trouble I've Seen: White Journalist/Black Movement*. Washington, D.C.: Howard University Press, 1975.

Gooding-Williams, Robert, ed. *Reading Rodney King/Reading Urban Uprising*. New York: Routledge, 1993.

Goodman, James. *Stories of Scottsboro*. New York: Vintage Books, 1994.

Gordon, Avery F. *Ghostly Matters: Haunting and the Sociological Imagination*. Minneapolis: University of Minnesota Press, 1997.

Gould, Stephen Jay. *The Mismeasure of Man*. New York: W. W. Norton, 1981.

Gramsci, Antonio. *Selections from the Prison Notebooks*. New York: International Publishers, 1971.

Grant, Donald L. *The Anti-Lynching Movement, 1883–1932*. San Francisco: R and E Research Associates, 1975.

Greenberg, Cheryl Lynn, ed. *A Circle of Trust: Remembering SNCC*. New Brunswick, N.J.: Rutgers University Press, 1998.

Griffin, Farah Jasmine. *In Search of Billie Holiday: If You Can't Be Free, Be a Mystery*. New York: Ballantine Books, 2001.

Grove, Jeffrey D. *After 1968: Contemporary Artists and the Civil Rights Legacy*. Atlanta: High Museum, 2008.

Guinier, Lani, and Gerald Torres. *The Miner's Canary: Enlisting Race, Resisting Power, Transforming Democracy*. Cambridge, Mass.: Harvard University Press, 2002.

Gunning, Sandra. *Race, Rape and Lynching: The Red Record of American Literature, 1890–1912*. New York: Oxford University Press, 1996.

Hale, Grace Elizabeth. *Making Whiteness: The Culture of Segregation in the South, 1890–1940*. New York: Vintage Books, 1998.

Hall, Jacquelyn Dowd. "The Long Civil Rights Movement and the Political Uses of the Past." *Journal of American History* 91, no. 4 (March 2005): 1233–63.

———. "Private Eyes, Public Women: Images of Class and Sex in the Urban South, Atlanta, Georgia, 1913–1915." *Atlanta History*, Winter 1993, 24–39.

———. *Revolt against Chivalry: Jessie Daniel Ames and the Women's Campaign against Lynching*. New York: Columbia University Press, 1993.

Hall, Stuart. "Encoding/Decoding." In *Culture, Media, Language: Working Papers in Cultural Studies, 1972–79*. London: Hutchinson, 1980.

———. "Gramsci's Relevance for the Study of Race and Ethnicity." In *Stuart Hall: Critical Dialogues in Cultural Studies*, edited by David Morley and Kuan-Hsing Chen. London and New York: Routledge, 1996. (Originally published in 1986)

———. "New Ethnicities." In *Stuart Hall: Critical Dialogues in Cultural Studies*, edited by David Morley and Kuan-Hsing Chen. London and New York: Routledge, 1996. (Originally published in 1986)

———. "Race, Articulation, and Societies Structured in Dominance." In *Black British Cultural Studies: A Reader*, edited by Houston A. Baker Jr., Manthia Diawara, and Ruth H. Lindeborg. Chicago: University of Chicago Press, 1996. (Originally published in 1980)

Hamlin, Françoise. *The Story Isn't Finished: Continuing Histories of the Civil Rights Movement*. Chapel Hill: University of North Carolina Press, forthcoming.

Hansberry, Lorraine, and Danny Lyon. *The Movement: Documentary of a Struggle for Equality*. New York: Simon and Schuster, 1964.

Haraway, Donna. *Primate Visions: Gender, Race and Nature in the World of Modern Science*. New York: Routledge, 1989.

Harris, Trudier. *Exorcising Blackness: Historical and Literary Lynching and Burning Rituals*. Bloomington: Indiana University Press, 1984.

Harris, William J., ed. *The LeRoi Jones/Amiri Baraka Reader*. New York: Thunder's Mouth Press, 1991.

Hartman, Saidiya. *Scenes of Subjection: Terror, Slavery and Self-Making in Nineteenth Century America*. New York: Oxford University Press, 1997.

Hatt, Michael. "Race, Ritual and Responsibility: Performativity and the Southern Lynching." In *Performing the Body/Performing the Text*, edited by Amelia Jones and Andrew Stephenson. London and New York: Routledge, 1999.

Hayden, Casey. "Fields of Blue." In *Deep in Our Hearts: Nine White Women in the*

Freedom Movement, edited by Constance Curry. Athens: University of Georgia Press, 2000.

Hayes, Robin J. "A Diasporic Underground: African Liberation and Black Power." Unpublished manuscript.

Heath, G. Louis. *Off the Pigs!: The History and Literature of the Black Panther Party*. Metuchen, N.J.: Scarecrow Press, 1976.

———, ed. *The Black Panther Leaders Speak: Huey P. Newton, Bobby Seale, Eldridge Cleaver and Company Speak Out through the Black Panther Party's Official Newspaper*. Metuchen, N.J.: Scarecrow Press, 1976.

Higginbotham, Evelyn Brooks. *Righteous Discontent: The Women's Movement in the Black Baptist Church*. Cambridge, Mass.: Harvard University Press, 1994.

Higham, John. *Strangers in the Land: Patterns of American Nativism, 1860–1925*. New York: Atheneum, 1963. (Originally published in 1955)

Hilliard, David, and Lewis Cole. *This Side of Glory: The Autobiography of David Hilliard and the Story of the Black Panther Party*. Boston: Little, Brown, 1993.

Hine, Darlene Clark. "Rape and the Inner Lives of Black Women in the Middle West: Thoughts on the Culture of Dissemblance." In *Unequal Sisters*, edited by Ellen Carol Du Bois and Vicki L. Ruiz. New York: Routledge, 1990.

Hirsch, Marianne. *Family Frames: Photography, Narrative and Postmemory*. Cambridge, Mass.: Harvard University Press, 1997.

———. "Surviving Images: Holocaust Photographs and the Work of Postmemory." *Yale Journal of Criticism* 14, no. 1 (Spring 1991): 5–37.

———, ed. *The Familial Gaze*. Hanover, N.H.: University Press of New England, 1999.

Hogan, Wesley C. *Many Minds, One Heart: SNCC's Dream for a New America*. Chapel Hill: University of North Carolina Press, 2007.

Holland, Sharon Patricia. *Raising the Dead: Readings of Death and (Black) Subjectivity*. Durham, N.C.: Duke University Press, 2000.

Holloway, Camara Dia. *Portraiture and the Harlem Renaissance: The Photographs of James L. Allen*. New Haven, Conn.: Yale University Art Gallery, 1999.

Holmes, Oliver Wendell. "The Stereoscope and the Stereograph." *Atlantic Monthly* (1859). Reprinted in *Classic Essays on Photography*, edited by Alan Trachtenberg. New Haven, Conn.: Leete's Island Books, 1980.

Holquist, Michael. *Dialogism: Bakhtin and His World*. New York: Routledge, 1990.

hooks, bell. *Black Looks: Race and Representation*. Boston: South End Press, 1992.

———. "In Our Glory: Photography in Black Life." In *Picturing Us: African American Identity in Photography*, edited by Deborah Willis-Thomas. New York: News Press, 1994.

Huey Newton Talks to "The Movement" *about the Black Panther Party, Cultural Nationalism, SNCC, Liberals and White Revolutionaries*. Boston, Mass.: New England Free Press, n.d. Originally published in the *Movement*, August 1968.

Hunter, Jefferson. *Image and Word: The Interaction of Twentieth-Century Photographs and Texts*. Cambridge, Mass.: Harvard University Press, 1987.

Hunter-Gault, Charlayne. *In My Place*. New York: Farrar, Straus and Giroux, 1992.

"Is It Too Late to Be Pals with a Black Panther?" *Esquire*, November 1970, 142–47.

Jackson, Phyllis. "Re-Living Memories: Picturing Death." *IJELE: Art EJournal of the African World*, no. 5 (2002).

Jacobson, Matthew Frye. *Barbarian Virtues: The United States Encounters Foreign Peoples at Home and Abroad, 1876–1917.* New York: Hill and Wang, 2000.

———. *Whiteness of a Different Color: European Immigrants and the Alchemy of Race.* Cambridge, Mass.: Harvard University Press, 1998.

James, Joy. *Resisting State Violence: Radicalism, Gender, and Race in U.S. Culture.* Minneapolis: University of Minnesota Press, 1996.

———. *Shadowboxing: Representations of Black Feminist Politics.* New York: Palgrave Macmillan, 2002.

James, Winston. *Holding Aloft the Banner of Ethiopia: Caribbean Radicalism in Early Twentieth Century America.* New York: Verso, 1999.

Jameson, Fredric. *The Political Unconscious: Narrative as a Socially Symbolic Act.* Ithaca, N.Y.: Cornell University Press, 1981.

———. *Postmodernism; or, The Cultural Logic of Late Capitalism.* Durham, N.C.: Duke University Press, 1991.

JanMohamed, Abdul. *The Death-Bound-Subject: Richard Wright's Archeology of Death.* Durham, N.C.: Duke University Press, 2005.

Jappe, Anselm. *Guy Debord.* Translated by Donald Nicholson-Smith. Berkeley: University of California Press, 1999.

Jay, Martin. "Scopic Regimes of Modernity." In *Vision and Visuality*, edited by Hal Foster. Seattle: Bay Press, 1988.

Jeffries, Hasan Kwame. *Bloody Lowndes: Civil Rights and Black Power in Alabama's Black Belt.* New York: New York University Press, 2009.

Jeffries, Judson L. "'Don't Believe the Hype': Debunking the Panther Mythology." In *The Black Panther Party Reconsidered*, edited by Charles E. Jones. Baltimore, Md.: Black Classic Press, 1998.

Jenkins, Reese. *Images and Enterprise: Technology and the American Photographic Industry, 1839 to 1925.* Baltimore, Md.: Johns Hopkins University Press, 1975.

Jennings, Regina. "Poetry of the Black Panther Party: Metaphors of Militancy." *Journal of Black Studies* 29, no. 1 (September 1998): 106–29.

Johnson, James Weldon. *Along This Way: The Autobiography of James Weldon Johnson.* New York: Viking Press, 1933.

———. "Lynching: America's National Disgrace." New York: NAACP, 1924.

Johnson, Walter. *Soul by Soul: Life inside the Antebellum Slave Market.* Cambridge, Mass.: Harvard University Press, 1999.

Jones, Charles E., ed. *The Black Panther Party Reconsidered.* Baltimore, Md.: Black Classic Press, 1998.

Jordan, Joseph F. "'Truth as a Way to Reconciliation.'" *Atlanta Journal-Constitution*, April 28, 2002, <http://www.ajc.com>. January 23, 2003.

Kasher, Steven. *The Civil Rights Movement: A Photographic History, 1954–68.* New York: Abbeville Press, 1996.

Katsiaficas, George. "Organization and Movement: The Case of the Black Panther Party and the Revolutionary People's Constitutional Convention of 1970." In *Liberation, Imagination, and the Black Panther Party: A New Look at the Panthers and Their Legacy*, edited by Kathleen Neal Cleaver and George Katsiaficas. New York: Routledge, 2001.

Kaufman, Michael T. "Obituary: Stokely Carmichael." *New York Times*, November 16, 1998.

Keating, Edward M. *Free Huey!* Berkeley, Calif.: Ramparts Press, 1971.

Keeling, Kara. *The Witch's Flight: The Cinematic, the Black Femme, and the Image of Common Sense*. Durham, N.C.: Duke University Press, 2007.

Kelley, Robin D. G. *Race Rebels: Culture Politics and the Black Working Class*. New York: Free Press, 1994.

Kellogg, Charles Flint. *NAACP: A History of the National Association for the Advancement of Colored People*, vol. 1, *1909–1920*. Baltimore: Johns Hopkins University Press, 1967.

King, Martin Luther, Jr. *Why We Can't Wait*. New York: Harper and Row, 1964.

King, Mary, *Freedom Song: A Personal Story of the 1960s Civil Rights Movement*. New York: William Morrow, 1987.

Klandermans, Bert, and Hank Johnston, eds. *Social Movements and Culture*. Minneapolis: University of Minnesota Press, 1995.

Knabb, Ken, ed. *Situationist International Anthology*. Berkeley, Calif.: Bureau of Public Secrets, 1981.

Lacan, Jacques. *Écrits: A Selection*. New York: W. W. Norton, 1977.

Lang, Robert, ed. *The Birth of a Nation: D. W. Griffith, Director*. New Brunswick, N.J.: Rutgers University Press, 1994.

Langa, Helen. "Two Antilynching Art Exhibitions: Politicized Viewpoints, Racial Perspectives, Gendered Constraints." *American Art* 13, no. 1 (Spring 1999): 11–39.

Laraña, Enrique, Hank Johnston, and Joseph R. Gusfield, eds. *New Social Movements: From Ideology to Identity*. Philadelphia: Temple University Press, 1994.

Lawson, Stephen F., and Charles Payne. *Debating the Civil Rights Movement, 1945–1968*. Lanham, Md.: Rowman and Littlefield, 1998.

Lazerow, Jama, and Yohuru Williams, eds. *In Search of the Black Panther Party: New Perspectives on a Revolutionary Movement*. Durham, N.C.: Duke University Press, 2006.

Lester, Julius. *All Is Well*. New York: William Morrow, 1976.

———. *Look Out, Whitey! Black Power's Gon' Get Your Mama!* New York: Grove Press, 1968.

Lewis, David Levering, ed. *The Portable Harlem Renaissance Reader*. New York: Penguin Books, 1994.

———. *W. E. B. Du Bois: The Fight for Equality and the American Century, 1919–1963*. New York: Henry Holt, 2000.

Lewis, John, with Michael D'Orso. *Walking with the Wind: A Memoir of the Movement*. New York: Simon and Schuster, 1998.

Lhamon, W. T., Jr. *Raising Cain: Blackface Performance from Jim Crow to Hip Hop*. Cambridge, Mass.: Harvard University Press, 1998.

Lichtendorf, Vivian. "Road to Freedom: Interview with Julian Cox." *art: 21*, June 3, 2009, <http://blog.art21.org/2009/06/03/road-to-freedom-interview-with-julian-cox/>. August 15, 2009.

Linebaugh, Peter, and Marcus Rediker. *The Many-Headed Hydra: Sailors, Slaves, Commoners, and the Hidden History of the Revolutionary Atlantic*. Boston: Beacon Press, 2000.

Ling, Peter J., and Sharon Monteith, eds. *Gender in the Civil Rights Movement.* New York: Garland, 1999.

Liss, Andrea. *Trespassing through Shadows: Memory, Photography and the Holocaust.* Minneapolis: University of Minnesota Press, 1998.

Long, Worth. *We'll Never Turn Back.* Washington, D.C.: Smithsonian Performing Arts, 1980.

Lott, Eric. *Love and Theft: Blackface Minstrelsy and the American Working Class.* New York: Oxford University Press, 1995.

Lowe, Lisa. *Immigrant Acts: On Asian American Cultural Politics.* Durham, N.C.: Duke University Press, 1996.

Lyon, Danny. *Memories of the Southern Civil Rights Movement.* Chapel Hill: University of North Carolina Press, 1992.

———. *Photo Film, 1959–1990.* Germany: Edition Braus, 1991.

Mao, Tse-tung. *Quotations from Chairman Mao Tse-tung.* New York: Bantam Books, 1967.

Marable, Manning. *Race, Reform, and Rebellion: The Second Reconstruction in Black America, from 1945 to 1982.* Jackson: University Press of Mississippi, 1984.

Marable, Manning, Leith Mullings, and Sophie Spencer-Wood. *Freedom: A Photographic History of the African American Struggle.* London: Phaidon, 2002.

Margolick, David. *Strange Fruit: The Biography of a Song.* New York: Ecco Press, 2001.

Marriott, David. *On Black Men.* New York: Columbia University Press, 2000.

Martin, Courtney J. "Leslie Hewitt." In *Frequency*, edited by Thelma Golden and Christine Y. Kim. New York: Studio Museum in Harlem, 2005.

Martinez, Elizabeth, ed. *Letters from Mississippi: Reports from Civil Rights Volunteers and Freedom School Poetry of the 1964 Freedom Summer.* Brookline, Mass.: Zephyr Press, 2002. (Originally published in 1965)

Matthews, Tracye. "'No One Ever Asks What a Man's Role in the Revolution Is': Gender Politics and Leadership in the Black Panther Party, 1966–71." In *Sisters in the Struggle: African American Women in the Civil Rights–Black Power Movement*, edited by Bettye Collier-Thomas and V. P. Franklin. New York: New York University Press, 2001.

Maurantonio, Nicole. "Crisis, Race, and Journalistic Authority in Postwar Philadelphia." PhD diss., University of Pennsylvania, 2009.

McAdam, Doug. *Freedom Summer.* New York: Oxford University Press, 1988.

———. *Political Process and the Development of Black Insurgency 1930–1970.* Chicago and London: University of Chicago Press, 1982.

McClintock, Anne. *Imperial Leather: Race, Gender and Sexuality in the Colonial Contest.* New York: Routledge, 1995.

McDowell, Deborah E. "Viewing the Remains: A Polemic on Death, Spectacle, and the [Black] Family" In *The Familial Gaze*, edited by Marianne Hirsch. Hanover, N.H.: University Press of New England, 1999.

McGovern, James R. *Anatomy of a Lynching: The Killing of Claude Neal.* Baton Rouge: Louisiana State University Press, 1992.

Meier, August, Jr., John Bracey, and Elliot Rudwick, eds. *Black Protest in the Sixties.* New York: Markus Wiener, 1991.

Metress, Christopher. *Emmett Till: A Documentary Narrative.* Charlottesville: University of Virginia Press, 2002.

Mirzoeff, Nicholas. "The Shadow and the Substance: Race, Photography and the Index." In *Only Skin Deep: Changing Visions of the American Self*, edited by Coco Fusco and Brian Wallis. New York: Harry N. Abrams, 2003.

Mitchell, W. J. T. *Picture Theory: Essays on Verbal and Visual Representation*. Chicago: University of Chicago Press, 1994.

Monges, Miriam Ma'at-Ka-Re. "'I Got a Right to the Tree of Life': Afrocentric Reflections of a Former Community Worker." In *The Black Panther Party Reconsidered*, edited by Charles E. Jones. Baltimore, Md.: Black Classic Press, 1998.

Monson, Ingrid. "Monk Meets SNCC." *Black Music Research Journal* 19, no. 2 (Autumn 1999): 187–200.

Moody, Anne. *Coming of Age in Mississippi*. New York: Dell, 1968.

Moore, Charles, and Michael Durham. *Powerful Days: The Civil Rights Photography of Charles Moore*. New York: Stewart, Tabori and Chang, 1991.

Morley, David, and Kuan-Hsing Chen, eds. *Stuart Hall: Critical Dialogues in Cultural Studies*. New York: Routledge, 1996.

Morris, Aldon D. *The Origins of the Civil Rights Movement: Black Communities Organizing for Change*. New York: Free Press, 1984.

Morrison, Toni, ed. *Race-ing Justice, En-gendering Power: Essays on Anita Hill, Clarence Thomas, and the Construction of Social Reality*. New York: Pantheon Books, 1992.

Moten, Fred. *In the Break: The Aesthetics of the Black Radical Tradition*. Minneapolis: University of Minnesota Press, 2003.

Moutoussamy-Ashe, Jeanne. *Viewfinders: Black Women Photographers*. New York: Dodd, Mead, 1986.

Murray, Paul T. *The Civil Rights Movement: References and Resources*. New York: G. K. Hall, 1993.

Nancy, Jean-Luc. "Finite History." In *States of Theory*, edited by David Carroll. New York: Columbia University Press, 1990.

Nasstrom, Kathryn L. "Down to Now: Memory, Narrative, and Women's Leadership in the Civil Rights Movement in Atlanta, Georgia." In *The Civil Rights Movement in American Memory*, edited by Renee Romano and Leigh Raiford. Athens: University of Georgia Press, 2006.

Natanson, Nicholas. *The Black Image in the New Deal: The Politics of FSA Photography*. Knoxville: University of Tennessee Press, 1992.

National Association for the Advancement of Colored People. *An Appeal to the Conscience of the Civilized World*. New York: NAACP, 1920.

———. *Notes on Lynching in the United States*. New York: NAACP, 1912.

———. *Thirty Years of Lynching in the United States, 1889–1918*. New York: NAACP, 1919.

Nelson, Alondra. *Body and Soul: The Black Panther Party and the Politics of Race and Health*. Berkeley and Los Angeles: University of California, forthcoming.

Newhall, Beaumont. *The History of Photography, from 1839 to the Present Day*. New York: Museum of Modern Art, 1982.

Newton, Huey. *The Genius of Huey P. Newton, Minister of Defense, Black Panther Party*. San Francisco: Ministry of Information, Black Panther Party, 1970.

———. *Revolutionary Suicide*. Harcourt Brace Jovanovich, 1973.

———. *To Die For the People*. New York: Random House, 1972.

New-York Historical Society. "Without Sanctuary: Lynching Photography in America." Press release, n.d., <www.nyhistory.org/prelease.html>. February 2, 2003.

Nora, Pierre. "Between Memory and History: *Les Lieux de Mémoire.*" In *History and Memory in African-American Culture,* edited by Geneviève Fabre and Robert O'Meally. New York: Oxford University Press, 1994.

Obama, Barack. "Victory Speech." *New York Times,* November 4, 2008, <http://elections .nytimes.com/2008/results/president/speeches/obama-victory-speech.html>. 18 August 2009.

Olick, Jeffrey K. "Collective Memory: The Two Cultures." *Sociological Theory* 17, no. 3 (November 1999): 333–48.

Omi, Michael, and Howard Winant. *Racial Formation in the United States: From the 1960's to the 1990's.* New York: Routledge, 1994.

Painter, Nell Irvin. *Sojourner Truth: A Life, a Symbol.* New York: W. W. Norton, 1996.

"The Panthers and the Law." *Newsweek,* February 23, 1970.

Park, Marlene. "Lynching and Antilynching: Art and Politics in the 1930's." *Prospects* 18 (1993): 311–65.

Patterson, Orlando. *Rituals of Blood: Consequences of Slavery in Two American Centuries.* New York: Civitas, 1999.

Payne, Charles M. *I've Got the Light of Freedom: The Organizing Tradition and the Mississippi Freedom Struggle.* Berkeley: University of California Press, 1995.

Pearson, Hugh. *Shadow of the Panther.* New York: Addison-Wesley, 1994.

Peebles, Mario Van, Ula Y. Taylor, and J. Tarika Lewis. *Panther: A Pictorial History of the Black Panthers and the Story behind the Film.* New York: New Market Press, 1995.

Pinney, Christopher, and Nicholas Peterson, eds. *Photography's Other Histories.* Durham, N.C.: Duke University Press, 2003.

Pollack, Harriet, and Christopher Metress, eds. *Emmett Till in Literary Memory and Imagination.* Baton Rouge: Louisiana State University Press, 2008.

Powell, Richard J. *Cutting a Figure: Fashioning Black Portraiture.* Chicago: University of Chicago Press, 2008.

Price, William A. "SNCC Charts a Course: An Interview with Stokely Carmichael, Chairman, Student Nonviolent Coordinating Committee." *National Guardian,* June 4, 1966.

Raeburn, John. *A Staggering Revolution: A Cultural History of Thirties Photography.* Urbana and Chicago: University of Illinois Press, 2006.

Raiford, Leigh. "'Come Let Us Build a New World Together': SNCC and Photography of the Civil Rights Movement." *American Quarterly* 59, no. 4 (December 2007): 1129– 57, <http://muse.jhu.edu/journals/american_quarterly/v059/59.4raiford.pdf>.

———. "The Consumption of Lynching Images." In *Only Skin Deep: Changing Visions of the American Self,* edited by Coco Fusco and Brian Wallis. New York: Harry N. Abrams, 2003.

———. "Restaging Revolution: Black Power, *Vibe* Magazine, and Photographic Memory." In *The Civil Rights Movement in American Memory,* edited by Renee Romano and Leigh Raiford. Athens, Ga.: University of Georgia Press, 2006.

Raines, Howell. *My Soul Is Rested: Movement Days in the Deep South Remembered.* New York: Penguin Books, 1983.

Randall, Herbert, and Bobs M. Tusa. *Faces of Freedom Summer*. Tuscaloosa: University of Alabama Press, 2001.

Ransby, Barbara. *Ella Baker and the Black Freedom Movement: A Radical Democratic Vision*. Chapel Hill: University of North Carolina Press, 2003.

Raper, Arthur. *The Tragedy of Lynching*. Chapel Hill: University of North Carolina Press, 1933.

Reid, Mark. *Redefining Black Film*. Berkeley: University of California Press, 1993.

Rhodes, Jane. *Framing the Panthers: The Spectacular Rise of a Black Power Icon*. New York: New Press, 2007.

Riis, Jacob. *How the Other Half Lives*. New York: Dover Publications, 1971.

Roach, Joseph. *Cities of the Dead: Circum-Atlantic Performance*. New York: Columbia University Press, 1996.

Roberts, Gene, and Hank Klibanoff. *The Race Beat: The Civil Rights Struggle and the Awakening of a Nation*. New York: Vintage, 2006.

Robnett, Belinda. *How Long? How Long?: African-American Women in the Struggle for Civil Rights*. New York: Oxford University Press, 1997.

Rogin, Michael. *Blackface, White Noise: Jewish Immigrants in the Hollywood Melting Pot*. Berkeley: University of California Press, 1998.

Romano, Renee, and Leigh Raiford, eds. *The Civil Rights Movement in American Memory*. Athens: University of Georgia Press, 2006.

Royster, Jacqueline Jones, ed. *Southern Horrors and Other Writings: The Anti-Lynching Campaign of Ida B. Wells, 1892–1900*. Boston: Bedford Books, 1997.

Rushdy, Ashraf. "The Exquisite Corpse." *Transition* 9.3 (2000): 70–77.

Rydell, Robert, ed. *The Reason Why the Colored American Is Not in the World's Columbian Exposition*. Urbana: University of Illinois Press, 1999. (Originally published in 1893)

Sayre, Nora. "Politics." *Esquire*, January 1971: 36–42.

Scarry, Elaine. *The Body in Pain: The Making and Unmaking of the World*. New York: Oxford University Press, 1985.

Schecter, Patricia A. *Ida B. Wells-Barnett and American Reform, 1880–1930*. Chapel Hill: University of North Carolina Press, 2001.

Schwarz, Benjamin. "The Killing Fields, Part One." *Los Angeles Times*, February 13, 2000, <http://www.latimes.com>. January 20, 2003.

Scott, David. "Introduction: On the Archaeologies of Black Memory." *Small Axe* 26 (June 2008): v–xvi.

Scott, James C. *Domination and the Arts of Resistance: Hidden Transcripts*. New Haven, Conn.: Yale University Press, 1990.

Seale, Bobby. *A Lonely Rage*. New York: Times Books, 1978.

———. *Seize the Time*. New York: Random House, 1970.

Sekula, Allan. "The Body and the Archive." In *The Contest of Meaning: Critical Histories of Photography*, edited by Richard Bolton. Cambridge, Mass.: MIT Press, 1989.

———. "On the Invention of Photographic Meaning." In *Photography in Print: Writings from 1816 to the Present*, edited by Vicki Goldberg. New York: Simon and Schuster, 1981.

Sellers, Cleveland. *The River of No Return: The Autobiography of a Black Militant and the Life and Death of SNCC*. New York: William Morrow, 1973.

Shakur, Assata. *Assata: An Autobiography*. Chicago: Lawrence Hill Books, 1987.

Shames, Stephen. *The Black Panthers*. New York: Aperture, 2006.

Singh, Nikhil Pal. *Black Is a Country: Race and the Unfinished Struggle for Democracy.*
Cambridge, Mass.: Harvard University Press, 2004.

———. "The Black Panthers and the 'Undeveloped Country' of the Left." In *The Black
Panther Party Reconsidered*, edited by Charles E. Jones. Baltimore, Md.: Black
Classic Press, 1998.

Sirmans, Franklin. "Art Chronicle." In *30 Americans*, edited by Franklin Sirmans and
Rubell Family. Miami: Rubell Family Collection, 2009.

———. "Deborah Grant." In *Freestyle*, edited by Thelma Golden. New York: Studio
Museum in Harlem, 2001.

Sligh, Clarissa. "Reliving My Mother's Struggle." In *Liberating Memory: Our Work and
Our Working-Class Consciousness*, edited by Janet Zandy. New Brunswick, N.J.:
Rutgers University Press, 1994.

Smith, Cherise. "In Black and White: Constructing History and Meaning in Civil
Rights Photography." In *Let My People Go: Cairo, Illinois 1967–1973*, photographs
by Preston Ewing Jr., edited by Jan Peterson Roddy. Carbondale: Southern Illinois
University Press, 1996.

Smith, Gary, ed. *Benjamin: Philosophy, History, Aesthetics*. Chicago: University of
Chicago Press, 1989.

Smith, Shawn Michelle. *American Archives: Gender, Race and Class in Visual Culture.*
Princeton, N.J.: Princeton University Press, 1999.

———. *Photography on the Color Line: W. E. B. Du Bois, Race, and Visual Culture.*
Durham, N.C.: Duke University Press, 2004.

Snead, James. *White Screens, Black Images: Hollywood from the Dark Side*. Edited by
Colin MacCabe and Cornel West. New York: Routledge, 1994.

Solanas, Fernando, and Octavio Getino. "Towards a Third Cinema: Notes and
Experiences for the Development of a Cinema of Liberation in the Third World." In
Twenty-five Years of the New Latin American Cinema, edited by Michael Chanan.
London: BFI, 1983.

Sontag, Susan. *At the Same Time: Essays and Speeches*. New York: Farrar, Straus and
Giroux, 2007.

———. *On Photography*. New York: Farrar, Straus and Giroux, 1977.

———. *Regarding the Pain of Others*. New York: Picador, 2003.

Spillers, Hortense. "Mama's Baby, Papa's Maybe: An American Grammar Book."
diacritics 17, no. 2 (Summer 1987): 65–81.

Springer, Kimberly. *Living for the Revolution: Black Feminist Organizations, 1968–1980.*
Durham, N.C.: Duke University Press, 2005.

Stange, Maren. *Symbols of Ideal Life: Social Documentary Photography in America,
1890–1950*. Cambridge, Mass.: Harvard University Press, 1989.

Steele, Shelby. *The Content of Our Character: A New Vision of Race in America*. New
York: Harper Perennial, 1991.

Stewart, Jacqueline Najuma. *Migrating to the Movies: Cinema and Black Urban
Modernity*. Berkeley: University of California Press, 2005.

Stewart, Kathleen. *A Space on the Side of the Road*. Princeton, N.J.: Princeton University
Press, 1996.

Stott, William. *Documentary Expression and Thirties America*. New York: Oxford University Press, 1973.

Sussman, Elizabeth, ed., *On the Passage of a Few People through a Rather Brief Moment in Time: The Situationist International, 1957–1972*. Cambridge, Mass.: MIT Press, 1989.

Tagg, John. *The Burden of Representation: Essays on Photographies and Histories*. Minneapolis: University of Minnesota Press, 1993.

———. "The Currency of the Photograph." In *Thinking Photography*, edited by Victor Burgin. New York: Palgrave Macmillan, 1982.

———. *The Disciplinary Frame: Photographic Truths and the Capture of Meaning*. Minneapolis: University of Minnesota Press, 2009.

Taussig, Michael. *Shamanism, Colonialism, and the Wild Man: A Study in Terror and Healing*. Chicago and London: University of Chicago Press, 1987.

Taylor, John. *Body Horror: Photojournalism, Catastrophe and War*. New York: New York University Press, 1998.

Taylor, Ula Y. *The Veiled Garvey: The Life and Times of Amy Jacques Garvey*. Chapel Hill: University of North Carolina Press, 2002.

Telfair Museum of Art. *Freedom's March: Photographs of the Civil Rights Movement in Savannah by Frederick C. Baldwin*. Athens: University of Georgia Press, 2008.

Toll, Robert C. *Blacking Up: The Minstrel Show in Nineteenth-Century America*. New York: Oxford University Press, 1974.

Tolnay, Stewart Emory, and E.M. Beck. *A Festival of Violence: An Analysis of Southern Lynchings, 1882–1930*. Urbana: University of Illinois Press, 1995.

Torres, Sasha. *Black, White, and in Color: Television and Black Civil Rights*. Princeton, N.J.: Princeton University Press, 2003.

Trachtenberg, Alan. *Reading American Photographs: Images as History—Matthew Brady to Walker Evans*. New York: Hill and Wang, 1989.

———, ed. *Classic Essays on Photography*. New Haven, Conn.: Leete's Books, 1980.

Turner, Patricia A. *Ceramic Uncles and Celluloid Mammies: Black Images and Their Influence on Culture*. New York: Anchor Books, 1994.

U.S. House of Representatives, Staff Study by the Committee on Internal Security, *The Black Panther Party: Its Origin and Development as Reflected in Its Official Weekly Newspaper* The Black Panther Black Community News Service, 91st Cong., 2nd sess., October 6, 1970. Labadie Collection at the University of Michigan, Ann Arbor.

Van Deburg, William L. *New Day in Babylon: The Black Power Movement and American Culture, 1965–1975*. Chicago: University of Chicago Press, 1992.

Vendryes, Margaret Rose. "Hanging on Their Walls: An Art Commentary on Lynching; The Forgotten 1935 Art Exhibition." In *Race Consciousness: African-American Studies for the New Century*, edited by Judith Jackson Fossett, and Jeffrey A. Tucker. New York: New York University Press, 1997.

Vincent, Frederick. "'Party Music': The Story of the Lumpen, Black Power, and the Soul of the Revolution." PhD diss., University of California–Berkeley, 2008.

Visions of Peace and Justice: San Francisco Bay Area, 1974–2007. Berkeley, Calif.: Inkworks Press, 2007.

Wajda, Shirley Teresa. "History Writing, with Light." *Reviews in American History* 26, no. 3 (1998): 565–74.

Wakayama, Tamio. *Signs of Life*. Canada: Coach House Press, 1969.

Wallace, Maurice O. *Constructing the Black Masculine: Identity and Ideality in African American Men's Literature and Culture, 1775–1995*. Durham, N.C.: Duke University Press, 2003.

Wallace, Michele. *Black Macho and the Myth of the Superwoman*. New York: Warner Books, 1980.

——. *Dark Designs and Visual Culture*. Durham, N.C.: Duke University Press, 2004.

——. "Race, Gender and Psychoanalysis in Forties Film: *Lost Boundaries, Home of the Brave*, and *The Quiet One*." In *Black American Cinema*, edited by Manthia Diawara. New York: Routledge, 1993.

Wells, Carol A. "Have Posters, Will Travel." In *Visions of Peace and Justice: San Francisco Bay Area, 1974–2007*. Berkeley, Calif.: Inkworks Press, 2007.

Wells, Ida B. *A Red Record* [1895]. In *Southern Horrors and Other Writings: The Anti-Lynching Campaign of Ida B. Wells, 1892–1900*, edited by Jacqueline Jones Royster. Boston: Bedford Books, 1997.

Wells, Ida B., with Alfreda M. Duster. *Crusade for Justice: The Autobiography of Ida B. Wells*. Chicago: University of Chicago Press, 1970.

Wells-Barnett, Ida B. *On Lynchings*. New York: Arno Press, 1969.

Wexler, Laura. "Black and White and Color: American Photographs at the Turn of the Century." *Prospects* 13 (1988): 341–90.

——. "Seeing Sentiment: Photography, Race and the Innocent Eye." In *The Familial Gaze*, edited by Marianne Hirsch. Hanover, N.H.: University Press of New England, 1999.

——. *Tender Violence: Domestic Visions in an Age of U.S. Imperialism*. Chapel Hill: University of North Carolina Press, 2001.

White, Walter. *Rope and Faggot: A Biography of Judge Lynch*. New York: Alfred A. Knopf, 1929.

Whitfield, Stephen J. *A Death in the Delta: The Story of Emmett Till*. Baltimore, Md.: Johns Hopkins University Press, 1988.

Wiegman, Robyn. *American Anatomies: Theorizing Race and Gender*. Durham, N.C.: Duke University Press, 1995.

Williams, Juan. *Eyes on the Prize: America's Civil Rights Years, 1954–65*. New York: Viking Press, 1987.

Williams, Patricia. "Diary of a Mad Law Professor: Without Sanctuary." *Nation*, February 14, 2000, <http://www.thenation.com>. March 1, 2000.

Williams, Raymond. *Marxism and Literature*. Oxford: Oxford University Press, 1977.

Willis, Deborah. *An Illustrated Bio-Bibliography of Black Photographers, 1940–1988*. New York: Garland, 1988.

——. *Let Your Motto Be Resistance: African American Portraits*. Washington, D.C.: Smithsonian, 2007.

——. *Reflections in Black: A History of Black Photography, 1840 to the Present*. New York: W. W. Norton, 2000.

——, ed. *Picturing Us: African-American Identity in Photography*. New York: New Press, 1994.

Wilson, J. Finley. *The Mockery of Harding: An Open Letter*. Washington, D.C.: NAACP, 1922.

Wolfe, Tom. *Radical Chic and Mau-Mauing the Flak Catchers*. New York: Farrar, Straus and Giroux, 1970.

———. "Radical Chic: That Party at Lenny's." *New York*, June 8, 1970, <http://nymag.com/news/features/46170/>. July 18, 2009.

Wollen, Peter. "Bitter Victory: The Art and Politics of the Situationist International." In *On the Passage of a Few People through a Rather Brief Moment in Time: The Situationist International, 1957–1972*, edited by Elizabeth Sussman. Cambridge, Mass.: MIT Press, 1989.

———. *Raiding the Icebox: Reflections on Twentieth Century Culture*. London: Verso, 1993.

Wood, Amy Louise. *Lynching and Spectacle: Witnessing Racial Violence in America, 1890–1940*. Chapel Hill: University of North Carolina Press, 2009.

Wypijewski, Jo Ann. "Executioners' Songs." *Nation*, March 27, 2000, <http://www.thenation.com>. April 1, 2000.

Yerba Buena Center for the Arts. "Risk and Response: Black Panther Rank and File." *Life Amplified*, March 2006.

Young, Cynthia Ann. *Soul Power: Culture, Radicalism, and the Making of a U.S. Third World Left*. Durham, N.C.: Duke University Press, 2006.

Zangrando, Robert L. *The NAACP Crusade against Lynching, 1909–1950*. Philadelphia: Temple University Press, 1980.

Zinn, Howard. *SNCC: The New Abolitionists*. Boston: Beacon Press, 1964.

graphs and, 17, 53, 57–58, 60, 61; "The Shame of America" (advertisement) and, 30–32, 58, 59, 61